THE
ROYAL WOMEN
OF AMARNA

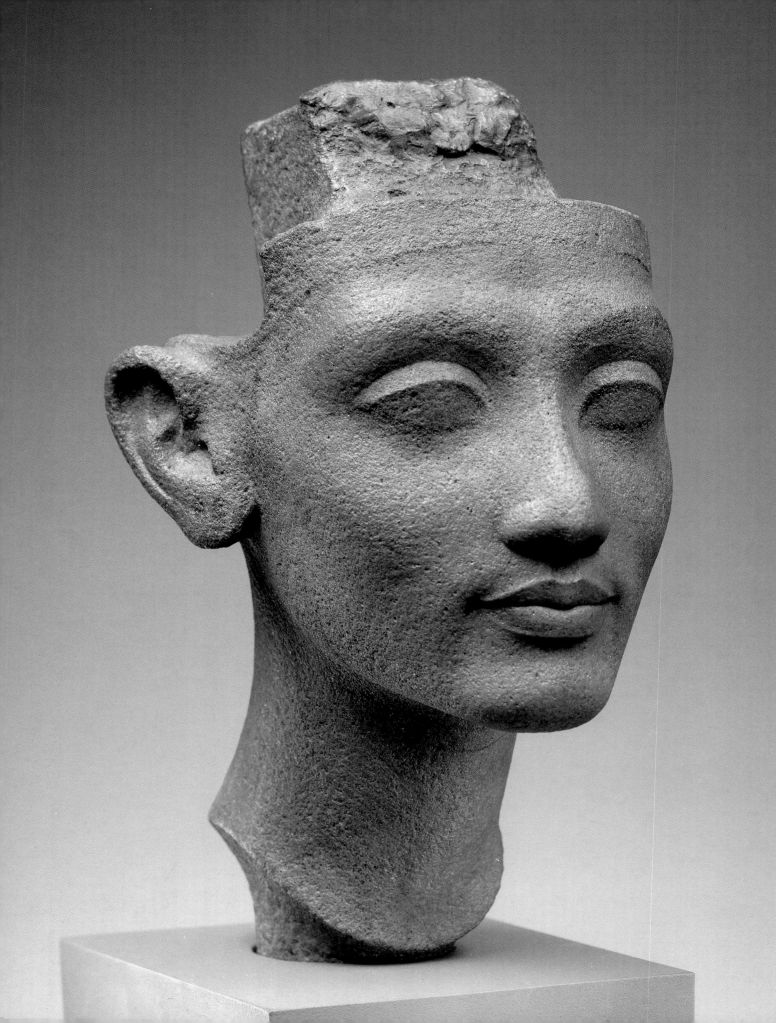

THE ROYAL WOMEN OF AMARNA

Images of Beauty from Ancient Egypt

DOROTHEA ARNOLD

With contributions by
James P. Allen and L. Green

THE METROPOLITAN MUSEUM OF ART
Distributed by Harry N. Abrams, Inc., New York

This publication is issued in conjunction with the exhibition "Queen Nefertiti and the Royal Women: Images of Beauty from Ancient Egypt," held at The Metropolitan Museum of Art, New York, October 8, 1996–February 2, 1997.

The exhibition is made possible in part by Lewis B. and Dorothy Cullman.

This publication is made possible by the Doris Duke Fund for Publications.

Published by The Metropolitan Museum of Art
John P. O'Neill, Editor in Chief
Teresa Egan, Editor
Bruce Campbell, Designer
Richard Bonk, Production
Penny Jones, Bibliographer
Robert Weisberg, Computer Specialist

Photography by Bruce White, except as noted in the List of Illustrations
Color separations by Prographics, Rockford, Illinois
Printed and bound by Meridian Printing Company, East Greenwich, Rhode Island

Jacket/Cover: Head of a princess from the Thutmose workshop at Amarna. Brown quartzite.
Ägyptisches Museum, Berlin
Frontispiece: Head of Nefertiti from the Thutmose workshop at Amarna. Yellow quartzite.
Ägyptisches Museum, Berlin

Library of Congress Cataloging-in-Publication Data
Arnold, Dorothea.
The royal women of Amarna: images of beauty from ancient Egypt /
Dorothea Arnold with contributions by James P. Allen and L. Green.
p. cm.
Catalogue for an exhibition, Oct. 8, 1996–Feb. 2, 1997, at The Metropolitan Museum of Art.
Includes bibliographical references and index.
ISBN 0-87099-816-1 (hc). – ISBN 0-87099-818-8 (pbk.) – ISBN 0-8109-6504-6 (Abrams)
1. Portrait sculpture, Egyptian—Egypt—Tell el-Amarna—
Exhibitions. 2. Portrait sculpture, Ancient—Egypt—Tell
el-Amarna—Exhibitions. 3. Amenhotep IV, King of Egypt—Family—Art—
Exhibitions. 4. Queens—Egypt—Tell el-Amarna—Portraits—Exhibitions.
5. Princesses—Egypt—Tell el-Amarna—Portraits—Exhibitions.
I. The Metropolitan Museum of Art (New York, N.Y.) II. Title.

NB1296.2.A75 1996
732'.8'0747471—dc20

96-34517
CIP

CONTENTS

DIRECTOR'S FOREWORD

The exhibition "Queen Nefertiti and the Royal Women: Images of Beauty from Ancient Egypt," to which this book serves as introduction and guide, came about through a fortunate coincidence involving two major collections of ancient Egyptian art. In 1995, a generous gift from Judith and Russell Carson enabled the Metropolitan Museum to undertake a much-needed gallery reconstruction and a totally new installation of the Museum's collection of art from the Amarna and the post-Amarna Periods, that is, the reign of the pharaoh Amenhotep IV / Akhenaten (ca. 1353–1336 B.C.) and the generation after him (ca. 1336–1295 B.C.). At virtually the same time, in May 1995, the Ägyptisches Museum in Berlin opened the first comprehensive display since 1939 of that museum's outstanding collection of Amarna art. This presentation was now possible because the reunification of Germany had brought together the two parts of the Berlin Egyptian art collection that World War II had divided into eastern and western sections. For the first time since the groundbreaking exhibition arranged in 1973 by Bernard V. Bothmer at The Brooklyn Museum, major works from Amarna could be seen together, with special emphasis on the finds from the studios of the sculptor Thutmose, which had been excavated by German archaeologists in 1912.

While studying our own collection, Dorothea Arnold, Lila Acheson Wallace curator in charge of the Museum's Department of Egyptian Art, had come to realize the importance of female images among the extant works of Amarna art. This impression was strengthened during her visit to the new display in Berlin whose centerpiece is the famous painted bust of Queen Nefertiti. But the Nefertiti icon does not by any means stand alone. The Metropolitan head of Queen Tiye in red quartzite (here, figs. 42, 44) finds an exquisite counterpart in Berlin's wooden head of the queen from Medinet el-Ghurab (figs. 23, 26), and the discourse on female beauty intriguingly opened by the artist of the Metropolitan's yellow jasper fragment (figs. 27, 29) is carried on and expanded in the Berlin

images of Queen Nefertiti (figs. 31, 65–69, 71, 72, 74) and her daughters (figs. 46–53). To unite—and in a way reunite—in an exhibition some of these remarkable sculptures under the common theme of the royal female image in Amarna art was an exciting possibility; and the thought that such an exhibition might accompany the opening of our own new Amarna display was irresistible. Indeed, both the new installation and the exhibition were initiated by Dorothea Arnold, to whom we are also indebted for this catalogue. Through the generosity of the Director of the Ägyptisches Museum und Papyrussammlung, Berlin, Professor Dietrich Wildung, the largest lender, and the cooperation of the General Director of the Staatliche Museen zu Berlin, Professor Wolf-Dieter Dube, as well as the other lenders mentioned below, the idea materialized in the present exhibition. We are most grateful as well to Lewis B. and Dorothy Cullman, whose financial support allowed us to proceed.

No major statement about ancient Egyptian art can be made, of course, without including at least some works from the rich collections of the Egyptian Museum, Cairo. The Cairo museum's General Director, Dr. Mohamed Saleh, was most cooperative and generous in allowing us to photograph and study the relevant works under his care. A number of crucial sculptures, above all the quartzite head of Nefertiti from Memphis (figs. 31, 65), the heads of princesses (figs. 50–53), an early head of Nefertiti (fig. 2), and two important sculptors' relief models (figs. 62, 108) could thus be incorporated into the enterprise. The Supreme Council of Antiquities of Egypt and its Secretary General, Professor Abdel Halim Nur el-Din, also lent significant support, and I want to thank them most sincerely for their cooperation.

From elsewhere, other sculptures could be included, such as the magnificent torso and the princess's bust from the Musée du Louvre. Paris (figs. 21, 22, 117–119) and works in the Petrie Museum, London; the Ashmolean Museum, Oxford; the Ny Carlsberg Glyptotek, Copenhagen; The Brooklyn Museum; the Museum of Fine Arts, Boston; the University Museum, Philadelphia;

and the Regio Museo Archeologico, Florence, thanks to the kind collaboration of these institutions.

The pharaoh who ascended the throne of Egypt in about 1353 B.C. as Amenhotep IV and later changed his name to Akhenaten was forgotten soon after his death, his memory lost even to later historians in Egypt, Greece, and Rome. Only in the middle of the last century was Akhenaten rediscovered by travelers and Egyptologists who visited—and later excavated—the ruins of his city at present-day Tell el-Amarna, between el-Minya and Asyut in Middle Egypt. From the ruins at Amarna, from inscriptions, reliefs, paintings, and sculptures the image of a remarkable personality has been resurrected. Founder of the world's oldest known monotheistic religion, Akhenaten propagated the belief in a single deity—the Aten, sun disk—whose ultimate manifestation was light itself. Its emphasis on the visible and tangible reality of all things, the here and now in life, had a deep and far-reaching impact on the culture and art of Egypt. Narrative reliefs and paintings included naturalistic details and lively gestures that replaced the often static representations of earlier periods. Sculptures in the round rendered the physical appearance of the king and members of his family and court in a personalized manner of unprecedented subtlety and refinement. Significantly, not only the king and male officials but to a large extent also the queen, queen mother, and other female members of the royal family and court were portrayed in this way. Such is the immediacy of these images that one comes away from contemplating them with the impression of knowing intimately a group of remarkable women who lived more than three thousand years ago, and of discovering an approach to art of a refinement, expressiveness, and originality of absolutely the highest order.

Philippe de Montebello
Director
The Metropolitan Museum of Art

ACKNOWLEDGMENTS

The author wishes to thank all those who contributed to "Queen Nefertiti and the Royal Women: Images of Beauty from Ancient Egypt," held at The Metropolitan Museum of Art, October 8, 1996–February 2, 1997. This exhibition was made possible in part by Lewis B. and Dorothy Cullman. The publication was made possible by the Doris Duke Fund for Publications.

Thanks go especially to the following institutions that made generous loans and to their directors and staff members who provided invaluable assistance and expertise. Berlin: Professor Dietrich Wildung, Director of the Ägyptisches Museum und Papyrussammlung; Cairo: Dr. Mohamed Saleh, Director General of the Egyptian Museum; London: Dr. Barbara Adams, Curator, the Petrie Museum; Oxford: Dr. Helen Whitehouse, in charge of the Egyptian collection, the Ashmolean Museum; Paris: Dr. Christiane Ziegler, Conservateur Général Chargée du Département des Antiquités Égyptiennes, Musée du Louvre.

Boston: Dr. Rita Freed and Dr. Peter Lacovara, the Museum of Fine Arts; Brooklyn: Dr. Richard Fazzini and Dr. James Romano, The Brooklyn Museum; Copenhagen: Dr. Mogen Jørgensen, Ny Carlsberg Glyptotek; Florence: Soprintendente Dott. Francesco Nicosia and Ispettore Dott. Maria Cristina Guidotti, Il Regio Museo Archeologico di Firenze; Munich: Dr. Sylvia Schoske, Staatliche Sammlung Ägyptischer Kunst; Philadelphia: Professor David Silverman and Jennifer R. Houser, University Museum, the University of Pennsylvania.

Warmly appreciated also were the loans from the Thalassic Collection (courtesy Mr. and Mrs. Theodore Halkedis) and the collection of Jack Josephson, New York, as well as from an anonymous collector.

All these individuals and institutions were not only willing to lend objects to the exhibition but also allowed the works of art in their collections to be photographed and studied, and staff members were most generous with their time and expertise. In Berlin, Dr.

Hannelore Kischkewitz made the field inventory of the Deutsche Orientgesellschaft's Amarna excavations available and graciously allowed us the use of her study for our work. Both she and Dr. Rolf Krauss took part in most informative discussions, and Dr. Krauss provided a number of rare publications. In Cairo, we were kindly and ably assisted by the curator of the New Kingdom section, Adel Mahmoud, and his colleagues, and in Paris, Christophe Barbotin and Geneviève Pierrat of the Musée du Louvre helped in every possible way. In Oxford, Dr. Helen Whitehouse and Mark Norman were our gracious hosts at the Ashmolean Museum, and in London Rosalind Janssen at the Petrie Museum gave welcome assistance. To all these colleagues, we extend our most grateful appreciation.

At the Metropolitan Museum first thanks are due to the director, Philippe de Montebello, without whose stimulating interest and encouragement nothing could have been achieved. Next, appreciation goes to John P. O'Neill, editor in chief, and his talented and efficient staff: Teresa Egan, editor; Bruce Campbell, designer; Richard Bonk, production manager; Penny Jones, bibliographer; Peter Rooney, indexer; and Robert Weisberg, computer specialist.

The photographs by Bruce White speak for themselves. It was a pleasure to work with such an accomplished, sensitive, and gifted photographer. Discussions with colleagues in the Museum's Department of Egyptian Art, especially James P. Allen (a contributing author) and Marsha Hill, but also Dieter Arnold and Catharine Roehrig, were of great importance to the formation of the thoughts and interpretations presented in this publication. Barry Girsh created the computer reconstructions of the Thutmose workshop (figs. 34, 35) and produced maps and other drawings. Anne Heywood of the Department of Objects Conservation lent her expertise to the preparation of the exhibition. Adela Oppenheim checked references, ably assisted by Laurel Flentye, and posed pertinent questions.

Alessandra Caropresi assembled a valuable collection of articles from periodicals, and Susan Allen was indefatigable in searching for literature not in the Museum's library. To all of them, heartfelt thanks.

Of the colleagues and friends from outside the Museum, I thank Dr. L. Green for participating in our project by providing the prosopographical essay and Dr. David Minnenberg for taking time from his busy schedule to review the anatomy of the human head with me and provide relevant literature. Ute Seiler Liepe restored the statuette of a female from a private collection (fig. 124). My sister and brother-in-law, Helene and Heinz Amtmann, welcomed me to their apartment in Berlin during the period of study and photography spent there. And my children, Felix and Anja, drove me to Paris during the railway strike of 1995.

ANKHU DJET NEHEH
(May they all live forever continually!)
D. A.

LIST OF ILLUSTRATIONS

(For an explanation of the dates, see Checklist of the Exhibition, p. 129.)

xi

CHRONOLOGY: THE AMARNA PERIOD

Absolute dates	Years in Akhenaten's reign	Political events and events in the royal family's life	Major art works
	Before Year 1	Amenhotep becomes crown prince; marries Nefertiti; Meretaten born	
ca. 1353	1	Amenhotep IV ascends the throne; early names of the Aten not in cartouches	Temple reliefs in traditional style
		Early names of the Aten in cartouches	Colossal statues at Karnak *(figs. 1, 2, 9)*
		sed-festival	Sandstone reliefs *(figs. 10, 11)*
		Meketaten born	
		Nefertiti adopts Nefernefruaten as second name	
ca. 1349	5	Decision to move to Amarna; Amenhotep IV changes name to Akhenaten	Boundary stelae X and M
ca. 1348	6	Affirmation of decision	Eight more boundary stelae with statues *(fig. 103)*
			Reliefs from walls and columns of Great Palace and other buildings *(figs. 14, 15, 17, 109)*
		Ankhesenpaaten is born	Great Temple sculptures *(fig. 16)*
			Torso of princess (Louvre) *(figs. 21, 22)*
			Head of Queen Tiye (Berlin) *(figs. 23, 26)*
		Nefernefruaten-Tasherit is born	Head of princess (Berlin) *(figs. 46–48)*
			Stela (Cairo) *(fig. 94)*
			Unfinished head of Nefertiti *(fig. 61)*
			Sculptor's model; bust of Nefertiti *(fig. 62)*
			Yellow jasper head fragment *(figs. 27, 29)*
			Shrine stela (Berlin) *(figs. 8, 88, 91, 97)*
ca. 1346	8	Last dated inscription with early name of the Aten	Boundary stelae completed
		Nefernefrure is born	Gypsum-plaster face of a man *(fig. 28)*
			Head of Queen Tiye (MMA) *(figs. 42, 44)*

Absolute dates	Years in Akhenaten's reign	Political events and events in the royal family's life	Major art works
			Gypsum-plaster head of Nefertiti (figs. 39, 40)
		Setepenre is born	Bust of Nefertiti (Berlin) (figs. 58, 60)
ca. 1342	12	First dated inscription with later name of the Aten	
		War in Nubia after incursion of people of the eastern desert	Memphis head of Nefertiti (figs. 31, 65)
		Tribute of the Nations festival	
			Reliefs from temples and ceremonial halls (figs. 75, 77, 100, 101)
			Torso of princess (Petrie Museum) (figs. 104–7)
			Fragmentary shrine stela (Berlin) (fig. 98)
			Sculptor's model with princess (Cairo) (fig. 108)
		Death of Meketaten	
ca. 1340	14	Death of Queen Tiye	Lid of canopic jar (fig. 116)
		Nefertiti becomes coruler(?)	Sculptor's model (Brooklyn) (fig. 81)
			Statuette of Nefertiti (figs. 68, 69, 71)
			Gypsum-plaster heads of women (figs. 36–38)
			Fragment of stela (Louvre) (figs. 93, 123)
		Death or disappearance of the minor queen Kiya	Yellow quartzite head of Nefertiti (figs. 66, 67)
			Heads of princesses (Cairo) (figs. 50–53)
ca. 1337	17	At Thebes, worship of Amun revived	Granodiorite head of Nefertiti (figs. 41, 72, 74)
ca. 1336		Death of Akhenaten	Statuette of princess (Philadelphia) (fig. 121)
	1 (of Smenkhkare)	Smenkhkare ascends the throne	
	1 (of Tutankhaten)	Tutankhaten ascends the throne	
ca. 1335	2 (of Tutankhaten)	The court leaves Amarna	
		Tutankhaten becomes Tutankhamun and traditional religion is reinstated	Statuette of princess (Louvre) (figs. 117–119)
			Woman (Florence) (fig. 122)

GENEALOGY: THE ROYAL FAMILY OF AMARNA

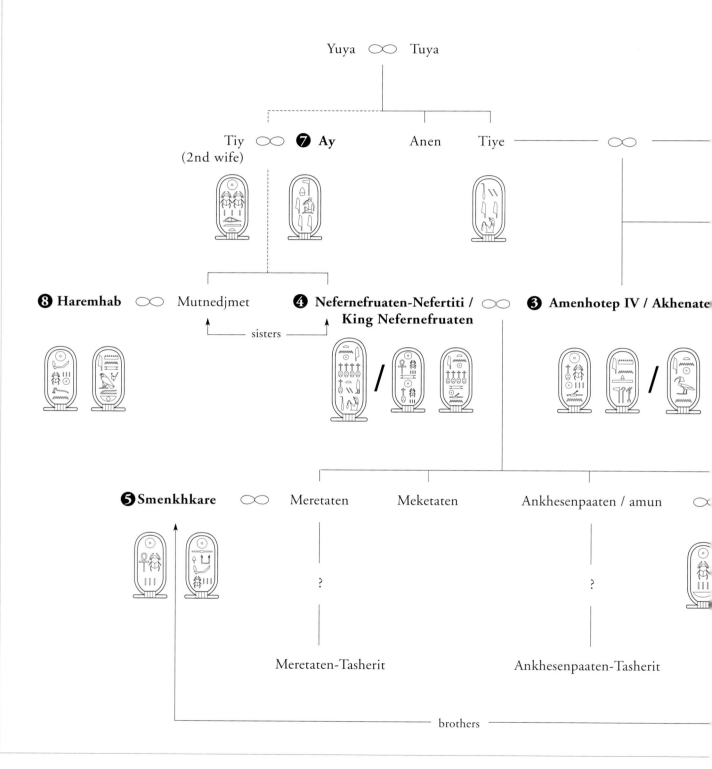

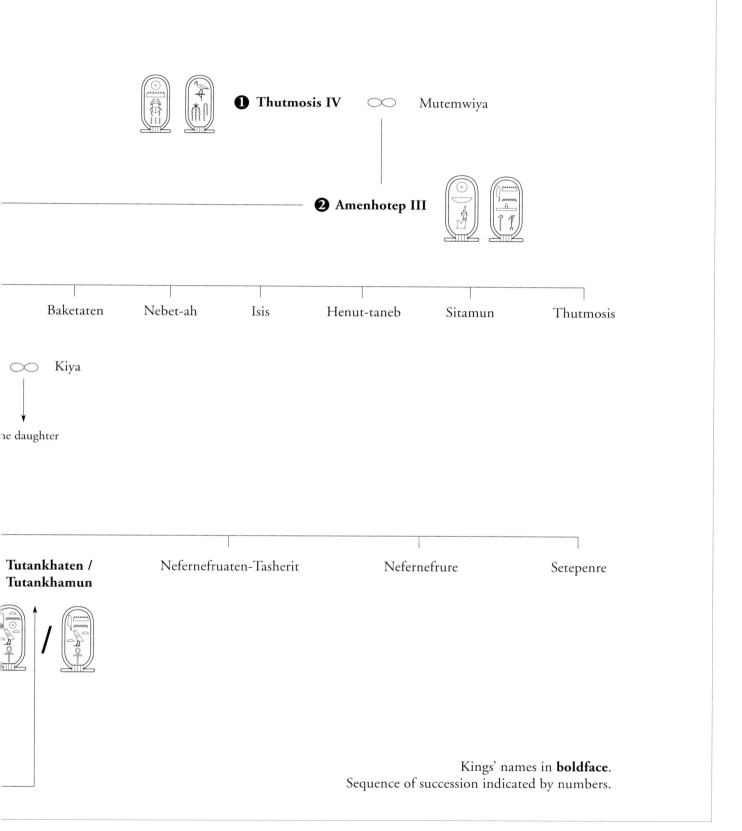

❶ Thutmosis IV ∞ Mutemwiya

❷ Amenhotep III

Baketaten Nebet-ah Isis Henut-taneb Sitamun Thutmosis

∞ Kiya

…e daughter

Tutankhaten /
Tutankhamun Nefernefruaten-Tasherit Nefernefrure Setepenre

Kings' names in **boldface**.
Sequence of succession indicated by numbers.

xxi

MEDITERRANEAN
SEA

SINAI

MEMPHIS

Faiyum

el-Lahun

Medinet
el-Ghurab

Serabit
el-Khadim

*Nile
River*

Hermopolis

Tell el-Amarna
(Akhetaten)

Meir

RED
SEA

THEBES

Aswan

NUBIA

E G Y P T

THE
ROYAL WOMEN
OF AMARNA

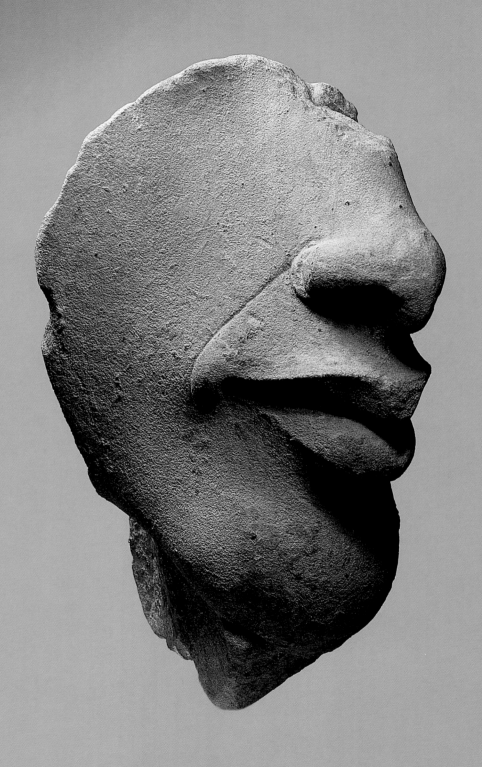

THE RELIGION OF AMARNA

JAMES P. ALLEN

For all its revolutionary aspects, the Amarna Period of Egyptian history was traditional in one central respect: each of its innovations was carried out in the name of—and in service to—religion.

The role of religion in the life of ancient Egypt can be difficult for modern minds to appreciate. In most contemporary societies, religion represents only one means by which human beings relate to the world around them, along with politics, science, and social mores. In addition to the values by which people govern and judge their behavior, religion today generally encompasses an individual's relationship to those aspects of life that cannot be explained "scientifically."

In ancient Egypt, as in other ancient societies, religion and science were one. Where modern science explains the universe in terms of a set of physical laws, ancient minds saw natural phenomena as the manifested wills of sentient beings: in other words, gods. In Egyptian thought, there were as many such beings as there are elements and forces in the universe: the sun (Re), the earth and sky (Geb and Nut), the atmosphere (Shu), the annual inundation (Hapy), life and growth (Osiris), order (Maat), disorder (Seth), and kingship (Horus)—to name only a few.

In simplest terms, the intellectual revolution known as the Amarna Period represented an attempt to replace this time-honored view of reality with one based on a single governing principle of life: a "sole god, with no other except him."[1]

The notion of a single ultimate principle did not originate at Amarna. Perhaps by as early as the Middle Kingdom (ca. 2040–1640 B.C.),[2] Egyptian theologians had come to believe that everything must finally derive from the creative power of a single divine force above and beyond the physical universe. This transcendent deity was called Hidden (Amun), because his nature was not evident in any of the world's elements or forces.[3] The Eighteenth Dynasty (the later part of which included the Amarna Period) witnessed a rise in the prominence of Amun in the Egyptian pantheon and in theological speculation about his role in the created universe.[4] Both movements focused on the daily manifestation of Amun's life-giving power through the light of the sun, in the form of the combined god Amun-Re, "whose rays illuminate at his emergence of the daytime."[5]

This "new solar theology"[6] was reformulated at the beginning of Amenhotep IV's reign. In the king's earliest inscriptions, the place of honor formerly occupied by Amun-Re was now given to the god Re Horus of the Akhet (Re-Horakhty), embodiment of the life-giving power of the sun (Re) as the dominant force in the universe (Horakhty).[7] Although this combined god had existed in the Egyptian pantheon since the Old Kingdom, under Amenhotep IV he received not only central prominence but also a ubiquitous new epithet, which described him as "Re-Horakhty, who becomes active from the Akhet in his identity as the light that is in the sun disk."[8] This didactic name serves as the credo of the Amarna revolution. In effect, it united standard Egyptian solar theology (Re-Horakhty) with a radical new concept of light as the ultimate force in the universe.

At first, the new god was portrayed as a falcon-headed man, the traditional symbol.[9] In Amenhotep's third or fouth year, however, the image was discarded, along with many other traditional forms of Egyptian art. From then on, the god was depicted only through the symbol of the sun disk with rays.[10] Although his earlier didactic name was retained in a set of double cartouches flanking the new image, elsewhere the god was referred to only as the Sun Disk (Aten).[11] At the same time, the king changed his given name (which identified him as Son of Re) from Amenhotep (Amun Is Content) to Akhenaten, which probably means "Effective for the Aten."[12]

Opposite: Fig. 1. Fragment from a colossal head of Amenhotep IV from Karnak. Sandstone. Staatliche Sammlung Ägyptischer Kunst, Munich

Despite these visual and textual references to the sun disk, however, Akhenaten's new religion did not involve worship of the sun per se. As the god's didactic name emphasized, the object of Akhenaten's devotion was rather "the light that is in the disk." The rayed sun disk that dominates Amarna art is not an icon of worship but simply a hieroglyph for *light*.[13]

The new religion seems initially to have tolerated the traditional Egyptian pantheon, although official texts avoid any mention of other gods after the royal family moved to Amarna, in the king's fifth year or later. Sometime between Year 8 and Year 12, however, Akhenaten's deity was elevated from the foremost among many gods to the one and only god. The older religion seems to have been officially banned, and the plural word *gods*—as well as the names of Amun and his consort Mut—was erased from monuments throughout the country.[14]

At the same time, the didactic name of Akhenaten's own god was altered to "The Sun, ruler of the Akhet, who becomes active from the Akhet in his identity as the light that comes in the sun disk." This involved three changes: substitution of "Sun, ruler of the Akhet" for "Re-Horakhty" ("Sun, Horus of the Akhet"); replacement of one word for light by another; and alteration of the phrase "that is in the sun disk" to "that comes in the sun disk." These changes not only removed all reference to older gods;[15] they also made clear the true object of Akhenaten's worship, which was light itself rather than the sun disk through which light comes into the world.

Though it is addressed initially to "the living Aten, who begins life," the great "Hymn to the Aten" from Amarna is equally clear about both the nature of the god and the distinction between the god and his vehicle:

When your movements disappear and you go to rest
 in the Akhet,
the land is in darkness, in the manner of death . . .
darkness a blanket, the land in stillness,
 with the one who makes them at rest in his Akhet.

The land grows bright once you have appeared in
 the Akhet,
shining in the sun disk by day.
When you dispel darkness and give your rays,
the Two Lands are in a festival of light.[16]

This and other Amarna texts emphasize the daily nature of the god's activity. Although there are occasional references to his original creation of the universe,[17] these are rare. Far more important is the fact that the god continues to re-create the world every day.[18]

This focus on the present rather than the eternal is one of the hallmarks of the Amarna Period and one of the features that set it off most strongly from traditional Egyptian culture. It is perhaps most recognizable in the immediate, dynamic quality of Amarna relief and painting, as compared with the more formal, static quality that usually characterizes Egyptian art. But it can be seen in other facets of Akhenaten's revolution as well: for example, in the adaptation of writing to reflect the contemporary spoken language. It even appears in the architectural innovation of *talatat*: buildings constructed of these small stones, which could be handled by one worker, could be put up very quickly, though they proved to be less enduring than structures erected with the multiton blocks of traditional Egyptian masonry.

Together with the emphasis on the present, Akhenaten's religion also stressed visible and tangible reality at the expense of the unseen and the mysterious. This undoubtedly contributed to the antagonism between the new theology and that of Amun, the "Hidden" par excellence. The traditional Egyptian temple was a place of mystery, with the god's image hidden within its innermost recess. In contrast, the Amarna temple was a place of light, its courts unroofed and even its doorways open to the sun.

Despite this apparent openness, however, the new religion was even more restrictive than its predecessor. Direct access to the new god was effectively limited to the king and his family. Images of the Aten show its rays presenting life to the king and queen alone. Private monuments of the time do not depict the beneficiary directly before the god, as they had prior to the Amarna Period; rather, they show the royal family itself as intermediary between the Aten and lesser mortals. Such features suggest that Akhenaten and his queen alone could worship the new god, and the texts themselves say as much: "There is no other who knows you except your son, Nefer-kheperu-re wa-en-re [Akhenaten]."[19] The rest of humanity was apparently constrained to worship Akhenaten himself, or the royal couple jointly, since "everyone who hurries on foot . . . you sustain them

for your son . . . Akhenaten . . . and the chief queen, his beloved."[20]

This situation is reflected in depictions of the royal family on typical Amarna "house stelae" (shrine stelae, see pp. 96–104), which were erected in private houses at Amarna.[21] With its sole god, the religion of Amarna faced a theological problem that had also confronted earlier Egyptian philosophers: in a culture that understood all creation as an act of birth, how can the generation of the universe from a single ultimate source be explained? The older solar theology had posited an answer in the concept of the Ennead—a group of nine deities descended from the god Atum, the original source of all matter.[22] In the Ennead, life began when Atum evolved into the first two gods, the twins Shu and Tefnut: "when he was one and evolved into three."[23] At Amarna, this older group of nine gods was replaced by a new Ennead, consisting of light, the ultimate origin of all life; the king and queen, the royal "twins" through whom life passes into the world;[24] and their six daughters. Here again, Akhenaten's religion commuted the abstract mystery of traditional Egyptian theology into the concrete reality of everyday life.

The Amarna texts leave no doubt as to the source of this radical new theology—Akhenaten himself:

My lord promoted me so that I might enact his
 teaching . . .
How fortunate is the one who hears your teaching
 of life,
for he will be satisfied from seeing you, and reach
 old age.[25]

He is the one who taught me, and I am telling you:
It is good to listen to it . . .
He [the king] makes his force against him who is
 ignorant of his teaching and his blessing to him
 who knows it.[26]

Perhaps in part because of this close association, the new religion did not long survive the death and ultimate condemnation of its founder as "the enemy of Amarna."[27]

Undoubtedly more serious in the Egyptian mind, however, were the intellectual limitations inherent in the new theology itself. Certainly, Akhenaten's philosophy—with its emphasis on the present, its rejection of mystery in favor of reality, and its insistence on the singleness of divinity—resonates more closely with modern thought than do the concepts of traditional Egyptian theology: witness, among others, Freud's attempt to make of Akhenaten "the mentor of Moses and the instigator of Jewish monotheism,"[28] and Breasted's characterization of him as "the world's first idealist and . . . the earliest monotheist . . . a brave soul, undauntedly facing the momentum of immemorial tradition, and thereby stepping out from the long line of conventional and colourless Pharaohs, that he might disseminate ideas far beyond and above the capacity of his age to understand."[29]

The Egyptians themselves, lacking such romantic hindsight, could only view Amarna theology in the context of their own religious traditions, and by that measure they found it wanting. In place of the traditional richness and diversity of Egyptian thought, it imposed a single-minded view of the universe—one which, in many respects, was less a religion than a natural philosophy.[30] Intellectually, its identification of the natural phenomenon of light as the ultimate principle of all life was less satisfying, if not also less sophisticated, than the belief in a divine power that existed above and beyond the phenomena of the created universe. And on the emotional level, this natural force was too impersonal and too far removed from the experience of daily life to fulfill the common human need for a recognizable god who could be addressed not only in hymns of awe but also in prayers of need.

Like many movements in the history of human thought, the Amarna revolution began with the insight of a single person; but like all too many such movements, it seems also to have degenerated eventually from liberating revelation to stifling fanaticism. What makes Amarna unique—and ultimately, perhaps, so continually fascinating—is its primacy: for the first time in recorded history, we are able to witness the profound effect that the thought of a single individual can have on human life.

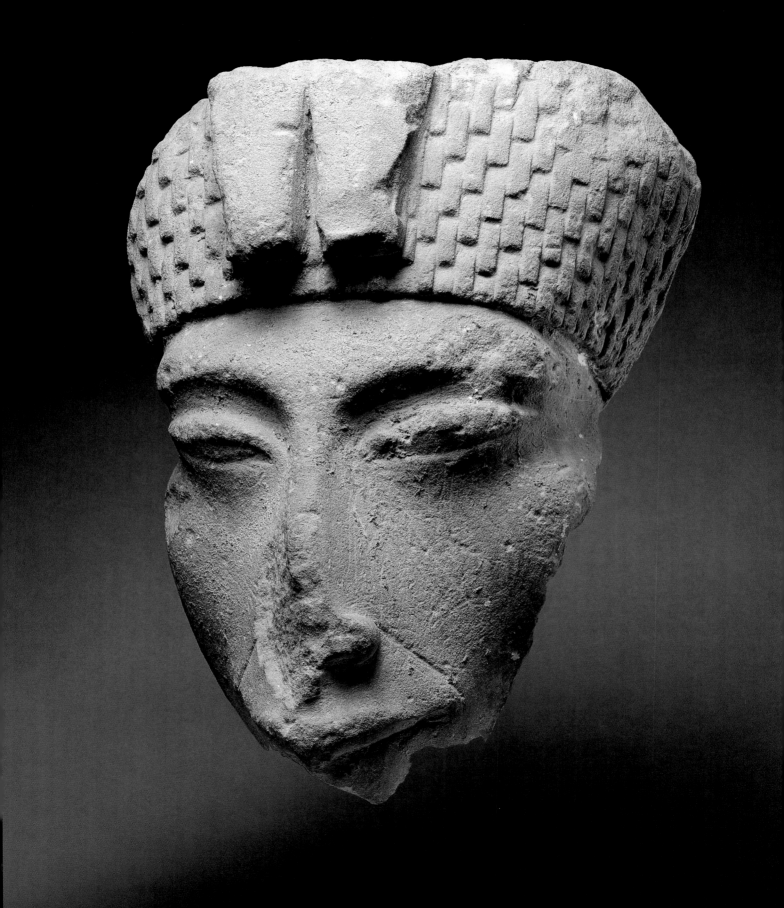

THE ROYAL WOMEN OF AMARNA: WHO WAS WHO

L . GREEN

The King's Chief Wife, King's Daughters,[1] and other royal women of Amarna have aroused much interest and controversy. Paradoxically, the controversies concerning these royal women arise in large part because far more information about them has survived than exists for almost all the other queens and princesses of Egypt combined. The writings of scholars attempting to re-create the history of the Amarna Period from this evidence make for fascinating—but sometimes confusing—reading. It is rare for any theory about the royal women to appear in print without two more articles being written to corroborate or contradict it. Thus, what follows is a mere sampling of the academic debate surrounding these dynamic women and their times.

THE WOMEN OF AMENHOTEP III'S FAMILY

Amenhotep III seems to have lived surrounded by powerful women. Apart from his numerous and various wives, he had at least four daughters whose importance rivaled that of his wife, Tiye. In fact, they shared with Tiye the rank of Royal Wife or King's Chief Wife and played prominent roles in various cult ceremonies. A princess with the title Royal Wife probably enacted the role of goddess in some of the royal rituals and perhaps took the place of the queen at some court functions as well. Whether these young women were truly wives to their father is problematical. Modern taboos may make scholars reluctant to accept a sexual relationship between parent and child, but there is no proof that any of the King's Daughters who were also Royal Wives bore offspring by their father.

The King's Chief Wife, Tiye

Tiye is generally remembered as the "commoner queen" of ancient Egypt. She was not born of a king and a royal consort but of the God's Father and Commander of the Chariotry, Yuya, and the Priestess of Min, Tuya, titles that do not suggest a royal relationship. However, scholars have suggested that members of Tiye's family were "old retainers" of the Thutmosid line, a military family from Middle Egypt with close connections to royalty,[2] and her father may also have had Asian ancestors.[3] Other members of her family attained prominence: Anen, Second Prophet of Amun, was Tiye's brother; Ay, successor to Yuya as God's Father and a future pharaoh, may also have been a brother.

Despite her lack of divine (i.e., royal) blood, Tiye was a powerful force in her husband's reign. Shown at the king's side on monumental statues and in numerous royal monuments and private tombs, she seems to have established a role for herself at both secular and religious ceremonies. She was even venerated as a living goddess at the temple of Sedeinga in Nubia. Tiye's influence survived her husband's death. In letters from foreign rulers, the new pharaoh, Amenhotep IV/

Fig. 3. Fragment of a relief showing Queen Tiye. Obsidian. The Metropolitan Museum of Art, New York

Opposite: Fig. 2. Fragment from a colossal head of Nefertiti from Karnak. Sandstone. Egyptian Museum, Cairo

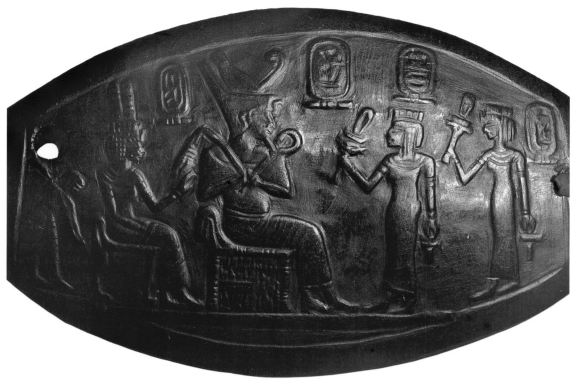

Fig. 4. Detail of a bracelet plaque showing Princesses Henut-taneb and Isis before their father, Amenhotep III. Carnelian. The Metropolitan Museum of Art, New York

Akhenaten, is urged to seek his mother's advice because of her familiarity with international affairs (see p. 30).[4]

Within a few years of taking the throne, Amenhotep IV/Akhenaten moved his family and court to a new site. The tombs of officials at Amarna record the presence of Tiye in the new capital, Akhetaten; among other privileges, she was given a Sunshade temple of her own, and Akhenaten is shown leading her into the new house of worship. Whether she remained at Akhetaten until her death, sometime around Year 14 of her son's reign, or returned to one of the older capitals is not known, but it seems likely that she was eventually buried in her husband's Theban tomb in the Western Valley, a branch of the Valley of the Kings,[5] although a few items intended for her burial were found in Tomb 55 in the nearby Valley of the Kings itself. These objects were most probably transferred to Thebes from the Royal Tomb at Amarna. And it is therefore likely that her first place of burial was at Akhetaten (see p. 26).[6] A mummy, the so-called Elder Woman B from a cache of mummies reburied in the tomb of Amenhotep II, has

been identified as Tiye, but recent studies have cast serious doubt on the earlier conclusions.[7]

Sitamun

Sitamun (Daughter of Amun) was, apparently, the eldest daughter of Amenhotep III and Tiye, but relatively few of her monuments survive. However, she is attested by inscriptions on the monuments of her parents, by objects in the tomb of her grandparents Tuya and Yuya, and by fragmentary inscriptions from the Royal Tomb at Amarna. The most famous objects associated with her are two wooden chairs from the tomb of Tuya and Yuya,[8] which date to her early youth. Even then, Sitamun was elevated to a special position, that of King's Chief Daughter. Other documentation attests that by the time her father celebrated his first *sed*-festival, or thirty-year jubilee, Sitamun was already a queen with her own household. She has sometimes been suggested as the mother of Tutankhamun,[9] but her name does not appear on any objects from his tomb, and there is no evidence to suggest that Sitamun bore her husband/father any children.

Henut-taneb

This second daughter of Amenhotep III and Tiye bore a name that was actually a title of Egyptian queens; Henut-taneb means "Mistress of All Lands." The name was especially appropriate because she seems to have been elevated to a position equivalent to that of her mother and older sister. Although she is not identified with the title Royal Wife, the colossal statue group of Amenhotep III and Tiye from Medinet Habu in the central hall of the Cairo Museum portrays her at the side of her parents, in a smaller scale, wearing the vulture cap of a queen, and she is described as "the companion of Horus, who is in his heart." This is the only time a King's Daughter was given this queenly title.[10] Since on other monuments her name is often enclosed within a cartouche—a prerogative of royal wives—we may have to include her among the many wives of her father.

Isis

Another daughter of Amenhotep III and Tiye was named Isis, or Aset, after the goddess Isis, wife of Osiris. The evidence suggests that this princess held an important position: her name is frequently enclosed within a cartouche, and on the back pillar of a statue she is given the title *hemet nesu* (King's Wife).[11] On a bracelet plaque in the Metropolitan Museum, she and Henut-taneb are depicted holding out *renpet* signs, notched staves which convey wishes for a long reign and a long life to their parents, and on another plaque (fig. 4) they rattle sistra in front of the king and queen.[12]

Nebet-ah

Like her sisters, Princess Nebet-ah was given a name that derived from a title which means "Lady of the Palace." Otherwise, she is an obscure figure among the daughters of Amenhotep III. She appears on only one monument, the colossus from Medinet Habu in the Cairo Museum.[13] Since she does not seem to be present in the numerous small scenes in which Sitamun, Isis, and Henut-taneb appear, she may have been a somewhat younger sister.

THE ROYAL WOMEN OF AKHETATEN

With the move to the new capital, Akhetaten/Amarna (pp. 20–22), came changes in the way the royal women were portrayed, not only in style but also in iconography. This suggests a unique role—along with a unique appearance—for the women of Amarna.

The King's Chief Wife, Nefertiti

The woman we call Nefertiti (the Beautiful One Is Here) would have been known to her contemporaries at Akhetaten as Nefernefruaten-Nefertiti (Nefernefruaten means "Perfect One of the Aten's Perfection."). She added Nefernefruaten even before her husband changed his name from Amenhotep to Akhenaten in the fifth year of his reign (see p. 20).[14] Her image evolved as well. In the earlier years of the reign, she is shown wearing the queen's crown of feathers, cow horns, and sun disk (figs. 5, 10, 11), which associated her with the goddess

Fig. 5. Fragment of a relief excavated at Amarna showing Nefertiti or Tiye. Indurated limestone. Petrie Museum, University College, London

Hathor. By the time of the move to Amarna, however, Nefertiti was portrayed in an original headdress peculiar to her. Perhaps based on the Blue Crown of the king (figs. 30, 58, 62, 76, 88) or on the caps worn by various deities (see p. 107), this flat-topped blue helmet would become her hallmark. From the earliest years of Akhenaten's reign, Nefertiti was distinctive because of her prominence in representations of cult scenes. Her participation in the rituals of the new religion was equal to that of her husband (pp. 85–87). In some parts of the Karnak temples of the Aten, the figure of the queen actually dominates the decoration. Such prominence[15] for a queen, almost unprecedented, led to suggestions in the 1970s that Nefertiti was the real force behind Akhenaten's religious revolution.

"Nefertiti's parentage has been a subject of much speculation," wrote Cyril Aldred,[16] but Egyptologists are mostly inclined to follow Aldred's own suggestion that Ay, the man who became king after Tutankhamun's death, was her father and Ay's wife, Tiy, served as the queen's nurse. Since Ay is also thought to be Queen Tiye's brother,[17] this means that Akhenaten would have married his cousin. However, the family connections are still hypothetical.

The date of Nefertiti's death is difficult to ascertain. The evidence of a fragmentary shawabti-figure, a statuette placed with the dead, which bore her name[18] suggests that she was buried in the Royal Tomb at Amarna late in Akhenaten's reign or shortly after his death.[19] At one time, scholars noted her disappearance from monuments after Year 12 and hypothesized that she fell from power and was replaced as queen by her eldest daughter, Meretaten. But the changes of names on monuments have turned out to concern the minor queen Kiya, not Nefertiti (see pp. 105–6, 112). More recent theories have suggested that rather than disgrace, a change in status to full coregent is behind her absence from the records dating to the late years of Akhenaten.[20]

"The King's Daughters of His Flesh"

Nine "Beloved King's Daughters of His Flesh" are documented at Amarna, and six of them are specified as "born of the King's Chief Wife Nefernefruaten-Nefertiti." Two of them also appear in the Egyptian records as queens: Meretaten, the eldest child of Akhenaten and Nefertiti, and their third-born daughter, Ankhesenpaaten, who later changed her name

to Ankhesenamun. Some of the King's Daughters are known only from a few inscriptions or representations. The tomb of Meryre, Overseer of the Royal Quarters, is one of the few places where all six daughters can be seen, since it is there that the great reception of foreign tribute held in Year 12 was recorded (fig. 78, pp. 86–87, 114). Representations of the royal daughters have suggested to some scholars the presence of physical abnormalities that the princesses supposedly inherited from their father. The girls' elongated craniums have especially been explained as the result of various pathological conditions, most recently Marfan's syndrome, a hereditary disorder (see, however, pp. 19, 52, 55).[21] On the other hand, art historians have argued that Amarna artists overemphasized physical traits of a perfectly normal character for stylistic reasons. (See more on this topic, pp. 19, 52, 55.)

Baketaten

Princess Baketaten (the Aten's Handmaiden) is known only from Tell el-Amarna, where her image appears in the tomb of Huya, Tiye's steward.[22] She is represented seated near Queen Tiye at scenes of banqueting (fig. 110), having her statue made in the workshop of Queen Tiye's sculptor, Iuty (fig. 32), following Tiye into the queen's Sunshade temple, and in a family group with Tiye and Amenhotep III. She is represented as a child in the reliefs, indicating that she must have been born at the end of Amenhotep III's reign. Because the names of her parents are not mentioned in the texts that refer to her, it has been claimed that she might have been a daughter of Akhenaten.[23] But her close association with Queen Tiye and Amenhotep III speaks strongly for this royal couple being her parents.

Meretaten

Meretaten (the Aten's Beloved), the eldest daughter of Nefertiti and Akhenaten, was probably born before her father ascended the throne. She is depicted following her mother in reliefs from the Aten temples at Karnak, Thebes, that can be dated to the earliest years of Akhenaten's reign, a small figure in a long adult gown holding a sistrum.[24] At Amarna, she continued to be represented in a similar way in offering scenes (figs. 15, 30); she is also seen with her sisters, joining their parents during state ceremonies (figs. 78, 111), and her statue stands beside those of the king and queen (fig. 103). In

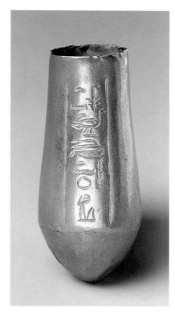

Fig. 6. Small gold situla inscribed with the name of Princess Meketaten. The Metropolitan Museum of Art, New York

many representations Meretaten is singled out from her sisters by being nearest to her father. On a domestic stela (fig. 88), she appears—somewhat anachronistically, because this stela must date to just before Years 8–12 of the king's reign (pp. 39, 97)—as a baby in the king's arms as he lifts her up and kisses her. On another stela (fig. 94) and a wall relief (fig. 95) she receives an earring from his hands, and in an unfinished group sculpture she is most probably the young woman whom Akhenaten kisses (fig. 96).

It has been suggested—because of a single inscription, which could be erroneous[25]—that Meretaten was given the title King's Chief Wife while the temples at Karnak were still under construction, that is, in the early years of her father's rule. Her status certainly rose during the later years of the reign, when she took over monuments originally decorated with images of the minor queen Kiya (see pp. 105–6) by having her name superimposed over Kiya's, and Kiya's wig changed to the hairstyle of a princess (figs. 79, 100, 101). Eventually Meretaten was definitely designated King's Chief Wife[26] and her name written in the cartouche as appropriate for a queen at this period of Egyptian history (fig. 83). Her elevated status became known even in foreign countries: cuneiform letters addressed to Akhenaten by the king of Babylonia mention gifts sent to Meretaten after the Babylonian king's "having heard about her."[27]

Two Egyptian rulers appear, tantalizingly, linked to Meretaten as if they were her husbands: Nefernefruaten[28] and Smenkhkare.[29] Nefernefruaten may have been the name of Nefertiti when she became coruler with Akhenaten during his late years (see pp. 88–93). Coupled with her, the King's Chief Wife's role of Meretaten can only have been of a ritual character (see, however, fig. 82, p. 93). Smenkhkare,[30] on the other hand, was a male successor of Akhenaten who ruled at Amarna for a brief period after the latter's death. He is thought to have been Tutankhamun's elder brother. His mummy appears to be the one found in a coffin that was reattributed from minor queen Kiya and eventually buried in Tomb 55 in the Theban Valley of the Kings (see pp. 38, 115–16). Nothing is known about Meretaten's end and burial place.[31]

Meketaten

Meketaten, whose name means "She Whom the Aten Protects," must have been born in the early years of her father's kingship, since her figure is incorporated in some of the blocks from the temples at Karnak.[32] Apart from her many portrayals in tomb and palace reliefs (figs. 111, 112) and stelae (fig. 88), Meketaten is known from the Royal Tomb at Amarna, where she was buried. A representation on the walls of this tomb, of a child being carried from the room in which a royal woman lies on her deathbed, has led some scholars to suppose that Meketaten died in childbirth (see, however, p. 115).[33]

Ankhesenpaaten

A third daughter was born to Nefertiti in about the sixth year of Akhenaten's reign, perhaps as late as Year 7 or 8,[34] and was given the name Ankhesenpaaten, which means "May She Live for the Aten." Little more is known about the early life of this princess than is known of her sisters. She is depicted on tomb reliefs with her sisters (figs. 78, 99, 111, 112) and on stelae on her mother's arm (fig. 88). She is also the only Amarna princess whose nurse (menat) is known by name. On a block in the Metropolitan Museum a woman called "the nurse of the king's daughter Ankhesenpaaten, Tia" is depicted bringing offerings.[35]

Ankhesenpaaten (later called Ankhesenamun), the consort of a successor to Akhenaten, is still a figure of mystery in many ways. Her relationship to Tutankhamun, her tentative identification as the author of two letters to the Hittite king Shuppiluliumash, and her possible marriage to her father have all contributed

Fig. 7. Lid of a small box from the tomb of Tutankhamun showing a child and the name of Princess Nefernefrure. Wood with glass inlays. Egyptian Museum, Cairo

to the controversy surrounding her. As the third daughter of Akhenaten, her chances of becoming queen were originally slim, but with the death or disappearance of her mother (Nefertiti), stepmother (Kiya), and elder sisters, Ankhesenpaaten was the logical choice to marry Tutankhaten, a young prince who was probably the only male of the royal line still alive. With the return to orthodoxy Ankhesenpaaten became Ankhesenamun, as the young king became Tutankhamun, and they moved to Memphis or Thebes to live. She is represented on many of her husband's public monuments as well as on numerous smaller objects from his tomb, and we might assume from this that she was influential in the government. However, it was only after Tutankhamun's death that she became a truly controversial figure—because of the letters to the Hittite king that were attributed to her. In these letters (see p. 124),[36] an Egyptian queen writes to a foreign ruler asking that he send his son to be her consort—an unprecedented and scandalous move. Since the queen is referred to as Dahamunzu, a phonetic rendering of the title *ta hemet nesu*, one can

only attempt to identify the author of the letters.[37] Nefertiti, Kiya, and Meretaten have all been suggested as "Dahamunzu," but recent thought suggests that Ankhesenamun is still the most likely candidate. In the letters, the queen protests against marrying her "servant"; this possibly refers to the God's Father Ay, who became pharaoh after Tutankhamun. A ring bearing the conjoined names of Ankhesenamun and Ay has been proposed as evidence that after the failure of her plot, a marriage did take place between Tutankhamun's widow and his chief minister,[38] but there is no record of Ankhesenamun during Ay's reign, and she disappeared from history.[39]

Nefernefruaten-Tasherit

The fourth daughter of Nefertiti was named Nefernefruaten the Younger after her mother and first appears in the tomb of Panehsy, First Servant of the Aten, in a scene that contains the earlier version of the Aten name (see p. 4) that was abandoned in Years 8–12 of Akhenaten's reign.[40] In the tomb of Meryre, the high priest of the Aten, there is a short inscription that seems to refer to her as King's Wife and Daughter, but this unique occurrence could easily be an error on the part of the artists who decorated the tomb.[41] She is represented with her sisters at the festival of Year 12 of her father's reign (fig. 78), and she sits at her mother's feet in the painting from the King's House at Amarna (fig. 49).

Nefernefrure

Little is known about Princess Nefernefrure (the Perfect One of the Sun's Perfection) except for her order (fifth) in the procession of royal daughters and her approximate birth date, sometime in about her father's ninth regnal year. She seems to have had a tomb in the Royal Wadi at Tell el-Amarna, but a box lid with her name on it was found in the tomb of her brother-in-law Tutankhamun (fig. 7).[42] In a painting (fig. 49) she sits with her elder sister at Queen Nefertiti's feet, and Nefernefruaten-Tasherit chucks her under the chin. Both princesses wear only jewelry. At the Year 12 festival (fig. 78) Nefernefrure holds a young gazelle on her arm.

Opposite: Fig. 8. Detail of a relief (fig. 88) showing Nefertiti with Princess Ankhesenpaaten. Limestone. Ägyptisches Museum, Berlin

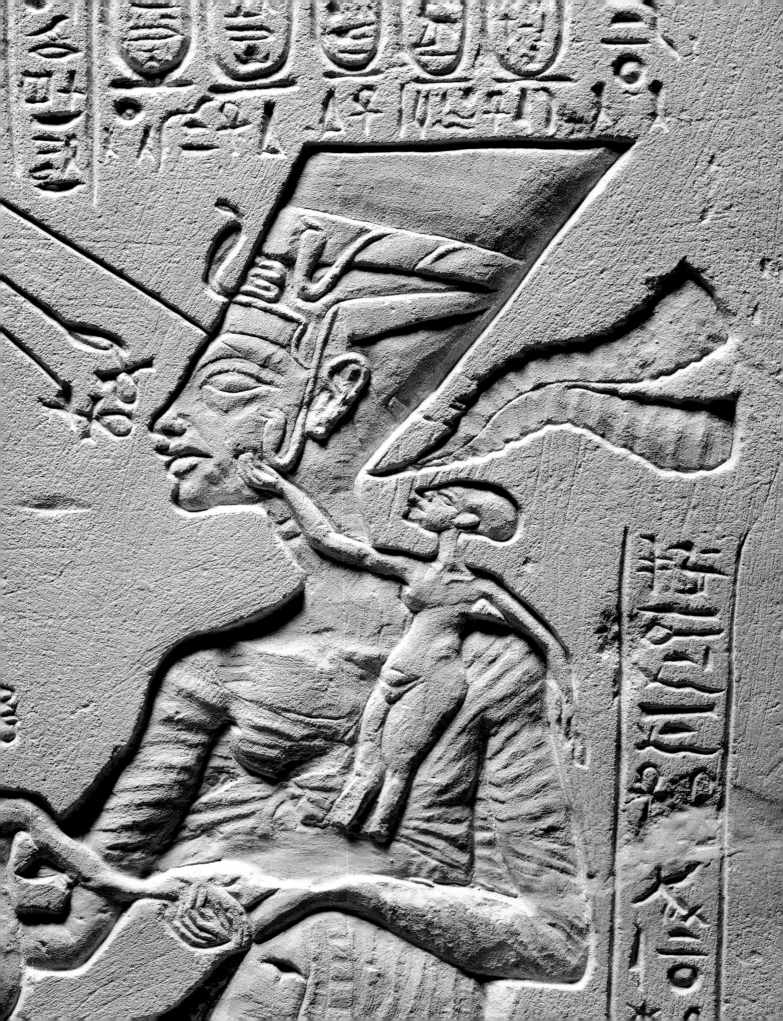

Setepenre

Setepenre (She Whom the Sun Has Chosen) is the least known of all Nefertiti's children. She appears only on a few monuments, primarily tombs of nobles.[43] Like several of her older sisters, she is believed to have died before her father, perhaps, as has been suggested, as a result of an epidemic in the Mediterranean basin.[44]

Meretaten-Tasherit

From the end of the Amarna Period there are a number of mysterious princesses whose names are attested in texts on blocks from dismantled temples and palaces. One such is Meretaten the Younger, whose mother has been identified as the eldest daughter of Nefertiti,[45] although some scholars suggest that the mysterious Kiya was her mother.

Ankhesenpaaten-Tasherit

Damaged and altered texts that have been reconstructed refer to a King's Daughter called Ankhesenpaaten the Younger. This problematic princess is mentioned only in a few incomplete inscriptions on blocks found at Hermopolis and Karnak.[46] The possibility of her existence has led to the suggestion that Akhenaten married his third daughter and had a child by her, or that both Ankhesenpaaten the Younger and Meretaten the Younger were Kiya's children.[47]

THE FOREIGN QUEENS

Amenhotep III and Akhenaten contracted diplomatic marriages with Babylonian and Mitannian princesses, as did their predecessors. These princesses would probably have been honored with their own estates, and perhaps temples to the Aten, but their place within the royal hierarchy was circumscribed because of their foreign origin. As members of foreign royalty, they were not elevated to the position of King's Chief Wife, but behind the scenes they would have exercised whatever influence they had.

Gilukhipa

Mitanni, or Naharin, in western Mesopotamia, was among the most important allies of the Egyptians during the reign of Amenhotep III. Gilukhipa, the daughter of Shuttarna II of Mitanni, was sent to Akhenaten's father as a bride in the tenth year of his reign. Her impressive entourage is mentioned in his

commemorative scarabs.[48] Afterward, she seems to have disappeared from view and is not mentioned again until the negotiations for the marriage of her niece, Tadukhipa, took place.[49]

Tadukhipa

In the closing years of the reign of Amenhotep III, yet another Mitannian princess was sent to Egypt. The daughter of King Tushratta, Tadukhipa is referred to in letters from Mitanni as the Mistress of Egypt, that is, the queen. She is mentioned in the cuneiform Amarna correspondence until the fourth year of Akhenaten's reign,[50] and some scholars identify her as Kiya, Akhenaten's secondary consort.

THE WIFE AND GREAT BELOVED OF THE KING, KIYA

This mysterious figure has fired the imagination of many scholars and friends of ancient Egypt since her existence was rediscovered in the 1960s and 1970s. The queen was virtually unknown even among Egyptologists until Herbert W. Fairman published two cosmetic vessels from the British Museum and the Metropolitan Museum that were inscribed with her name.[51] In recent decades she has become the focus of many reassessments of Amarna chronology, society, and art. One of the most difficult tasks has been the identification of Kiya's origins. A popular theory holds that she is Tadukhipa with an adopted Egyptian name.[52] Certainly there is some evidence to suggest that Kiya might have been a foreigner and thus ineligible for the position of King's Chief Wife. Her titles were unique, similar to but not identical with those of a queen; she is described as the "wife and great beloved of the king of Upper and Lower Egypt, who lives on Maat, Neferkheprure-Waenre [Akhenaten], the beautiful child of the living Aten, who shall live forever continually: Kiya," and perhaps she is the "Noble Lady" (*ta shepeset*) mentioned in small inscriptions at Amarna.[53] Although scarcely as prominent as Nefertiti, Tiye, or the royal daughters, Kiya was honored at Amarna with Sunshade sanctuaries for the sun cult and chapels of her own (see pp. 27, 105). Such institutions of worship in the name of a female member of the court were always accompanied in ancient Egypt by an institutional framework, ownership of land, and income from other institutions securing the livelihood of the queen.[54] Kiya

seems to have borne at least one child to Akhenaten, a daughter whose name is not known. It has, moreover, been suggested that Kiya was also the mother of Tutankhamun, but there is no evidence to corroborate this.[55]

In reliefs, Kiya is seen accompanying the king at offerings and official ceremonies, just as Queen Nefertiti does (fig. 79), but the two queens never appear together. Several reliefs show Kiya officiating alone at priestly functions (fig. 100).[56]

The year of Kiya's death and her final resting place are not known, although there is evidence from a wine docket that she was still alive as late as the sixteenth year of Akhenaten's reign[57] and that various items from her burial—including a magnificent coffin covered with gold and colorful inlays—were reused in Tomb 55 of the Valley of the Kings (see pp. 38, 115–16).[58]

QUEENS OF THE POST-AMARNA PERIOD

Tiy, the Great Royal Nurse Who Became Queen

Another "commoner queen" (after Queen Tiye and Queen Nefertiti; see pp. 7, 10) succeeded Ankhesenamun as Lady of the Two Lands. Tiy (her name is written thus by Egyptologists to distinguish her from the queen of Amenhotep III) was the wife of Ay. Among her titles were: *khekeret nesu*, or Royal Ornament, Nurse of the King's Chief Wife, Governess of the Goddess, One Who Praises the King's Chief Wife, and Chief Singer of Waenre [Akhenaten]. Because she is not specifically said to be Nefertiti's mother—although Ay is believed to be her father (see pp. 10, 51)[59]—Tiy is often identified as Nefertiti's stepmother. There is a considerable gap between her first appearance in Amarna reliefs and her appearance as queen. However, since her husband remained at the center of the government throughout the reigns of Akhenaten's successors, we may assume that Tiy too remained prominent until her death. She appears in Ay's tomb in the Valley of the Kings and on numerous public monuments.[60] At Amarna her elegant figure and impressive face were carved in relief in the tomb of her and her husband.[61]

Mutnedjmet, Last Queen of the Eighteenth Dynasty

With the death of Ay and the succession of Commander in Chief Haremhab, a new queen appears: Mutnedjmet (Sweet Mother). Although she is relatively unknown, she has been the subject of both a scholarly dissertation[62] and a German novel. Like Nefertiti, Tiye, and Tiy, Mutnedjmet was not a King's Daughter. On the rare occasions when she appears in the record at Amarna she is described as Sister of the King's Chief Wife Nefertiti. The fact that she is seen in the tomb of Ay at Amarna might be understood as a confirmation that she was related to him as well as to Nefertiti, but she appears not only in his tomb following the daughters of Akhenaten and Nefertiti but also in two other tombs of Amarna officials.[63] In Ay's tomb and in the one of the Fanbearer Mau, Mutnedjmet is accompanied by two court dwarfs, which suggests that she held a high position as lady-in-waiting. Although almost certainly younger than Nefertiti, she seems to be a young adult rather than a child in these reliefs, certainly young enough to have survived the reigns following that of Akhenaten.

There is no record of Mutnedjmet from Tutankhamun's reign, but after his death she again becomes prominent as the queen of Haremhab.[64] Human remains found in the tomb that Haremhab had prepared for himself in the Memphite necropolis of Saqqara before he became king were identified as hers, indicating that she died about Year 13 of King Haremhab, aged thirty-five to forty. That a queen was buried in an unused tomb of a king is not unprecedented and does not imply that she had fallen into disgrace. Along with the bones, fragments of an infant's skeleton were found, leading to the suggestion that she died trying to give Haremhab an heir.[65]

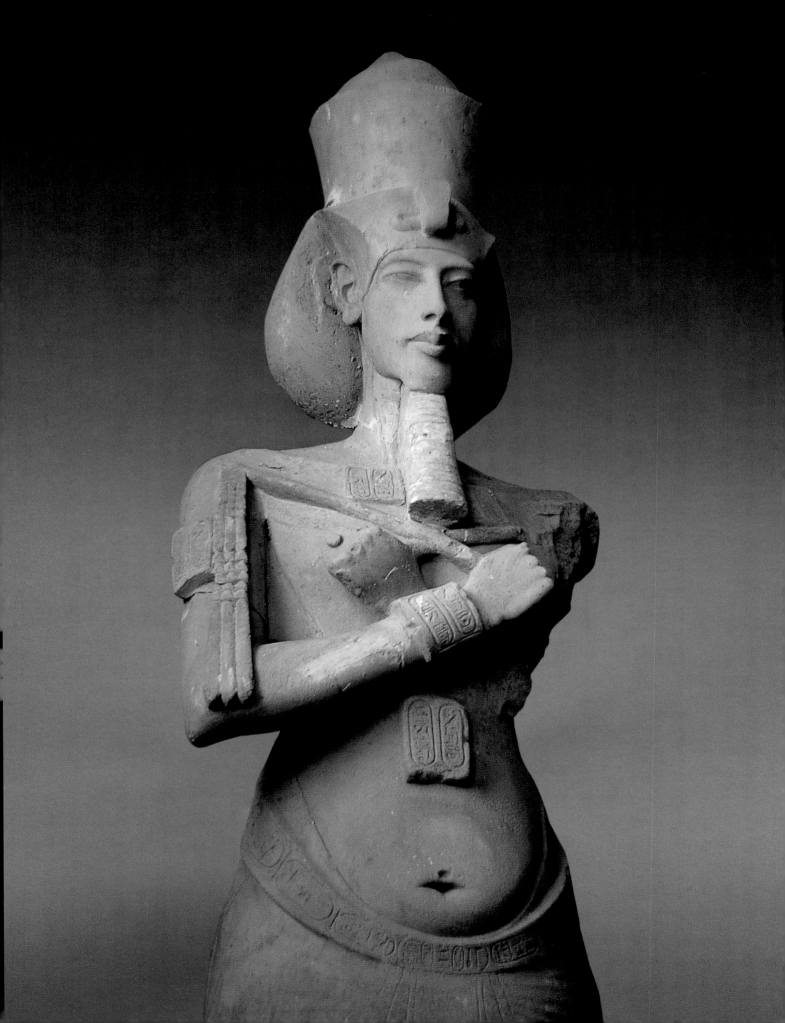

AN ARTISTIC REVOLUTION: THE EARLY YEARS OF KING AMENHOTEP IV/AKHENATEN

DOROTHEA ARNOLD

Early in the reign of King Amenhotep IV (ca. 1350 B.C.) Egyptian art underwent a transformation that must have shocked the king's subjects as much as it does the uninitiated modern viewer. At a temple of the Aten at Karnak, colossal sculptures about 16.5 feet (5 meters) high were erected against massive pillars that surrounded the temple court on at least three sides.[1] In these figures traditional royal iconography appears strangely—almost grotesquely—distorted (fig. 9). The king's enormous thighs are tightly drawn together by a knee-length pleated kilt whose upper edge, supported by a heavy, angular belt, droops below the pharaoh's protruding belly. Long, sinewy arms are crossed above a narrow waist; the hands are placed on somewhat effeminate breasts that are positioned unnaturally close to the shoulders.[2] Above the large bony hands holding the royal crook and flail, a ceremonial beard of great length is flanked by the sharply ridged, overextended clavicles. The king's names are inscribed on the buckle of the belt, whereas the belt itself is decorated with the cartouches of the Aten. The god's names are also incised on rectangular plaques, similar to stamp seals, that are fixed to the king's waist, arms, and clavicles.

Head, headgear, and ceremonial beard occupy almost one-third of the statue's total height. Beneath the impressive mass of the huge double crown, the face is framed by enormous drop-shaped lobes, the side parts of a royal *khat* headdress.[3] Hollow cheeks and an aristocratically thin, elongated nose separate the mouth from the widely spaced, slanting eyes set under a bony brow. The king peers, as if shortsighted, through narrowly slit eyes that are hooded by heavy, angularly

banded upper lids. The double-wing shape of the lower part of the nose is repeated, in much stronger terms, in the boldly sculptured mouth, undoubtedly the liveliest feature of this uncompromising face (fig. 1, no. 29). A curved line extending from the nose to the corners of the mouth indicates a muscle fold that Egyptian artists used, commonly in a more three-dimensional way, to give individuality to sculptured faces. Here, it is linearly incised, as if to emphasize through this stylization the superhuman qualities of this visionary's face.

The somewhat aloof smile gives human expression to the Karnak statue's surprising head, but the size and shape of the head and face clearly exceed natural dimensions. We are confronted less with a representation of a human face than with artistic variations of human features. The effect is awesome: pharaoh's divinity expressed through a transfiguration of human forms.

Images of Queen Nefertiti were almost as omnipresent as those of her husband in the temples of the Aten at Karnak. Among sculptures in the round, the sandstone fragment of an over-lifesize head (fig. 2, no. 41) has been preserved in a famous temple deposit (known as the Karnak cachette) along with hundreds of other sculptures of various periods.[4] The piece must have been mishandled before it came to be mingled with works from totally different periods. This would account for the pitted appearance of the surface. However, most of the queen's face—except for the right side of the mouth, part of the chin, the right cheek, and the ears—is preserved. Of the wig of echeloned curls there remains only the part above the forehead, with the superimposed bodies of two cobras (uraei). The presence of a pair of cobras, not a single uraeus, indicates an image of Nefertiti rather than of Amenhotep IV/Akhenaten: only queens wore double uraei during the Eighteenth Dynasty.[5]

Opposite: Fig. 9. Colossal statue of Amenhotep IV from Karnak. Sandstone. Egyptian Museum, Cairo

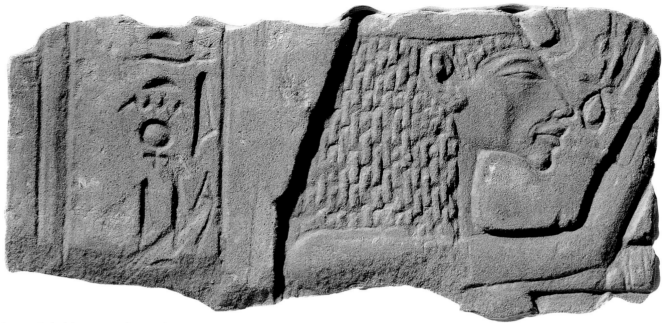

Fig. 10. Relief showing Nefertiti offering. Sandstone. The Brooklyn Museum

Except for the differences in hairstyle and royal accoutrements, the queen's head is remarkably similar to that of the king (fig. 9). When viewed originally, perhaps standing close to each other, the Karnak statues of the king and queen must have seemed to be portrayals of the same person in different clothes. In earlier Egyptian art queens were not usually depicted with the same facial features as the king;[6] only in representations of the royal couple immediately preceding Amenhotep IV/Akhenaten and Nefertiti, Amenhotep III and Tiye, does a certain similarity of features emerge.[7] The phenomenon of Nefertiti appearing as a sculptural double of Akhenaten is paralleled most closely in the facial resemblances of kings or queens to deities. Many sculptures of gods and goddesses in Egyptian art of all periods are endowed with the facial features of the ruling king or queen. It was a way of expressing the Egyptian belief that the pharaoh was the representative of god on earth.[8] The similarity of Nefertiti's face to that of her husband in the Karnak statues may be understood in the same way. If the pharaoh was the all-important human link with the divine, then the queen's resemblance to the king must have assured her a share in his close relationship to the god.[9]

The similarity of Nefertiti's features to those of the king is not restricted to the colossal sandstone statues; it was a recurrent phenomenon in art during the early years of their reign. Many reliefs on so-called *talatat* of sandstone (building blocks of a uniform size, roughly 21 × 9 × 10 in. [53.3 × 22.9 × 25.5 cm]) from the Aten temples at Karnak depict Queen Nefertiti either together with her husband or performing offering rites accompanied by her eldest daughter, Meretaten, or—more rarely—by the two next-born daughters, Meketaten and Ankhesenpaaten.[10] Although a number of styles can be observed in these reliefs and the faces of both king and queen vary accordingly, the facial resemblances of the queen and the princesses to the king are unmistakable.[11]

Praying to the Aten, probably near an altar heaped with offerings, Nefertiti (figs. 10, 11, nos. 32, 39, 48) wears the same ceremonial wig of echeloned curls as in her colossal statue (fig. 2). Over the forehead, the uraeus cobra (fig. 10) or the queenly double cobras (fig. 11) emerge from below a fillet that encircles the wig. Above the wig (but only partly preserved on the relief in fig. 11) sat a high crown comprising a modius adorned with cobras, a sun disk between two cow horns, and two high feathers (figs. 5, 15). Like the queens before her, Nefertiti was linked through this elaborate headgear to Hathor, daughter of the sun god, Re,[12] and this solar implication may have made the crown acceptable to believers in the Aten. The sun-ray hands of the Aten hold signs of life to the queen's nose and embrace the cobras on her brow (fig. 11).

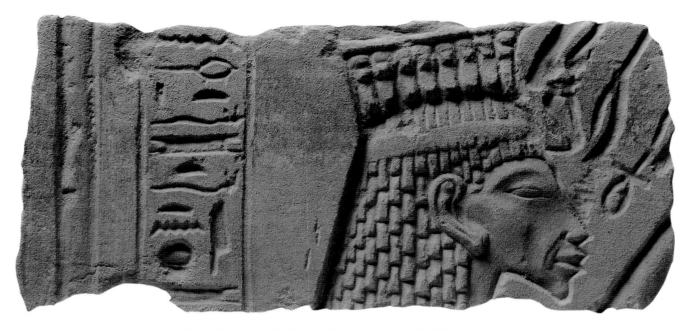

Fig. 11. Relief showing Nefertiti offering. Sandstone. Collection of Jack Josephson, New York

The style of these Karnak reliefs recalls the elongations and expressive distortions of the colossal statues from the same site. Above a strikingly long neck, the face protrudes forward to a degree that in reality is only found with heads of animals, not humans. The queen's nose is so long that its tip forms a unit with the full mouth and drooping, round chin, while the slitlike eye under the bony brow is placed so high that it almost touches the edge of the wig. This leaves ample space for the cheeks and jaws, and the artist has used it to emphasize the jawbones as a major structural element of the head.

Though fascinating and otherworldly, this head does not project an image of pleasing, sweetly feminine beauty. The cheeks are ascetically hollow, the chin droops unbecomingly, and the lines between nose and mouth and at the corners of the mouth are more appropriate for an old woman than a young queen. True, the lips are sensuously rounded, and the small head is elegantly balanced on the long, slender neck, while the massive wig forms a richly textured counterweight to the protruding face. It cannot be denied, however, that this is an astonishing image for a queen whose name meant "the Beautiful One Is Here" and whose predecessor's imagery, even where character and determination were emphasized, never departed from feminine elegance and polish.

Viewers have argued that the Karnak sculptures and reliefs depicted the "true" features of the king and queen, and that the artists worked under the king's personal directive to portray him and his queen exactly as they looked.[13] This understanding of early Amarna art as realistic has led to an ongoing search for explanations (pathological and otherwise) for the "abnormal" in the representations of members of the royal family.[14] Recently, Edna R. Russmann repudiated this whole approach with her liberating statement that "diagnoses of this kind are based on false premises. They arise from modern perceptions and preoccupations—from scientifically oriented curiosity and from our irresistible tendency to assume that distinctive features must, like a photograph, mirror an actual appearance. Akhenaten's concerns, of course, were entirely different. In departing radically from the styles of all earlier royal representations . . . the . . . representations of Akhenaten at Karnak are deliberately unrealistic."[15] In other words: Amenhotep IV/Akhenaten and Nefertiti are depicted with unprepossessing, ugly features in order to express a radically new concept of kingship and queenship, and the ugliness of the images is indicative of the intensity behind the new beliefs.

Notwithstanding the drive to replace traditional artistic methods with very different ones, Egyptian artists of the early years of Akhenaten's reign were still

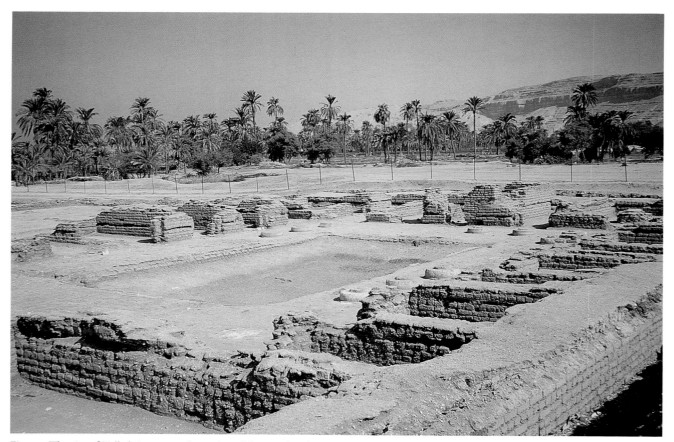

Fig. 12. The site of Tell el-Amarna today: ruins of the North Palace

Egyptian artists, and in their search for hitherto untried forms they made use of what had served in previous periods in order to express the different and the "abnormal." Traditionally, the subjects of such abnormal images were foreigners, herdsmen, or other people living outside ordinary Egyptian society—old people and persons of strong character or what we would call "individuality."[16] To depict human beings—or human conditions—of this type, Egyptian artists since early times endowed them with certain features that served almost as codified symbols: hollow cheeks, strongly marked cheekbones, hooded eyes, and lines and folds at the corners of the mouth and between mouth and nose. All these features were now incorporated, as we have seen, into the early images of King Amenhotep IV/Akhenaten and Queen Nefertiti (figs. 10, 11). To Egyptian eyes, king and queen were thus characterized as extraordinary beings.

In the fifth year of his reign[17] the king changed his name from the traditional Amenhotep (Amun Is Content) to Akhenaten (Effective for the Aten, or Illuminated Manifestations of the Aten).[18] The same year, having experienced events that were "worse [than] those heard by any kings who had (ever) assumed the White Crown,"[19] the king also decided to move the royal residence and seat of government, the chief cult place for the god, and the burial site for himself, the royal family, and officials from Thebes to an area in Middle Egypt that modern archaeologists have named Amarna.[20] The ancient name of the new city was Akhetaten (Horizon of the Aten).[21] There is not enough evidence to reconstruct what actually happened. Somehow, forces—political as well as religious—at Thebes must have created a situation that could only be resolved by separation. Since Egypt's internal affairs were peaceful for the next ten years at least, the move was a wise one, assuring a measure of equilibrium between conservatives and the Aten believers.

Opposite: Fig. 13. Map of Tell el-Amarna as excavated

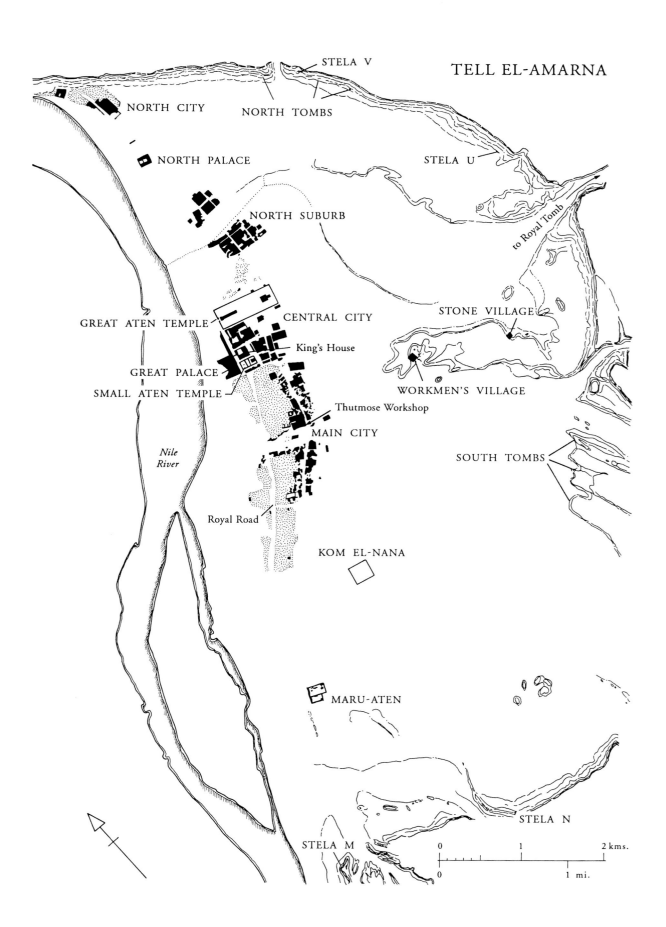

STELA V

TELL EL-AMARNA

NORTH CITY

NORTH TOMBS

NORTH PALACE

STELA U

to Royal Tomb

NORTH SUBURB

GREAT ATEN TEMPLE

CENTRAL CITY

STONE VILLAGE

King's House

GREAT PALACE

SMALL ATEN TEMPLE

WORKMEN'S VILLAGE

Thutmose Workshop

MAIN CITY

SOUTH TOMBS

Nile River

Royal Road

KOM EL-NANA

MARU-ATEN

STELA N

STELA M

0 1 2 kms.

0 1 mi.

Boundary stelae flanked by statues of the king, queen,[22] and princesses were carved into the limestone cliffs to define the area of the new city and commemorate the founding rites performed in Year 5 as well as a renewal by solemn oath in the following year. Final adjustments to the stelae texts were added later, in Year 8.[23] The queen took part in all ceremonies.[24] An argument between the couple and their courtiers about the place chosen for the new city echoes through the ages, because the king saw fit to affirm in the stela text: "Nor shall the King's Chief Wife say to me: 'Look, there is a nice place for Akhetaten someplace else.'"[25] And the same is said about "any officials" who should utter words against the choice.

To erect a new royal residence, official cult place, and seat of government, a huge construction project had to be initiated. Temples, palaces, administrative buildings, workshops, storehouses, and lodgings for hundreds of officials and thousands of dependents, royal workmen, servants, and laborers had to be constructed within a few years. The demands on architects, sculptors, painters, draftsmen, and other artists and artisans were immense, but the challenge was met with a burst of creativity seldom equaled in ancient Egypt or anywhere else.

The city's main artery was the Royal Road, a north–south thoroughfare that linked the principal official and religious buildings and served as a processional route from palace to temple for the royal chariot.[26] In the center of the city, on the east side of the Royal Road, were two main sanctuaries of the Aten: the Great Aten Temple and the Small Aten Temple. On the west side of the road a large building complex faced the Small Aten Temple and another group of buildings that filled the space between the Small and the Great Aten Temples. The function of the building complex west of the Royal Road has been the subject of much scholarly discussion. Early excavators had identified the whole group of buildings as a "Palace"[27] or a "Great Palace."[28] Subsequent scholars have argued that, although the smaller part of the complex, built of mud brick and brightly painted, seemed to have had an "intimate" character,[29] the larger part, consisting of courts and halls built of stone, could not have served domestic or administrative purposes,[30] however royal, but was either a large Aten sanctuary, a place for the jubilee (*sed*) festival that Akhenaten celebrated for himself and the god, or, more generally, a "sumptuous, semi-religious setting which

advertised [the king's] new religion and art and in which formal receptions and ceremonies could be held."[31]

In the part of this complex that was built of stone stood twice-lifesize statues of the king and queen; balustrades of marblelike indurated limestone and, possibly, granite (no. 36) carried relief decoration (fig. 5), and the walls were adorned with colorful ceramic inlays and more relief decoration.[32] On the lintels of doors in the columned central hall, carvings in relief showed the king as a sphinx (fig. 14, no. 40).[33] Columns in the stone buildings, as well as in the more intimate brick-built structures, were decorated with scenes that showed the king, accompanied by Queen Nefertiti and the royal princesses, offering to the Aten.[34] Such representations are certainly testimony to the predominantly religious function of the buildings.

Relief fragments that most probably came from columns of the building complex called the Great Palace (figs. 5, 15, 17, 109, nos. 18, 24, 34)[35] include figures of Queen Nefertiti and her oldest daughter with facial features closely resembling those of the Karnak temple reliefs (figs. 10, 11). The queen appears again with hollow cheeks, slitlike eyes, and an overly large mouth with full lips; her head rests precariously on a neck of unnatural length. The heads and faces of the accompanying princesses resemble those of their mother (fig. 109, no. 34). These striking similarities notwithstanding, a noticeable difference in style distinguishes the reliefs carved at Amarna from their counterparts in Karnak: their carving is more rounded, the outlines of the figures are softer, and the individual features are more sensuous and alive. In comparison, the Theban Karnak reliefs seem rigid, angular, and dry.

Such changes in style can only be explained by the presence at Amarna of new groups of artists whose background and training were different from those of the Karnak sculptors. Actually, it is not difficult to trace the origins of the sculptors who worked in the new style at Amarna. When Akhenaten transferred his capital to Middle Egypt and set up workshops to carry out the great task of adorning the new city of the Aten, he must have employed artists who resided in the Amarna area, possibly in the ancient city of Hermopolis. In addition, artists from the northern capital city of Memphis, near modern Cairo, were evidently called to Amarna.

Reliefs carved for Hermopolis and the Memphite cemetery of Saqqara during the reign of Akhenaten's

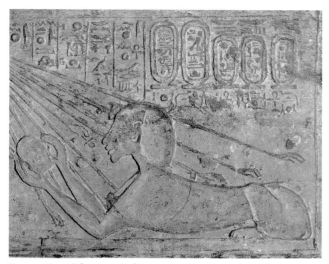

Fig. 14. Detail from a relief showing Akhenaten as a sphinx. Limestone. Thalassic Collection, courtesy Mr. and Mrs. Theodore Halkedis, New York

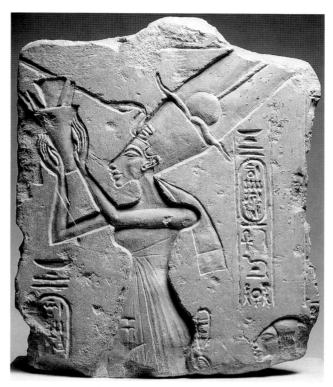

Fig. 15. Fragment from a column excavated at Amarna showing Nefertiti and Princess Meretaten offering to the Aten. Limestone. Ashmolean Museum, Oxford

father, King Amenhotep III, already display characteristics that have many affinities with the new style of Amarna. The Hermopolitan and Memphite reliefs are more rounded than the contemporaneous Theban ones; their outlines are more fluid and the bodies and facial features are livelier.[36] A good example of northern Egyptian relief style from the earlier years of Akhenaten's reign is a fragment showing Queen Nefertiti that was excavated at Memphis (fig. 18, no. 19). The face of the queen is almost completely destroyed, but most of the upper body and the wig remain, presenting a remarkably three-dimensional image. The queen's long tripartite wig is given roundness and depth; it curves naturally and organically over the shoulder, and a play of light and shadow creates a shimmering textural effect on the faceted surfaces of the curls, which are noticeably smaller than those on the Karnak reliefs. The ear of the Memphite queen is fleshy, and the fillet that binds the mass of the wig appears to have a life of its own. The same qualities of roundness, sensuousness, and tactility differentiate Amarna reliefs (figs. 14, 15, 17, 19) from the Karnak works

(figs. 10, 11), which look flat and intellectually dry in comparison. There can be no doubt that the new art at Amarna was essentially northern in character, and it is more than probable that Memphite artists became members of the newly created sculptors' workshops at Amarna.[37]

During the early years at Amarna, statues of the king and queen in indurated or soft limestone, quartzite, and diorite were placed in the Great Aten Temple on the east side of the Royal Road. They portrayed the royal couple in a variety of postures: seated, kneeling, and standing. Some figures held offering plates in their hands, in accordance with an age-old image personifying fertility. Others held large stelae inscribed with the names of the Aten.[38] Fragments of faces show that the Amarna temple sculptors transformed the Karnak conception of the royal image, as can be seen in the reliefs. Nose and mouth are still boldly sculptured in fragments from the temple statuary (fig. 16),[39] and the incised line from the nostrils to the corners of the mouth is again present. But, as in the reliefs, there is a new sensuousness and a feel for the organic in the features

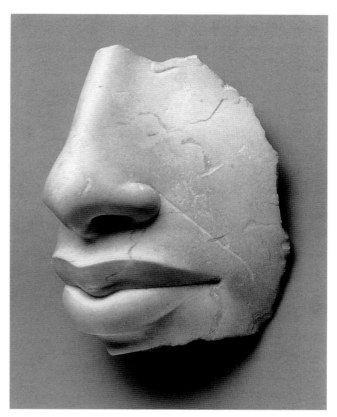

Fig. 16. Fragment from a statue of Akhenaten, from the dump of the Great Aten Temple, Amarna. Indurated limestone. The Metropolitan Museum of Art, New York

of the Amarna statues; the manneristic artificiality of the Karnak works has almost completely disappeared.[40]

Three sculptures in the round representing female members of the royal family are masterpieces created during the early phase of Amarna art: a quartzite torso, now in the Louvre (figs. 21, 22), a wooden head in Berlin (figs. 23, 26, no. 1), and the fragment of a yellow jasper head in The Metropolitan Museum of Art (figs. 27, 29). The torso, of dark reddish quartzite, is roughly one-third lifesize and depicts a young woman with a high narrow waist, small breasts, and an impressively full lower body. The expanse of belly, buttocks, and thighs, especially in profile (fig. 21), is reminiscent of predynastic Great Mother Goddess figures. By New Kingdom times, this was as unusual an ideal of beauty as it is today. The extraordinary character of the torso becomes even more evident when compared with a group of only slightly earlier female statuettes that were found at Medinet el-Ghurab in the Faiyum Oasis (figs. 20, 64, 124, nos. 46, 54). They date to the end of the reign of Akhenaten's father, Amenhotep III, or the first years of

Akhenaten himself.[41] A round belly and pronounced buttocks are also features of these female images, as can be seen in the statuette from this group in the Metropolitan Museum (fig. 20, no. 46). But the wooden statuette does not in any way equal the sculptural boldness that the torso shares with the Karnak statues of Akhenaten and Nefertiti (figs. 2, 9).

The woman represented in the torso wears an undergarment consisting of a long tunic of very fine thin linen. At the front of the neck, the partly open head slot of the tunic is just visible. Over the right shoulder and upper chest the linen clings so closely to the body that the appearance of bare flesh is created. Farther down, at the front, the tunic's widely spaced pleats also cling tightly. Over the tunic the woman wears a shawl of very fine, more narrowly pleated linen with fringes on two adjoining edges: a short looped weft fringe and a longer warp fringe. The two other edges are plain.[42] The corner where the two fringed edges meet is tucked under the woman's right arm so that the short fringe emerges from under the right arm and crosses diagonally between the clavicles to the left shoulder, while the long fringe hangs over the waist and the lower left arm. The shawl covers both breasts and the left arm and shoulder. It then passes around the back, and one unfringed edge overlaps the undergarment along the right hip and thigh. Below the right breast a knot was tied between the ends of the unfringed and long-fringed edges to hold the shawl in place.

Fine Egyptian linens were a wonder of the ancient world, but it is clear that the artist has exaggerated the thinness of this garment so that the pleats, fringes, and knotted ends play, to some degree, the role of a graphically defined pattern of vertical and oblique lines that emphasize the shape of the body. This use of garment pleats—and the fan-shape arrangement over the breasts and under the right arm—is reminiscent of the pleated kilt in the Karnak statue of Akhenaten (fig. 9). The Amarna artist, however, used the scheme in an infinitely more refined way, shaping pleats and interstices to convey an almost tangible impression of flimsy fabric. Under the subtle layering of stretched, clinging linen, the sharp-edged collarbone and soft body flesh are brought to life in masterly fashion.

Opposite: Fig. 17. Detail from a relief (fig. 15)

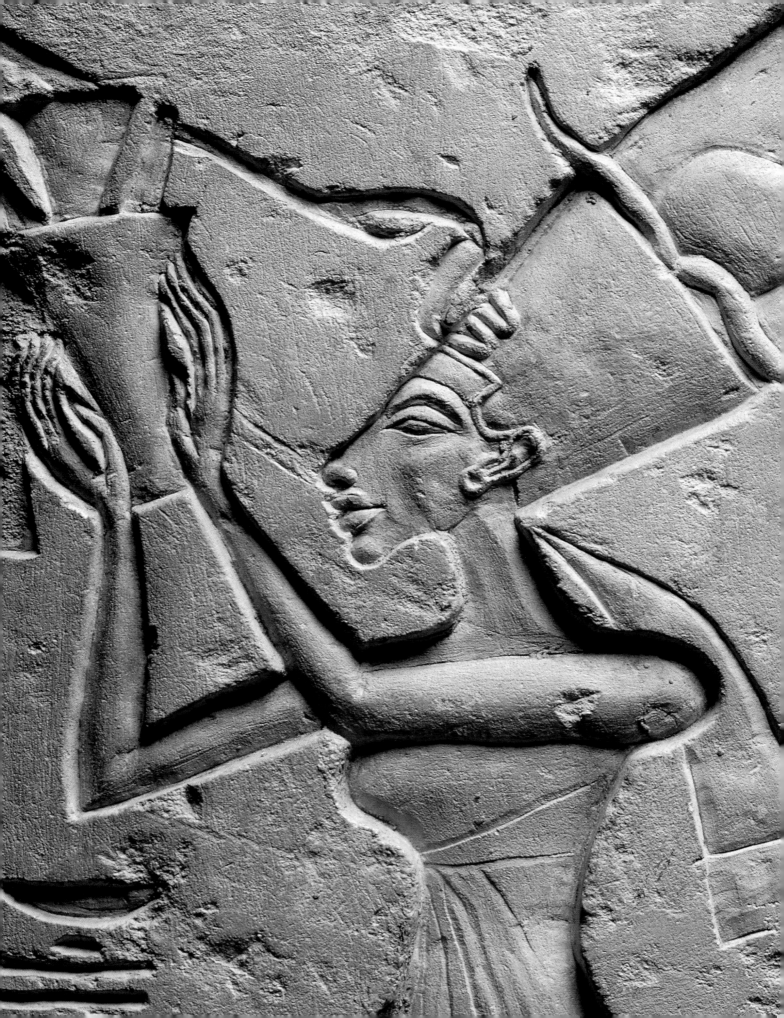

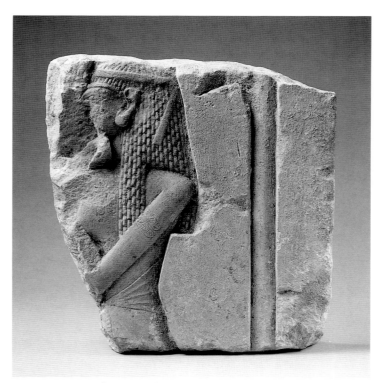

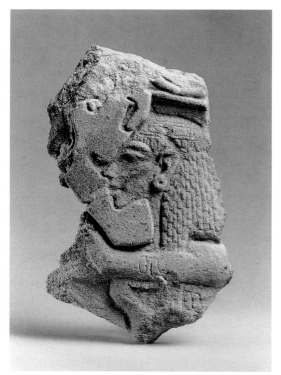

Fig. 18. Fragment from a relief excavated at the Temple of Ptah, Memphis. Limestone. Petrie Museum, University College, London

Fig. 19. Fragment from a relief showing Nefertiti. Reddish quartzite. The Metropolitan Museum of Art, New York

The slight forward movement of the woman's left leg balances the gesture of the now-lost right arm. Judging from what remains of the shoulder, the right arm would have stretched away from the body and to the right. The lower part of the arm was probably bent upward. A slab of stone was attached at the side of the right breast to support the arm. Since Egyptian stone statues do not usually include objects held in the hand of an outstretched arm, the hand of the quartzite woman presumably touched a neighboring figure, thus making her part of a group in which each figure was given a separately fitted back pillar.[43] The outstretched arm gesture is best known from statues and statuettes of princesses (fig. 103).[44] In Amarna statuary it is only in the rare seated figures that the queen touches or embraces the king;[45] standing royal couples usually hold hands.[46] It would, moreover, be very unusual for the queen's body to lack incised cartouches of the god, as was customary in Karnak and in early Amarna art.[47]

Astonishingly, therefore, iconography indicates that this "mother goddess" figure represents a princess, most probably the eldest daughter of Akhenaten and Nefertiti, Meretaten, who was probably in her early

teens when the torso was made, during the Years 6–8 of her father's reign.[48] In the complete work the princess was grouped either with her mother and father or with another sister, as often seen in tomb and temple reliefs (fig. 112). That no traces of a side lock are preserved on the shoulder does not necessarily indicate that her head was bare-skulled, like the one from the workshop of Thutmose (see pp. 55–61, figs. 46–48, 50–53). The statues of princesses flanking the boundary stelae had short side locks that did not reach the shoulders.[49]

Whatever the outcome of an ongoing discussion of the late years of Akhenaten's father, Amenhotep III,[50] it is certain that his mother—"the King's Mother, King's Chief Wife Queen Tiye may she live forever continually"—lived for a number of years after the new capital, Akhetaten, was founded. She probably resided at Amarna[51] and certainly was buried there after Year 9 of Akhenaten's reign,[52] possibly as late as after Year 14.[53] Most significantly, her steward Huya, the highest official of her household, had his tomb prepared at Amarna. On the walls of this tomb[54] two images depict a banquet (fig. 110) at which the Queen Mother, represented much as in figure 5, feasted with Akhenaten,

Nefertiti, and their elder daughters. Beside Tiye's chair stands little Princess Baketaten, who may have been the queen's late-born child by Amenhotep III (see p. 10).

The banquet, which took place outside the city in a rural setting,[55] may well have celebrated the inauguration of the Queen Mother's Sunshade temple at Akhetaten, which is depicted on another wall of Huya's tomb.[56] Scholars have debated the meaning of the word *Sunshade*, and only the following points appear to be certain.[57] Sunshades (the word *shut*, which is traditionally translated as "shade," may not have meant a shady place) were sacred structures in which daily offerings were made to the sun god. At Amarna, Sunshade sanctuaries were closely connected with female members of the royal family; landscaped gardens, whose trees, flowers, and pools provided ample allusions to nature— the special realm of all Egyptian solar deities and, above all, of the Aten—are a frequent feature. We will come back to these mysterious structures later (pp. 104–7). Suffice it here to state that Queen Tiye was fully a part of the religious building and cult programs at Akhetaten.

Queen Tiye is represented by a considerable number of still-extant images in relief and in the round.[58] For the most part, these sculptures portray the queen with a youthfully round face surrounded by an overpowering, enveloping wig; the slanting eyes are large and almond shaped, and the small mouth tends to look pursed. In profile, the chin, mouth, and nose protrude beyond the line of the forehead. Similar features are found not only on certain images of the king but also on representations of private persons.[59] It is a kind of "official-person image" that was given an especially pleasing aspect for the queen.

Surprisingly different is the face of a small head of Tiye made of steatite and excavated from the Hathor sanctuary of Serabit el-Khadim in the Sinai Desert (fig. 24).[60] It shows the queen in an ample tripartite wig. The corners of her naturally curved and sensuously full mouth are turned down and extended by sharply incised lines; more softly carved oblique folds separate the slightly drooping flesh of the cheeks from the roundly protruding upper lip. The lower lip pushes firmly upward, which gives the face its expression of strong-willed determination, especially in the profile view.[61] Undoubtedly, the same person at a somewhat more

advanced age is represented in the small wooden head owned by the Ägyptisches Museum, Berlin (figs. 23, 26, no. 1). Personality is so strongly expressed in this small face (only two inches [5 cm] high) that Queen Tiye—if it is indeed she who is represented—has become one of the best-known women of antiquity.[62]

The head was bought on the Cairo antiquities market in 1905 for the Berlin collector James Simon by Ludwig Borchardt, who was subsequently able to research its provenance.[63] The piece had been found together with a number of other objects of wood or ivory at Medinet el-Ghurab, an ancient site at the entrance to the Faiyum Oasis, about fifty miles south of

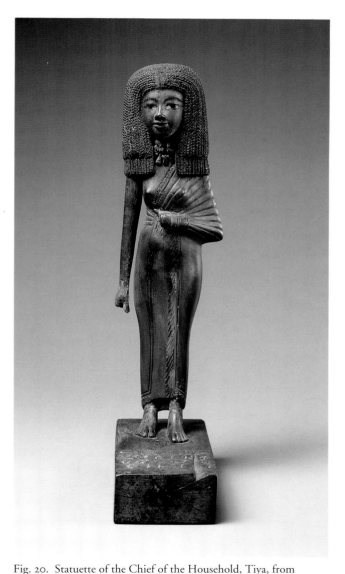

Fig. 20. Statuette of the Chief of the Household, Tiya, from Medinet el-Ghurab. Wood. The Metropolitan Museum of Art, New York

Cairo. Earlier, William M. Flinders Petrie and other British archaeologists working at Ghurab had uncovered remains of a mud-brick complex consisting of a large outer wall surrounding two rectangular inner enclosures and an extensive array of smaller structures.[64] Influenced by the high quality of the wooden head, Borchardt associated these ruins with the palace that King Amenhotep III and Queen Tiye had inhabited at Malqata on the west bank of the Nile, opposite Thebes, in southern Egypt.[65] This was certainly understandable, since many objects found with the head were inscribed with the names of Amenhotep III and Queen Tiye.[66] No wonder, then, that Borchardt came to the conclusion that the little head was an image of Queen Tiye and that the Ghurab ruins were the remains of a palace in which she had lived. Over time, other scholars added further pieces to the puzzle[67] until there emerged an intriguing picture of a royal dowager's house at Ghurab, in which Akhenaten's mother spent her last years.[68]

On closer examination, the evidence for Queen Tiye's having had a palace at Ghurab is very slight. The excavations of the ruins, for instance, did not produce any of the features, decorative or otherwise, usually found in palaces of her time,[69] and scrutiny of the objects found at the site and carrying inscriptions dating them to the time of Amenhotep III and Tiye reveals that these pieces are of a predominantly religious—indeed, in some instances, outright funerary—character.[70] The sources, in fact, suggest that a cult for the deceased Amenhotep III existed at Ghurab and that the offerings made in the name of Queen Tiye were part of this cult.[71] Since the Berlin head was found—so far as can be ascertained—together with objects dedicated to this cult, its identification as Queen Tiye still remains the only possible conclusion.

The head was once part of an approximately one-third lifesize statuette composed of various woods and precious materials. Modern technology—brilliantly brought to bear on the piece by the director of the Ägyptisches Museum, Berlin, Dietrich Wildung—has recently revealed the remarkable history of this masterpiece and clarified its original appearance (fig. 25).[72] What we see today is a later version of the head after it had undergone considerable alteration. Only the face and the neck appear to have survived these changes practically untouched.

The face is astonishing enough (figs. 25, 26). We see a woman somewhat beyond middle age[73] depicted with

unflattering details, but nevertheless she is a beauty of rare appeal. The triangular shape of the face is not found in any other Tiye image, but it is reminiscent of the Karnak heads of Akhenaten and Nefertiti (figs. 2, 9), as is the strong emphasis on the bone structure of the head, expressed by the angularity of cheekbones, jaw, and chin. Even the forehead, with its vertical depression above the nose, is shaped to convey the impression of a distinct skeletal type; the slanting, somewhat tired-looking eyes with heavy protuberant lids are set so deeply into the bony cavities that the application of even a short cosmetic line—which usually extended toward the temples—was impossible. The right eye is slanted slightly more than the left, and the upper lid is

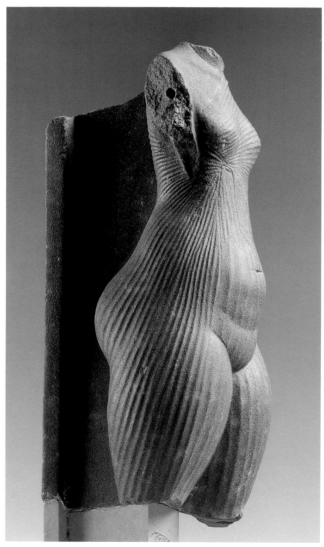

Figs. 21, 22 (opposite). Torso of a princess. Red quartzite. Musée du Louvre, Paris

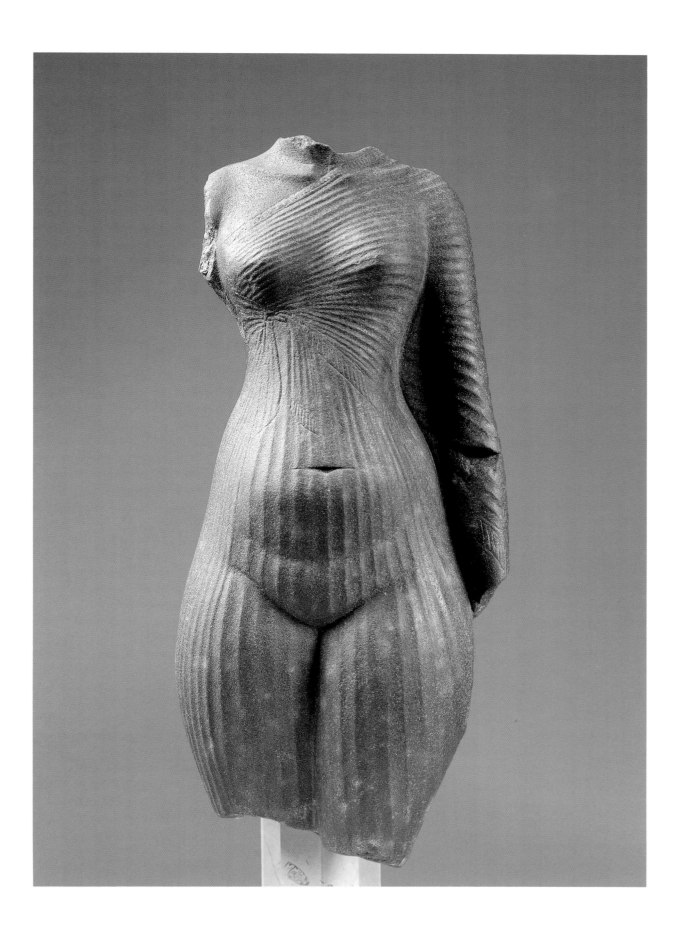

raised more, an asymmetry often found in Egyptian art but here used to fascinatingly lifelike effect.

The rather large nose and the full mouth are the only really fleshy parts of this face. Together with the chin, they protrude considerably beyond the line of the forehead, and the point of departure is the decidedly inward curve at the bridge of the nose. The lips have the downward turn at the corners seen on the Sinai head (fig. 24), but here the lower lip does not push against the upper, and the flesh covering the chin droops conspicuously. The result is a more passive expression. The experiences of a lifetime are inscribed in the deep grooves that run from the strongly modeled nostrils almost to the corners of the mouth. Resignation lies in the weary eyes and the laboriously arched brows. Two shallow folds are incised around the upper neck, and below the chin the rendering of sagging flesh between the jawbones is an almost hidden study in naturalism.

Some details in the rendering of Queen Tiye's face are paralleled in a pre-Amarna sculpture. The most important precursor is not a female but a male head and belongs to a famous representation of Amenhotep Son of Hapu, Amenhotep III's high-ranking overseer of all works, who was widely venerated as a wise man.[74] According to the inscription, he was eighty years old when the statue to which the head belongs was carved. The heavy-lidded eyes, the broad mouth—and the creases and lines around it—are strikingly similar to those of Queen Tiye. But it is equally apparent that the queen's head could not have derived from such an image without the intervening artistic achievements of the early years of Amenhotep IV/Akhenaten's reign. Only after the Karnak statues (figs. 1, 2, 9) and the reliefs from the Karnak temples were carved could an artist turn the traditional scheme of "old man's" features seen in the Son of Hapu statue into an image with the bold naturalism of Tiye's head. Comparison with the Son of Hapu statue dates the Tiye head unequivocally to the Amarna Period. Another version of the wise old man is a gypsum plaster head (fig. 28) that is suggestively similar to the wooden head of Tiye. It is important to keep in mind that the features of middle age in Tiye's image derive from the ancient Egyptian concept of the wise man. Significantly, a letter written by Tushratta, the king of Mitanni (Syria), to Akhenaten contains the following reference to the Queen Mother: "Tiye, your mother, knows all the words that I spoke

with yo[ur] father. No one else knows them. You must ask Tiye, your mother, about them so she can tell you."[75] It seems that even in foreign countries Akhenaten's mother was reputed to be the one "who knows," the wise woman.

The computer images reveal that the neck and face of the Tiye head were carved from one piece of Cypriot yew wood, the top of which ends in a domed tenon not visible in figure 25. The upper part of the head, made of Egyptian acacia wood, was fastened to the lower by means of the tenon. An overlay of hammered sheet silver covered the acacia wood and represented the queen's kerchief headdress (fig. 25); the silver was fixed to the underlying acacia wood with gold nails. The ancient Egyptian headdress called *khat*[76] was bound tightly around the forehead and temples; the rest of the kerchief completely covered the hair, falling at the sides behind the ears; at the back of the neck the end of the linen cloth was loosely gathered into a rectangular pouch that lay between the shoulder blades. On the Tiye head, most of the headdress is still preserved under the brown cap that now covers it (fig. 23); only the computer images make it possible to see the original effect (fig. 25). Visible on the piece itself because of damage to the brown covering are one earring and the edge of the silver *khat*, blackened by corrosion, above the forehead, whereas on top of the head, where the brown material has decayed, a glimpse of uncorroded silver can be discerned. The gathered end of the headdress at the back no longer exists; it was broken off when the head was removed from the body.

The queen's headdress of precious silver was further adorned with a broad gold band along the forehead and temples. Pieces of this band, which was partly tucked under the silver, remain at both sides, and a layer of yellow adhesive used to fix the band is above the forehead. Four golden cobras and two ear ornaments of gold and lapis lazuli further enhanced the queen's head in its original splendor. Parts of the bodies of two cobras still protrude from the brown cap above the forehead and the tails cause the covering to swell along the top of the head. The foreparts of the bodies and the heads of these cobras, possibly inlaid with glass or precious stones, were once attached by means of the two holes in the silver overlay. A single central hole has

Opposite: Fig. 23. Head of Queen Tiye from Medinet el-Ghurab. Yew wood. Ägyptisches Museum, Berlin

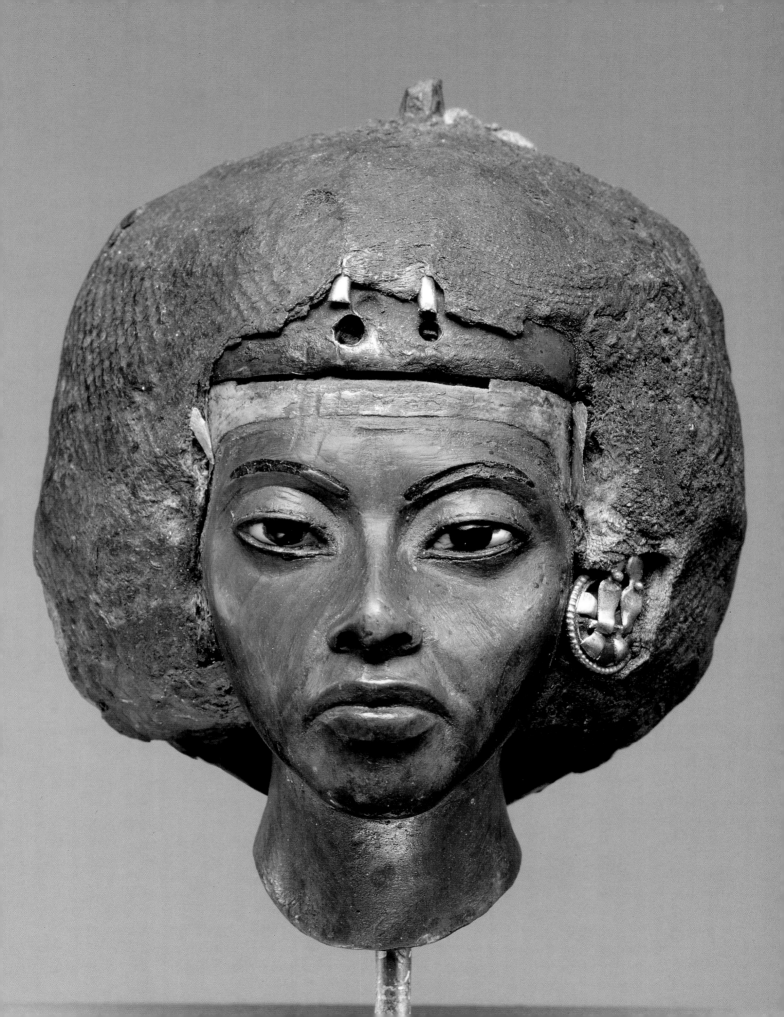

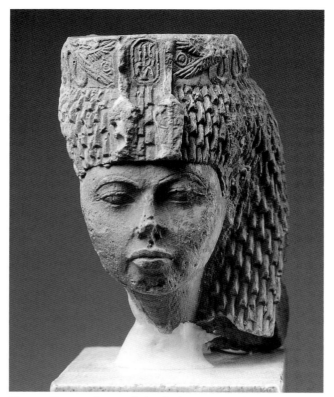

Fig. 24. Excavator's cast of a head of Queen Tiye from Serabit el-Khadim, Sinai. Petrie Museum, University College, London (steatite original in the Egyptian Museum, Cairo)

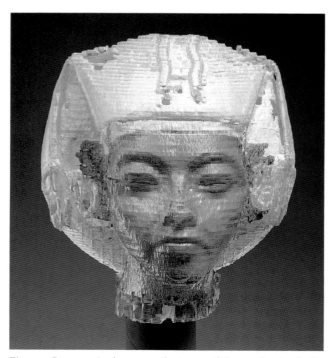

Fig. 25. Computerized tomography image of the wooden head of Queen Tiye without later head cover, showing silver headdress and gold ornaments. Ägyptisches Museum, Berlin

been closed up; its function is unknown. Computerized tomography revealed the existence of two other cobras whose tails lie on the top of the head (fig. 25), whereas the bodies extend along the sides of the *khat* to behind the queen's ears. The circular ear ornaments consist of dentiled gold rings that encircle broader hoops of gold and lapis lazuli fitted with two small cobra figures.

The face of yew wood under this rich array of gold and silver is highlighted by the different colors of brows, eyes, and mouth. Brows and edges of lids are inlaid with dark brown ebony,[77] the cornea is probably white alabaster, and the pupils are obsidian or black glass. The lips are painted red. On the bottom of the neck are the remains of yet another tenon that served to fit the head to the body. The outline of the neck still shows that the queen wore a broad collar, probably richly inlaid, over her shoulders. The figure in its original silver *khat* headdress with gold and inlaid adornments was undoubtedly a wonder to behold, and it is difficult to understand why the brown cover, which hides much of the effect, was added.

As far as can be ascertained, the cover consists of linen, wax, and glue. Originally, it completely concealed the *khat* headdress and all its ornaments, the bodies of the cobras, and the beautiful ear ornaments. In the altered version the top of the head was adorned with one of the familiar plumed crowns of the queen; the outline of the circular modius that formed the base of the crown is still visible on top of the brown cap, and part of a wooden plug that fastened it to the head remains. The rest of the cap was covered by a layer of small blue glass beads, which were set into the moist glue. The effect that the work gave after these alterations must have been quite different from the one made by the first version.[78] Instead of gleaming silver and gold, a more subdued but still glittering blue mass covered the head; the proportional balance was also altered by the high feathers of the crown of gilded wood and plaster, which make the head look smaller.[79] The upper part of a queen's crown consisting of cow horns, sun disk, and feathers was acquired by the Ägyptisches Museum, Berlin, with the group of objects reported to have been found in conjunction with Tiye's head. It may well be a piece of the crown that once adorned the head in its altered version.

The image of the queen wearing the plumed crown was, of course, the one people knew best, before and

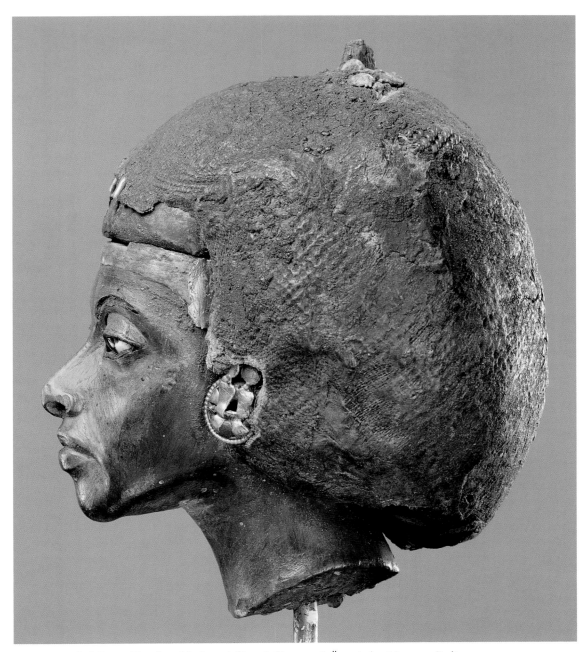

Fig. 26. Head of Queen Tiye from Medinet el-Ghurab. Yew wood. Ägyptisches Museum, Berlin

during the Amarna Period. It is how Tiye appears on the reliefs in the tomb of her steward Huya (fig. 110).[80] The only difference in her adornments in the Berlin head's second version is a round wig instead of a long tripartite one. This wig is rare in representations of this queen, but the Metropolitan Museum owns a small obsidian relief fragment dating to the reign of Akhenaten's father, Amenhotep III, in which the unmistakable face of Tiye (fig. 3) appears beneath a similar wig.[81]

The *khat* headdress of the original version of the wooden head was worn much less frequently by Tiye; she appears in it only at her husband's first *sed*-festival.[82] Since the Berlin head dates stylistically to a time after the Karnak colossi of Akhenaten and Nefertiti, the statuette to which it belonged cannot have served at a *sed*-festival of Amenhotep III.[83] There is also no evidence that Queen Tiye took part in the *sed*-festivals of her son Akhenaten.[84] A clue to understanding the original

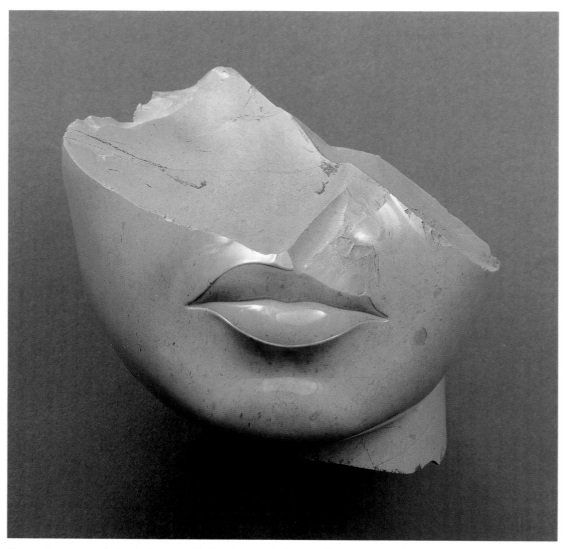

Fig. 27. Fragment of a head of a queen. Yellow jasper. The Metropolitan Museum of Art, New York

function of the wooden statuette may be provided by the *khat* headdress that adorned it. As Marianne Eaton-Krauss has shown,[85] the use of this headgear for female figures in pre- and post-Amarna art is confined to representations of goddesses such as Isis and Nephthys and their companions Selket and Neith. Figures of these deities wearing the *khat* while guarding the canopic shrine of King Tutankhamun are among the most widely known pieces of ancient Egyptian art (fig. 86).[86] "When worn by these goddesses," Eaton-Krauss writes, "the headdress has a specific funerary reference."

The statuette of Queen Tiye to which the Berlin head belonged cannot have been part of King

Amenhotep III's funerary equipment because that funeral took place at Thebes, in southern Egypt, where the king's tomb is located. Considering, however, the fact that a cult for the deceased king existed at Ghurab, one might suggest that it was for this cult that the first version of the statuette was created. It would have depicted the queen in the role of a funerary deity with the profusely added cobras underlining her status. Such an interpretation parallels Nefertiti's presence on the sarcophagus of her husband at Amarna (see pp. 93–96, fig. 85).[87]

The change to the second version of Tiye's stat-uette[88] is best understood—again following Eaton-Krauss's

34

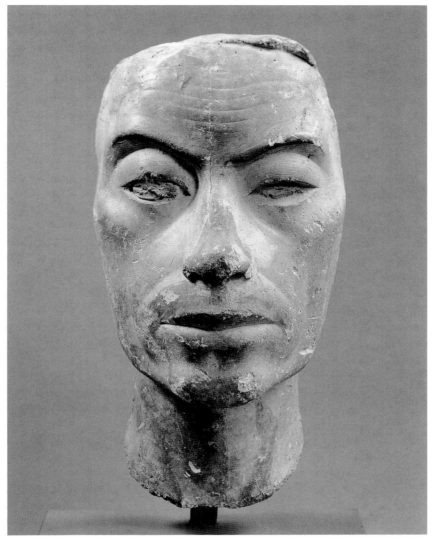

Fig. 28. Face of a man, possibly Ay, from the Thutmose workshop at Amarna. Gypsum plaster. Ägyptisches Museum, Berlin

reasoning—as having happened in the post-Amarna "return to orthodoxy" days, when the direct identification of a queen with a funerary goddess could no longer be tolerated.

The third sculptural masterpiece of early Amarna art that represents a female subject is the yellow jasper fragment in the Metropolitan Museum (figs. 27, 29).[89] The provenance of the piece is unknown.[90] Amarna has always been thought to be the most probable place of origin, despite the known existence of a Theban tradition of working with very hard semiprecious stone and the find of a red jasper fist from a statue at Medinet Habu in western Thebes.[91] The Metropolitan Museum's

yellow jasper head fragment retains part of the left side of the neck and the entire chin and mouth area. Above the center of the upper lip, the lower end of a ridged philtrum remains barely visible. On the side of the neck two incised lines define furrows in the flesh. The fragmented edges above the mouth convey the impression that the head was intentionally and viciously destroyed.

Most illustrations of the jasper fragment do not show any sculptural details in the chin and mouth area because the mirrorlike polish of the stone surface makes the piece extremely difficult to photograph. Proper lighting, however, reveals that the sculptor has indicated two oblique muscles above each side of the

mouth. They are delineated by subtly indented furrows, with the lower furrow continuing into a crescent-shaped curve that encircles each pointed corner of the mouth. Below the lower lip, which protrudes considerably more than the upper, a sinew-flanked groove runs against the mouth from the crescent-shaped indentation that defines the ball of the chin. This groove creates the impression that the heavy lip needs support from below.

In contrast to what is seen in the wooden head of Queen Tiye (figs. 23, 26), the furrows around the mouth of the jasper face are not inscribed in sagging flesh; they define strong, even tense, musculature. In combination with the forward thrust of the chin and the powerful set of the jaw, this taut musculature lends the face character and individuality, thus adding personality to the sensuously rounded lips. The voluptuous lips are all the more expressive because they are tightly constrained by the wonderfully soft edge of the vermilion line. It is not a meek beauty who is depicted here, and the unevenness of the mouth, whose left side is considerably lower than the right, definitely adds to her interest.

Initially identified as an image of Queen Nefertiti, the yellow jasper fragment has since commonly been ascribed to Queen Tiye, following William C. Hayes's argument that the cheeks are too full and rounded and the neck too straight for an image of Nefertiti.[92] However, the question of the identity of the woman depicted in the jasper face cannot yet be called definitely solved, because a comparison of the piece with the wooden head of Tiye reveals a number of differences between the two works of roughly the same date. These differences go beyond stylistic considerations and are not explained by the observation that the wooden head was made in the Memphite area, whereas the jasper head was created by a sculptor at Amarna who may have been a member of the Thutmose workshop. One of the most impressive gypsum plaster heads from that workshop (fig. 28, see below, p. 51) shares with the jasper fragment the individualistic groove below the lower lip, the square chin, the full mouth, and the general boldness of sculptural workmanship.

To enumerate a few of the differences between the head of Queen Tiye and the jasper fragment: In her wooden head, as well as in her small head from Sinai (fig. 24), Tiye's mouth is characterized by downward drooping corners; the corners of the jasper face's mouth

do not droop, and there are no vertical indentations beside the mouth. Tiye's chin is pointed; the jasper face's chin is square. Tiye's neck is broader at the base and narrows toward the jaws; the jasper face's neck is columnlike and straight. The main difference between the two images is, after all, one of age and character. Tiye was definitely a middle-aged or even older woman by the time Akhenaten took up residence at Amarna, and her image was that of a wise woman. That she was represented as such in sculpture in the round not only at Ghurab but also at Amarna is attested by the quartzite head in the Metropolitan Museum (fig. 42, pp. 51–52). The jasper face represents a woman not only in youthful bloom but also of decided sex appeal. Would that have been the proper approach to a depiction of the king's mother at Amarna? Therefore, the identity of the woman represented in the jasper face remains in question. One can only advance a few suggestions.

It can be stated with confidence that the person depicted in the jasper piece was female. In spite of the fact that during the Amarna Period women of the royal family were often rendered with brown or reddish-brown faces (figs. 23, 26, 42, 46–48, 50–53, 65), yellow was the traditional color of female skin in Egyptian art,[93] and some impressive images of Nefertiti from the Thutmose workshop were rendered in yellow quartzite (figs. 66, 67) or with a light reddish paint (fig. 58). There can also be no doubt that the subject of the jasper head had royal status. The precious material alone attests that. We will presently have more to say about the technique of making composite statues in which the head, limbs, and parts covered with garments were made of different types of stone (pp. 62–63).[94] That the jasper head once belonged to such a statue is clearly indicated by the structure of its back. A deep groove (5.1 cm [2 in.] wide) with a roughened surface in the center and smooth inclined sides is partly preserved. This groove functioned as the mortise for a tenon that would have been at the top of the body of the now-lost statue.

The existence of a mortise at the back of the head excludes the possibility that originally a fully sculptured round neck formed one piece with the face. This makes all reconstructions of the head with the various off-the-neck crowns worn by Nefertiti extremely unlikely. The same applies to the short round wig worn by Tiye (fig. 3)

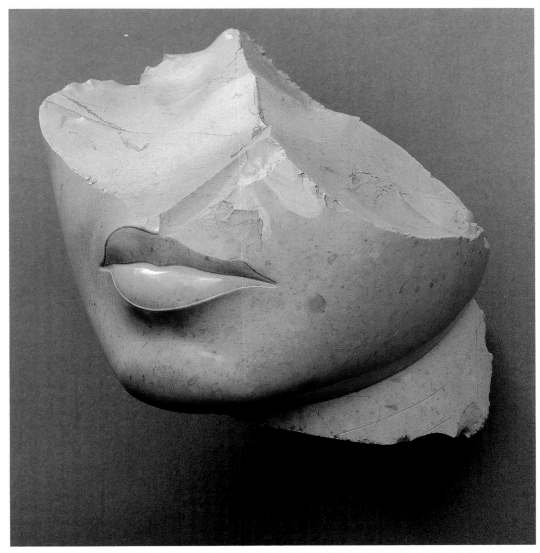

Fig. 29. Fragment of a head of a queen. Yellow jasper. The Metropolitan Museum of Art, New York

and Nefertiti.[95] The amount of sculptured neck at the side of the fragment (fig. 29) also rules out the tripartite or enveloping wigs that would have covered the sides of the neck. Among all female headdresses known from the period, only two remain for possible reconstruction with the jasper face: the *khat* headdress and the Nubian wig.

Among the *khat* headdresses, the one worn by Queen Tiye in the original version of the wooden head (fig. 25) again covers too much of the neck to match what is preserved of the jasper fragment's neck. However, King Akhenaten's *khat* in the Karnak statues (fig. 9) and in a number of relief representations is set back far enough to make possible a reconstruction of

the original jasper statue with such a head ornament (fig. 81).[96] Some reliefs[97] depicting Queen Nefertiti in the *khat* also show the cloth at the sides of the neck set back far enough to present a parallel to what is preserved in the jasper fragment; an upper part of a head of the queen—unfortunately without a preserved neck—in Hamburg[98] documents, moreover, that statues of Nefertiti with this headdress actually existed. So it appears, after all, that an identification of the jasper head with Nefertiti cannot be entirely ruled out. If it is, indeed, her image, she would have been represented wearing a *khat* headdress.

There is, however, one other head ornament that might fit the yellow jasper face: the Nubian wig. This

wig is characterized by pointed ends that fall to the clavicles. At Amarna, the wig was the most frequently worn hairstyle, and it appears on the heads of commoners—both male and female—princesses, and king and queen alike.[99] In sculpture in the round the sides are usually carved hanging away from the neck and lower cheeks, as seen in a small limestone head in The Metropolitan Museum of Art.[100] A reconstruction of the jasper head with such a wig would correspond, therefore, with the fully carved jaws and neck of the piece. Indeed, one peculiar feature of the preserved neck portion would best find its explanation with this headdress. Toward the back, the neck of the jasper fragment ends in a remarkably flat area. This somewhat lifeless shape becomes understandable if the view was partly obscured by a wig.

The only problem with reconstructing a Nubian wig on the jasper head arises at the back. In reliefs the Nubian wig (especially when worn by women) usually ends fairly high up so that a good part of the neck is visible. This is also seen in the Metropolitan Museum limestone head in the round, where a good portion of the back of the neck is visible beside the small back pillar. If we assume that the jasper head was fitted with a Nubian wig, we must accept that either the statue had a back pillar, which is—as we will see presently—unusual for composite works (pp. 62–63), or the wig reached down to the back, as it does in a canopic jar of alabaster depicting a royal woman of Amarna (fig. 116, pp. 115–18). Who could the woman in the Nubian wig have been, if such a headdress was, indeed, part of the jasper head?

Although the Nubian wig is worn, albeit rarely, by Queen Tiye[101] and more often by Nefertiti and her daughters (figs. 37, 77, nos. 10, 17),[102] the royal woman who appeared most frequently in this headgear was the minor queen Kiya (see pp. 105–6).[103] Known images of this interesting woman at the court of Akhetaten are mostly in relief, but they all depict her with a prominent chin and a full mouth (figs. 100, 101) rather comparable to those seen in the jasper fragment. It is true that in the reliefs Kiya's neck is usually not straight but thrust forward obliquely, as was customary in the portrayals of many royal women, especially Nefertiti (figs. 60, 62, 66). But we must remember that as yet we know of no depictions of Kiya in the round.

It is very tempting to suggest that the yellow jasper head once belonged to a composite statue of Kiya.

This statue might have stood in her Sunshade temple, called Maru-Aten, south of the city of Amarna (see pp. 105–7). The precious material and doubtlessly colorful appearance of the statue would have been appropriate in the parkland setting and the richly decorated architecture.[104] A number of stone inlays from heads were found in a small temple in the Maru-Aten Precinct. They are stylistically very close to the jasper head fragment.[105]

If this tentative identification as Queen Kiya is correct, the jasper head would be the most impressive image extant of the woman who, in her coffin texts, addresses funerary poetry to Akhenaten that can only be called a forerunner of the New Kingdom love songs:

May I breathe the sweet air that comes from your mouth. May I see your beauty daily. My wish is that I hear your sweet voice of the north wind, that my body may grow young with life for love of you. May you give me your arms bearing your life-force, that I may receive it and come to life. May you call on my name continually, without it having to be sought in your mouth. My lord Akhenaten, who shall be here continually forever, alive like the living disk.[106]

Looking at the yellow jasper fragment in near profile (fig. 29), one is struck by the absence of any drooping of the chin, which was so much a part of the royal heads from the very beginning of Akhenaten's reign (figs. 1, 15). Below the chin only a very subtle groove separates the ball of the chin from the area between the jaws. Reliefs show that the image of at least one royal woman, Queen Nefertiti, changed after the initial years of Akhenaten's residence at Amarna. Nefertiti's new face is no longer similar to that of her husband: her jaw and chin have become square and the lower face no longer droops. Her new face is seen in a column relief that Petrie found in the area of a garden pool in the more intimate brick-built sections of the so-called Great Palace at Amarna (fig. 30).[107] The theme is again an offering to the Aten; the figures of Akhenaten, Nefertiti, and Princess Meretaten are partly preserved. Enough remains of the king's jaw and chin to show that he still had the by now familiar drooping chin, which the queen's face no longer possesses. Her jaw is square, the lips are straight, and the deep furrows are gone from the areas around the mouth. Most importantly, the proportions of the head and its relation to the neck are changed. Before, the face protruded almost horizontally from the

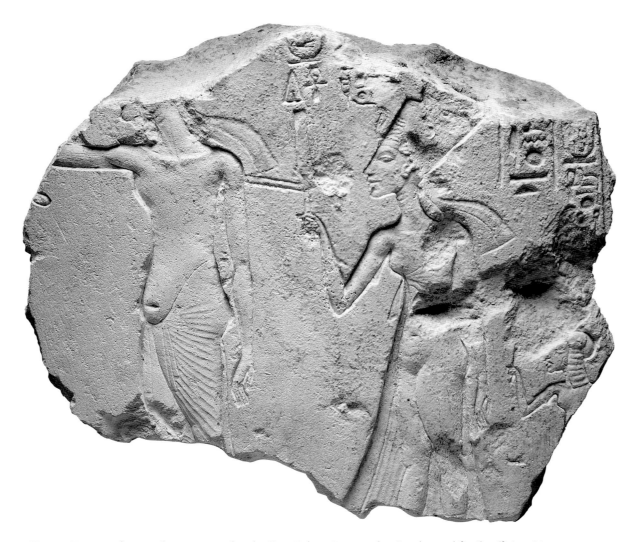

Fig. 30. Fragment from a column excavated at the Great Palace, Amarna, showing the royal family offering. Limestone. Ashmolean Museum, Oxford

neck, and the distance between the front of the face and the back of the head was considerably wider than the distance between the chin and the top of the forehead. In the new style (fig. 30) these dimensions are roughly equal, and Nefertiti's tall crown tends to extend the head upward rather than backward as in the early images (fig. 15).

The change in the representation of the queen's face can be dated to the period immediately preceding Years 8–12, when the writing of the names of the Aten was altered, because the Berlin shrine stela (fig. 88), which is inscribed with the early version of the god's name, already shows the new style of representing Nefertiti's face. It should be noted that the children in this relief retain their likeness to Akhenaten,[108] and so their heads are shaped according to the earlier style. Given its simi-

larity to Nefertiti's face on the stela, the yellow jasper face (figs. 27, 29) must date to about the same period as the Berlin shrine stela. The jasper face is thus, probably, the first extant example of a newly softened presentation of female features in a sculpture in the round. With stupendous mastery of one of the hardest materials ever used by a sculptor, this artist has opened a new vista on an extraordinary royal female: a boldly, almost aggressively sensuous beauty.

In the following chapter we turn to an examination of the most important sculptor's workshop known from Amarna—and perhaps from all of ancient Egypt. In the context of this workshop's achievements, the change in the image of Amarna's chief queen will become even more clearly defined.

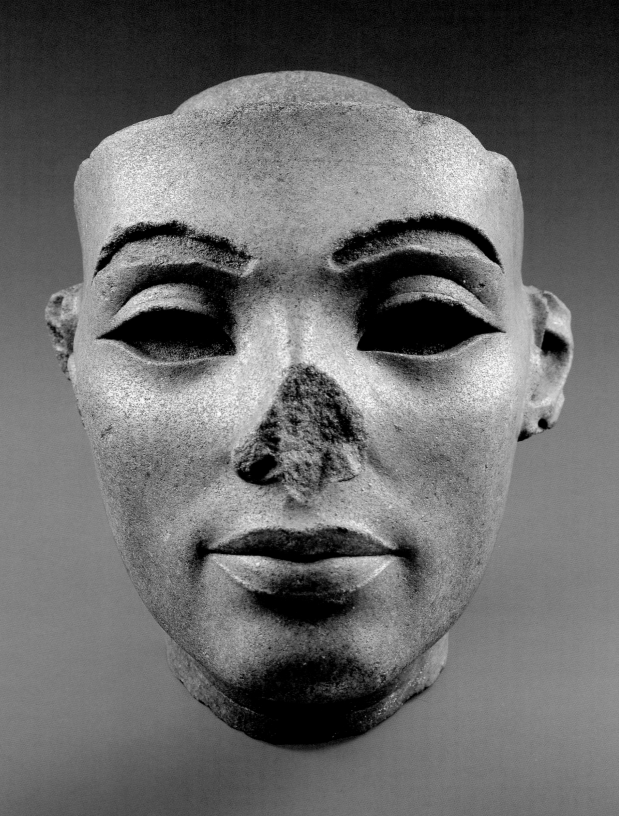

THE WORKSHOP OF THE
SCULPTOR THUTMOSE

DOROTHEA ARNOLD

THE ARCHAEOLOGICAL REMAINS

In the center of Akhetaten, east of the Royal Road and parallel to it, runs a curved street. Earlier archaeologists called it the High Priest Street; the British team presently excavating at Amarna refers to it as East Road South. At a point just north of the street's easternmost bend, a narrower east–west lane meets the East Road;[1] at the corner of the street and the lane is a compound of houses and workshops (figs. 34, 35). An inscription on an ivory horse blinker found in a pit in one of the courtyards mentions a man "praised with the perfect god, the Chief of Works, the Sculptor: Thutmose."[2] It is assumed that only the proprietor of an establishment would have owned horses and a chariot, the luxury vehicle of the New Kingdom. The identification makes Thutmose one of the few ancient Egyptian artists whose name is known and whose style can be identified.

In order to understand the structure and function of Thutmose's workshop, one has to realize that Egyptian artists were generally not independent entrepreneurs like, for instance, the painters and sculptors of Renaissance Italy. Artists in ancient Egypt were above all part of a royal, state, or temple institution, and as members of such they had titles that described their place in the hierarchy. The primary locations for their activities were royal, state, or temple building sites, or a workshop attached to a palace or temple.[3] At Amarna, artists evidently also worked in compounds that were under the control of certain officials in an administrative capacity. The Chief Sculptor of the King's Great Wife Tiye, Iuty, for instance, is depicted in the tomb of Queen Tiye's steward, Huya (fig. 32).[4] Iuty sits on a stool correcting with pen and ink the carving of a statue representing Princess Baketaten; the carver of the piece bows

to him deferentially. The scene takes place in a columned hall that is entered through a door from a larger complex consisting of courtyards and studios where carpenters, jewelers, and other craftsmen are depicted performing their respective tasks (fig. 33). The head of this establishment is not the Chief Sculptor Iuty but Queen Tiye's steward, Huya, who stands in the large courtyard of the compound accompanied by a scribe and another subordinate. The inscription states that Huya is "appointing the craftsmen,"[5] which means that the artists and artisans, including the sculptors, are under Huya's command, although Huya is not an artist himself, but a courtier and administrator of high rank. Thutmose, therefore, most probably would have overseen a large sculptor's workshop not because he was a sculptor but because he was Chief of Works, that is, an administrator of construction and manufacturing projects.[6]

A number of compounds that might have served as workshops were excavated at Amarna. They usually consisted of a large courtyard, regularly aligned storerooms, and—if any at all—very simple and small living quarters, suitable only for workmen of low status.[7] Only the Thutmose workshop is connected with—and incorporated in—one of the elaborate houses of the Amarna villa type. The reason may be that Thutmose was Chief of Works and a sculptor as well.

It was customary for all Egyptian state artisans to undertake "outside work" (i.e., privately contracted and directly remunerated work) in order—one would suppose—to increase their income and status in the community.[8] At present, we cannot determine whether Thutmose's workshop functioned as a location for such outside work—performed in addition to the activities that he oversaw officially—or whether the workshop was his main responsibility as Chief of Works. What we do know is that Thutmose's artisans performed two

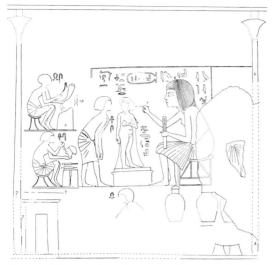

Fig. 32. Master sculptor Iuty correcting the work of an assistant. Drawing by Norman de Garis Davies after a relief in the tomb of Huya at Amarna

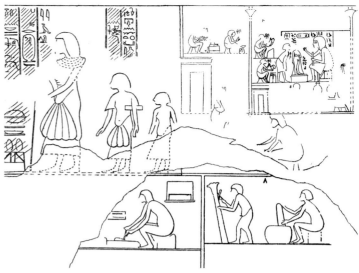

Fig. 33. Workshops under the supervision of Queen Tiye's steward, Huya. Drawing by Norman de Garis Davies after a relief in the tomb of Huya at Amarna

very specialized tasks: one was related to the production of heads and limbs for composite statues; the other concerned casting in gypsum plaster from heads of statues representing royalty and persons of rank, male and female. It is unthinkable that Akhenaten and his queen and daughters would have gone "shopping" at Thutmose's private workplace for their statues. Therefore, the royal sculptures must have been created on royal command by Thutmose and his coworkers, who were then compensated according to their rank and merit. The images of commoners (mainly preserved in casts of gypsum plaster) could have been made as "outside work," but they were probably also commissioned for favorites by the king and queen.

If Thutmose and his entourage of sculptors worked mainly on royal commissions, it does not necessarily follow that their business was static. On the contrary, the archaeological history of the compound as it emerges is a true success story of progressive expansion. The original house, in which Thutmose lived with his family, was entered from the small east–west lane (fig. 35 [1]*).[9] A gate from High Priest Street [2] was presumably used as an entrance for the chariot and horses and the delivery of bulky commodities such as blocks of

stone. Through the main northern gate on the lane [1], one first entered a front courtyard [3], from which a flight of stairs led into two entry rooms [4]. The visitor then reached a reception hall [5] whose ceiling was supported by two wooden columns. To the left of this lofty hall was a small room with a table or bench [6] and a doorway that led into a large courtyard with a well [7]. Directly beyond the reception hall was the central living room [8] furnished with mud-brick benches and a basin in which pots of cool water were kept; a door opened into a screened-off bathroom and toilet [9], and from there, to the left, was the master bedroom [10]; on the right a staircase [11] led to the second story. The ceiling of the entire center section of the house was higher than those of the outer rooms; clerestory windows allowed light into the reception hall and living room. The computer reconstruction shows only the ground-floor level.

At the back of the main house, a smaller court [12] surrounded four silos where grain was stored for making bread and beer, the staple foods of the ancient Egyptians. Thutmose had to feed not only his family but also his artists and apprentices. To ensure control over the supplies, access to the silo court was possible only through the house. A cluster of baking ovens occupied a small corner at the back of the large court [13], and nearby a large barn with two strong pillars served as the stable [14].

*Numerals in brackets refer to figures 34 and 35.

As visitors turned right in the second entry room beyond the entrance of Thutmose's house [4], they reached a series of courts and rooms with inner partitions [15]. During the excavation, large amounts of gypsum plaster were found in most of these rooms, evidence that they were the areas used for casting. Broken pieces from older objects of alabaster and obsidian[10] were probably waiting to be recycled as the inlaid eyes of new statues.

Broken bits of alabaster and fragments of diorite and quartzite sculptures[11] in the large courtyard [7] around the well on the opposite side of Thutmose's house show that stone carving was performed there. Various walls along the enclosure around the well court may originally have belonged to workshops. A small unfinished quartzite head of a princess[12] was found in the corner of a half-destroyed structure near the trees that adjoined one side of the well [16]. Another almost finished quartzite head of a princess (figs. 46–48, no. 5), one of the greatest pieces of art from ancient Egypt, was discovered near the south wall of the same court [17].

At some point Thutmose employed a younger sculptor, who may well have been his son. He had a small house [18] built for this artist and his family in the northeast corner of the compound, with a separate entrance from the lane. Later—it is difficult to say when—a third, still smaller, house [19] was added for another young sculptor, filling the space between the second house and the enclosure wall to the north. The two younger families seem to have shared the well and the ovens in the large court with Thutmose's family and to have depended on Thutmose for grain.

The first young sculptor had workrooms adjacent to the enclosure wall east of his house [20]; considerable amounts of diorite and granite chips were found in these rooms. One of his works, the pink quartzite head from the statuette of a nonroyal woman in an enveloping wig,[13] was found in the living room of this house. Evidently, the second young sculptor also worked in diorite; another masterpiece, a granodiorite head of Queen Nefertiti (figs. 72, 74, no. 3),[14] was found in the working area of his house [21].

In time—when the younger sculptors were employed or later—the workshops around Thutmose's well courtyard were no longer large enough to accommodate all the work that was undertaken, so the compound was enlarged by annexing adjacent land to the south. Access to this area was through a gateway in the center of the south wall [22]. The new plot comprised another courtyard with a well [23], around which were built smaller groups of rooms that appear to have served as a combination workshop and sleeping quarters, perhaps for artisans who had no families. In addition, there were two substantial houses (for supervisors?) in the southeast corner of this court [24]. Many unfinished pieces of sculpture were found in the smaller workshop units, among them the small figure of a kneeling king,[15] work on which had just been started; pieces of arms and hands of quartzite statues;[16] an unfinished head of a statue of the king;[17] and fragments of an unfinished female statue of alabaster.[18] Clearly, the workshop was a busy place.

Finds indicate that the addition of the second court and its workshops still did not provide adequate space, and the compound was enlarged by the addition of another plot to the south; an earlier villa may have stood there, since a typical Amarna garden chapel remained [25].[19] Found inside the main house of this part of the compound [26] were a headless statuette of Nefertiti with an offering plate[20] and one of the most intricate group studies extant from Amarna art: the king kissing a queen or princess who sits on his lap (fig. 96). On the west side of this third part of the compound, a walled-in passage allowed direct access to yet another building (the West House) that may have been used by another member of Thutmose's workshop (not included in fig. 35).[21]

A Deposit of Works of Art

The story of the growth of the Thutmose sculptors' establishment at Amarna is interesting, but the main significance of the workshop in the history of ancient Egyptian art lies in the events that occurred when the sculptors left Akhetaten to follow King Tutankhaten (later Tutankhamun) to Memphis or Thebes. When people leave their dwellings voluntarily, they usually take all their important belongings with them and leave behind only what they no longer need. Since this is what happened when Egyptians reverted to their traditional religion and places of royal residence after Akhenaten's death, the excavators did not find a Pompeii-like situation at Amarna, but rather what is

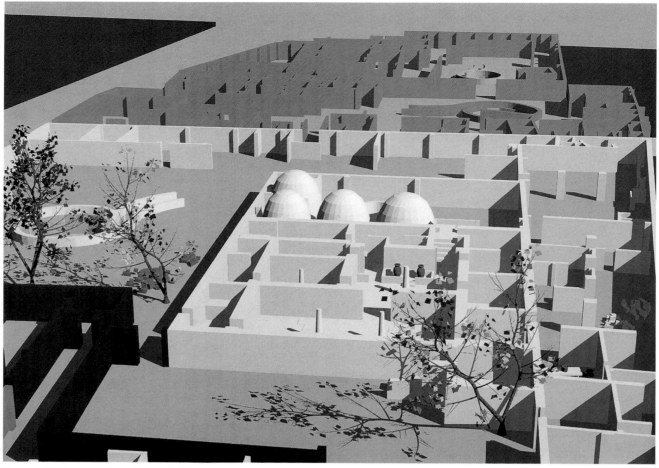

Fig. 34. The house and workshops of Thutmose at Amarna. Computer reconstruction of the ground-floor level

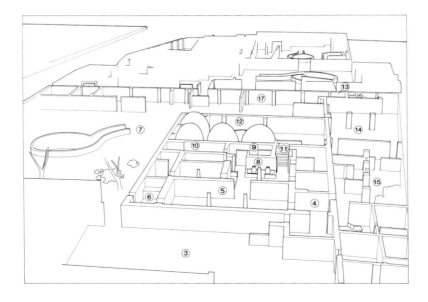

1. Entrance from lane
2. Entrance from High Priest Street
3. Front courtyard
4. Entry room
5. Reception hall
6. Small deposit room (pantry)
7. Large courtyard
8. Central living room
9. Bathroom and toilet
10. Master bedroom
11. Staircase to second floor and exit to granary
12. Granary
13. Bakery ovens

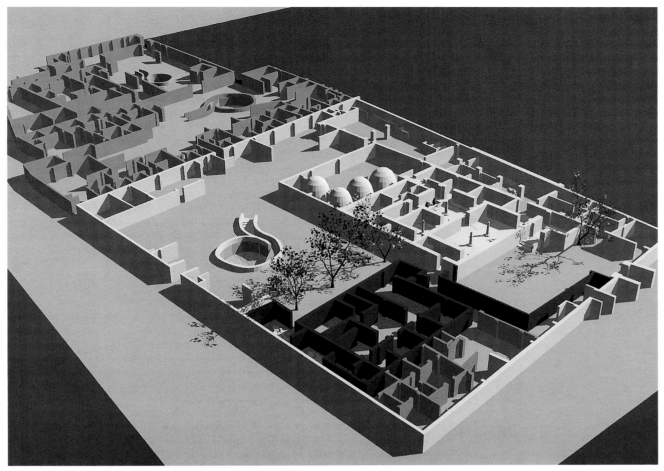

Fig. 35. The compound of houses and workshops under the supervision of the Chief of Works, the sculptor Thutmose, Amarna. Computer reconstruction of the ground-floor level

14. Stable
15. Gypsum plaster workrooms
16. Workshop
17. Find spot of head of a princess (figs. 46–48)
18. House of younger sculptor
19. House of second younger sculptor
20. Workshop
21. Find spot of head of Nefertiti (figs. 72, 74)
22. Gateway with workshops at left and right
23. Courtyard
24. Supervisors' houses
25. Garden chapel in third courtyard
26. Sculptor's house in which group (fig. 96) was found

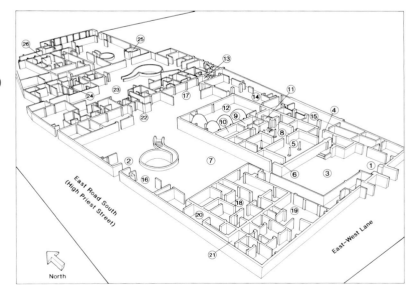

45

usually called "negative selection." Objects that would have been of use to the departing populace were not found, and those left behind did not necessarily remain in the places where people had used them.

Thutmose and his coworkers probably took with them their most valuable tools[22] and such models, molds, and unfinished works that might still be useful. What they left behind were, mainly, images—and models for images—of Akhenaten, Nefertiti, the royal daughters, and the successor, King Smenkhkare; these could be discarded because the royal persons were now dead and their memory was not honored in the new "back to orthodoxy" era. Thus the famous bust of Queen Nefertiti (figs. 58, 60) remained,[23] pristinely preserved along with more than fifty other works of art, in a small side room adjoining Thutmose's reception hall [6].[24] This roughly 2.25-by-5.7 meters (7.5 by 19 feet) room off Thutmose's columned hall[25] originally had two doors, one connecting it to the hall, the other leading into the large court with the well [7], where much of the heavy stonecutting was performed. Like the second anteroom on the other side of the hall, through which the gypsum workshops were reached [4], the side room functioned as a passage. But like other side rooms of its type in Amarna houses, it also served as a pantry: two water jars, partly sunken into the floor, stood there, and a thin cross wall held a wooden table that served for storage. A small alabaster cosmetic vessel[26] found in the room may be a last remnant of the chamber's original contents, since Egyptians offered cosmetics to guests at parties and festivities.

At some time, the doorway from the little room into the well court was blocked by a mud-brick wall. Since this alteration would have hindered the Thutmose family's access to the well, bakery, and stable, the blocking makes sense only in relation to the final use of the side room. When the sculptors closed their workshop, they evidently collected the unfinished artwork and the obsolete models and casts and deposited them in the pantry, which was then shut off.[27] This treasure trove of art objects was discovered during excavations in December 1912,[28] one of the most rewarding and illuminating finds ever made in Egypt, and Ludwig Borchardt's 1913 statement that "years of study" would be necessary to "really grasp their full value" is still true after almost a century.[29]

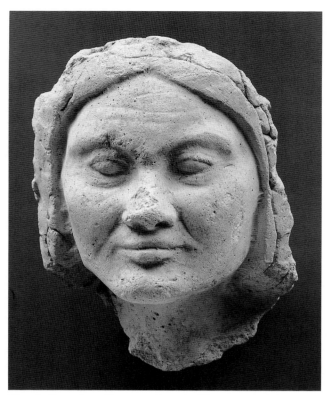

Fig. 36. Face of an old woman from the Thutmose workshop at Amarna. Gypsum plaster. Ägyptisches Museum, Berlin

THE GYPSUM PLASTER HEADS AND THEIR RELATION TO THE STONE SCULPTURES

The more than fifty objects found in the "pantry" deposit were made of one of three materials: quartzite, limestone, or gypsum plaster. There were twenty-seven objects of gypsum plaster,[30] twenty-three of them heads or faces. In addition, there were gypsum plaster models of a single ear, a mouth, and two feet.[31] Four heads are fully sculpted in the round; only their headdresses are missing (fig. 39).[32] The rest are faces only that either include the ears (figs. 38, 43) or omit them (figs. 28, 36).[33] Seven gypsum images apparently represent royal males,[34] whereas two are images of Queen Nefertiti (figs. 39, 40).[35] Most royal male faces or heads include the forehead band and ear tabs of the Blue Crown worn by Egyptian kings (fig. 43),[36] whereas a smaller face of the queen shows the band of Nefertiti's tall, flat-topped crown (see p. 107).[37] A young woman's face—one of five gypsum plaster pieces depicting possibly nonroyal women[38]—is surrounded by the horizontally arranged curls of a round wig (fig. 37, no. 10);[39] a number of other faces, among them an impressive image of an old

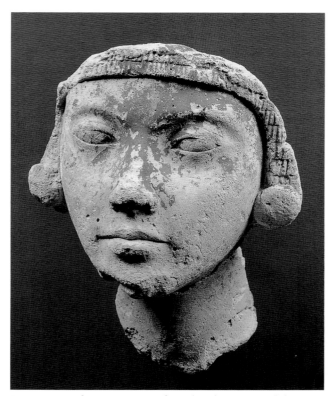

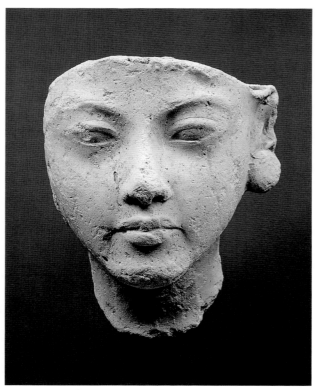

Fig. 37. Face of a young woman from the Thutmose workshop at Amarna. Gypsum plaster. Ägyptisches Museum, Berlin

Fig. 38. Face of a young woman from the Thutmose workshop at Amarna. Gypsum plaster. Ägyptisches Museum, Berlin

woman (fig. 36, no. 11), are finished with irregularly shaped layers of gypsum around the forehead and sides of the face.

The ten images in gypsum plaster that depict nonroyal males are among the most memorable faces in all Egyptian art (fig. 28).[40] William M. Flinders Petrie[41] called a similar gypsum head a "death mask"; Borchardt thought that at least some of these faces were "molded from nature."[42] It was the German art historian Günther Roeder who finally demonstrated[43] that all these heads and faces—royal and nonroyal—are actually casts taken at various stages in the creation of the clay models that formed the basis for the final carved stone sculptures. It appears that the sculptor began by molding a face in pliable wax or clay; this three-dimensional sketch was then modified until a model was ready for the final carving in stone. At various stages during this creative process, casts were made from the wax or clay studies, probably in order to show the work to the supervising chief sculptor (or even the king?)[44] for correction. Apparently, in most cases it was sufficient to use a single mold to cast just the face. In

other cases, the whole head was cast, for which two molds had to be used (figs. 39, 40).[45] At certain stages in the process, the eyes and eyebrows of the clay model were hollowed out (figs, 28, 43, 45) to achieve an impression close to that of the final work in stone at the stage before inlays of alabaster, obsidian, or glass were added.

It makes sense that the casts taken at earlier stages in the creative process are more naturalistic than the ones taken at later stages. Of the two female images in gypsum plaster illustrated here, the one of the old woman (fig. 36) gives the impression of having been sculpted from life, whereas the young woman's head (fig. 37) already conforms closely to the canonical scheme of an Egyptian statue. This statement is not based only on the presence of a wig and ear adornments on the young woman's image; the more idealized character of the young woman's face is clearly seen in her eyes, which are almond shaped with stylized incised lines on the upper lids. The older woman's eyes have fleshy, irregularly shaped lids and naturally rounded double folds of uneven length beneath the lower lids. The softly modeled mouth of the young woman, on the other hand, is

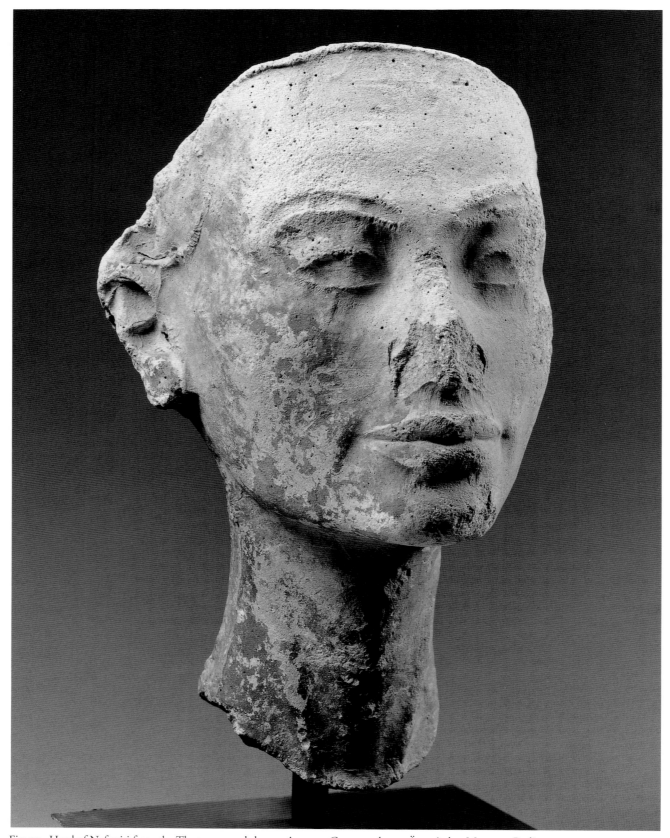

Fig. 39. Head of Nefertiti from the Thutmose workshop at Amarna. Gypsum plaster. Ägyptisches Museum, Berlin

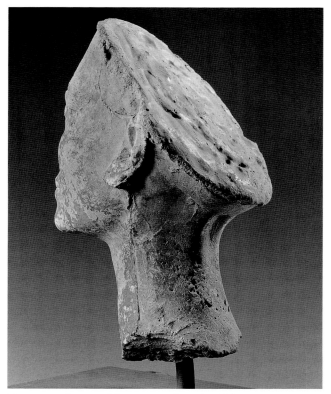

Fig. 40. Back view of the gypsum plaster head (fig. 39)

have been created from the models that were preserved in the deposit.

Among the limestone sculptures found in Thutmose's little room, a case might be made that the famous painted bust of the queen (fig. 58) was based on the gypsum plaster model (fig. 39). The rounded lips of the cast might have been altered to become the austere lips of the bust. There is, however, a great difference in the upper eyelids, which are remarkably short and concave in the cast, but large, heavy, and convex in the bust. In the final analysis the similarities are only what might be expected in two different images of the same person.

The almost total absence of a connection between the gypsum plaster models and the unfinished works of stone found with them is puzzling but might, in fact, provide a clue to reconstructing procedures in the workshop. One has to assume that a plaster model was discarded once it had been transferred into stone. Thus, all plaster casts still in the workshops at the time

more naturalistic than is usual in Egyptian statuary, even during the Amarna Period; this detail certainly would have required further work before the piece could have become a model for the stonecutter. There is, indeed, another young woman's face in the Thutmose gypsum plaster group whose small mouth is stylized enough to be the model for a stone statue (fig. 38).[46] This head could well represent a later stage in the creation of the same young woman's image.

Comparing the gypsum plaster casts with the unfinished works of stone that were found in the same deposit, one is struck by the remarkable lack of a direct correspondence between the casts and the stone pieces. Among the fourteen pieces of quartzite are a head of Queen Nefertiti in yellow quartzite (figs. 66, 67, no. 2), two red and yellow quartzite heads of princesses (figs. 50, 51),[47] a light red face of a young woman,[48] fragments from a female statuette with back pillar, and hands and arms that were made, like the heads, to be incorporated into composite works.[49] Neither the queen, the princesses, nor the young woman have enough features in common with any of the few female images in gypsum plaster to

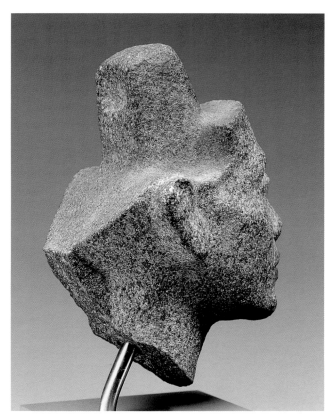

Fig. 41. Back view of the head of Nefertiti from the Thutmose workshop at Amarna (figs. 72,74). Granodiorite. Ägyptisches Museum, Berlin

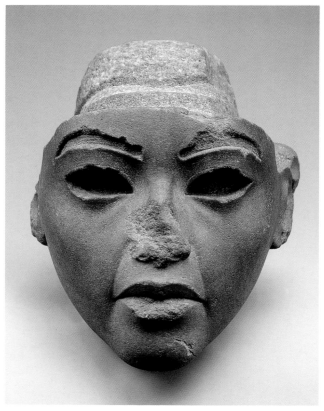

Fig. 42. Head of Queen Tiye. Red quartzite. The Metropolitan Museum of Art, New York

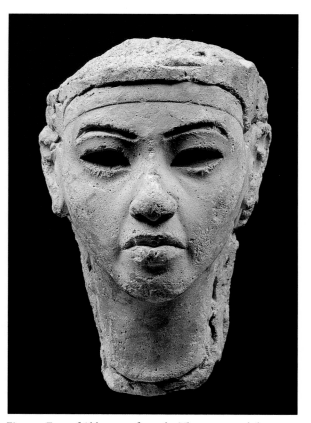

Fig. 43. Face of Akhenaten from the Thutmose workshop at Amarna. Gypsum plaster. Ägyptisches Museum, Berlin

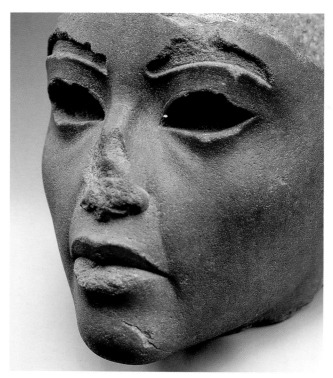

Fig. 44. Detail of the red quartzite head of Queen Tiye (fig. 42)

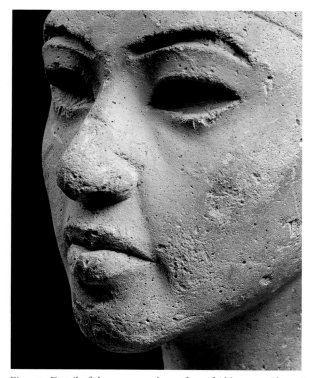

Fig. 45. Detail of the gypsum plaster face of Akhenaten (fig. 43)

of Thutmose's departure from Amarna would be works that had not yet been rendered in stone. Such an explanation might also account for the considerable number of casts depicting nonroyal males. At Amarna, statues of nonroyal individuals were not placed in the temples of the Aten, and small statuettes of such persons were only rarely kept in house shrines.[50] The only possible location for a near-lifesize nonroyal image was a tomb. The statue of the tomb's owner, to be carved from the rock matrix, was planned for the innermost offering niche of almost all Amarna tombs. Since most of the tombs are unfinished, and the niches were the last areas to be carved, only a few such statues were actually executed. None of these has escaped the ravages of time or the destructive zeal of the anti-Aten faction.[51] What remains, moreover, has never been properly documented, so at present it is not possible to verify our suggestion that the tomb statues at Amarna were attempts at fairly realistic images and that the gypsum plaster casts from Thutmose's workshop served as their models. Figure 28 has long been thought to depict Ay, "overseer of all the horses of His Majesty," possibly the brother of Queen Tiye and father of Queen Nefertiti, and certainly the successor of King Tutankhamun.[52] One might suppose that the gypsum plaster model for the face of Ay's tomb statue remained in the sculptor's workshop at the end of the Amarna Period because work on Ay's tomb had not advanced far enough for the model to be taken to the tomb site. The nonroyal female plaster images, such as that in figure 36, would have been used to create a statue of the tomb owner's wife, as for instance in the tomb of Ramose.[53]

THE SCULPTOR OF THE METROPOLITAN MUSEUM'S RED QUARTZITE HEAD OF QUEEN TIYE

Studies of the relationship between gypsum plaster casts and stone statuary are facilitated by the existence of a dark brownish red quartzite head (fig. 42), now in the Metropolitan Museum,[54] that can be linked stylistically to the sculptor of three gypsum plaster heads from the Thutmose workshop. The Metropolitan head must once have belonged to a two-thirds-lifesize statue that was composed of various stone materials; its head, arms, and feet would have been made of quartzite. The back and top of the head (fig. 54) were prepared to

receive either a crown or a wig. Because of the similarities between the Metropolitan Museum piece and the wooden head of Queen Tiye in Berlin (fig. 23), the identification as Tiye appears certain, despite the dark reddish color of the stone, which has led scholars to describe the head as male. Although Egyptian women are usually depicted with yellow skin, during the Amarna Period images of the royal princesses and Queen Nefertiti were made of dark brown or reddish quartzite (figs. 31, 46–48, 50–53, 65).[55]

The presence of a rough area below the ears and the shape of the edges around the forehead and ears of the Metropolitan Museum's quartzite head (fig. 44) suggest that the figure once wore a tripartite wig similar to those adorning Queen Nefertiti on reliefs from Karnak, Memphis, and Amarna (figs. 5, 10, 11) and an image of Queen Tiye banqueting at Akhetaten (fig. 110). The sculptor has achieved a beautiful balance among bones, flesh, and skin. The bone structure of the head is accentuated at the top of the cheeks and around the jaws, while a slight drooping of flesh and muscle is indicated below the smooth surface around the mouth, on the cheeks, and below the chin. As in the Berlin and Sinai heads of Queen Tiye (figs. 23, 24), the mouth of the quartzite head is flanked by deeply incised furrows that run almost vertically downward from the nostrils to join the indentations at the corners of the mouth. There is bitterness and disdain in the highly arched brows, the double wing-shaped upper lip, and the downward curve of the mouth. It is the face of a determined woman, past the peak of her beauty, who still fascinates through the exquisite grace of her head, her poise, and the freshness of her skin.

The eyelids of the Metropolitan quartzite head are exceptional: the upper lids are reduced to narrow bands that are set off from the area above by thinly incised lines. Bernard V. Bothmer[56] has pointed out that during the time of Akhenaten's father, Amenhotep III, inlaid eyes often had no lids at all. This, however, is not true of the stone heads from the Thutmose workshop, whose eyes are hollowed out to receive inlays. Nefertiti's painted bust (fig. 58), the quartzite head of a princess (fig. 46), and the queen's head from Memphis (fig. 31) have broad upper lids that hood the inlaid eyes and are separated from the area above by sharply incised grooves. It is all the more remarkable that reduced upper eyelids very similar to the ones of the Metropolitan

queen appear on three gypsum plaster faces from the Thutmose compound.

The three parallel pieces are now in the Ägyptisches Museum, Berlin. They are casts of faces only, but they include the ears and the edge of a royal Blue Crown. Two of the three faces appear to represent King Akhenaten; the third has a square face and may well be identified as Amenhotep III.[57] One of the Akhenaten faces is the same size as the quartzite head of Queen Tiye, whereas the Amenhotep III and second Akhenaten heads are slightly larger. Figures 43 and 45 illustrate the supposed Akhenaten gypsum plaster head that is slightly larger than the quartzite head in the Metropolitan Museum.[58]

The similarities between this gypsum image and the Metropolitan queen's head (figs. 42, 44) are striking. Both heads have the same narrow upper lids, soft pockets of flesh below the eyes, loose flesh over the cheeks, and deep furrows that run almost vertically downward from the nostrils to the corners of the mouth. Also similar are the shapes of the cutouts for the eyebrow inlays, which begin with rounded ends just beside the nose, peak above the outer corners of the eyes, and end in a pointed tip. The mouths have the same double wing-shaped upper lip and protruding, crescent-shaped lower lip, and like other works of the Thutmose workshop, the heads share the softly rounded muscle ridge running obliquely from the inner corners of the eyes toward the cheekbones.

The two other gypsum plaster faces in the group, although closely related to the third, differ slightly from the one in figures 43 and 45 and the Metropolitan head (figs. 42, 44). The upper lids in these two faces have somewhat more volume and overlap the lower lids at the outer corners of the eyes. The furrows between nostrils and mouth end at a distance from, and above, the outer corners of the mouth, and the mouth is more deeply imbedded in soft musculature. Clearly, none of the gypsum faces can be a direct cast taken from the Metropolitan Museum head, because even the face most closely related to the queen's head is different in size, accoutrements (the Blue Crown), and gender. The close relationship between the gypsum faces and the quartzite head must, however, lead to the conclusion that all four pieces represent the work of a single artist.

If it was right to identify one of the casts as Amenhotep III and the other two as Akhenaten, this group would be joined by the Metropolitan Museum image of Queen Tiye. It is tempting to suggest that these objects are related to work done by a member of the Thutmose workshop for the Sunshade temple of the queen; a relief in the tomb of Huya shows that statues of Tiye, Amenhotep III, and Akhenaten stood in its court.[59]

The similarity in the shape of the ball and the underside of the chin, best seen in profile view (figs. 44, 45, 54), indicates that the quartzite head of Tiye and the three kings' heads were made about the same time as the Berlin wooden head from Ghurab (figs. 23, 26) and the yellow jasper fragment (figs. 27, 29). However, a greater sensitivity in rendering the fleshy parts of the face is noticeable in the works from the Thutmose workshop. The sculptor of the quartzite head has taken a further step away from the intellectual expressionism of early Amarna and toward an organic rendering of living forms, and his works are certainly not the earliest that the Thutmose workshop produced.

IMAGES OF PRINCESSES AND THE TECHNIQUE OF COMPOSITE STATUARY

Three quartzite heads of princesses, approximately two-thirds lifesize, are preserved from the Thutmose compound. Two, now in Cairo, were found in the small-room deposit (figs. 50–53, no. 43), whereas the third (figs. 46–48), now in Berlin, was discovered at the southern enclosure wall of the large courtyard [17]. In addition to these three images there is another head of about the same size. Of somewhat different style, it was found not far from the Thutmose compound in an area of small, insignificant houses.[60] A number of smaller quartzite and granite heads and statuettes of princesses, possibly copied from the three larger pieces,[61] were found in the compound itself.

The head of the Berlin princess has distinct front, profile, and back views, so one still senses the original cubic block from which it was carved. In traditional Egyptian art, such sculptural qualities were usually further emphasized by a back pillar. Not so here: no slab of stone encumbers the elegantly curved back of the princess's thin neck (fig. 47). All the more striking, then, is a peculiarity of the head, best revealed in

Opposite: Fig. 46. Head of a princess from the Thutmose workshop at Amarna. Brown quartzite. Ägyptisches Museum, Berlin

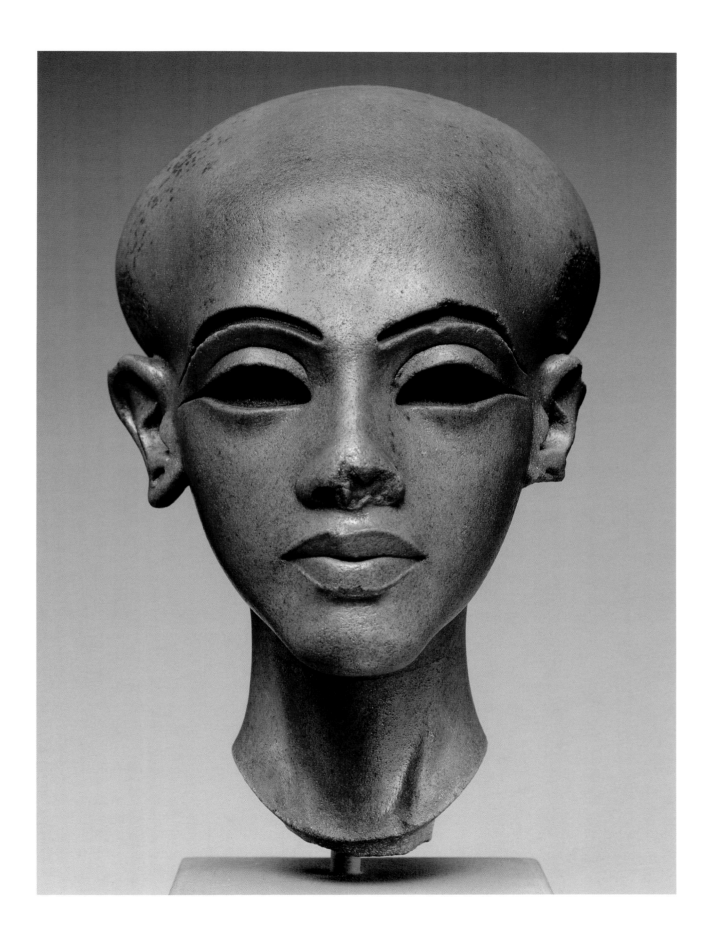

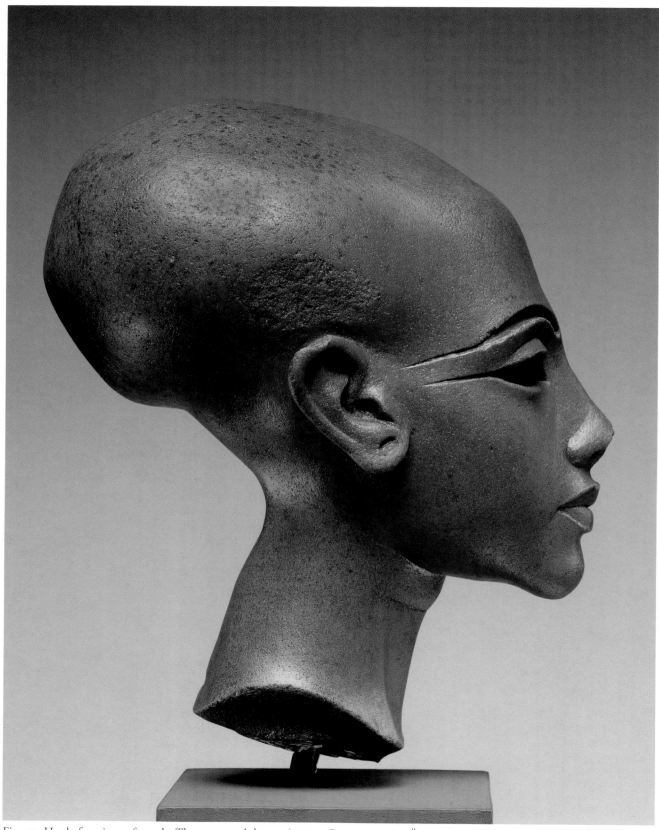

Fig. 47. Head of a princess from the Thutmose workshop at Amarna. Brown quartzite. Ägyptisches Museum, Berlin

profile view: the overly elongated, shaved skull. To many viewers, this feature suggests a pathological explanation: an illness such as hydrocephalus. Other scholars have assumed that the heads of Akhenaten's daughters were artificially deformed in early infancy, a view that was convincingly refuted in the 1960s by the German physical anthropologist Kurt Gerhardt.[62]

Pathological explanations of unusual forms in works from Amarna fail to take into consideration the predominantly conceptual—not naturalistic—character of Egyptian art (see pp. 19–20). With the princesses' heads, Amarna artists probably overemphasized hereditary traits, a view reinforced by a comparison of the princesses' sculptured heads with the mummified heads of Smenkhkare and Tutankhamun. Elongated skulls were characteristic of these two young men who followed Akhenaten as Pharaoh. Since Akhenaten's successors must have been members of the royal family, it is safe to assume that his daughters, whose mummies are not preserved, possessed the same traits.[63] The question, then, is: Why did the artists emphasize this particular feature to a seemingly abnormal degree?

In Egyptian art, the representation of adults with shaved or close-cropped heads has a long history, which has been described by Bernard V. Bothmer.[64] Starting in the Old Kingdom and becoming very popular in the Middle Kingdom, representations of predominantly male figures with shaved heads were executed throughout the earlier Eighteenth Dynasty, into the reign of Akhenaten's father, Amenhotep III, and the Amarna Period. Later, especially during the post-Persian era (404–343 B.C.), the type was revived in many impressive sculptures of officials.

Initially, the cropped hairstyle was probably just a fashion suited to the hot climate of Egypt, aiding cleanliness and the wearing of courtly wigs. However, at least from the Middle Kingdom on, the shaved head was also associated with purification rites prescribed for persons performing priestly tasks.[65] During the reign of Akhenaten, the shaved head was a common sight. Reliefs at Karnak and in the tombs and temples of Amarna depict innumerable bareheaded men, mostly officials and temple and cult personnel.[66] Many royal servants are also depicted bareheaded. This is logical because serving the king was considered a ritual task, and the servants also handled the royal family's food.[67] Servants of high officials were also depicted with

shaved heads.[68] The style became widespread during the post-Amarna era,[69] when, apparently, shaved heads were no longer restricted to those who performed specific tasks.[70]

The depiction of children with shaved heads also had a long tradition in Egyptian art, but children were more usually represented with an added braid or side lock,[71] as Akhenaten's daughters were in reliefs (figs. 15, 32, 78, 83, 109, 112, 118–21; see pp. 60, 112). When a bareheaded princess appeared in a narrative context, she usually portrayed the youngest sibling (figs. 8, 88, 97).[72]

It is difficult to determine why the Thutmose artists represented the princesses with entirely bare heads. Since the direct predecessors of the Thutmose workshop princesses were depicted wearing side locks, this must have been a deliberate decision. The impressive stelae cut from the rock of the limestone cliffs surrounding Akhetaten, commissioned by Akhenaten in Years 6–8 of his reign, have been described (pp. 20–22). Rock-cut statues of Akhenaten, Nefertiti, and their daughters flanked most of these stelae (fig. 103). Initially, the two eldest, Meretaten and Meketaten, appeared; later, statues of Ankhesenpaaten joined those of her sisters.[73] Few heads from the boundary stelae statues of the princesses have been preserved, but there are enough to demonstrate that the skulls were elongated and that enormous side locks were attached to one temple.[74] Why, then, were there no side locks on the princesses' heads from the Thutmose compound?

The omission of a side lock may have been meant to characterize a particular princess as the youngest in a group, which could be of help in determining which princess is represented (see p. 65). But it is also possible that the traditional connotation of elite status and ritual cleanliness was used to contribute to the otherworldliness that is a distinguishing quality of the Berlin and Cairo princesses' images.

The Thutmose artists added a totally new aspect to the tradition of depicting children with shaved heads. A view of any of the heads from the back (fig. 53) reveals that the sculptor has given the skull the unmistakable shape of an egg.[75] "Egyptian theologians speculating about the creation of the world," writes Ricardo Caminos, "spoke of a miraculous egg placed upon a hill surrounded by the primeval waters. The egg hatched, and from it flew a bird that was a god and brought forth light, ending chaos and marking the beginning of

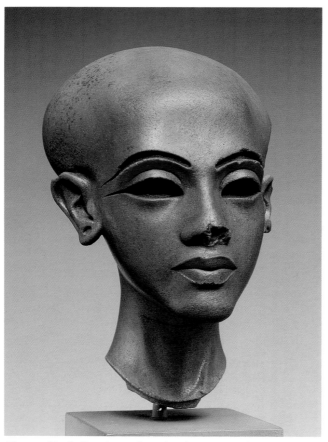

Fig. 48. Head of a princess from the Thutmose workshop at Amarna. Brown quartzite. Ägyptisches Museum, Berlin

things."[76] Thus, traditional Egyptian theology saw in the egg a symbol of the divine creation of the cosmos.

James P. Allen has described (p. 4) how, during the Amarna Period, the emphasis in religious thinking shifted from the mythology of cosmic origins to a concept of the gods' continuing creative activity "here and now," on earth.[77] The Great Hymn to the Aten, at the climax of its praise of god the creator, describes the everyday occurrence of the birth of a chick from the egg as a symbol of the divine origin of life: "When the chick is in the egg, speaking in the shell, you [Aten] give him breath within it to cause him to live; and when you have made his appointed time for him, so that he may break himself out of the egg, he comes out of the egg to speak at his appointed time and goes on his two legs when he comes out of it [the egg]."[78]

The egg-shaped princesses' heads are best understood in the context of such Amarna imagery.[79] In the next chapter more will be said about the particular role

of the princesses as embodiments of divine creation (pp. 98–104, 108). This symbolic role is intricately connected with the belief in Akhenaten's own status as the child of the Aten, which has, significantly, also found tangible expression in the work of a Thutmose artist. Marianne Eaton-Krauss has drawn attention to a fragmentary—indeed, willfully smashed—alabaster head of Akhenaten, parts of which were found scattered over a rather large area of the Thutmose compound.[80] No fragments of the body were found, but the complete statue can be reconstructed following a number of known representations, especially ones of Akhenaten and Tutankhamun[81] and a charming inlaid figure depicting Akhenaten's next-to-last daughter, Princess Nefernefrure (fig. 7).[82] The king was probably depicted squatting on the ground, one hand on a knee, the other raised toward his chin with one finger at his mouth, a traditional pose of children in Egyptian art. Significantly, at Amarna this image of the king also served as the subject of small faience amulets that attest to the power of the concept.[83]

Viewed from the back, the alabaster head fragment reveals the egg shape of the king's cranium, an impression that is intensified by the whiteness of the stone. The head differs from the princesses' egg-shaped heads in one respect: the youthful side lock was attached, as it had been to the heads of the boundary stelae princesses. The fragmentary state of the alabaster head makes it difficult to ascertain when the complete statue was created. What remains of the right eye appears to have a shape similar to the eye of the Berlin princess's head (fig. 46). Therefore, it is possible that the alabaster statue portraying Akhenaten as a child was the first to incorporate the symbolism of the egg into a representation of a child with a shaved head. Together with the boundary stelae statues, this figure of Akhenaten was a prototype for the representations of the king's daughters made by the artists of the Thutmose workshop.

Profile views of the Berlin princess's quartzite head (fig. 47) reveal its affinity to early works of the Amarna Period. In reliefs of that time—as we have seen (pp. 38–39)—the area between the front and the back of the head was greater than that between the chin and the forehead (figs. 5, 10, 11, 15, 17, 19). A date not much later than that of these early reliefs is certainly indicated for the Berlin princess. Despite their striking anatomical correctness, the princess's features are more abstract

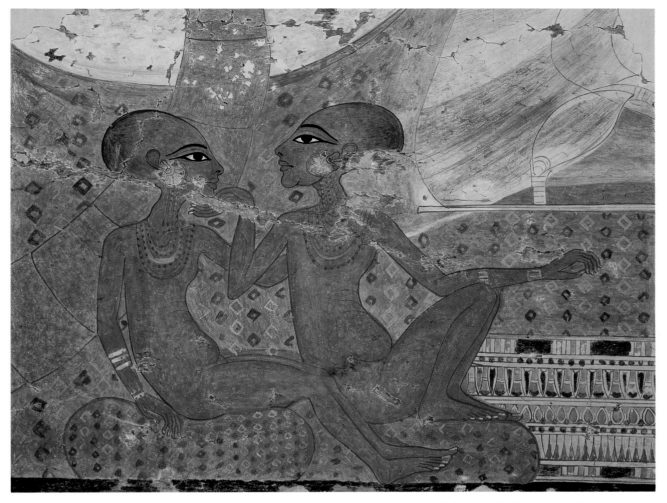

Fig. 49. Princesses Nefernefruaten-Tasherit and Nefernefrure at the feet of Nefertiti. Facsimile by Nina de Garis Davies after a painting in the Ashmolean Museum, Oxford. The Metropolitan Museum of Art, New York

than those of the Metropolitan Museum's Queen Tiye (figs. 42, 44), so an earlier date seems probable. The wooden head of Tiye from Ghurab (fig. 23) may be roughly contemporaneous with the princess in Berlin, whereas the yellow jasper fragment (figs. 27, 29) may have been created slightly later than the Berlin princess, and closer in time to the Metropolitan's Queen Tiye. Each of these four closely related pieces represents the style of a different artist, and the group exemplifies the richness of Amarna art.

The Berlin princess's head is remarkably lean, almost emaciated, and the form of the features is largely determined by the bone structure of the skull. Even the hump at the back of the neck—which all the royal daughters shared with Akhenaten (see fig. 88), and which was (if it actually existed) probably caused by an accumulation of fat—has the appearance of cartilage.

The oblique sternocleidomastoid muscles at the side of the neck flank a columnlike throat with a delicate Adam's apple. At the back, above the nape of the neck, the sculptor has depicted the semispinalis muscles as two strong cords. Anatomists have expressed admiration for the correctly rendered details of this head.[84] Behind the ears, for instance, the mastoid processes are denoted as delicately raised mounds, and the skull is a study in bone structure, its overly elongated shape notwithstanding.

Above the deeply recessed temples, the princess's forehead is marked at left and right by angular, frontal tuberosities, connected by a round horizontal ridge. The inclined vertical part of the forehead between this ridge and the eyebrows is slightly concave. The shape of the forehead as well as the softly rounded central area above are appropriate for a young child. Child-

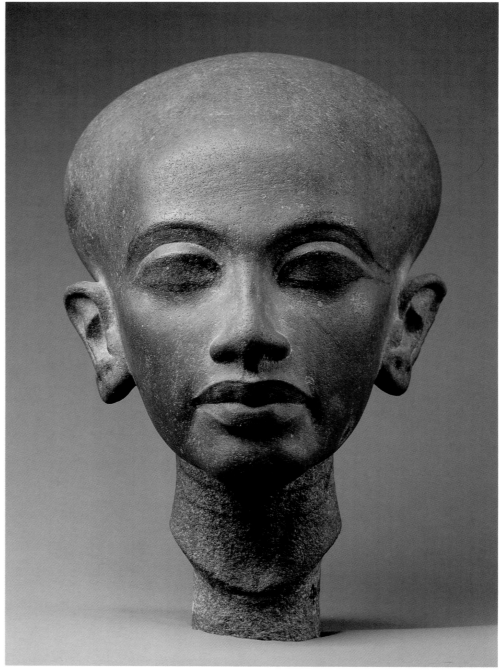

Fig. 50. Head of a princess from the Thutmose workshop at Amarna. Red quartzite. Egyptian Museum, Cairo

hood traits are also discernible in the "baby fat" below the princess's chin, the shell-like ears, and the relatively large eyes.

When viewed from the back, the strikingly broad, lobelike protuberances above the ears on both sides of the princess's head emphasize its egg shape; from the front, this imposing feature lends substance to the slender face. If portrayed in natural dimensions, these bulging sides might be seen as parietal tubers, a prominent feature in infants' skulls. However, anatomists have also described the bulges as enlarged temporal muscles.[85]

Despite its numerous infantile features, the quartzite head is not the image of a baby; it represents a young woman of poise and dignity. The thoughtful expression

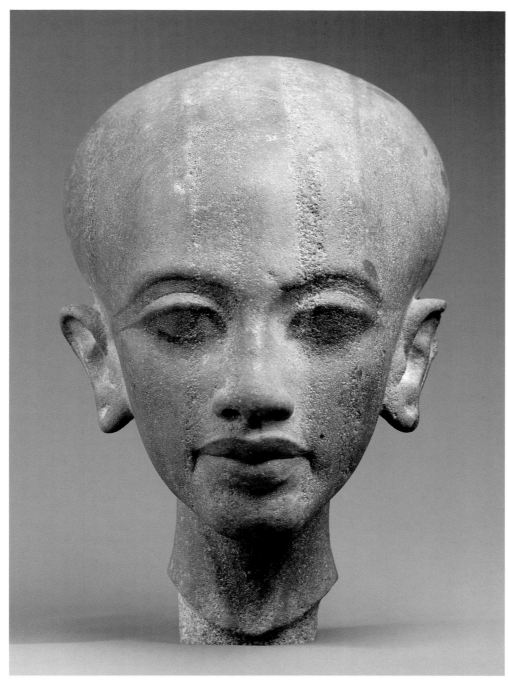

Fig. 51. Head of a princess from the Thutmose workshop at Amarna. Yellow quartzite. Egyptian Museum, Cairo

around her eyes is reminiscent of Akhenaten's introverted, visionary gaze in the Karnak statues (fig. 9); and the sensitively, if sparingly, rendered surface qualities of the skin combine with the sensuous mouth to create an impression of delicate femininity. The exaggerated shape of the skull, the length of the neck, and the drooping of the chin no longer strike the viewer as repellent, unlike similar features in the Karnak statues of Akhenaten and Nefertiti. On the contrary, the large temple lobes are harmoniously incorporated into the circumference of the head, and the length of the chin is counterbalanced by the angular solidity of the forehead. In this head the Thutmose workshop artist achieved the trans-

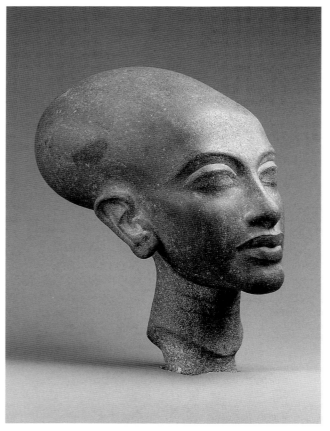

Fig. 52. Head of a princess from the Thutmose workshop at Amarna. Red quartzite. Egyptian Museum, Cairo

formation of Akhenaten's awe-inspiring ugliness into an image of delicate feminine youth.

Many representations of Akhenaten and Nefertiti's daughters were made at Amarna. In reliefs, the princesses usually wear thin linen garments and side locks, as was fitting for girls in Egyptian society (figs. 78, 83, 112).[86] A number of sculptures in the round also represented the royal daughters in garments and the most impressive among these is certainly the torso in the Louvre (figs. 21, 22). But most depicted the princesses nude. The earliest examples are the boundary stelae statues (fig. 103).[87] The princesses' statuettes that were found in the Thutmose compound,[88] a torso excavated by Flinders Petrie at an unknown location in Amarna (figs. 104–7), and a small statuette now in the Nelson-Atkins Museum of Art, Kansas City, are also unclothed.[89] The latter statuette wears the youthful side lock, as does an unclothed princess on a cursory limestone artist's sketch now in the Metropolitan Museum (no. 49).

A painting that once decorated a room in the small town palace (King's House) between the Great and Small Aten temples at Amarna (fig. 49) is stylistically closest to the Berlin princess's head. Barry Kemp has identified the location of the famous "window of appearance" in this small palace.[90] At this window the king, queen, and royal children appeared before a crowd to reward chosen officials with the Gold of Honor (fig. 83). The room with the painting was part of a suite used, according to Kemp's interpretation, by the royal family to prepare for these ceremonies and to relax during and after them.

Figure 49 shows the largest preserved fragment from the King's House painting, now in the Ashmolean Museum, Oxford.[91] The facsimile copy made by Nina de Garis Davies in 1928, now in the Metropolitan Museum, is illustrated in figure 49 (no. 50).[92] Besides the Oxford fragment, numerous other smaller fragments are preserved.[93] The complete painting represented the entire royal family—Akhenaten, Nefertiti, and all six daughters—resting in a columned hall.[94] The king sits on a chair while Nefertiti squats before him on an ornate cushion. The three elder daughters, Meretaten, Meketaten and Ankhesenpaaten, lean against their mother's knee, and she cradles the youngest, Setepenre, on her lap. The fragment shows the fourth and fifth royal daughters, Nefernefruaten-Tasherit and Nefernefrure, beside Nefertiti's feet in an intimate group. One of the queen's feet is visible in the background, together with a sash that falls over her hip. Each little princess sits on her own brightly colored cushion. The girls are naked, but they are adorned with an elaborate array of jewelry: bracelets and armlets encircle their arms, necklaces hang down between their breasts, and elaborate horseshoe-shaped gold disks decorated with somewhat faded blue lotus petals ornament their ears. The disks are fastened to the pierced earlobes by pins that end in small blue lotus blossoms; from each ear ornament three strings of beads hang to the girls' shoulders.

The princesses' poses are relaxed. The one on the right is squatting, her left arm resting between her drawn-up knees. The other princess stretches her legs; her right arm is at her side as she embraces her sister with her left. The princess on the right responds by chucking her sister under the chin. The drawing of the figures accords with traditional principles of Egyptian

representation. The heads, upper torsos, and legs are in strict profile, and only at the navel do the lower bodies turn to a three-quarter view. The hands appear in back and side views, not with the innovative view of the palm as seen, for instance, in the trial piece from the North Palace (fig. 108).[95] The depiction of the toes in side view follows general Amarna artistic practices.[96] However, the painter has used traditional means to create an intricate group composition with multiple spatial layering, reminiscent of relief art. In the center, for instance, the left arm of the girl on the left is at the back of the princess on the right, but her legs are in front of the other's hips.[97] Brushwork and coloration are very fine in this painting. The right thigh of the left-hand princess, for instance, touches the cushion on which she sits. To demonstrate the soft quality of the cushion, the thick line that silhouettes the princess's leg is replaced by a much thinner broken line. Shadows are indicated in various places, such as the abdomen and below the left-hand girl's right thigh, and at the back and between the two feet of the princess on the right. Thin brown brushstrokes on the skulls of both princesses indicate hair that is starting to grow.

The heads of the princesses are striking. In small details they are similar to the Berlin princess's head. One sees the same round cushions of baby fat below the chin, the large eyes, the elongated skulls, and the angled ears. There can be no doubt that the painter was familiar with the work of the Thutmose sculptor, the Berlin head itself, or a closely related piece. Possibly, he was commissioned to paint the two princesses, following the representations created by the Thutmose workshop artist. If this was actually the case, the painted figures of the princesses can help to reconstruct the complete figure of the Berlin princess's head.

As we have seen, images of princesses in the round are usually unclothed, so there can be little doubt that the princess was represented in the nude, and the painting corroborates this view. The Berlin head as well as its closely related counterparts now in Cairo (figs. 50–53) were parts of composite statues. Tenons at the bottoms of the two Cairo heads are still preserved, and traces show that the Berlin head ended similarly (fig. 55).[98] When a composite statue represented a figure wearing a garment, the body was made of different stone. If we are right in assuming that the figures of the princesses were nude, the bodies must have been made of the same quartzite stone material as the heads. Since practically no body parts were found in the Thutmose compound, we must assume that the bodies were made in another workshop or at another location. It is difficult to explain why bodies made of the same stone material as the heads were not created at the Thutmose workshop. Perhaps the division of labor between artists who made heads and, on occasion, arms and legs, and those who created bodies of different materials had become an established custom and was employed when no difference in material was involved.

The Berlin head's neck is curved so that the upper edge of a collar or necklace would have fitted exactly. A join between the body and the neck at this point was easy to conceal. Like many clothed representations of royal women, the complete statue would have been adorned with a collar or, perhaps, a series of necklaces, as seen in the painting (fig. 49). We do not know whether the artist intended to attach ear ornaments. In most statues and reliefs the pierced holes where such

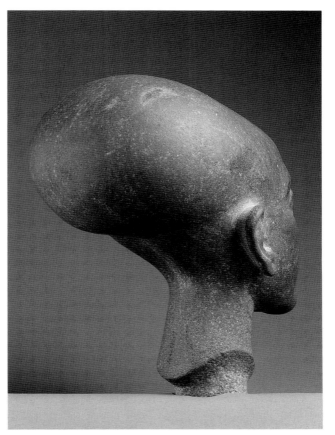

Fig. 53. Head of a princess from the Thutmose workshop at Amarna. Red quartzite. Egyptian Museum, Cairo

ornaments were to be added were indicated. The princess of the statue may have carried a fruit in her hand—a pomegranate or a fig—as seen in a number of smaller statuettes. Thus reconstructed, the statue may be a variant of the well-known type that showed Akhenaten and Nefertiti with offering plates in their hands, fruit being more appropriate as a gift from a small child. This princess was probably destined for an Aten temple. Alone or together with statues of her parents and sisters, she would have stood offering her fruit to the god. Egyptian viewers would have been reminded of the figures of nude girls who served the goddess Hathor, the Aphrodite of ancient Egypt.[99]

The techniques used in the making of composite statues need further study.[100] Unfortunately, very few torso parts—or possible torso parts—have been found, and none were recovered in the workshop of Thutmose, which appears to have specialized in heads, arms, hands, and feet.[101] The following points, however, seem certain: The separately made heads ended in long, fairly narrow tenons (fig. 55) that were inserted into mortises in the torsos. The tenons were so long and the heads so heavy that no adhesive was necessary to ensure a secure

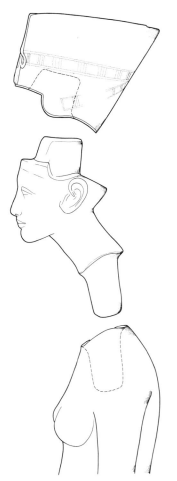

Fig. 55. Composite statuary. Demonstration drawing by Barry Girsh

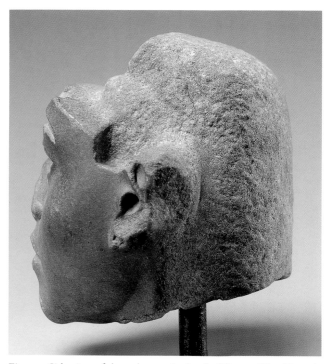

Fig. 54. Side view of the red quartzite head of Queen Tiye (fig. 42). The Metropolitan Museum of Art, New York

join between the parts. Plaster may have been used to conceal the seam. Headdresses were affixed with the help of a tenon on the top of the head (figs. 41, 54, 66); the areas that were to be covered by the headdress were painted red on a number of heads, possibly the remains of a paint layer used to guide the sculptor during the final fitting.[102] Most headdresses appear to have been made of stone; dark gray to black diorite or granodiorite were the preferred materials (fig. 56, no. 23).[103] Arms were fitted to the torso by sliding their tenons into mortises in the shoulders and sides of the statue's body. This method can be observed in a statue of Amenhotep III in the Metropolitan Museum (fig. 57);[104] the left arm has been repaired by joining two pieces of stone within mortise slots prepared in the shoulder. A mortise cutout at the back left corner of the throne served the

Fig. 56. Part of a wig from a composite statue excavated at Amarna. Granodiorite. Petrie Museum, University College, London

same purpose. Again, no adhesive was necessary because the weight of the pieces held them in place.[105]

The reduced size of the back pillar is an important feature of composite statues. None of the heads of the princesses (figs. 47, 52, 53) had a pillar that reached to the neck of the statue. A statue of King Sety I in the Egyptian Museum, Cairo, shows how a composite work was attached to a back pillar at the backs of the legs only as far up as the buttocks; evidently, this was enough to fix this composite statue to the base. It may be that the increased possibility of creating stone statues with reduced back pillars was one of the reasons the composite statue occurs so frequently during the Amarna Period.

More insight into the art of the Thutmose sculptors is obtained by comparing the finished Berlin head of a princess (figs. 46–48) with the two unfinished heads from the deposit room now in Cairo (figs. 50, 52, 53; 51, no. 43). The Berlin head received a final smoothing and burnishing, so the surface is shiny; only the inlays are missing. The quartzite Cairo heads did not receive a final finishing; therefore, they lack some fine details and have a matte surface. The eyes and eyebrows, moreover, have not yet been hollowed out to receive inlays, although the master sculptor indicated these areas with black brushlines, including the traditional cosmetic lines at the outer corners of the eyes and the elongations of the eyebrows toward the temples. These cos-

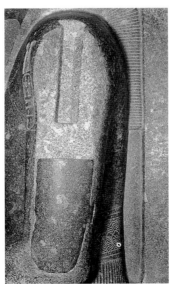
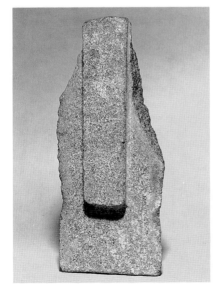

Fig. 57. Mortise and tenon joints on a statue of Amenhotep III. Granodiorite. The Metropolitan Museum of Art, New York

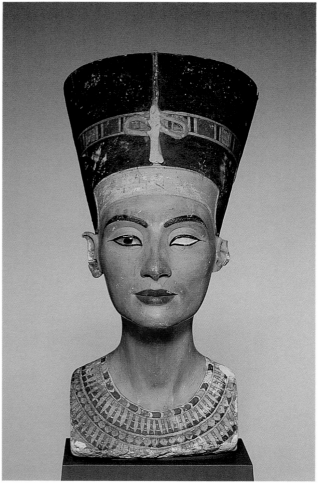

Fig. 58. Bust of Nefertiti from the Thutmose workshop at Amarna. Painted limestone with gypsum plaster layers. Ägyptisches Museum, Berlin

The two unfinished heads of princesses (figs. 50–52, no. 43)[106] clearly follow the same model as that of the Berlin head; indeed, the Berlin head may have been this model. All three heads have the thin, outward curving neck that Akhenaten's daughters share with their father, whereas the back of Queen Nefertiti's neck is always depicted with an inward curve. All three heads show the same two cordlike muscles, with a hollow indentation between them, at the point where the neck joins the huge egg-shaped back of the head (fig. 53).[107] All three faces have the same triangular shape and at the forehead the same bony ridge, the same left and right tuberosities. All three necks are dominated by the strongly emphasized sternocleidomastoid muscles at either side; in all three pieces the small chins droop in a manner strongly reminiscent of the Karnak statues of Akhenaten (figs. 1, 9, 47, 52).

Some of the differences among the three heads are due to the fact that the two from the Thutmose deposit room (figs. 50–53) did not receive their final details and have not been completely smoothed. In the two unfinished heads, for instance, there is no muscle ridge running from the inner corners of the eyes toward the cheekbones, a feature that we have already noted in the Metropolitan Museum quartzite head of Tiye (fig. 44). The feature reappears in the Berlin princess in an especially angular version, making it clear that the sculptor intended this to look like a sinew although, anatomically, it is most probably the edge of the orbicularis muscle that encircles the eye. Also, the unfinished heads do not yet show the slight curve in the upper eyelids, or the sagging of soft flesh below the eyes that is seen in the finished princess. The sculptor would have worked out these details during the final smoothing and rubbing process.

Other discernible differences among the three heads are found in the overall shape. All the ears, for instance, are crescent shaped, but they differ in size and volume. The Berlin head (figs. 46–48) has the smallest ears; the two heads from Cairo have the next largest (figs. 50, 52) and the largest (fig. 51). This last head also has leaner features than the other two: the lips are thinner and the two folds that run downward from the corners of the mouth are incised at an angle. The other unfinished head in Cairo is broader than either of the others: the features are fleshier, the lips thicker, and the lines at the corners of the mouth more softly delineated. These

metic lines have been hollowed out in the more finished Berlin head, but one may wonder what kind of inlay was planned for such thin grooves. The lips of all three princesses are painted red. The interiors of the nostrils are outlined in black, and two black lines indicate where folds were to be incised in the front of the neck. There is a groove on the neck of the Berlin head below the Adam's apple (fig. 46). Depressions indicate that the princesses' ears were pierced for earrings. The finished head (fig. 47) and the yellow unfinished one (fig. 51) have one round depression in each ear, whereas the red head (fig. 52) has two in each ear. These areas are marked in black, and it is possible that they were to be drilled for the attachment of actual earrings of gold and semiprecious stones, as was the wooden head of Queen Tiye (fig. 23).

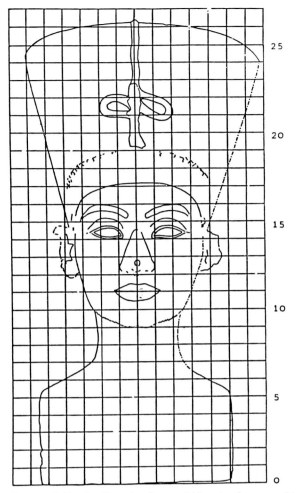

Fig. 59. Grid using Egyptian finger-width unit of measure (³/₄ in.) superimposed on photogrammetric image of Nefertiti's bust in the Ägyptisches Museum, Berlin. After Rolf Krauss

depicted, since she was born just before Year 12 and would have been about five at the end of her father's reign. However, the baby princess image was probably revived in the two Cairo heads for two later princesses: Meretaten-Tasherit and Ankhesenpaaten-Tasherit (see p. 14).

The considerably earlier Berlin head must have been made for a princess who was the baby during the earlier years of the Thutmose workshop. Ankhesenpaaten seems the most probable. In the painting from the King's House (fig. 49), Nefernefruaten-Tasherit and Nefernefrure have been invested with the same image.[108] The very fact that this type of representation could be transferred from one princess to another shows that it is not a portrait in the strictest sense of the word but an image whose religious function went beyond the person who was represented.

It is difficult to understand why the Berlin quartzite head was never used on a statue, since it is nearly finished and lacks only the inlays. The clue may lie in the two rough, flat areas above the ears (fig. 47). Here, too much stone had been removed during the primary carving, and the sculptor perhaps did not want to remove more stone during the smoothing process. He therefore decided to abandon the head, leaving for posterity a singular masterpiece in which youthful innocence is blended with exquisite femininity.

THE IMAGES OF QUEEN NEFERTITI

The Painted Bust and an Unfinished Limestone Head: The Definitive Image

Among the finds from the Thutmose deposit were two royal limestone busts and the lower part of a third, the head of which is missing.[109] The two complete busts depict King Akhenaten and Queen Nefertiti. The king's bust, now in the Ägyptisches Museum, Berlin,[110] was intentionally smashed, presumably before the piece was deposited in the small room of Thutmose's house. Deplorable breaks, therefore, now disfigure the face of what once was an imposing masterpiece.[111]

The queen's bust is the best-known work of art from ancient Egypt—arguably from all antiquity (figs. 58, 60).[112] The piece, which is 48 cm (18⅞ in.) high, was made from what appears to be a fairly dense but brittle limestone to which layers of gypsum plaster were applied. It includes the head and neck as well as an area

differences are best understood if one assumes that, at a later date, the two unfinished heads were made by two different younger sculptors with the Berlin head as a model. It is safe to assume that both copies after the Berlin model were made fairly late in the history of the Thutmose workshop.

If we are right in saying that a princess shown bare-headed is likely to be the youngest of the family, the unfinished heads carved late in Akhenaten's reign cannot depict any of the king's elder daughters. Meretaten was about seventeen years old at the time the two Cairo heads were made; Meketaten had died after Year 12; Ankhesenpaaten was approximately twelve, and Nefernefruaten-Tasherit and Nefernefrure, nine and eight. The youngest, Setepenre, could be the child

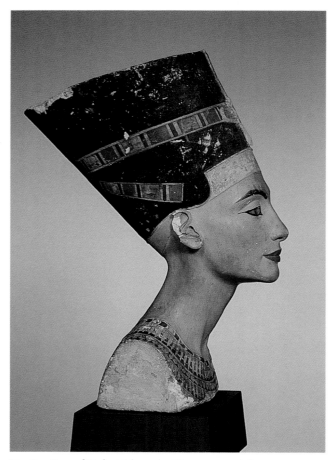

Fig. 60. Bust of Nefertiti from the Thutmose workshop at Amarna. Painted limestone with gypsum plaster layers. Ägyptisches Museum, Berlin

roundel, to which two lotus flowers are attached. Two parallel painted streamers hang down from the nape of the neck over the back; their undulating outline suggests a flimsy material. The right eye only is inlaid with rock crystal. On the reverse of the inlay black pigment has been applied to represent the pupil and iris, and the white of the eye is suggested by the limestone of the eye socket showing through the crystal at the sides of the dark pupil.

Art historical studies of the Nefertiti bust have not been as numerous as one would expect, considering the fame of the piece and the vast amount of literature on other Amarna Period topics. Are scholars reluctant to deal with such a widely publicized icon?[114] Whatever the reason, no book has as yet been exclusively dedicated to the piece, and, except for pigment analyses,[115] basic technical research has only just begun (see below, p. 68).

A point of particular interest—about which one would wish to have more technical information—is the question of the inlay missing from the left eye of

from the clavicles to just above the breasts; the shoulders were not rendered and the sides of the bust were cut vertically. Except for a few losses at the ears, the edges of the crown, and the front part of the uraeus cobra, the image is pristine. The entire piece with the exception of the eye sockets and the vertical shoulder sections is richly painted. The queen wears the tall, flat-topped crown, which is painted dark blue and has a multicolored band encircling it. Gold is indicated by yellow paint at the edges of this band and on the frontlet and correlated back band of the crown; the uraeus is also painted yellow.

The queen's face is light brownish pink, the eyebrows and lines around the eyes are black, the lips are a deep brownish red, and the petals and small fruits strung on the floral collar are yellow, red, and green. At the back,[113] the band painted on the crown is represented as tied into a bow given the traditional shape of a

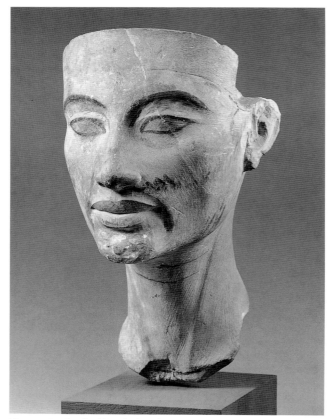

Fig. 61. Unfinished head of Nefertiti from the Thutmose workshop at Amarna. Limestone. Ägyptisches Museum, Berlin

66

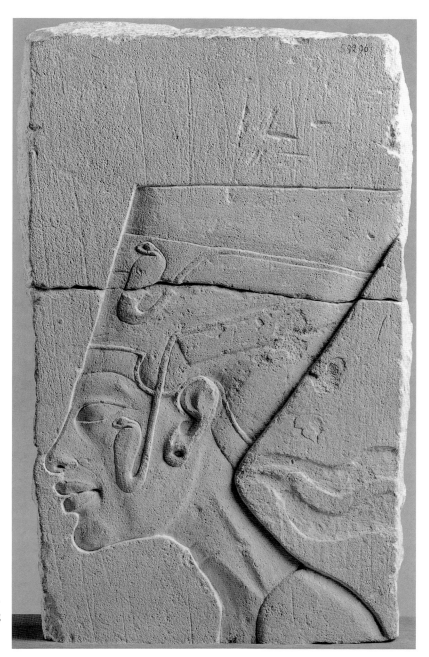

Fig. 62. Sculptor's model excavated near the sanctuary of the Great Aten Temple, Amarna, showing a bust of Nefertiti in profile. Limestone. Egyptian Museum, Cairo

the queen's bust. Borchardt was not able to find another eye inlay in the debris, although his reported promise of a high sum to the workman who found the missing piece must have resulted in a very thorough search.[116] He later recognized that "no trace of an adhesive can be detected in the hollow of the eye; also the background is smooth and has not been carved in any way to receive an inlay," and he concluded that "the left eye was never filled with an inlay."[117] An examination of the Nefertiti bust in its case in the museum corroborates Borchardt's conclusion, and unless a microscopic investigation of the left eye demonstrates that traces of adhesive are present,[118] it must be accepted that a left-eye inlay never existed.

This observation has far-reaching consequences for determining the original function of the bust. Without an eye inlay, the piece can only have served as a sculptor's model,[119] despite recent arguments that favor interpreting the bust as a cult object for use in a private house.[120] The empty eye socket makes sense only in a model, since it demonstrates how a sculptor prepares hollows in a stone sculpture for the later insertion of

67

eye inlays. It should, moreover, be noted that all busts so far excavated at Amarna were found in conjunction with sculptors' workshops; none were found in houses.[121]

A function as sculptor's model to demonstrate a definitive image of the queen best explains the bust's predominant artistic properties: its careful execution, thoroughly calculated proportions and symmetries, and impeccable finish. Rolf Krauss, an Egyptologist at the Berlin Museum, has recently shown how,[122] in typical Egyptian fashion, the shape of the bust appears to have been determined with the help of a grid that used the smallest longitudinal measure of ancient Egypt, a finger (1.875 cm; ¾ in.), as its basic unit. Krauss drew this grid over a photogrammetric image of Nefertiti that had previously been constructed by scientists from the Berlin Technical University.[123] Drawn over this photogrammetric image in frontal and profile views, the grid measured some major facial features (fig. 59). The chin, for instance, is located two fingers below the median line between the lips, the tip of the nose is another finger width above the median line of the

mouth, the lower eyelids are two fingers above the tip of the nose, and the peaks of the eyebrows[124] are another two fingers above the lower lids. Since in the ancient Egyptian measuring system, four fingers equaled one palm (7.5 cm; 3 in.), it can also be said that there was a distance of one palm between the tip of the nose and the peak of the eyebrows, and two palms between the chin and the edge of the crown.

Art historians have always stressed the symmetries in Nefertiti's face. Contrary to most Egyptian sculptures—for instance, the wooden head of Queen Tiye (fig. 23)—the facial features of the bust are remarkably symmetrical. Nefertiti's chin, mouth, and nose, and the uraeus cobra are placed exactly along the vertical axis of the face. The nostrils are exactly one finger distant from each side of this median line; the outer ends of the eyebrows are three fingers from the median line; and the center of each ear is four fingers, if again the photogrammetric image is used that projects the sculptural details onto a plane.[125] Krauss has shown that major deviations from this unusually strict adherence to symmetry appear only in areas other than the face. The left side of the crown is slightly broader than the right side, and the right shoulder is slightly wider than the left.

Dietrich Wildung's important computerized tomography studies (see also pp. 28, 30) revealed that careful balancing also occurred in the earlier stages of the creation of Nefertiti's bust.[126] It appears that the bust's limestone core originally had a considerably longer and thinner neck, shoulders of rather uneven height, and a crown straighter in the back line and narrower from front to back. To correct these faults and achieve the final equilibrium, the sculptor used gypsum plaster to heighten and even out the shoulders. Plaster was also added to the back of the neck, and the crown. Borchardt had already suggested that certain details in the face itself were molded with the help of a thin layer of gypsum plaster.[127] The actual amount of plaster used for the facial details is still to be determined.

The gypsum plaster additions to the shoulders and crown stress the importance of weight equilibrium in the structure of the bust.[128] This equilibrium becomes particularly obvious in the profile view, where the face appears to be at the vertex of an angle whose sides are formed by the neck and crown. Together, the crown and head have considerable weight, which is counterbalanced

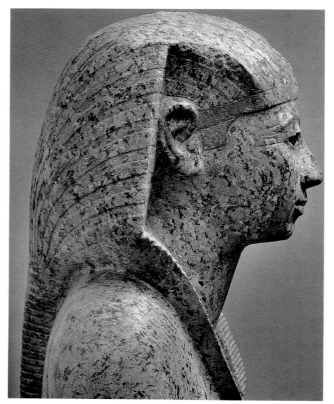

Fig. 63. Head and shoulders of a statue of Queen Hatshepsut. Granite. The Metropolitan Museum of Art, New York

by the neck's forward thrust. Thus, the pose of the queen has both a passive and an active aspect. Her head and neck are pressed down by the massive crown, but the neck visibly strains against this weight, a tension that is most obvious at the back of the neck where the two long neck muscles are strongly marked. The tension is visible most clearly at the point where the neck merges into the back of the head in a narrow curve.

Borchardt, in his initial publication of the piece, described how the forward position of the neck causes the throat to protrude "more than usual in women,"[129] to which Krauss has added the observation that it was mainly the forward push of the chin that produced the slight Adam's apple on the queen's throat. Krauss also remarked[130] that "in order to look straight in front, when the neck is in this position, a person needs to lower the eyes to an angle of about 30 degrees." This, Krauss continued, causes the eyelids to be lowered over the eyeballs, as can be observed in Nefertiti's bust.

It may be useful to add a few remarks to these observations concerning the position of Nefertiti's neck. The forward thrust of the neck is a feature that is not unique to the painted bust; it is one of the characteristic properties of almost all representations of the queen, the king, and other members of the royal house, beginning at least at the time of the move to Amarna (figs. 17, 30, 62, 66, 69, 74, 81, 100).[131] In traditional Egyptian art, such a neck position was used predominantly in representations of persons engaged in some activity. Among sculptures in the round, the so-called servant figures of the Old Kingdom and, in a few instances, also of the New Kingdom come to mind.[132] During the latter period, the forward bend of the neck also appears in statues of scribes,[133] and since ancient times, the heads of kings have been depicted as weighed down by the crown on the occasion of the thirty years' jubilee festival.[134]

Carefully structured according to a strict numerical system, the painted bust of Nefertiti occupies a key position in the development that led from her expressively ugly early representations to the softer new version that emerged just before Years 8–12 of Akhenaten's reign. There can be no doubt that the bust presents the prototypical new face of the queen in its purest form. Was it the definitive model that demonstrated the new way to depict the queen? And does this function explain the bust's unusually rigid symmetries and "draw-

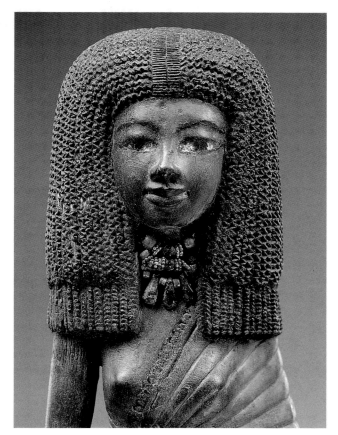

Fig. 64. Upper part of wooden statuette of the Chief of the Household, Tiya (fig. 20). The Metropolitan Museum of Art, New York

ing-board" adherence to a set system of proportions? Another—unfinished—limestone head from the same deposit in the Thutmose workshop may corroborate this understanding of the bust's particular character.

The face of the unfinished limestone head (fig. 61)[135] is roughly the same height as the face of the painted bust, but the piece lacks the bust's partial shoulders and high crown. It was, indeed, clearly made as a model for a head to be carved in quartzite for a composite statue. In order to affix a separate crown to the existing piece, curved indentations were cut out above the ears, and a rectangular hole was provided at the top of the head for the insertion of a tenon. The features of the unfinished limestone head are only roughly delineated, and thick black lines indicate the eyes and eyebrows. Black lines also show where the master sculptor wished to have more stone carved away: above the left corner of the mouth, on the right cheek and left jaw, and beside the bridge of the nose. Rough chisel marks are visible

around and on the ears, and there is a median line marked in ink on the philtrum and the lower lip.

Despite its unfinished condition, the head shows the sure hand of a master sculptor who, in creating the face of Nefertiti, still followed to a large extent the earlier conventions of Amarna art. This is attested to by the overlong neck with its prominently marked frontal tendons; the large and fleshy mouth whose corners are set into deep, angularly carved furrows; and the typical vertical ridges that separate the front parts of the cheeks from their sides. All these features are well known from the sculptures and reliefs of the early Amarna years (figs. 15, 16, 17). The unfinished limestone head, however, has the eyes and the straight jaw of the later style. We have here a version of the queen's image that must have been carved during the earliest stage of the Thutmose compound, just before the definitive version of the queen's image was incorporated in the painted bust. Perhaps the sculptor also intended to cover this image with a layer of gypsum plaster.

Slightly closer to the painted bust than the limestone head is a gypsum plaster head (figs. 39, 40)[136] that shows the rounded cheeks of the later, softened face of the queen—as well as her straight chin—but with a mouth that is still very full and disproportionately large. Step by step, therefore, one can follow the sculptors' attempts to achieve the queen's new image, and it appears more and more probable that the Thutmose workshop was decisively involved in the creation of the queen's new face.

A limestone slab that had been thrown into the foundation trench of a wall was found in the sanctuary of the Great Aten Temple.[137] The rectangular piece (fig. 62, no. 45) has the fairly regular shape common to relief models. The master sculptor carved an image, and his assistants then followed the model in carving temple and tomb wall reliefs (pp. 89–90). This particular slab shows a kneeling figure (not illustrated here) on one side, and the head, neck, and shoulders of Nefertiti on the other (fig. 62).

The composition of the queen's image on the slab matches the painted bust from the Thutmose workshop (fig. 60) as closely as could be expected. The only important iconographical difference is the inclusion of two cobras at the upper edge of the band around the queen's crown, one raising its hood and head at the center of the crown, the other hanging down in front of Nefertiti's ear, with its menacing eye just beside hers. In relief, this cobra-encircled head of Nefertiti is remarkably similar to her head on the family shrine stela in Berlin (fig. 88, pp. 96–104). Since the rather large, slightly open mouth and the large ear are on both the stela and the slab, the two works must have been made at about the same time—just before the change in the names of the Aten during Years 8–12. The shrine stela is inscribed with the earlier versions of the Aten's names (see p. 97).

The similarities between the relief slab and the painted bust of Nefertiti are striking. The outline of the oblique neck and square jaw, the forward thrust of the face, and the distinctive curve at the back combine to make the relief an almost exact two-dimensional version of the bust. True, the relief slab was evidently created earlier than the bust, and its exact counterpart may actually be the limestone head from the workshop (fig. 61). But the slab forms an important link between the Thutmose workshop and the relief sculptors who decorated the Great Aten Temple and, possibly, carved the shrine stelae (see pp. 96–104).

The Head from Memphis: The Ruler

Three years after the artistic treasure trove of the Thutmose workshop was found by Ludwig Borchardt, an excavator from the University of Pennsylvania, Clarence S. Fisher, discovered another work that is surely by the sculptor of the Berlin princess's head. He found the piece near a Ramesside palace in the ancient Egyptian capital of Memphis, just south of Cairo.[138] The head (figs. 31, 65) is carved from quartzite of only a slightly lighter brown than that used for the Berlin princess. The piece is broken at the middle of the neck, but the cut edge above the forehead and the broad, fairly short cylindrical tenon on the top of the head provide evidence that it was part of a composite statue. In determining the form of the headdress that originally crowned the head, it is easy to rule out various wigs—including the tripartite wig—because of the high forehead and the expanse of smooth neck below and behind the ears. A softly incised line runs across the middle of the forehead and forms the outline of a

Opposite: Fig. 65. Head of Nefertiti from Memphis. Brown quartzite. Egyptian Museum, Cairo

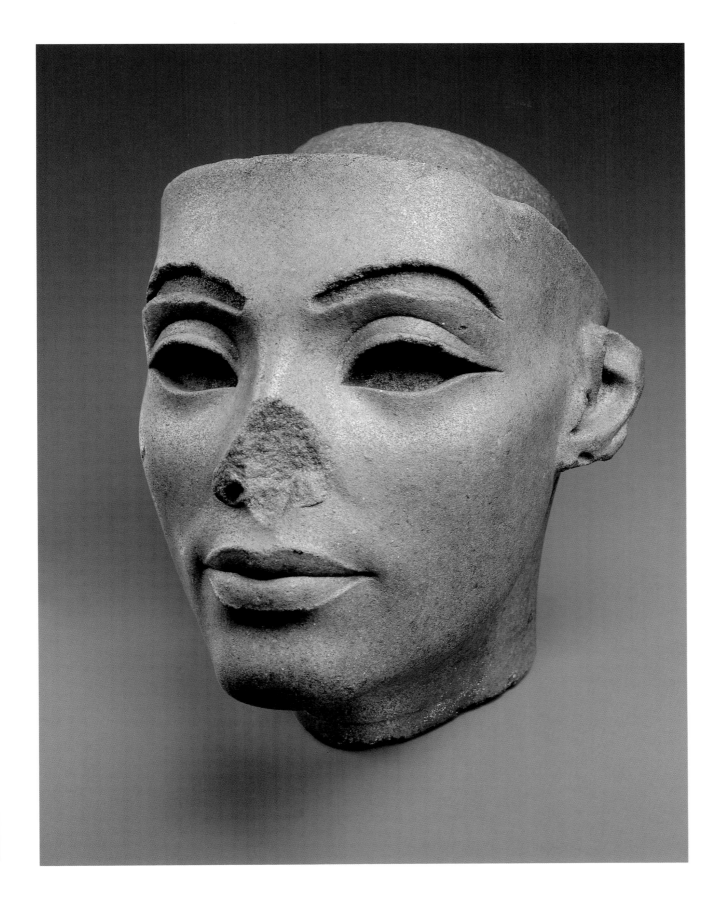

tab in front of the ears, indicating that the original headdress included a frontlet (of gold?) whose upper edge dipped in front of the ears. Royal persons of the Amarna Period wore one of three types of headdress with bands of this shape: the male Blue Crown (fig. 43), Nefertiti's tall, flat-topped crown (fig. 60), and her cap crown (figs. 68, 69).[139] If the Blue Crown is posited, the Memphis head would have to represent a male, either Akhenaten or his successor, Smenkhkare. Both kings' images are well known, and both have triangular faces and drooping, pointed chins,[140] so the square-jawed, lean-cheeked person represented by the Memphis head can only be Nefertiti.[141] Her tall, flat-topped crown, however, appears to have required a higher tenon (figs. 66, 74) than the one provided for the Memphis head, suggesting the cap crown as the most probable headdress. At the very back of the neck a vertical area has been left unsmoothed. This is difficult to explain. The presence of a back pillar that supported the neck is not very probable, because that would have been carved in one piece with the head. It is possible that metal streamers covered the back of the head. A relief slab found at Memphis shows a figure wearing an incompletely preserved off-the-neck crown with a uraeus cobra and streamers. In front of the figure are remains of a taller companion who must be a king.[142] If the smaller figure is Nefertiti, this image is close to the head preserved in figure 65.

There can be no doubt that the head found at Memphis was created by an artist of the Thutmose workshop at Amarna. The holes for the eye and eyebrow inlays of both this work and the Berlin princess head (figs. 46–48) end in similar sharply pointed tips. In both works, the upper margins of the eyelids are marked by the same deeply incised groove. And since the entire eyelid area is softly rounded, the impression is created that the lids push upward against the flesh over the brow ridges. The princess's upper lid is slightly concave and ends with a soft, round edge over the hollow for the eye inlay. In the queen's head from Memphis, the impression of the softness of the upper lid is increased by the addition of a second groove near the lid's edge. In both works, the undelineated lower lids bulge, suggesting the pressure of the eyeball, and two flat grooves run from the inner corners of the eyes toward the cheekbones, flanking a ridge. It is not easy to determine which anatomical feature this ridge represents. Most probably

it is the lower edge of the concentric eye muscle. The ridge is frequently seen in sculpture from the Thutmose workshop.

The indication of the lower edge of the eye muscle is more angular in the princess and softer in the queen, as befits the difference between a leaner young face and the fleshier features of an adult. On the queen's face, two even more softly indented furrows also run from the nostrils toward a point above the corners of the mouth. This feature is inappropriate for the representation of a young girl and is omitted from the princess's head.

The mouths of both heads are encircled by vermilion lines that end in rounded tips at the corners. Again, the queen's riper age finds expression in delicate muscle cushions that flank the corners of the mouth, whereas on the princess's face only an almost imperceptible rising of the flesh at both sides of the mouth is indicated. The shapes of the philtra, double-arched upper lips, and flat-bowed lower lips are almost identical in the two heads; the chins differ in shape, as is appropriate for images of Akhenaten's daughter and wife. There is also enough left of the neck of the Memphite head to show that the two sharply delineated, oblique sternocleidomastoid muscles, which start between the clavicles and run toward the ears, are present here. Accentuation of this muscle is another common feature of Amarna art (figs. 15, 88) and particularly of the Thutmose workshop (figs. 28, 48, 60, 62).

The Memphite head of Queen Nefertiti (figs. 31, 65) is surely one of the most remarkable images of an Egyptian woman ever created. This is due to more than the sensitivity with which the sculptor has rendered the minutest details of a beautiful woman's face. Structure and proportion distinguish this head—and its few rivals, such as the yellow quartzite (figs. 66, 67) and diorite (figs. 72, 74) heads and the bust in Berlin (fig. 58)—from all previous female images in Egyptian art. Traditionally, Egyptian sculptures and paintings depict women with slender bodies and broad, round faces. This type of ancient Egyptian female image was further accentuated during the earlier Eighteenth Dynasty by a growing predilection for massive wigs that cover the back and sides of the head and give the face a masklike appearance (fig. 64).[143]

Opposite: Fig. 66. Head of Nefertiti from the Thutmose workshop at Amarna. Yellow quartzite. Ägyptisches Museum, Berlin

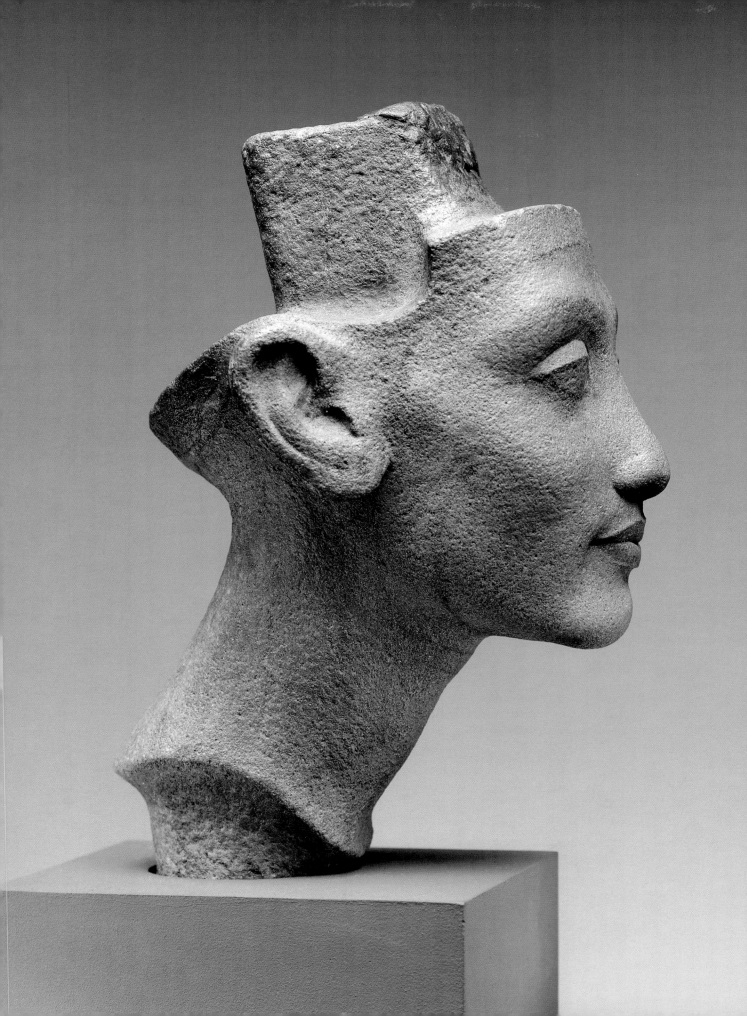

Egyptian art of all periods, moreover, tended to emphasize three-dimensional sculpture's origin in four-sided blocks of stone. As a result, fronts, profiles, and backs of complete statues—or heads—present individually coherent views without there being much transitional linkage between them. Even Queen Hatshepsut's face (fig. 63) retains a decidedly frontal character, although her headgear is predominantly the off-face *nemes* or *khat* of male kings.[144]

The Karnak statues of Akhenaten (figs. 1, 9) and Nefertiti (fig. 2) still exhibit much of the typical Egyptian frontality, especially in the heads and faces. But after the change to the softer "new face," Nefertiti's heads are different, as exemplified in the painted bust (figs. 58, 60), the yellow quartzite head—to be discussed presently (figs. 66, 67)—and the head from Memphis (figs. 31, 65). The fronts of the faces in these works are less broad and flat, and the jaws and cheeks are more rounded, thus providing a gradual transition from the front to the sides of the face. The outer corners of the eyes are closer to the temples, so they are not fully visible from the front and can only be seen in a three-quarter view (figs. 58, 67); likewise, the eyebrow ridges and eyebrows continue in a curve from the front into the profile of the face.

The new three-dimensionality of Amarna heads is closely linked to the use sculptors made of the skull bones as decisive structural elements. Clear-cut jawbones form the basis of the face, and their firm curves are visible in the front, three-quarter, and side views. The forward ends of the cheekbones are visible as pronounced mounds just below the outer corners of the eyes; at the sides, the bony ridges at the lower ends of the temple bones stretch toward the ears, ending with a tiny knuckle (the condyloid process of the mandible) that indicates the joint between the mandible and the cranium (figs. 41, 66, 74). This small knuckle is a feature of all heads of Akhenaten and Nefertiti, but the similarity between king and queen that characterized early Amarna art is not continued into the time of Nefertiti's new face.

The skeletal structure of Nefertiti's "new face" is owed to the achievements of those early artists who represented the queen's—and the king's—face as expressively ugly (figs. 2, 9, 10, 11). In the unnaturally protuberant, lean faces of that revolutionary period the pleasing feminine mask of earlier times (fig. 64) was

first abandoned and then replaced by a three-dimensional female image. The creators of the softer new face needed only to free this initial concept from exaggeration to produce their image of a woman not only exceptionally beautiful but also determined to play an active role in life. Later (pp. 89–90) we will see that the king's face remained essentially as it had been, attaining only a softened, harmonized serenity.

In the Memphite head (figs. 31, 65), Nefertiti is presented in her most regal aspect. The smooth quartzite stone surface stretches tautly, but feelingly, over the strong bones of a ruler's face. The serene expression on the lean, austere face speaks of strength, equanimity, and that unwavering sense of justice that the ancient Egyptians understood to be the quintessential quality of a pharaoh. This is a queen who looks as if she is entirely capable of joining the king, on his "carrying chair of electrum, in order to receive the products of Kharu [lands in the Near East] and Kush [Nubia], the west and the east . . . while the granting of the breath of life is made to them,"[145] or in receiving from a high official the prayer that she may "grant an entry favored, a departure beloved, and contentment in Akhet-Aten."[146]

If the Berlin princess's head (figs. 46–48) appears to be one of the earliest works by a particular sculptor of the workshop, the Memphite head of Nefertiti (figs. 31, 65) is surely a later work, probably carved at the time when relief sculptors were occupied with decorating the Amarna temples and stone-built halls. A relief from Amarna, found reused at Hermopolis and now in The Metropolitan Museum of Art, is very close to the head.[147] The head of Queen Tiye in the Metropolitan Museum (figs. 42, 44) was certainly created later than the quartzite princess in Berlin, but it is still earlier than the Memphite head.

The Yellow Quartzite Head: The Beauty

There were three more representations of the queen among the works from the Thutmose compound: a yellow quartzite head (figs. 66, 67, no. 2), a limestone statuette (figs. 68, 69), and the head of a diorite statue (figs. 72, 74). Each of these images presents yet another

Opposite: Fig. 67. Head of Nefertiti from the Thutmose workshop at Amarna. Yellow quartzite. Ägyptisches Museum, Berlin

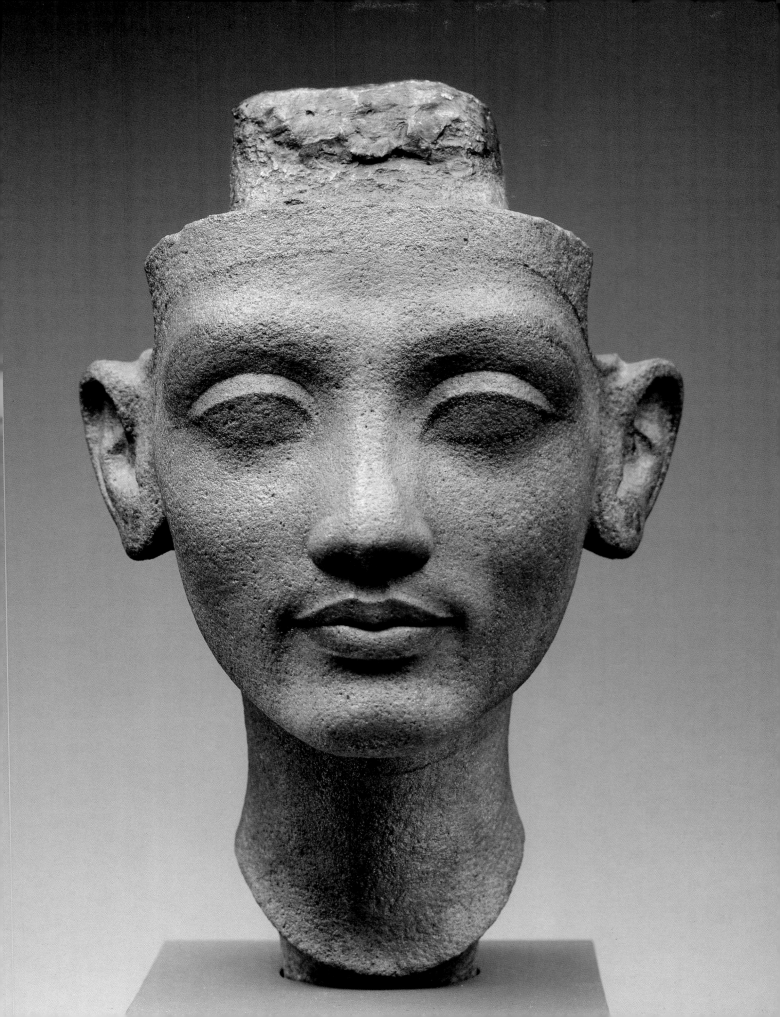

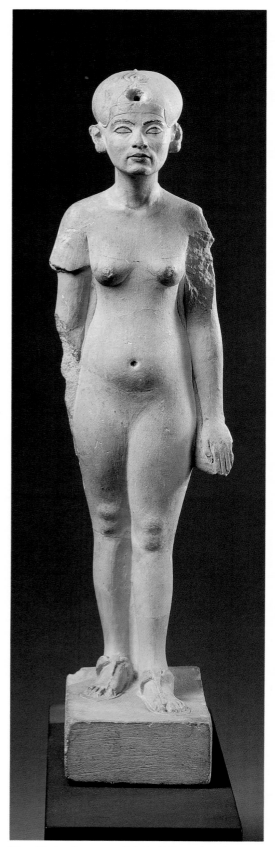
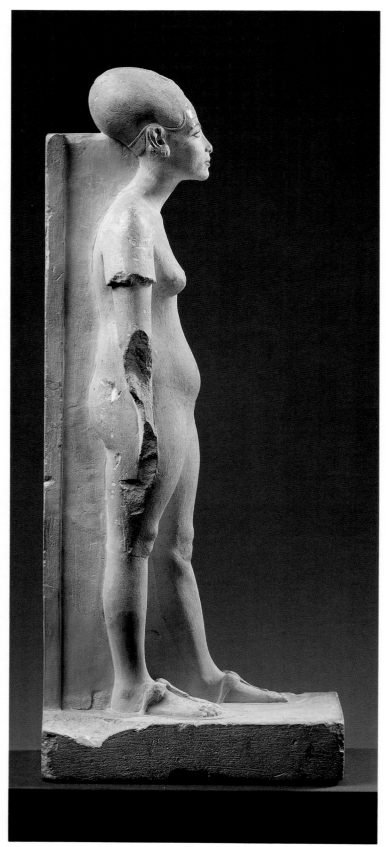

Figs. 68, 69. Statuette of Nefertiti from the Thutmose workshop at Amarna. Limestone. Ägyptisches Museum, Berlin

aspect of the queen's personality. The yellow quartzite head, now in Berlin, was certainly once adorned with the tall, flat-topped crown of Nefertiti. The piece is among the most intimate images of Nefertiti in the round. Graceful youth is expressed by the manner in which the head seems to turn on the neck (fig. 66) and in the unusually soft features of the face (fig. 67). The work is unfinished insofar as it lacks the drilled areas for eyebrows and eyes and also the final surface finishing. But the beautiful mouth, which seems to be on the verge of speaking, is complete and has been painted red. The sculptor was surely a member of the Thutmose workshop, but not the same artist who created the brown quartzite heads. His queen has a rounder face, a slightly broader nose, and fleshier ears. Moreover, the vermilion line around the lips, which on the brown heads is fairly sharp, is here an almost imperceptible soft edge that contrasts beautifully with the sharp ridges at either side of the philtrum.

The upper eyelids of the yellow quartzite queen are separated from the area above the eyes by the typical deeply incised groove. But this sculptor has made the area of the brows rounder and softer than those of the brown quartzite heads of the queen and the princess (figs. 46–48). He has also padded the cheeks so that the corners of the mouth are deeply embedded in slightly curved cushions of flesh. A dimple—more suggested than sharply modeled—divides the muscle cushions around the corners of the mouth from the cheeks. The areas below the eyes are not finished, so we do not know whether this head was going to be given the muscle ridges that run diagonally from the inner corners of the eyes toward the cheekbones in the brown quartzite heads. A scarcely noticeable rise in the surface in that area may indicate that this feature was going to be worked out in the final stage. Black lines in the ears, along the forehead, and on the neck indicate where further work was intended. But any modern viewer is entirely content with the state in which the sculptor left the piece. Its youthful dreaminess is actually intensified by the veil of the unfinished matte surface.[148]

Fig. 70. The royal family offering: relief on the sarcophagus of Queen Tiye in the Royal Tomb at Amarna.
Reconstruction by Maarten J. Raven

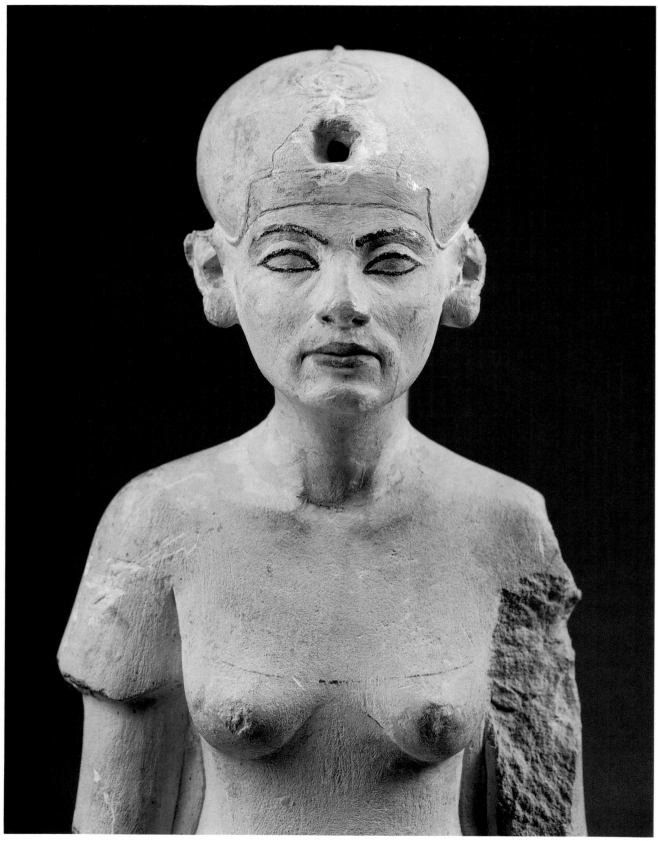

Fig. 71. Head of the limestone statuette of Nefertiti (figs. 68, 69)

The Limestone Statuette: Nefertiti in Advanced Age

The contrast could not be greater between the youthful yellow quartzite head (fig. 67) and the limestone statuette from the same deposit in Thutmose's "pantry" (figs. 68, 69, 71, no. 4).[149] The broken pieces of the small figure (40 cm [15.75 in.] high) were found in different corners of the room. Parts of the lower legs and the back pillar have been restored.[150] The queen stands with both arms hanging at her sides; her left hand is turned toward the viewer. This positioning of a hand is often seen in Amarna reliefs with people in repose; occasionally, the gesture conveys a somewhat deferential attitude.[151] It lends the statuette an aspect of piety.

The queen wears an ankle-length, tight unpleated dress of fine linen and over that, presumably, the usual flimsy shawl, whose fabric protrudes stiffly like a short sleeve on the right arm and clings tightly to the left.[152] On her head sits the cap crown with the uraeus cobra's body coiling on top of it in a complicated spiral pattern. The head and front of the body of the snake are missing. It was probably made of metal and fixed over the queen's forehead by the insertion of a peg into the rather large drilled hole. On the queen's feet are sandals with softly padded straps, and around the neck and over the shoulders lies a large collar that was indicated by black lines around the neck and above the breasts. The impression is created that the collar is of a soft material that follows the forms of the shoulders and breasts, a feature often seen in later Amarna art.[153] The queen's ears are adorned with disk-shaped earrings in front and back of the earlobe; the two disks are connected by a stud. Behind the figure is a narrow back pillar that reaches to the nape of the queen's neck. Its margins are set off on the sides by raised ridges.

The statuette is, without a doubt, unfinished. The eyes and eyebrows are delineated in black and the lips are painted red, as in the quartzite heads created by the workshop. There is also a black line on the lower abdomen to indicate a body fold seen through the thin linen; black pigment emphasizes the navel. In fact, the question arises whether this piece should not be called a sketch for a larger statue of Nefertiti rather than a work in its own right. It would be of the same character as the group with the king kissing his daughter (fig. 96) and the unfinished figure of a kneeling king (see p. 43).

All the more remarkable are the individualized features of the face and body. This is a woman past her youth but not old. The unmistakable square-jawed, lean face of the queen has acquired a certain heaviness. The curved flesh over the corners of her mouth has thickened and is set off from the cheeks by noticeable furrows. At either side of the mouth, two deep grooves run downward. This creates a slightly bitter expression, reminiscent of Queen Tiye (fig. 23). The flesh over Nefertiti's cheek is sagging, the neck has acquired a gaunt appearance, and the ears are fleshy and heavy. Pendulous breasts and a drooping abdomen reinforce the signs of advancing age shown on the face.

Nefertiti was repeatedly depicted in the cap crown,[154] with most of the representations dating after Years 9–12. The relief sculptor's model in the Brooklyn Museum (fig. 81, no. 30) shows her with this headdress and the deep furrows of advancing age between the nostrils and the corners of the mouth. A notable depiction of the aging Nefertiti in the cap crown and a close-fitting dress is found on the sarcophagus that Akhenaten had carved for his mother, Queen Tiye, at Amarna (fig. 70).[155] As discussed above (see p. 26), the Queen Mother probably lived at least until Year 14 of Akhenaten's reign. The depiction of Nefertiti on Tiye's sarcophagus could reasonably have introduced a few signs of age, though Nefertiti would have been barely forty at that time.

Why depict the most beautiful of queens with signs of advanced age? One point to keep in mind is that this is only a small statuette, perhaps a sculptor's sketch for a work never executed in a larger form. One cannot help but wonder whether this piece was ever shown to Nefertiti. Arguing against such a view is the fact that the queen has a similar face on the sculptor's model in relief (fig. 81), which was certainly meant to serve as a model for a later work. If our interpretation of that relief as a representation of Queen Nefertiti as coruler with Akhenaten (see pp. 89–90) is correct, there may be an explanation for the depiction of old age. As coruler, the queen had assumed the status of "wise woman." Perhaps, in fact, Queen Tiye, who had previously been seen in this character, was already dead when the statuette and relief were created, and Nefertiti had taken over her role. That would explain the very similar figure depicted on Tiye's sarcophagus.

Stylistically, the statuette is closer to the yellow quartzite head than to those of brown quartzite. Indeed, looking at the shape of the ears and the looseness of the

79

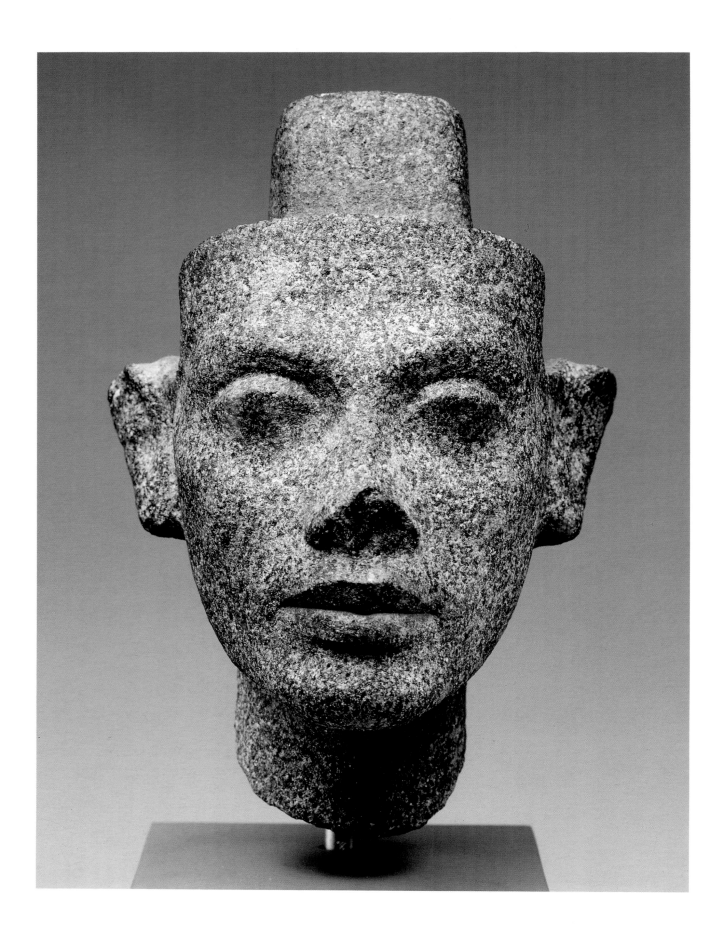

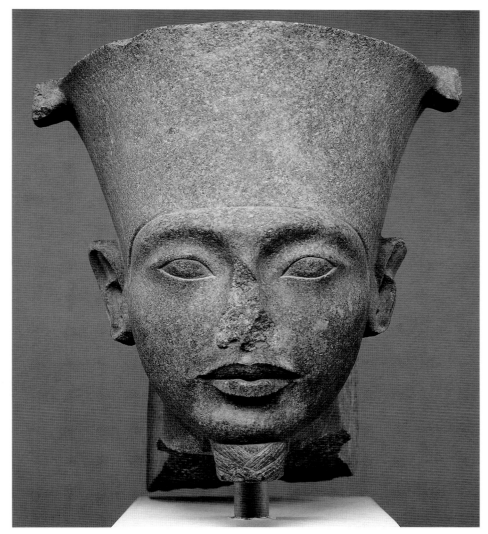

Fig. 73. Head of the god Amun. Granodiorite. The Metropolitan Museum of Art, New York

flesh of the face, which the statuette shares with the yellow quartzite head, they might well be by the same group of artists within the Thutmose workshop. It is truly remarkable how subtle the artistic means of the Thutmose artists had become, that they were able to follow the changes of time in the image of their most favored subject.

A Head of Nefertiti by the Youngest Sculptor of the Workshop: The Monument

A head found in the third—and smallest—house of the Thutmose compound (see p. 43) brings our brief history of this remarkable sculptors' workshop to a

Opposite: Fig. 72. Head of Nefertiti from the Thutmose workshop at Amarna. Granodiorite. Ägyptisches Museum, Berlin

close. This house was evidently the last residence built inside the original compound of Thutmose (fig. 35 [19]). The head was excavated in a workroom at the back of the house [21].[156] Made of granodiorite, the head (figs. 41, 72, 74), now in Berlin, is unfinished; work ceased at about the same stage at which the yellow quartzite head was abandoned. The tall tenon on top of the head attests that this is another representation of Queen Nefertiti in her tall, flat-topped crown. Red paint has again been applied to the places where the crown was to be attached, and the lips are painted red. The black brushlines found on other pieces are missing here, possibly because they would have disappeared on the gray stone. The line that indicates the lowest edge of the crown is not in ink but in slightly raised relief. It might

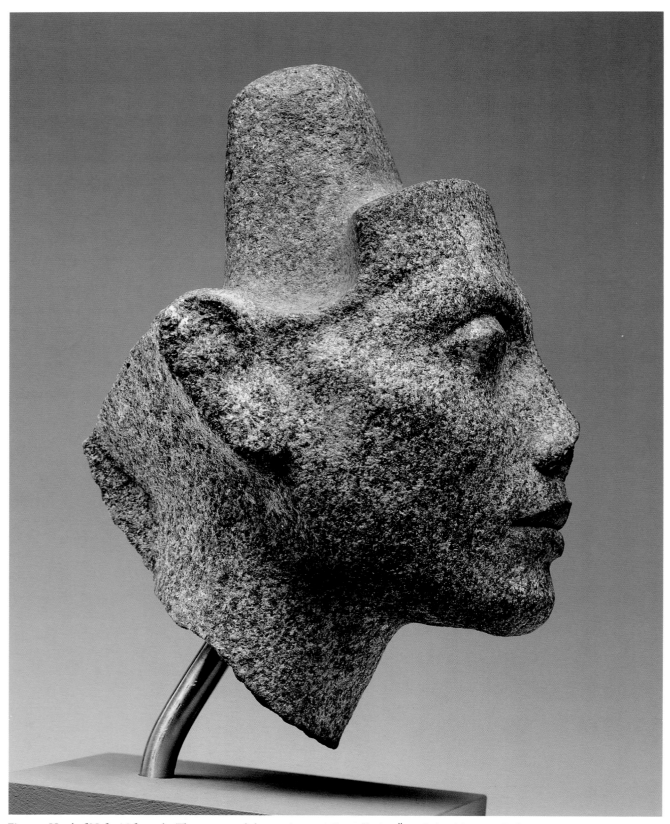

Fig. 74. Head of Nefertiti from the Thutmose workshop at Amarna. Granodiorite. Ägyptisches Museum, Berlin

also be that the piece was not corrected by the head sculptor before the workshop closed.

There are two important points to keep in mind about this head. First, the granodiorite stone material:[157] in the main deposit of the Thutmose workshop, this stone was found only in a two-part *nemes* headdress and a side lock for the figure of a princess.[158] Pieces of an arm from a sculpture in granodiorite were discovered in the courtyard area east of Thutmose's house and south of the house of the young sculptor,[159] while chips from the working of this stone were excavated in the workrooms of the young sculptor.[160] On the whole, granodiorite was rarely used by Amarna artists,[161] though it became very popular in the post-Amarna Period.

Second, the profile view of the head (fig. 74) shows that the head and a back pillar were one piece; the bottom break is fairly far down the neck and there is no trace of a tenon. Therefore, the statue was made from one large block of stone, with only the crown added as a separately carved entity. Statuettes of this type[162] are known from Amarna, but no other half-lifesize statue is preserved. These pieces can only be called partly composite; they are not true composite sculptures such as the quartzite and yellow jasper works previously discussed.

In style and expression, the head differs considerably from the brown and yellow quartzite heads. The features are less individual, the eyes are smaller, and the whole is more monumental than any of the other works made by the Thutmose sculptors. In trying to reconstruct the appearance of the finished piece, one arrives, in fact, at an image close to certain post-Amarna works. The closest parallels in stone material and style are a number of diorite heads of the god Amun and other deities created for Theban temples under King Tutankhamun.[163] Significant similarities between the granodiorite head from the Thutmose compound and a post-Amarna Amun head in the Metropolitan Museum (fig. 73)[164] begin with the position of the cheekbone mounds, which are located far to the sides, almost below the temples. In both heads the eyes are considerably smaller than in any quartzite head of Nefertiti. The lower eyelids are not indicated at all in the unfinished head, creating a sfumato effect. When finished, however, the lower lids would probably have looked much like those of the Amun head. The intention was evidently to achieve an impression of remoteness in the face by positioning the small eyes close to

the forehead and under angular, shadowy brows. The expression is intensified by the smooth transition between the cheeks and the lower lids. It is difficult to say whether or not the sculptor of the Thutmose head also intended to make the upper lids vertically banded like the ones of the Amun head (see p. 121 for this type of eyelid). He certainly gave the queen a particularly large and broad mouth and thus departed from the proportional harmony that characterized her images since the creation of the painted bust. There is a noticeable tension in the granodiorite face between the large mouth and the small, distant eyes; the same tension is a distinguishing feature of the head of Amun.

Based on the find spot, stone material, and style, the granodiorite head stands out as an image of Queen Nefertiti that has remarkable links with the post-Amarna Period. Its style may even indicate that some members of the Thutmose workshop joined the sculptors who worked for the temples of Thebes during the reign of Tutankhamun.[165] Queen Nefertiti must have died soon after the granodiorite head was created. It is all the more notable that this sculptor did not show her with any signs of old age. The age of the subtle, individualized art of the Thutmose workshop was over.

To sum up the art historical part of this chapter it may be appropriate to list the four sculptors whose works have been tentatively identified:

Sculptor One carved the Metropolitan Museum head of Queen Tiye (acc. no. 11.150.26; figs. 42, 44) and modeled the originals from which three ancient plaster casts in the Ägyptisches Museum, Berlin, were taken (inv. nos. 21 340, 21 354, 21 355; figs. 43, 45).

Sculptor Two created the head of a princess in the Ägyptisches Museum, Berlin (inv. no. 21 223; figs. 46–48) and the head of Queen Nefertiti, excavated at Memphis, in the Egyptian Museum, Cairo (JE 45 547, figs. 31, 65).

Sculptor Three is the master of the yellow quartzite head in the Ägyptisches Museum, Berlin (inv. no. 21 220; figs. 66, 67). He—or an assistant—may also have created the limestone statuette of the queen in the same museum (inv. no. 21 263; figs. 68, 69, 71).

Sculptor Four carved the granodiorite head of Nefertiti in the Ägyptisches Museum, Berlin (inv. no. 21 358; figs. 41, 72, 74). He may have been the owner of the house in the northeast corner of the Thutmose compound (fig. 35 [19, 21]).

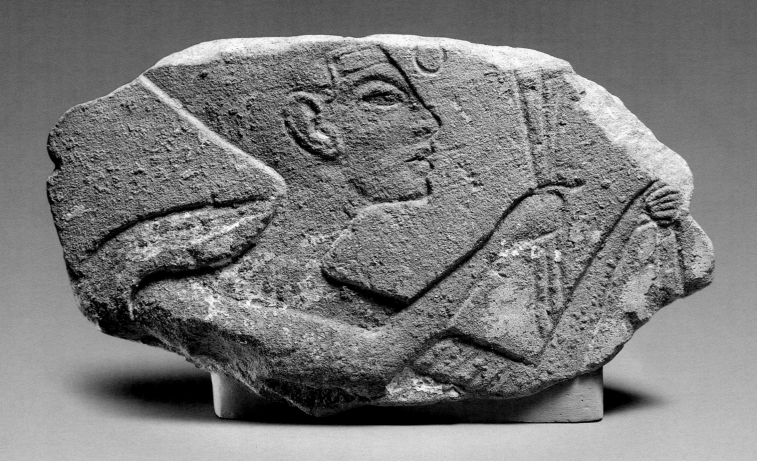

ASPECTS OF THE ROYAL FEMALE IMAGE DURING THE AMARNA PERIOD

DOROTHEA ARNOLD

The sculptors of the Thutmose workshop created a remarkable variety of female images, and each masterpiece presents a different aspect of a royal woman. Contemporaneous relief and painting from Amarna, being narrative in form, are of great use in corroborating, enriching, and refining our understanding of the sculpture.

THE LADY OF THE TWO LANDS

Lady of the Two Lands is a title that Nefertiti inherited from earlier queens of the Eighteenth Dynasty. However, no queen before her had been denoted solely by this appellation, and only for her does the designation appear directly in front of the cartouche with her name (fig. 15). Since Lord of the Two Lands (i.e., Upper and Lower Egypt) is a common description of the Egyptian king, the title Lady of the Two Lands emphasized Nefertiti's strong position as a counterpart to the pharaoh.

Reliefs that once adorned the temples and ceremonial halls of Akhetaten were later—after the city had fallen into decay—dismantled and shipped across the Nile to Hermopolis, where the blocks were used as building material for temples of the pharaoh Ramesses II (ca. 1279–1213 B.C.). Excavated in the 1930s, these relief blocks,[1] many of which are now in major American and European museums, help us to reconstruct the splendor of Amarna relief art. Among the multitude of subjects are scenes that amply demonstrate the queen's political and religious importance. For instance, on two relief blocks in the Museum of Fine Arts, Boston, Nefertiti appears in the age-old role of the pharaoh "smiting the enemy." Traditionally, this scene decorated the pylons of temples or other such conspicuous places

and depicted a male pharaoh in a powerful, striding posture. His left hand grasps by the hair the enemies who kneel before him while his right wields a formidable mace to smash their heads. A relief in The Metropolitan Museum of Art[2] shows this scene represented on the cabin wall of Akhenaten's state ship. The queen's ship in the Boston relief is, in every respect, equal to her husband's. The steering oars are decorated with images of the queen's head, wearing the tall, flat-topped crown with high feathers and a sun disk, and on the cabin wall her striding figure—wearing the same crown without the plumes—is depicted smiting a female enemy.[3]

In the religious realm, Queen Nefertiti's position as her husband's near equal is impressively demonstrated by the innumerable offering scenes in which she is represented. The early temple reliefs at Karnak presented a remarkable situation. On the one hand, the queen's role in the rituals was relatively traditional. Nefertiti is portrayed, for instance, as a considerably smaller figure behind the king,[4] holding the scepter of Egyptian queens or playing the sistrum, both appropriate functions for a female officiating in a temple ritual.[5] In certain scenes the queen—still much smaller than the king—innovatively echoes her husband's actions by holding offerings herself.[6] But in other quite extraordinary scenes found predominantly in the part of the sanctuary called *Hut-benben*, Nefertiti is the sole worshiper of the Aten, accompanied only by one or two of her daughters.[7] Not since Queen Hatshepsut, who was a pharaoh in her own right, had a queen been singled out in this manner.[8]

Paradoxically, the exclusivity with which the queen appears in the Karnak offering scenes may, in fact, simply follow an ancient custom in which the husband's figure is entirely omitted when his wife is the focus of a cult.[9] To some degree, therefore, the queen's ubiquitous presence as co-worshiper with the king at Amarna heralds

Opposite: Fig. 75. Fragment from a column excavated at Amarna showing Nefertiti offering flowers. Limestone. Ashmolean Museum, Oxford

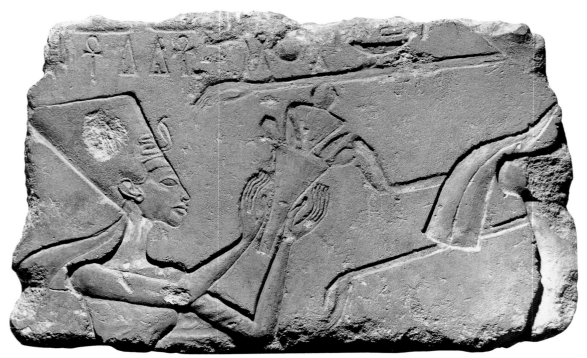

Fig. 76. Fragment from a column from Hermopolis showing Nefertiti, behind Akhenaten, offering. Limestone. The Brooklyn Museum

an even greater involvement in the state cult. Usually she is seen repeating Akhenaten's priestly gestures, her hands holding an object or a scepter similar to the one he holds or presents to the Aten (figs. 30, 75, 76, nos. 25, 35, 31).[10] Now the little daughters, who follow behind the queen, are the ones who shake the sistrum (fig. 15).[11] By the time of the Amarna reliefs, the difference in height between king and queen is diminished to the point where it can be understood as the natural discrepancy between men and women (fig. 76); at Amarna only occasionally is the queen shown dwarfed by the king (fig. 70).[12]

Nefertiti's prominence in the main temple cult was certainly a cause for astonishment, even shock, to contemporary Egyptians. Earlier queens had a role in certain rituals, above all in connection with the cults of female goddesses like Hathor and in fulfillment of the traditional office of the Eighteenth Dynasty queen as a "wife of the god."[13] But in the great state cults, earlier kings had ordinarily functioned as the sole representative of humankind before the god.[14] It should be noted, however, that not only Queen Nefertiti but also the minor queen Kiya, whom we have met as the possible subject of the jasper fragment (figs. 27, 29; see p. 38),

and later Princess Meretaten officiated on occasion behind the king.[15] One might, therefore, argue that it was not Nefertiti as a person who wielded power and entered into religious functions hitherto entirely dominated by the male pharaoh, but that the Aten religion called for inclusion of the female principle in the cult to counteract the exclusively male character of its single deity. The additional presence of the royal children demonstrated that the newly established wholeness of worship guaranteed creation in perpetuity.

Evidence for the political importance of Nefertiti might be deduced from the unique pairing of king and queen at certain state ceremonies. In Year 12 of his reign, Akhenaten celebrated a great Tribute of the Nations festival. On this epochal occasion, representatives of the Hittites of Anatolia, the Mitannians of western Mesopotamia and Syria, and the people of Canaan, Libya, and Punt (Nubia) paid homage to the king and presented gifts such as horses and chariots, animals, gold, copper ingots, ebony, textiles, and female slaves. The occasion, although possibly commemorating a victory in Nubia (see p. 114), was understood by the Egyptians primarily as a ceremonial

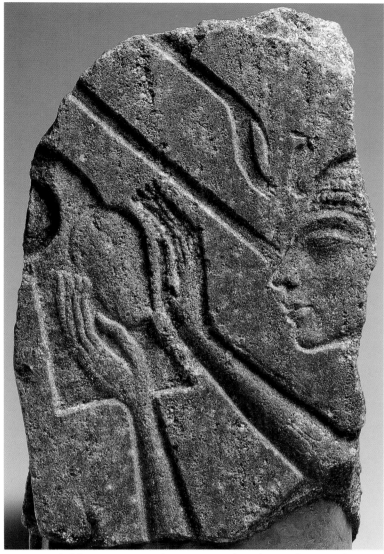

Fig. 77. Relief fragment excavated at Amarna with Nefertiti offering. Red quartzite. Petrie Museum, University College, London

affirmation of the king as master of the universe. It combined elements usual for a celebration of the pharaoh's accession to the throne[16] with rites that were part of a thirty years' jubilee (*sed*) festival.[17] Knowledge of these festivities has come down to us through representations in the tombs of Queen Tiye's steward Huya[18] and Meryre II (fig. 78), who was the Overseer of the Royal Quarters and the Apartments of the King's Great Wife [Nefertiti].[19] Both reliefs represent the king and queen in a singular way as twins, their images overlapping to such a degree that the queen's figure is only outlined beside the king's. In this manner, the royal couple share the palanquin in which they are carried to the

festival grounds and the throne from which they receive representatives of foreign lands.

Again, a parallel image of Akhenaten and Queen Kiya (fig. 79, no. 28) shows that the twin iconography was not confined to Nefertiti but was also used to depict the unity of Akhenaten and his other consort, "the wife and great beloved of the King of Upper and Lower Egypt . . . Kiya."[20] Later, Kiya's image was eradicated from most reliefs and superseded by the one of "the king's daughter" Meretaten or her sister Ankhesenpaaten. This was achieved by transforming Kiya's Nubian wig into an elaborate side lock, called a "modified Nubian wig" by Egyptologists.[21] In this guise, the princesses functioned

Fig. 78. The royal family under a baldachin during the presentation of tribute. Drawing by Norman de Garis Davies after a relief in the tomb of the Overseer of the Royal Quarters, Meryre, at Amarna

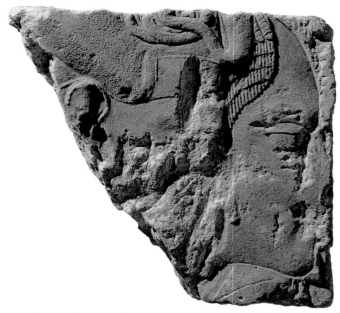

Fig. 79. Fragment from Hermopolis with the faces of Akhenaten and the minor queen Kiya (as changed into Princess Meretaten). Ny Carlsberg Glyptotek, Copenhagen

in rituals and political events as female counterparts to the king in a manner not much different from the roles previously played by Nefertiti and Kiya.[22] One cannot escape the conclusion that in performing these ceremonial roles, the queens and princesses did not function as individuals but as representatives of femininity in general. Therefore, it is hardly possible to gain a glimpse of the personalities from monuments that depict the royal women in state and cult ceremonies. Other, less official, sources have to be scrutinized.

Cyril Aldred[23] has stated with conviction that Queen Nefertiti died in Year 14 of her husband's reign. More recently, scholars have been reluctant to accept this chronology; on the contrary, many Egyptologists are now inclined to accept an argument advanced in the 1970s by the British Egyptologist John R. Harris.[24] According to this argument,[25] some inscriptions and reliefs indicate that Queen Nefertiti lived at least as long as her husband and played a strong political role during the last years of Akhenaten's reign—possibly, even for a brief period after his death. The evidence rests primarily on the occurrence of the second part of Nefertiti's name, Nefernefruaten, either in combination with a low date (Year 3)—which cannot refer to Akhenaten's reign because in his third year the queen had not yet

adopted the name—or with the name of Smenkhkare, who is otherwise attested as a successor of Akhenaten.

The inscription dated Year 3 is one of the most personal expressions extant from the period. Now badly damaged, it was copied in 1912 and recollated in 1923 by the great Egyptologist Sir Alan H. Gardiner.[26] The text consists of a prayer roughly sketched on the wall of a Theban tomb by an "outline draftsman," an artist who executed the basic drawings on tomb walls from which other artists would carve a relief. His name was Pawah, and he dates his graffito to "regnal Year 3" under the king "Ankhkheprure beloved of the Aten, the son of Re [the sun god]: Nefernefruaten beloved of Waenre [Akhenaten]." Astonishingly, Pawah's prayer is addressed to Amun, the traditional god of Thebes, and in its main passages it says:

My wish is to see you, (O) lord of persea trees! . . . My wish is to look at you, that my heart might rejoice, (O) Amun, protector of the poor man . . . Come back to us, (O) lord of continuity. You were here before anything had come into being, and you will be here when they are gone . . . O Amun, O great lord who can be found by seeking him, may you drive off fear! Set rejoicing in people's heart(s).

Joyful is the one who sees you, (O) Amun: he is in festival every day![27]

The terminology "beloved of the Aten" used in this text shows that when this prayer was written the Aten religion had not yet been eradicated, nor had Akhenaten been condemned as a heretic. But the address to the traditional deity of Thebes, the god Amun, is very warm and speaks of a deeply felt yearning for the traditional religion, to whose god poor people could turn for help. The inscription also shows that the royal powers had already started to yield to this yearning, because in another passage Pawah mentions a temple of Amun at Thebes called the Mansion of Ankhkheprure, implying that the new king had dedicated a cult to Amun. Who was King Ankhkheprure Nefernefruaten beloved of Akhenaten whose third regnal year is here mentioned?

A number of scholars have recently argued that this king was Nefertiti.[28] According to these scholars, she would have been a coregent with Akhenaten after about Year 13 of his reign, when Nefertiti as mere queen disappears from the sources available from Amarna. Her Year 3 as coregent would have been Year 16 or 17 (the last) of his reign, and under her, the traditional Amun religion probably regained some of its former importance at Thebes, as seen in the text quoted above. James Allen[29] has suggested that the rule was perhaps divided between the two, with Akhenaten continuing to rule in Amarna and Nefernefruaten (Nefertiti?) in the rest of the country, including Thebes. At Amarna the role of a King's Chief Wife—necessary for cult functions—was evidently taken over by Akhenaten and Nefertiti's eldest daughter, Meretaten; representations of the minor queen Kiya were changed to depict the princess (figs. 100, 101).[30] After Akhenaten's death, Nefertiti, as coregent, would have stepped down for Meretaten's husband, Smenkhkare, who was succeeded after possibly one year by Tutankhaten, later renamed Tutankhamun. Nefertiti probably died at some point during these reigns, but before Year 2 of Tutankhaten, while the court still resided at Amarna, because she was evidently buried (as queen, not as pharaoh) in the Amarna Royal Tomb.[31] It is a fantastic and complicated story, but there is supporting evidence.

A number of reliefs are discussed when scholars hypothesize about what happened at the end of Akhenaten's life. One of them is a great work of art. The Wilbour plaque (fig. 81, no. 30), thus named for Charles Edwin Wilbour, who purchased the piece at Amarna in 1881, is now in the Brooklyn Museum. The rectangular limestone slab of approximately 6 by 9 inches (15.2 x 22.9 cm) has a drilled hole in the center of the upper edge. Slabs of similar shape are commonly understood as sculptor's models carved by a master to show apprentices how to shape the heads of the king and queen.[32] Another example with the queen's head alone is seen in figure 62 (no. 45). The hole in the Wilbour plaque is thought to have served for insertion of a string or wire for convenient storage in a workshop.

The slab shows in sunken relief the profile heads of Akhenaten (left) and a slightly smaller Nefertiti (right) facing each other. The work is clearly by the hand of a master sculptor.[33] The king's face under the *khat* headdress presents the familiar features—drooping chin, long nose, hooded eye, large ear with pierced lobe—albeit in a softened version. Compared with the revolutionary early Karnak statues (figs. 2, 9) or even the Amarna images created before Years 8–12 (figs. 88, 94), the Wilbour king's expression is serene and withdrawn.

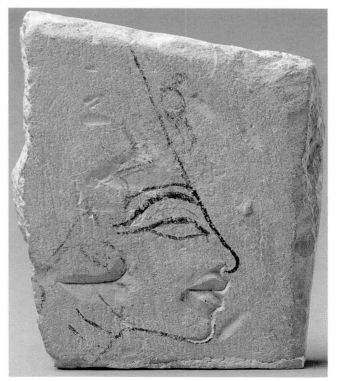

Fig. 80. Sculptor's trial piece with head of Nefertiti, excavated at Amarna. Limestone. Petrie Museum, University College, London

Fig. 81. Sculptor's model showing the heads of Akhenaten and Nefertiti. Limestone. The Brooklyn Museum

All furrows are smoothed, and only around the eye and mouth do faint marks of suffering mar the impeccable beauty of the face.

Nefertiti wears the cap crown on which her uraeus cobra twines in the intricate spirals familiar from other representations of the queen in this headgear, the most important being the limestone statuette from the Thutmose workshop (figs. 68, 69, 71).[34] Unmistakable signs of age—a deep vertical furrow at the corner of the mouth, a sharply incised curved line between nostril and mouth, and a flat cheek with slightly sagging flesh—are other features in the Wilbour Nefertiti reminiscent of the limestone masterpiece. The two images are not, however, identical.[35] The queen of the Wilbour relief may, to a certain extent, share the character of wise woman with Queen Tiye (figs. 23, 26) and the queen of the limestone statuette, but she is not the tired, bitter woman of the wooden head nor the spent beauty of the limestone statuette. Her image is dominated by the intent gaze of the eye and the energetic thrust of chin and neck, which is emphasized through the inclusion of shoulders and clavicles.

The Wilbour queen's face is, in fact, considerably more active and alert than that of the king, and, although clearly an experienced woman, she still possesses the regal poise of her quartzite head from Memphis (figs. 31, 65). The image on the plaque culminates in the two face-to-face cobra figures: Akhenaten's is the picture of dignity, with its erect pose and the simple double curve of the thick body, whereas Nefertiti's nervously spiraling snake, its hood spread threateningly, draws back ready to lunge. Did the sculptor knowingly differentiate the corulers by showing Akhenaten—his revolution achieved—in remote serenity and Nefertiti as the now more active and energetic partner, ready to meet the challenges of the day?

Another monument often cited in discussions of a possible coregency at the end of Akhenaten's reign may, in fact, not be relevant. It is a stela of unknown provenance now in the Ägyptisches Museum, Berlin (fig. 84, no. 7). According to the inscription, it was a votive dedicated by a man named Pasi who was a soldier of a military division with a rather cumbersome name: "[the King] appeared as right order." Two kings are depicted seated side by side on a couch with lion's legs; thickly cushioned footstools support their feet. In front of the pair, offerings of food and drink are heaped on a table and on stands. One king, who sits below the rays of the Aten, wears a pectoral and the Double Crown of Upper and Lower Egypt. He turns to the second king, who wears the Blue Crown, and touches him under the chin in a gesture of endearment. The king wearing the Blue Crown reciprocates by placing his left arm around the other's shoulder. In composition and gesture the group is remarkably similar to the princesses depicted in a painting from the King's House Palace (fig. 49, no. 50), and it must be assumed that somewhere in the Amarna temples there was a large and important representation in which one could see this type of intimate two-figure group.[36] The stela with two kings differs in shape from the domestic shrine stelae to be discussed below (see pp. 96–104). With its rounded top it is similar to votive stelae found in Amarna tombs[37] and chapels, recently thought to have served funerary and ancestor cults.[38]

In the Pasi stela two empty double cartouches flank the sun disk to the right and, at a slightly lower level, to the left; they were certainly intended to be inscribed with the names of the god Aten. The question is, whose names were to be inscribed in the three cartouches on the right above the table with offerings? Defenders of an Akhenaten and Nefertiti coregency argue that two cartouches would have shown the names of Akhenaten, the third the name of Nefertiti-Nefernefruaten.[39] According to this suggestion the stela depicts Akhenaten and Nefertiti (in the royal Blue Crown) as corulers.

The problem with this interpretation is the style of the little stela, because the figures, and especially the faces, date from the early rather than the late years of Akhenaten's reign. The outlines of both faces, although partly erased, are still clearly discernible; they are closest to the royal faces in the Karnak and early Amarna reliefs (figs. 10, 11, 14, 15, 17) that predate the emergence

of Nefertiti's "new face" (see pp. 38–39).[40] Therefore, the possibility must be considered that this stela does not depict Akhenaten and a successor but Akhenaten's father, Amenhotep III, and Akhenaten himself during their coregency, however long—or short—that may have been (see p. 26). The three cartouches above the offerings would then have been intended for the two names of Akhenaten and the one name of Amenhotep III that did not refer to the god Amun: Neb-Maat-Re.[41]

Most appealing in this context is a relief block now in the Musée du Louvre (fig. 82, no. 15),[42] which shows two figures that seem to be women in flimsy pleated garments, the one on the right seated on the lap of her companion at the left. The garment of the woman on the right is open in the center, revealing a smooth, youthful abdomen, whereas the fleshy abdominal folds of her companion on the left characterize an older person. With raised and bent left arm the older woman supports the younger on her knees, causing the thin, pleated linen of her shawl to spread out from below the bare breast to her raised arm. The younger woman places her right arm around the shoulder of the older. Her left arm is not preserved, but it was most probably stretched along the shoulders toward the head of the older woman (see fig. 17). On her right hand the older woman balances a necklace consisting of two strands of gold disks: the so-called Gold of Honor, because necklaces such as this were awarded by the pharaoh for meritorious service (fig. 83).

The block is a fine example of the Amarna relief sculpture produced during the last phase of Akhenaten's reign. The outlines of all figures—for example, the back of the woman on the right—are sunk against a raised background, but all interior details are worked as raised relief in a highly sophisticated gradation of overlapping layers. Thus, in the Louvre block the spread garment between breast and arm of the figure on the left forms a background that is overlaid first by the figure's breast and abdomen and then by her hand with the necklace. The woman on the right seems closer to the viewer because her delicately rounded body overlaps the bent arm of her companion. This intricate play of spatial relationships was achieved in relief work that was no more than a half inch in depth.

The distinguished French Egyptologist and former head of the Department of Egyptian Art at the Louvre, Christiane Desroches-Noblecourt, was the first to draw

Fig. 82. Relief from Hermopolis with two female figures: Nefertiti and Princess Meretaten(?). Limestone. Musée du Louvre, Paris

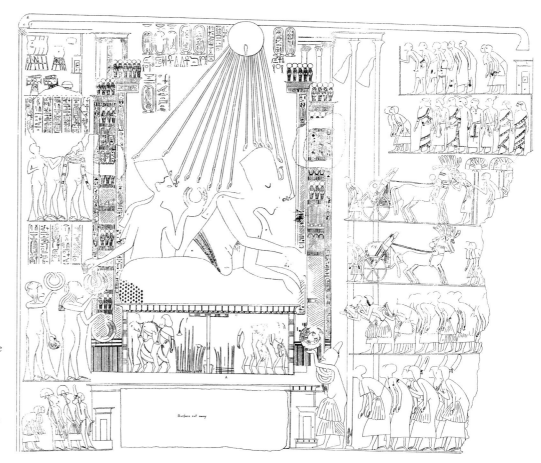

Fig. 83. The royal couple bestowing the Gold of Honor on the Overseer of the Royal Quarters, Meryre. Drawing by Norman de Garis Davies after a relief in the tomb of Meryre

attention to this beautiful fragment of wall relief. In a 1978 article she identified[43] the older woman on the left as Queen Nefertiti's nurse, Tiy,[44] who was also the wife of the future king Ay. The younger woman then logically became Queen Nefertiti, and the iconography of the whole scene could be understood to follow the well-known iconography showing a royal nurse or tutor holding a charge or pupil on the knees. Opposing this interpretation is the fact that the Gold of Honor was handled only by members of the royal family (fig. 83) or by recipients, who may have been assisted by a colleague or senior servants when donning the jewelry.[45]

If the two persons in the relief are assumed to be members of the royal family, two scenarios are possible: first, the figure on the left is not a woman, but Akhenaten, who was often depicted with feminine breasts and garments.[46] The younger person would again be Nefertiti, who is depicted sitting on the king's lap in at least one other instance (fig. 93, no. 14). The complete scene would have taken place in the Window of Appearance of a palace, with the couple bestowing the Gold of Honor on an official who might be reconstructed as standing on the right of the royal pair with an ointment cone on his head. Such a cone is indeed preserved at the lower right corner of the block, and in Amarna reliefs cones of cosmetic ointment were worn by a number of recipients of the Gold of Honor (fig. 83).[47]

However, it must be admitted that the identification of the person on the left as Akhenaten is not very convincing. The outline of the figure's abdomen is too soft, the full breast too rounded, even for this physically effeminate king. It is also unusual that a difference in age between Akhenaten and Nefertiti should be emphasized. Therefore, a second and historically intriguing interpretation of the scene should be considered. The older person, if indeed female, might be identified as Queen Nefertiti in advanced age. The younger woman would then be Princess Meretaten, sitting on her mother's knees, as her sisters often did when they were still children (fig. 88, no. 6),[48] while she, as the eldest, was usually held in her father's arms. A relief representing an elderly Nefertiti and a grown-up Meretaten would date to the last years of the reign, when Nefertiti-Nefernefruaten had become coregent and Meretaten the King's Chief Wife.[49]

The theme of the whole representation might have been the bestowal of the Gold of Honor on an official

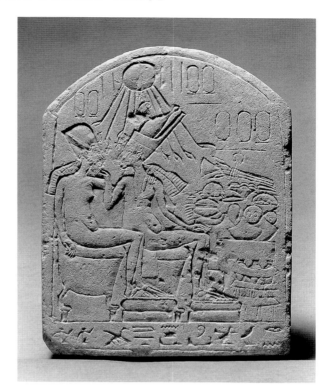

Fig. 84. Votive stela with two kings. Limestone. Ägyptisches Museum, Berlin

(the man on the right with the cone?), but the necklace also could have been presented to the younger woman (Meretaten) by the older. The scene would then be a parallel to the shrine stela in Cairo (fig. 94),[50] where the king gives an earring to Princess Meretaten while two Gold of Honor necklaces lie ready on his knee (see below, p. 101). The cone on the right, incidentally, is better reconstructed as placed on a table or stand with a bouquet of flowers. Two lotus blossoms are still preserved at the edge of the damaged area. This brings the scene even closer to the shrine stela in the Louvre (fig. 93). Conjectural as this interpretation may be, it is certainly pleasant to imagine that Nefertiti, the Lady of the Two Lands, had, at the end of her life, an intimate, loving relationship with her eldest daughter, now an adult woman and herself a queen.

A GODDESS?

The rock-cut tomb that Akhenaten intended as the last resting place for himself and his family is hidden in the limestone cliffs of the Royal Valley, east of Akhetaten/Amarna. "If I should die in any town of the downstream, the south, the west, or the orient in these millions of

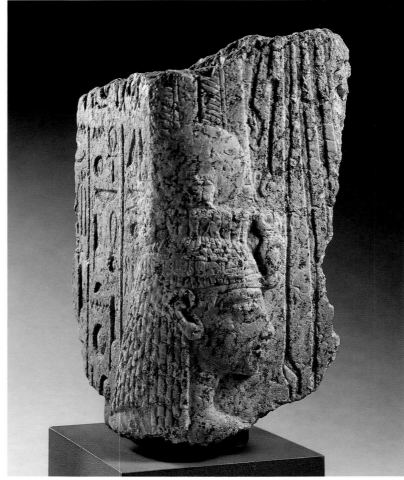

Fig. 85. Fragment with the head of Queen Nefertiti from Akhenaten's sarcophagus, the Royal Tomb at Amarna. Granite. Ägyptisches Museum, Berlin

years," Akhenaten decreed in his boundary stelae text,[51] "let me be brought (back) so that I may be buried in Akhet-Aten." For his interment the king had cut out of the rock a long passage, reached by a staircase and ending in another flight of stairs; beyond lay an anteroom with a broad well that barred access to the main hall of the tomb, in which there are still preserved the remains of two square pillars and the emplacement for a sarcophagus. The plaster wall decoration was almost totally obliterated by opponents of the Aten religion.[52] Here, the sarcophagus of King Akhenaten, carved from Aswan red granite, once stood.[53] In the upper center of each side, carved in sunken relief, was an enormous sun disk, its rays—ending in hands holding the signs of life—filling most of the space that was not occupied by inscriptions and large cartouches with the names of the Aten, the king, and Queen Nefertiti. Similarly, at the

end of the lid that covered the king's head a sun disk was carved, while a cloak of long rays spread over the length of the lid as if to shroud Akhenaten's body.[54]

At each of the four corners female figures were carved in—for Egyptian art—unusually high relief (fig. 85, no. 9). Fragments in the Egyptian Museum in Cairo show that their arms were spread at either side, embracing the large granite box and symbolically protecting the body of the king in its gilded—if not golden— coffins, which were placed, one inside the other, in the sarcophagus. The female figures wear the usual thin, pleated garments of Amarna; on each head, as seen in a fragment now in the Ägyptisches Museum, Berlin, is a tripartite wig composed of echeloned curls bound by richly decorated fillets and crowned by a modius adorned with a cobra frieze, topped by a sun disk and two high plumes. Double uraeus cobras raise their

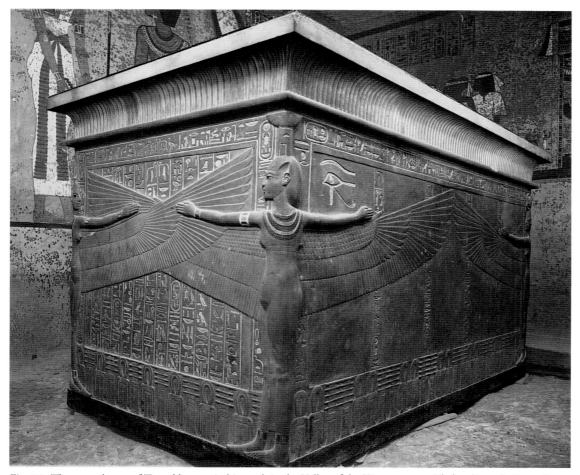

Fig. 86. The sarcophagus of Tutankhamun in his tomb in the Valley of the Kings, western Thebes (Luxor). Quartzite

crowned heads above the women's foreheads, and a pair of cobras placed at the base of the sun disk face the viewer. Inscriptions on a number of adjoining fragments proclaim that these female images represent Queen Nefertiti.[55]

At first glance one might hesitate to assign the head of this figure to Nefertiti. The neck, although furrowed and long, is straight and lacks the forward thrust commonly found in Nefertiti's images; the chin recedes, and the nose is considerably shorter than is otherwise seen. The eye of the granite image is also unusual. It is a true sfumato eye,[56] without any indication of a lower lid; the upper lid consists of a simple ridge. The brow, delineated by a deeply incised groove, is the most conspicuous part of this eye. The closest parallels to the queen's head are those of some of Akhenaten's *shawabtis*, or funerary statuettes,[57] and a red granite head in a pri-

vate collection that has also been thought to come from one of the king's funerary figures.[58] Clearly, we are confronted here with the style of a workshop that specialized in carving Aswan granite and was mainly employed to produce sculptures for the royal funerary equipment. A glass inlay with the head of a woman wearing a tripartite wig (fig. 87) seems close enough in style to indicate that it once belonged to a piece of royal funerary furniture. Sfumato—or near sfumato—eyes are also seen in the red and brown quartzite Amarna reliefs (figs. 19, 77).

The iconographic scheme of women with outstretched arms at the corners of sarcophagi is well known from the post-Amarna Period. The sarcophagi of King Tutankhamun (fig. 86), King Ay,[59] and King Haremhab,[60] as well as the canopic chest and shrine of Tutankhamun,[61] were adorned in this way. The figures adorning the canopic chest of a mid-Eighteenth

95

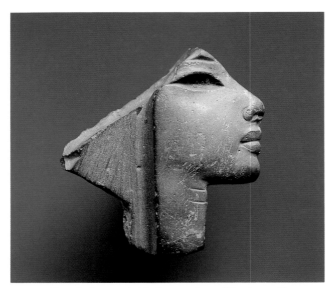

Fig. 87. Female face, probably from a piece of furniture. Glass inlay, originally red. Petrie Museum, University College, London

Dynasty king, Amenhotep II, appear to have initiated the custom.[62] Akhenaten seems to have been the first to order the use of the motif on a sarcophagus.

On all other sarcophagi and canopic chests, the female figures were identified by their appropriate head ornaments as representations of the four goddesses and divine protectresses of the dead: Isis, Nephthys, Neith, and Selket. No wonder, then, that scholars have argued that Queen Nefertiti's appearance on the king's sarcophagus implies the role of goddess.[63] Other indications of the queen's prominence thus acquired special significance. At some point early in Akhenaten's reign, for instance, Nefertiti was endowed with an additional title, Nefernefruaten (the Beauty of the Aten Is Perfect), and in its writing the hieroglyphs representing the Aten are usually reversed so that they face her name in the cartouches. More important, in the Amarna tombs the officials address prayers not only to the king but also to Nefertiti, asking her, for instance, "to grant the sight of the god's beautiful face every day." In these invocations she fulfills the same role of intermediary to the god as her husband the king.[64]

The elevation of Nefertiti to the rank of goddess has not gone uncontested. Recently, L. Green[65] has argued that many of Nefertiti's seemingly divine attributes and iconographical associations are intended to connote her share in the role of the divine pharaoh rather than her own divinity.[66] One cannot escape the thought that

such controversies about the degree of divinity in a pharaoh, queen, or certain private persons are complicated by our lack of understanding of the ancient Egyptian concept of the divine. In contrast to the modern world's compartmentalized thinking, there was no distinct separation between the worldly and the divine in ancient Egypt. Almost anything of meaning could be the manifestation of a god—a statue, an animal, the pharaoh, or even another human being—though the Egyptians were always aware that none of these manifestations could ever be identical with the deity. This belief in the overlap of divine and worldly spheres was so strong in Egyptian culture that not even Akhenaten's teaching of one god could eradicate it. On the contrary, Akhenaten used this concept to promote his own role as a divine mediator.

In the case of Queen Nefertiti, her presence at the corners of Akhenaten's sarcophagus clearly answered a spiritual need, the need of the deceased king for protection during his confrontation with death. This need was all the more pressing during the Amarna Period, because the Aten religion, in its adherence to the present (see p. 4), did not really provide much guidance in the face of death, beyond the hope of prolonged existence after entombment. "May he [the Aten] grant being in your [the deceased's] mansion of continuity and your place of everlastingness [the tomb], without it happening that your name is forgotten forever"[67] and "May he grant that the children of your house offer libation to you at the door of your tomb"[68] are typical invocations.

Aldred has pointed out that among much phraseology that seems obsequious to the modern observer there are a few instances where something strikes "a chord that is humane and sympathetic." For Aldred, one of these instances was the representation of the king groping "for Nefertiti's supporting arm in his daughter's [Meketaten's] death chamber."[69] The decision to have Nefertiti's figure carved at the corners of his own sarcophagus is certainly another such human touch. For Akhenaten, confronted with death, the presence of the queen met a need that the Egyptians had traditionally filled by invoking divine assistance.

FERTILITY AND THE FAMILY:
THE SHRINE STELAE

Every observer of the art of Amarna has remarked on the prominence and frequency of scenes that depict the

royal family in intimate companionship. The primary sources are representations in the royal palaces and tombs of Amarna's high officials (figs. 49, 110)[70] and relief slabs from the temples.[71] In addition, there are a number of remarkable stelae, sometimes called altars but best designated as shrine stelae (fig. 88 no. 6, fig. 93, no. 14, fig. 94).[72] Descriptions and evaluations of the scenes on these stelae have ranged from an emphasis on the extraordinary and revolutionary[73] to the assurance that "even here certain traditional pictorial concepts are still discernible."[74] Aldred summed up the general sense of viewers when he wrote of the Berlin shrine stela relief (fig. 88) that "surely no more appealing domestic conversation piece has survived from antiquity."[75]

Art historians have been interested in the spatial aspects of the groups of figures in these family scenes,[76] noting how the children's bodies, especially, overlap the figures of the parents (fig. 88), thus creating an impression of depth rare in Egyptian art to such a degree. Other studies, particularly those by Egyptologists Whitney Davis and Rolf Krauss, have detailed the carefully composed, basically concentric structure, for instance, of the Berlin family shrine stela.[77]

Stylistically, two of the stelae illustrated here (figs. 88, 94) belong to the early phase of Amarna relief art, whereas two others (figs. 93, 98) are from the late years. Both earlier pieces are inscribed with the first version of the Aten name (see p. 4), and the faces of the royal couple still resemble the Karnak style representations (see pp. 38–39).[78] On the relief fragment in Berlin (fig. 98, no. 8), the later version of the god's name is inscribed, dating this piece to after Years 8–12 of Akhenaten's reign. The Louvre fragment, depicting the queen on her husband's lap (fig. 93, no. 14), must also belong to the late phase of Amarna art because of its extremely sophisticated composition.[79] A stela now in the British Museum depicts, possibly posthumously, the parents of Akhenaten, King Amenhotep III and Queen Tiye. Its intricate relief structure is comparable to that of the Louvre fragment, and the late version of the name of the Aten in the inscription confirms a date after Years 8–12.[80] Evidently, there was considerable demand for reliefs of this type throughout the period, as demonstrated by fragments of two other reliefs of lesser quality now in the Berlin Ägyptisches Museum and the British Museum.[81]

Archaeological evidence about the original locations of the shrine stelae is tantalizingly scarce, and a lively discussion about the function of the pieces is under way. One point appears to be certain: the family stelae belonged to the domestic and private realm. The question is, however, exactly where were they placed within the house complex? The German scholar Ludwig Borchardt reconstructed the Cairo stela (detail, fig. 94) as part of a small brick house oratory that incorporated a short flight of steps and an enclosed space on top for the stela.[82] Remains of an oratory of this type were found in a small room off the central living room in one house; in another instance an oratory was located in the living room itself.[83] Unfortunately, no stela was found near any of these brick structures.

More recently, scholars have suggested that the stelae were placed inside chapels erected in the gardens of the larger Amarna houses.[84] In addition to fragments of statues representing members of the royal family, pieces of relief have been found in the ruins of some garden chapels. However, none of these appear to have illustrated the same themes as the shrine stelae (figs. 88, 93, 94, 98). As far as can be ascertained from the pieces, the garden chapel reliefs showed the king and royal family offering to the Aten,[85] and the best-preserved statues represented Akhenaten and Nefertiti with plates of offerings in their hands.[86] In short, these images duplicate statues and reliefs that decorated the temples of the Aten, so it is logical to suppose that the private garden chapels allowed the owners to participate in the same Aten cult rituals that were performed in the large temples of Amarna.[87]

In the one instance where the find spot of a shrine stela has been recorded, the piece was recovered from one of the columned halls of the house of the First Servant of the Aten, Panehsy. The corresponding room in Thutmose's house was tentatively called a reception hall in our description (fig. 34 [5]).[88] This find spot strongly suggests that all shrine stelae were originally placed inside the house itself; the layer of gypsum plaster still remaining on the back of the Berlin family stela (fig. 88) may be explained by its location in a wall niche, with the plaster serving to hold the thin slab in place.[89] In the most elaborate piece, the Cairo stela (detail, fig. 94), drilled pole-shoe holes are provided in the projecting base,[90] allowing the placement of wooden doors to close off the shrine; the doors would have been opened for prayer and offering ceremonies. The existence of stela niches in the main rooms of New

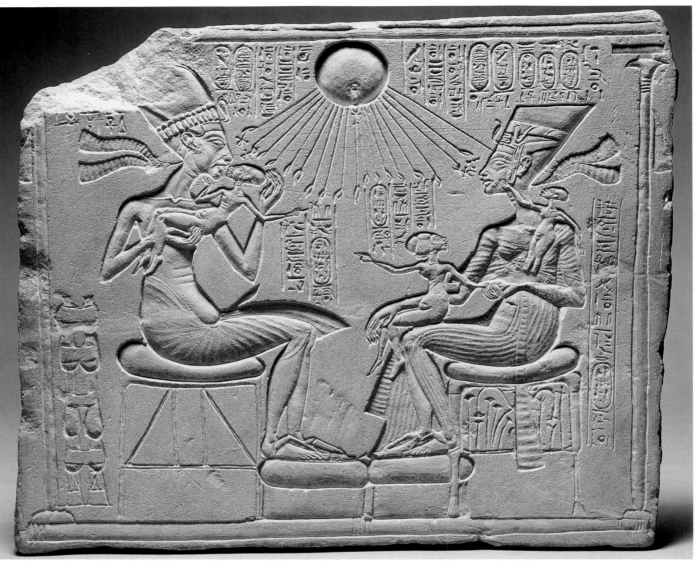

Fig. 88. Shrine stela with relief showing Akhenaten, Nefertiti, and Princesses Meretaten, Meketaten, and Ankhesenpaaten. Limestone. Ägyptisches Museum, Berlin

Kingdom Egyptian houses has been proved by finds from the Nineteenth and Twentieth Dynasties (ca. 1295–1070 B.C.) in the village of Deir el-Medina in western Thebes.[91] Remains of such niches may have eluded the excavators of Amarna houses.

That the reliefs depicting the royal family were intended for devotional use can be deduced from the general shape of the more elaborate stelae—a small shrine with a cornice at the top (fig. 98).[92] The largest piece of the group was fitted not only with holes for the pole shoes but also with projecting, pilasterlike jambs. Similar jambs at the sides of the British Museum relief from Panehsy's house were decorated with bou-

quets of flowers, and a frieze of grapes adorns the edge of the cornice.[93]

A further indication that the stelae had a devotional function is provided by the inner framing around some of the scenes. In the Berlin (fig. 88) and Cairo (fig. 94) stelae,[94] the royal persons sit on reed mats; in the Cairo piece (not visible in fig. 94), the complete Berlin relief (fig. 88),[95] and the Berlin fragment (fig. 98), the representation is enclosed on top by the sky ideogram (a horizontal bar with downward projections at each end).[96] The Berlin stela scene is also flanked by two slender columns; this framing of the shrine stelae reliefs[97] is strongly reminiscent of certain Egyptian ceremonial

98

objects. Well-known parallels are, for example, the ceremonial pectorals found in female royal burials of the Middle Kingdom (ca. 1900–1750 B.C.) and later in the tomb of King Tutankhamun.[98] The pectorals are rectangular plaques framed at the bottom by—among other devices—reed mat representations and at the top by sky emblems or shrine cornices. Columns, *was*-scepters (emblems of dominion), or plants frame the sides of the picture. Pectorals served as gifts to the pharaoh, for instance, at the thirty-year (*sed*) festival, and they were evidently also given by the pharaoh to a female member of his family; they were regalia that symbolized fundamental concepts of kingship and the cosmos.[99] As domestic icons the Amarna shrine stelae are certainly less ostentatious than the pectorals, but the framed structure surely hints at an underlying urge to propagate the Amarna doctrine of kingship. Even the composition of the scenes in the shrine stelae reproduces—albeit in a playful way—the heraldic position of two figures facing each other that was a standard feature of the ceremonial pectorals. On the stelae Akhenaten and Nefertiti repeat the heraldic opposition of falcons, griffins, and other emblematic figures of pectorals.

The didactic symbolism of the shrine stelae relates to the Aten religion's concepts of creation. Egyptologists have repeatedly stressed that a kind of divine triad is depicted in the shrine reliefs,[100] uniting the Aten (the sun disk) with Akhenaten and Nefertiti; king and queen appear in this context as the primeval "first pair" of Egyptian genesis myths. According to the theology of Heliopolis—the primary place of sun worship in Egypt, situated near Memphis—there was first one god, Atum. Of androgynous nature himself, Atum generated all other gods, and, eventually, all humans, by spontaneously procreating the first pair: the male god Shu (personifying the void, air, and, especially at Amarna, light)[101] and his female counterpart, Tefnut ("daughter of the sun").[102] In the stelae this initial creative act of the god is emphasized by the presence of the little princesses, who personify the multitudes descended from the primeval pair. An Egyptian hymn expresses it thus: "Then Shu and Tefnut gave birth to Geb and Nut [earth and sky]. Then Geb and Nut gave birth to Osiris, Horus the Two-Eyed, Seth, Isis and Nephthys from one womb, one after the other, and they gave birth to their multitude in this world."[103]

For a better understanding of why such allusions to creation myths had a place in Amarna house icons, one needs to look more closely at the architectural settings in the Berlin (fig. 88) and Louvre (fig. 93) stelae reliefs. The Berlin family group is flanked by two slender columns with papyrus capitals that stand on the same reed mat as the thrones of the king and queen; at the top each provided support for a separate portion of a roof that ends abruptly at either side of the inscriptions flanking the central sun disk. At first glance, one might be tempted to explain this configuration as indicating that the royal family sits in a narrow courtyard flanked by porticos. But it is more likely that the artist intended to show Akhenaten, Nefertiti, and the children seated in a building whose roof is supported by papyrus columns. However, in order to ensure that nothing obstructed the direct contact of the creative light with the king and queen, the ceiling above the pair had to be open.[104]

It has been suggested that the structure indicated by the two columns in the Berlin relief was a hall in the royal palace.[105] But another identification of the scene's location is more suggestive. Artists' sketches on limestone chips (ostraca) from the Nineteenth and Twentieth Dynasties show that during their confinement and immediately after, new mothers were cared for in ephemeral structures whose walls and roof of reed matting were supported by slender wooden columns with

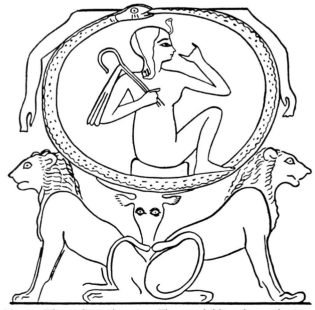

Fig. 89. The traditional version: The sun child on the two horizon lions. Papyrus of Herweben. Egyptian Museum, Cairo

Fig. 90. Artist's sketch from Deir el-Medina: mother and child. Limestone. British Museum, London

papyrus capitals (fig. 90).[106] On some ostraca one sees the mother nursing and tending her baby, just as the royal couple are seen with the three princesses in the Berlin relief. Even the jars with wine or other liquids placed on latticed stands in the Berlin relief would make sense in this context, because on some of the ostraca the newly delivered mother is being offered a drink or a cosmetic jar.[107]

An interpretation of the architectural setting of the Berlin relief as a birth bower appears to be corroborated by the reed structure that frames the royal family in the Louvre fragment (fig. 93). Instead of wooden columns, one sees here the lower sections of reed walls, which are part of a light reed booth called the *zeh netjer* in ancient Egyptian. It is a type of building, made from organic materials, that dates from the very beginnings of Egyptian architecture and later became, like other such structures, highly charged with manifold symbolic connotations.[108] In the case of the *zeh netjer* reed mat booth, the concept of birth and rebirth is often implied.[109]

Depictions of deities and scenes related to birth and child care have been found repeatedly on wall paintings in Egyptian houses, especially in rooms near the entrance.[110] The position of such works and their content (birth-protecting "demons" such as Bes and Taweret, figures of dancers, percussionists, and other musicians) point to an apotropaic (evil-averting) function, with strong emphasis on marriage, birth, and the protection of the newborn. The shrine stelae and these paintings were both placed close to the house entrance and share a preoccupation with lovemaking (figs. 93, 98), birth bowers (figs. 88, 93), and children. The only iconographic difference between the paintings and the stelae is that in place of the popular Bes and Taweret figures of the paintings the stelae present official Aten themes alluding to the creation myths and to the crucial place that the king and queen held in this context. Thus it seems that the shrine stelae functioned as domestic icons in Amarna houses, ensuring divine protection for marriage, birth, and the newly born. It is conceivable that they were presents given by the king to his favorite officials.

This interpretation might also explain the rather astonishing gestures of the princesses in the Berlin stela (fig. 88). Children pointing fingers appeared in a number of early Eighteenth Dynasty tomb paintings depicting fishing and fowling in the marshes.[111] These children stand in the bows of the boats with their fathers, who are going out to hunt or fish. The pointed finger was an age-old magical gesture employed to avert evil. Egyptian herdsmen used it when crossing a canal where cattle were endangered by crocodiles or during the birth of a calf (fig. 92).[112] In the hunting boats the gesture would also have been used against the ever-present crocodiles. In the same way, the pointed fingers of the royal children in the shrine stela provided protection for the young and the newborn of the home in which the stela was erected.

Despite their domestic associations, the shrine stelae reliefs are certainly esoteric objects that required theological knowledge. One had to be well versed in Egyptian theology and have faith in the Aten religion in order to comprehend what they expressed. This explains why many of the ordinary people of Amarna eschewed the highly intellectual symbolism of these reliefs, preferring the use of paintings, amulets, and votive figurines of Bes and Taweret to assure support in childbirth and other domestic cares.[113]

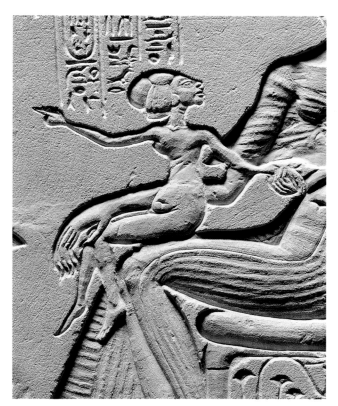

Fig. 91. Detail from the shrine stela (fig. 88): Princess Meketaten on her mother's knees

It is interesting to see how the general theme of creation was handled by the various shrine stelae artists. The sculptor of the Berlin relief (fig. 88) added drama to his family scene with the powerful rays of the sun disk and the flamboyant streamers issuing from Akhenaten's and Nefertiti's necks.[114] Under our very

eyes the Aten's light seems to burst into the presence of the royal pair. This is echoed, albeit less expressively, in the Cairo stela (fig. 94). Here, the king is seen giving an earring to his eldest daughter, Meretaten, who, standing almost exactly in the center of the relief, raises her open palms to accept the piece of jewelry. The princess holds her hands in a position that every Egyptian would have recognized as the traditional gesture of creative deities, such as that of Nun, the god of the primeval water, when he pushes up the rising sun in the morning.[115] The earring, moreover, has the shape of a sun disk, with pendants that represent the sun's rays; no more powerful symbol could have been found for the center of this stela.

It is possible to trace this motif of the princess receiving a disk-shaped earring to a large scene on the wall of a temple or ceremonial hall: William M. Flinders Petrie excavated a limestone block (fig. 95) in a possibly Third Intermediate Period (ca. 1070–712 B.C.) tomb at el-Lahun, a burial site at the entrance to the Faiyum Oasis just south of Memphis. The block had not been carved for the tomb; originally it would have been part of a large relief-decorated wall in a neighboring Amarna Period temple. The relief on this block, now in the University Museum, the University of Pennsylvania, shows part of a scene similar to the Cairo shrine stela. Princess Ankhesenpaaten, the third daughter of Akhenaten and Nefertiti, was probably the baby whose feet are preserved, while the recipient of the earring may again have been Meretaten.[116] Her hands are raised parallel to each other, not quite in the gesture of

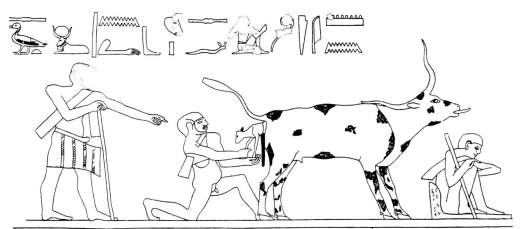

Fig. 92. The birth of a calf. Drawing by Aylward M. Blackman after a relief in the tomb chapel of Senbi at Meir

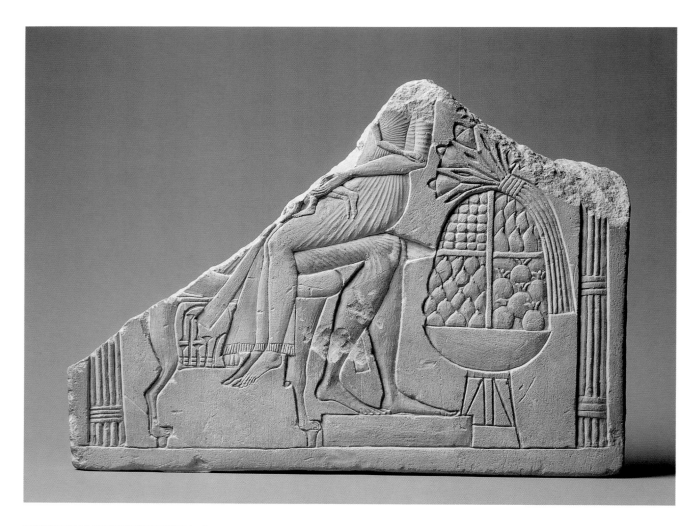

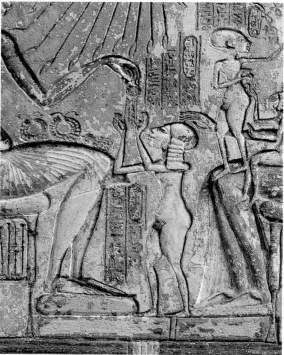

Above: Fig. 93. Fragment of a stela excavated at Amarna showing Akhenaten with Nefertiti and the children on his lap. Limestone. Musée du Louvre, Paris

Left: Fig. 94. Detail from a stela excavated at Amarna showing Akhenaten giving an earring to Princess Meretaten. Limestone. Egyptian Museum, Cairo

Below: Fig. 95. Relief block excavated at el-Lahun with Nefertiti holding a child and a princess receiving an earring. Limestone. The University Museum, University of Pennsylvania, Philadelphia

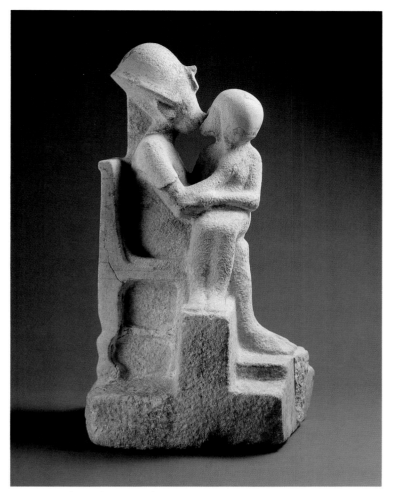

Fig. 96. Unfinished statuette from the Thutmose workshop: Akhenaten kissing a queen or princess. Limestone. Egyptian Museum, Cairo

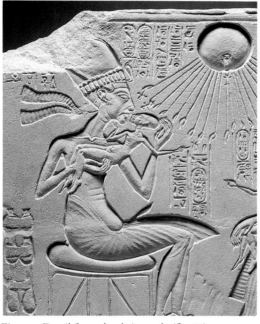

Fig. 97. Detail from the shrine stela (fig. 88): Akhenaten kisses Princess Meretaten

the deities who assist the rising sun. It is impossible to determine whether the version of the princess's gesture with opposed hands, which brought the scene so close to the well-known mythological iconography of sunrise, was conceived for a large wall relief at Amarna itself, which was then copied with variations by the sculptors at el-Lahun, or whether the scene was modified directly from the el-Lahun version to be used in the shrine stela. However that may be, it is interesting to note that the sculptor of the shrine stela either chose or actually conceived a version of the creation theme that carried an explicit association with traditional mythology.[117]

The most intricate composition among all extant shrine stelae is seen in the fragment from the Louvre (fig. 93). Here, the king sits on a lion-legged chair, his feet on a footstool, and holds the queen on his knees; the legs and one arm of at least two children are pre-

served. The babies appear to have taken rather playful positions on their mother's lap. The queen's fringed and pleated dress and long scarf were originally painted white; her lower legs were fully modeled to indicate the translucency of the linen. Akhenaten's legs show traces of red paint, and the cushion on the chair appears to have been white.[118] In front of the seated couple, but behind the footstool, is a latticed stand with a large basket containing pomegranates, figs, and two other kinds of fruit.[119] A bouquet of flowers lies across the basket. Four layers of relief, from back to front, can be differentiated: (1) the fruit stand, (2) the left leg of the king, (3) his right leg, and (4) the arms and legs of Nefertiti. The curves of the king's and queen's dress pleats serve to some degree to relate layers three and four, whereas the stems and binding of the bouquet echo the framing architectural reed work. The delicate

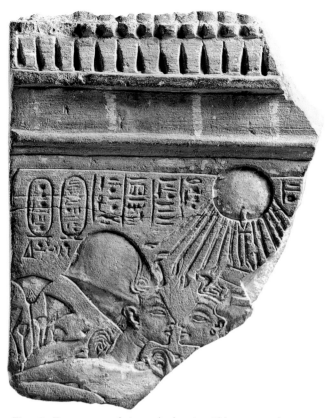

Fig. 98. Fragmentary shrine stela showing Akhenaten and Nefertiti. Limestone. Ägyptisches Museum, Berlin

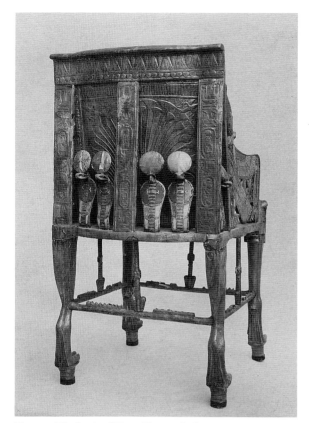

Fig. 99. The back of Tutankhamun's throne. Egyptian Museum, Cairo

feet of the queen contrast wonderfully with the large, strong feet of the king, and the way in which the queen's free-hanging feet are placed in front of the void below the chair makes the viewer strikingly conscious of the existence of that space (fig. 123).

The king's raised right heel and knee ensure the queen a comfortable seat. The king's position is the same as the one assumed by the mother in the birth bower of the British Museum ostracon (fig. 90). This association of Akhenaten with a nursing mother may well be intentional, since he is playing the mother's role in this image. Because of the fragmentary condition of the stela, we do not know whether Akhenaten was kissing the queen. To reconstruct the scene in this way would further emphasize its close relationship to the unfinished sculptural group found in the Thutmose sculptor's workshop (fig. 96) and to a relief block from an Amarna temple (now in the Brooklyn Museum) that shows the queen kissing one of her children.[120] Representations of two persons kissing are not uncommon in Egyptian art. In

the Old and Middle Kingdoms, brothers are seen kissing each other, but above all, gods kiss the king. Inscriptions attached to the latter type of scene tell us what the Egyptians thought was happening: "he [the god] gives life."[121] It is, therefore, a fitting theme for the birth-oriented shrine stelae (fig. 97).

The fragment of a shrine stela in Berlin (fig. 98) shows the royal couple in yet another situation. Here, Nefertiti is seen placing a floral collar around Akhenaten's neck, an act that traditionally implied a festive atmosphere and conveyed a wish for the recipient's well-being.[122] The queen stands directly under the sun disk while the king is seated, resting his right elbow on the back of his chair. Interesting features are the papyrus plants growing behind the king's chair, a motif that recalls Tutankhamun's ornate throne, the back of which (fig. 99) is decorated with a representation of ducks flying over a papyrus thicket. At the top of the throne scene cobras in a row face outward, as they do at the top of the shrine stela.[123] The scene is also reminiscent of one in the Amarna

tombs in which the royal family sits or stands under a baldachin with a cobra-protected roof supported by lotus-plant columns ornamented with dead ducks, the spoils of the hunt in the marshes. Flowers hang from the ceiling of the baldachin, and the royal children bring flowers and cosmetic fragrances in cone-shaped jars; female musicians perform and servants prepare drinks. The queen, her youthful body fully revealed under a thin linen dress, pours a specially prepared drink through a sieve into the king's cup.[124] The re-creative powers of nature could not be depicted more appropriately.

This emphasis on nature in relation to the royal couple of Amarna also recalls the garden sanctuaries and Sunshade temples (see p. 27) outside the city of Amarna proper. These sanctuaries have aptly been called parklands by Barry Kemp in a recent description of newly found complexes,[125] in which he also described such a sanctuary as "an enclosed rectangular space planted with trees and plants which surround a central rectangular body of water."[126] Up to now the best known of these landscape enclosures was the Maru-Aten. Situated—as were most other enclosures of the kind—in the southern outskirts of Amarna,[127] this parkland sanctuary was largely excavated in 1921 by the Egypt Exploration Society under Leonard Woolley.[128]

Floor paintings on stucco showing papyrus and other water plants with flying waterfowl were among the most spectacular finds. Two fragments from such paintings are in The Metropolitan Museum of Art.[129] Plant life was also depicted in relief on the columns and walls of the Maru-Aten buildings.[130]

Inscriptions show that all outlying parkland sanctuaries were closely connected with the female members of the royal family, although the king certainly played a part in the ceremonies that took place there.[131] At the Maru-Aten the principal female figure appears originally to have been the minor queen Kiya, who is called "the wife and great beloved of the King of Upper and Lower Egypt" on two alabaster vases in the British Museum and the Metropolitan Museum.[132] This rather enigmatic "other woman" in Akhenaten's life was nearly eradicated from memory during the king's last years when her name and figure were changed on almost all monuments to those of a daughter of Nefertiti, either Meretaten or Ankhesenpaaten. Twenty years of Egypto-logical research, however, has restored Queen Kiya to something of her original importance, but questions about her position and eventual disappearance from the Amarna court remain.[133] One fact that appears to be certain is that this woman was not an insignificant member of a harem but an important figure of the

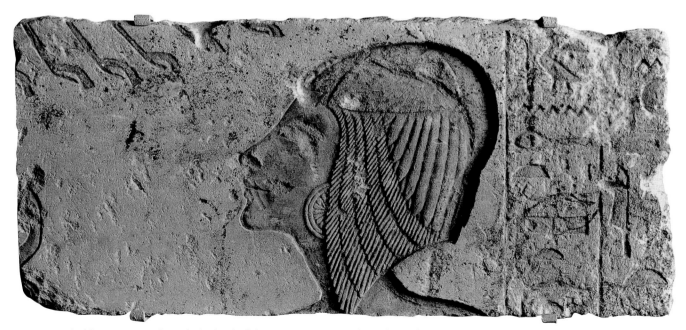

Fig. 100. Relief from Hermopolis with the head of the minor queen Kiya, later changed into Princess Meretaten. Limestone. Ny Carlsberg Glyptotek, Copenhagen

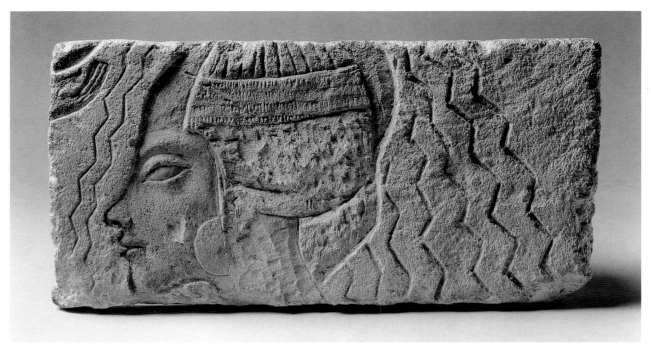

Fig. 101. Relief showing the purification of the minor queen Kiya, later changed into Princess Meretaten. Limestone. The Metropolitan Museum of Art, New York

royal circle at Amarna. We have already seen her on one relief (unfortunately in poor condition) "twinned" with Akhenaten (fig. 79, no. 28).

Another relief now in the Ny Carlsberg Glyptotek, Copenhagen (fig. 100, no. 27), is a typical example of an image of Kiya changed into Princess Meretaten. In the two columns of clearly superimposed inscription one reads now: "daughter of the king of his flesh, his beloved . . . Meretaten." But faint remains of the original inscription show that it once said "the wife and [great] beloved of the King of Upper and Lower Egypt, who lives on [Maat]," which is the beginning of Kiya's titulary.[134] The wig of the woman in the relief was originally a Nubian wig that was changed into what is called a modified Nubian wig by Egyptologists. This means the hair above the forehead and on the back of the head has been removed, and with the help of an added layer of plaster the hairstyle was transformed into a kind of broad side lock to signify the status of Meretaten as a princess (see p. 112).[135]

However, the face of the woman in the Copenhagen relief was not touched; only the eyes were damaged during the destruction of images of Akhenaten's family in the post-Amarna era. Despite the ravages of time, we have an impressive image of Queen Kiya's facial fea-

tures, her elegant long neck, and the proud upward thrust of her head. It is difficult to describe what it is in this head and face that is different from Queen Nefertiti who, after all, is occasionally seen lifting her head in a similar way (fig. 75). Kiya's nose seems more fleshy and her chin is definitely longer, her mouth is softer and her smile more relaxed, her cheekbone is less prominent, and the overall expression is more placid than Nefertiti's (figs. 31, 58, 61, 62, 69, 77). The same characteristic features—the long chin, the soft, slightly smiling mouth, and the delicate nose—recur in a relief in The Metropolitan Museum of Art (fig. 101).[136] Here the large, slanting almond-shaped eye under the ridge of its strongly rounded brow is beautifully preserved, but the fine contrast of smooth face and multifaceted wig seen in the Copenhagen piece is lost because the wig was almost completely carved away in the alteration of the hairstyle.[137]

The Metropolitan Museum relief shows Queen Kiya in a purification scene. The zigzag lines represent the water that is being poured over her head. The Copenhagen relief block appears to have been once part of an offering scene. Both the direction of the ray hands of the Aten and the curved object on the left (the neck of a duck?) are best understood if the queen is assumed to

be standing in front of an altar heaped with offerings.[138] In both cases Kiya performs important priestly functions. Her role in the cult of her Sunshade temple in the parkland at the Maru-Aten must have been similarly significant. If one can accept the suggestion that the Metropolitan Museum's yellow jasper fragment (figs. 27, 29, pp. 37–38) was once part of a statue of Kiya that stood in a shrine in the Maru-Aten, this royal woman must have had singular beauty and a truly important position in Akhenaten's life and religion.

The spiritual function of the parkland sanctuaries is perhaps best exemplified by the throne from the tomb of Tutankhamun (fig. 99).[139] On the front panel of the throne's back, the queen anoints the king, and, as Aldred has recognized, plays the role of the lion goddess, Weret Hekau, one of whose titles was "Mistress of the Palace" and who was particularly associated with the royal crowns and the coronation of the pharaoh.[140]

On the back of Tutankhamun's throne the marsh representation already mentioned (p. 104) associates the royal chair with Isis (one of whose manifestations is as a personification of the royal throne) and her mythical protection of the infant Horus in the marshes.[141] Horus, of course, emerges triumphant from the marshes to rule over Egypt. In these representations, and many others like them, the role of the women, queens, and goddesses was to protect and rejuvenate the king through a close association with the regenerative forces of nature. The Berlin stela fragment (fig. 98) is a less spectacular but charmingly intimate monument to the same beliefs.

To conclude this discussion of the Amarna queens' role as representatives of the concepts of creation, fertility, birth, and rebirth it may be appropriate to mention the various associations relating Queen Nefertiti's most frequently worn headdress, the tall, flat-topped crown (figs. 8, 62, 75, 80, 88), to imagery concerning deities and myths of fertility. Scholars have pointed out how crowns similar to Nefertiti's headgear are first seen on Queen Tiye, when she is represented as a powerfully striding sphinx in a relief from the Nubian site of Sedeinga and as a winged sphinx on a carnelian bracelet plaque in The Metropolitan Museum of Art (fig. 102).[142] In the bracelet, the plants that top the crown provide a link with the rejuvenation aspects of the female members of the Amarna royal family.[143] This relationship is even stronger when one considers the hairstyle of some of the women on the birth-bower ostraca (fig. 90): their long hair is bound up in exactly the shape of Nefertiti's crown, with loose tresses falling down on the sides. A

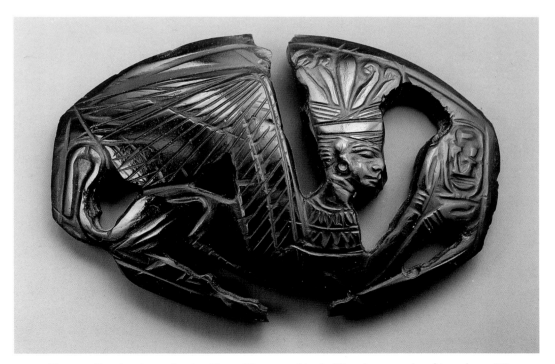

Fig. 102. Bracelet plaque showing Queen Tiye as a sphinx holding the cartouche of Amenhotep III. Sard. The Metropolitan Museum of Art, New York

Fig. 103. Statues flanking boundary stela A at Amarna. Drawing by Robert Hay (1927)

Akhenaten drew new meaning from the age-old belief that the king was the child of god. Invocations to the Aten refer to the king as "your child, who issued from your rays. . . . May you love him and make him be like the Aten. May you rise to give him continuity. . . . May you fashion him at dawn like (you do) your aspects of being. . . ."[147] This text from the tomb of Ay is a perfect example of the Egyptian method of expressing complicated theological concepts with a combination of different images. On the one hand, the invocations refer to the belief that the king is the child of god, "issued from your rays," while the words "May you fashion him at dawn" and "May you rise to give him continuity" allude to another ancient Egyptian concept that likened the rising sun to a child. Apart from the Amarna period, this last idea is expressed in many representations, especially of the funerary genre, that depict the morning sun as a child seated in the sun disk as it rises between the two mountains of the Nile Valley horizon (fig. 89).[148] The aim behind the combination of the two powerful child metaphors (child of god and rising sun) was to indicate that the king incorporated the sun god's creative powers and revealed the world's complete (i.e., childlike) dependence on the creator-god.[149] Similar reasoning may have been behind the creation of a statue of Akhenaten as a child with an egg-shaped head, his finger held to his mouth (p. 56). As we have seen, this work served as the prototype for the princesses' egg-shaped heads (figs. 46–48, 50–53) from the Thutmose workshop.

In the framework of Amarna religion, Akhenaten's daughters, the symbolic children of the primeval pair Shu and Tefnut (represented by Akhenaten and Nefertiti), could embody the essence of creation. Each princess might, in fact, play the role of the quintessential child that the sun god created in the mother's womb. "(O you) who brings into being foetuses in women," exclaims the poet of the great hymn to the Aten.[150] The hymn continues: "When the chick is in the egg, speaking in the shell, you give him breath within it to cause him to live," and goes on (see p. 56) to describe the birth of the chick as an example of all births initiated by the creator-god.

similar hairstyle is worn by the Syrian goddess Anat,[144] one of the great fertility deities of the ancient Near East.[145] Nefertiti's most frequently worn crown thus emphasizes her all-important role as the female counterpart of the king in the great scenario of the daily renewal of creation.

SUN CHILDREN

From early times Egyptians treasured children not only as desired offspring but also as symbols of rebirth and rejuvenation. Many Old Kingdom monuments include representations of children, mostly in the company of their parents and less frequently as single figures.[146] The prominence accorded Akhenaten's daughters in the art of Amarna is, therefore, not a novelty, but the artists of Amarna made astonishingly brilliant use of the traditional place of the child in the culture of ancient Egypt and added their own sensitively perceived and skillfully executed images.

Opposite: Figs. 104–107. Torso from the statuette of a princess, excavated at Amarna. Reddish brown quartzite. Petrie Museum, University College, London

104

105

106

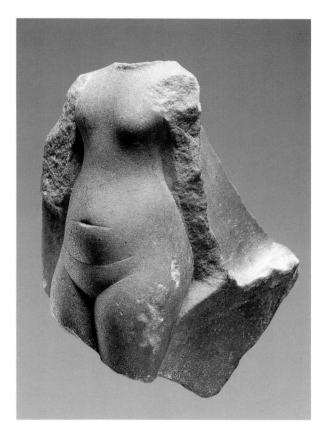

107

The importance of childhood within the framework of the solar religion inspired Amarna sculptors to create some of their most appealing works. Chief among extant pieces is the quartzite torso of a young princess now in the Petrie Museum, University College, London (figs. 104–7), which—despite its small size (15.3 cm [6 in.])—is surely one of the most beautiful sculptures of its time. As is so often the case, the torso is a fragment from a sculptural group. In this instance, the original group presumably represented several princesses and the king and queen. At the Petrie figure's right side, the block of stone is flat and the surface intentionally roughened (fig. 104).[151] Here the piece adjoined another block, which must have included the figures of the king, the queen, and possibly another sister.

The right forearm of the princess was raised and the hand touched an adjoining statue placed in front of her. Her left arm (fig. 106) stretches behind her and the hand, now mostly destroyed, once grasped that of a smaller sister who stood farther back; only traces of the right arm of the smaller princess are preserved. Solid stone is found in the spaces below the larger princess's right elbow and above and below her smaller companion's arm, so that the torso appears to have been worked in very high relief rather than as a sculpture in the round.

As demonstrated by the description above, the complete group of figures was arranged on a recessed ground plan. Roughly similar arrangements had previously been used in Egyptian art when figures of different sizes—or standing and seated figures—were combined.[152] At Amarna, this group structure was used in a still more intricate way for three-dimensional representations of the royal family. In two extant limestone statuette groups,[153] the queen is standing slightly behind and to the side of the king, with the figures of the royal daughters still farther behind the mother.[154] This recessing of the princesses' figures has been seen in the statues that flanked the boundary stelae (pp. 22, 60).[155] The scheme became even more complicated in the group to which the Petrie princesses belonged; here, not even the princesses stand on one line—one is recessed behind the other.

The intricate grouping of the royal family emphasized the strict hierarchy of Egyptian society, which remained basically unchanged during the Amarna Period, despite the strong position of the royal females.

Artistically, the gradually recessed position of figures in a group served to create individual space for each figure, an arrangement that is accentuated by the difference in height of the stone slabs at the backs of some of the figures.[156] The result is an extremely diversified sculptural body whose three-dimensional aspect is intensified by a rich play of light and shadow on the various figural entities. As in the reliefs at Amarna, space was a consciously manipulated part of the whole work. The modern viewer might see the effect as theatrical, but that is only another word to describe the highly charged religious intensity with which the Aten believers contemplated the royal family's place in the solar cult.

Erika Feucht[157] has recently reminded us that in Egyptian art children are characterized predominantly by the forms of their bodies rather than by specifically childish facial features; she has pointed out that usually the body of a six- to nine-year-old is depicted. The torso of the Petrie Amarna princess (figs. 104–7) seems to be that of a child about that age. She differs from her elder sister of the Louvre torso (figs. 21, 22) and her mother as depicted in the Berlin limestone statuette (figs. 68, 69) in being broader in relation to her height and, above all, by having a considerably shorter waist. Her body forms are softly rounded and lack the taut voluptuousness of adult women. Her thighs are more slender than those of the women, and her breasts are smaller, only slightly rounded, and set far apart. All these are traits characterizing in masterly fashion a very young girl approaching adolescence.

For the purpose of dating the small torso within the development of Amarna sculpture, one should note that the breasts of this little princess are not as close to the shoulders as those of the Louvre torso from the early years of the Amarna Period (figs. 21, 22). In strictly proportional terms—disregarding the youthful roundness of the subject—the princess in the Petrie Museum is quite similar to the statuette of Nefertiti in Berlin (see pp. 79–81). A date during the later phase of the Amarna Period is, therefore, most probable.

The finest qualities of the small torso are found in the treatment of the stone surface. The slightly pinkish-yellow quartzite with occasional brown areas is smoothed in such a delicate way that an impression of soft young skin is created. The few sharply incised lines, which define the navel (of the same shape as that in the

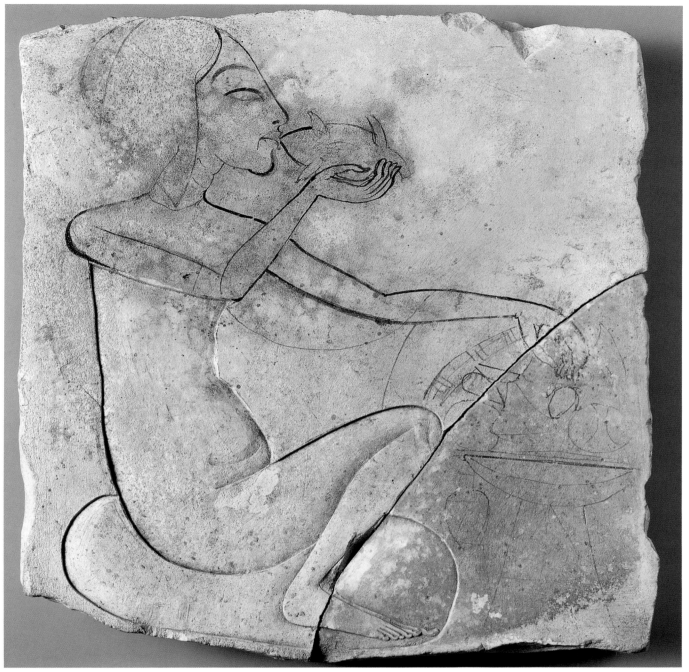

Fig. 108. Sculptor's model from the North Palace at Amarna showing a princess eating a roasted duck. Limestone. Egyptian Museum, Cairo

Louvre torso, fig. 22), abdomen, pubic area, and legs, accentuate the overall softness of the body. The pose of the figure is intentionally uneven. The princess pushes her belly forward while the upper body leans slightly backward; the position of the lower legs is difficult to determine—does she thrust the left leg forward or not?[158] The left arm is extended behind her in a somewhat ungainly curve, almost as though the princess wanted to hide the hand that holds on to her sister. All this expresses beautifully the youthful bashfulness of the little girl and underlines her freshness and vulnerability.

In Amarna paintings and reliefs the presence of Akhenaten's daughters in almost all the scenes in which the royal couple appear gave the artists endless opportunities to vary the groupings of two, three, or all six of the girls. It has already been pointed out (see p. 91)

Fig. 109. Relief fragment with the head of a princess, from the Great Palace at Amarna. Museum of Fine Arts, Boston

how the rarer representations of seated princesses (pp. 60–61; fig. 49) echo positions and groupings otherwise used in depictions of the king and queen.

Besides the painting in the King's House (fig. 49) a delightful artist's sketch (fig. 108, no. 45) in the Egyptian Museum, Cairo, is foremost among the images of seated princesses. The slab of limestone (23.5 x 22.3 cm [9¼ x 8¾ in.]) was found in 1924 by the British archaeologist Francis Giesler Newton in the so-called North Palace, a rectangular building compound situated in an isolated position between the North Suburb on one side and the North City and North Riverside Palace of Akhetaten on the other.[159] The North Palace buildings (fig. 12) are arranged around a forecourt and a large garden court. Among the various structures, each of which has its own court, are installations for the sun cult and a veritable zoological garden; antelope and ibex are depicted on animal feeding troughs. In the northeast corner of the compound is a court with flower beds surrounded by the rooms of an aviary.

Niches for birds' nests were installed in one central room, where one of the most remarkable of all Egyptian paintings was found. Luckily, it could be documented in drawing by Charles Wilkinson and in facsimile

by Nina and Norman de Garis Davies. The facsimile of the entire west wall of the room is in The Metropolitan Museum of Art (no. 51).[160] The painting once ran continuously around the room; it depicts a lush thicket of papyrus and other plants with birds (rock pigeons, palm doves, shrikes, and kingfishers) nesting in the thicket or darting toward the swamp water for prey. In other rooms around the court with flower beds were depictions of geese (no. 53) and a sensitive rendering of an olive tree (no. 52), a plant introduced to Egypt during the Eighteenth Dynasty.

The North Palace complex is clearly another example of the familiar Amarna nature habitats (see pp. 104–7). As in the Maru-Aten parkland sanctuary, inscriptions point to a close connection between the North Palace and female members of the royal family; in particular, the name of Princess Meretaten was found throughout the building, but again—as the excavators state—as in Maru-Aten, superimposed on another female name, as yet not entirely reconstructed. Nefertiti and Kiya are both possibilities.[161]

The upper half of the artist's sketch (fig. 108) still retains the original ink; in the lower half the sculptor had started carving. The princess is shown seated on a thick cushion, eating a roasted duck. Her left hand reaches out to grasp a fruit from among the delicacies heaped up in front of her on a large dish stand with gated legs. The artist has depicted her youthful body as if naked, but the outline of a seam around the neck and a shawl hanging over the left arm indicate a garment of thin linen.

The princess's hair is arranged in the modified Nubian wig style that was described above (pp. 105–6).[162] Princes and princesses were often depicted with such side braids even when grown up—to emphasize their relationship to the pharaoh. Amarna princesses are known to have worn the braided hairstyle and there is usually more than one braid to their side locks (fig. 109, no. 36; fig. 111).[163]

The artist who drew the North Palace sketch (fig. 108) depicted his princess with a decidedly grown-up face that has more in common with Akhenaten's image on the Wilbour plaque than with the quartzite faces of young princesses from the Thutmose workshop (figs. 46–53). The princess of the limestone sketch also has facial features different from those of the two princesses in the painting from the King's House

(fig. 49), who closely resemble the Thutmose royal daughters. This difference in the faces is all the more remarkable because the pose of the princess on the North Palace sketch is almost identical to that of the royal child on the right in the painting. Clearly a different artist worked on the sketch; the final piece was probably of considerably later date than the painting, and the artist may also be depicting a more grown-up princess.

A wall relief in the tomb of Queen Tiye's steward, Huya (fig. 110), provides a clue as to what the larger composition—for which the limestone sketch would have been executed—may have looked like. On the east side of the south wall of Huya's tomb is a depiction of a banquet that was attended by Akhenaten, Nefertiti, Queen Tiye, Tiye's daughter Baketaten, Nefertiti's daughter Meretaten, and another princess. Meretaten sits on a chair in this relief representation (left, in fig. 110), and her left hand gestures toward her sister, but her pose is almost exactly the same as that of the sketch. The object she was raising to her mouth has been destroyed, but above her Nefertiti holds a roasted duck in her hand, so probably Meretaten also held a duck in her hand. Does it go too far to suggest that the original composition after which the scene in Huya's tomb was composed was located in the North Palace? The sketch, however, is for a relief, and the North Palace was decorated solely with paintings. But it is

conceivable that a sculptor would copy from a painting if he wanted to include a particular figure in a relief that was being carved elsewhere.

In the more frequent depictions of standing princesses (figs. 111–13), they are never arranged in exactly the same way. Besides the simple line of princesses' figures in which one appears either behind the other[164] or below the other if the girls are arranged in registers,[165] there are groups of two and three little girls. If all six girls are represented, they are arranged in two groups of three.

In the two-figure groups, the girls may be of roughly the same height, in which case they either turn to each other,[166] they embrace, one chucking the other under the chin,[167] or they are closely united as a twin pair, one putting an arm around the other's shoulder.[168] If one of the princesses in a group is smaller, she may grasp the arm of her elder,[169] or the elder may put her arm around the younger.[170] The latter type of group is seen in a glass inlay belonging to the Petrie Museum (fig. 113, no. 21), an object that was once destined to adorn an elaborate piece of royal furniture.

In the groups of three princesses, the girls can again be either of roughly the same height or of different heights. In cases of even heights, two figures are usually looking at each other, while the third may hold the hand of one of her companions (fig. 78).[171] In other cases, each of the three girls is of a different height, and

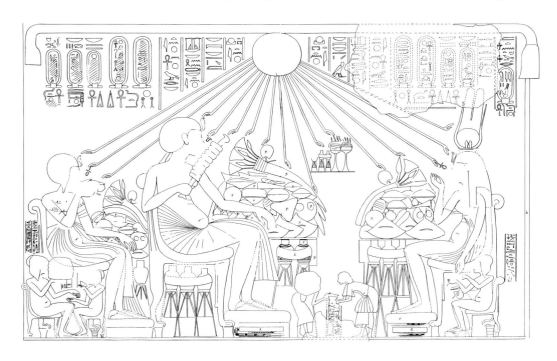

Fig. 110. The royal family dining; from left to right: Nefertiti with two daughters, Akhenaten, a servant, (Huya), Tiye, and Baketaten. Drawing by Norman de Garis Davies after a relief in the tomb of Huya at Amarna

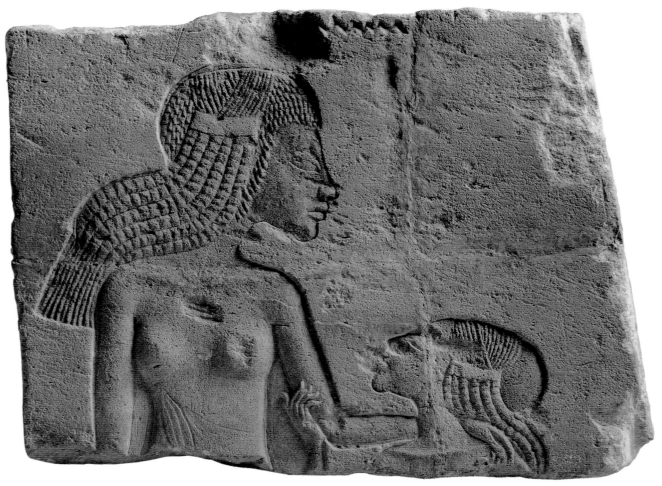

Fig. 111. Relief from Hermopolis with two princesses. Limestone. The Metropolitan Museum of Art, New York

they are arranged in descending order: the tallest in front, followed by the next in size, and then the smallest of the group. Again, two of the three usually confront each other, either embracing (fig. 112)[172] or with one chucking the other under the chin, while the third holds on to the sister nearest to her.[173]

It is significant that in the groups of two princesses and in the one comprising three little girls, two of them usually turn toward each other. Sometimes it is not just the head but the entire upper body that is turned,[174] so that the breasts of the particular princess are shown in frontal view (fig. 111), an extremely rare phenomenon in Egyptian art.[175] The turning of a figure toward another in a group tends to isolate that particular pair from the rest of the scene, creating the impression that here are figures who are not really involved in the activities represented. The princesses turning to each other are characterized as belonging to a world of

their own: a world of youth and delicate beauty that is a treasure to society, but as a promise of things to come rather than an activated function. As in other periods of Egyptian art, a point is made that the promise of youth is very vulnerable. This is emphasized in the narrative reliefs by the frequent presence of the princesses' nurses, who stand behind them bowing slightly and holding their hands protectively toward the children (fig. 112).[176]

There can be no doubt that both Akhenaten and Nefertiti were extremely proud of their six daughters. One has the distinct impression that this—and not just the girls' religious significance—was the reason they were so often depicted in Amarna art, and depicted with so much care, even love. At the peak occasion of his reign, the great tribute-bringing festival (fig. 78) celebrated, possibly, after a victory in Nubia,[177] the king and queen are enthroned with all six daughters behind

them: Meretaten, Meketaten, Ankhesenpaaten, Nefernefruaten-Tasherit, Nefernefrure, and Setepenre (see pp. 10–14). The scene is dated to Year 12 of the king's reign.

Probably less than two years later,[178] the second daughter, Princess Meketaten, died. The princess was buried in a side branch of the rock-cut chambers of the Royal Tomb at Amarna. Her burial chamber (room gamma) is reached by turning right before the second flight of stairs in the Royal Tomb and then traversing two more-or-less square rooms. On the walls she is depicted lying on a bier surrounded by mourners. Her parents, whose figures are now sadly damaged, stand beside the bier.[179] On another wall, the princess is represented standing in a birth bower (see pp. 99–100). It has been suggested that she died in childbirth,[180] but she seems too young—ten years old at most—to have borne a child, even at a time when women matured early.[181] Considering her youth and the well-known unwillingness of Egyptians to depict anything like the cause of death, this scene probably expresses, in symbolic terms, a wish for her rebirth rather than the fact that she died in childbirth.[182] In this scene Akhenaten and Nefertiti are seen throwing their arms over their heads in dejected mourning.

There can be no doubt that this death, which was closely followed by the deaths of Queen Mother Tiye (see p. 26) and the minor queen Kiya,[183] was a hard blow to the royal family. Indeed, one might argue that for Akhenaten himself this was the beginning of the end, and it is probably after these deaths that Amarna society began to show signs of growing instability: erasure of the names of traditional gods became frantic (see p. 4); the positions of the female members of the royal family changed, with Meretaten replacing Kiya (figs. 100, 101), and Nefertiti perhaps becoming a coruler with Akhenaten (see p. 89); and people in places like Thebes started to express openly their dissatisfaction with the Aten religion (see pp. 88–89).

The Metropolitan Museum of Art owns a number of objects that may originally have been part of the burial of princesses and other female members of the royal family. Two of these objects—an ivory writing palette (fig. 114)[184] inscribed, "the King's daughter of his flesh, his beloved Meketaten, born of the King's Chief Wife Nefernefruaten-Nefertiti, alive forever continually," and a gold situla only 1¾ inches (4.5 cm) high

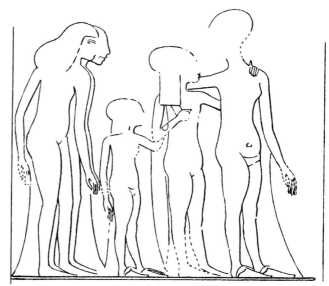

Fig. 112. Three princesses and their nurses. Drawing by Norman de Garis Davies after a relief in the tomb of Panehsy at Amarna

(fig. 6)[185] inscribed "the King's daughter Meketaten"—are especially poignant because of the dollhouse size of the situla and the implication from the palette that the princess (as well as her sisters) received a scholarly education.[186] A miniature alabaster vase with the applied

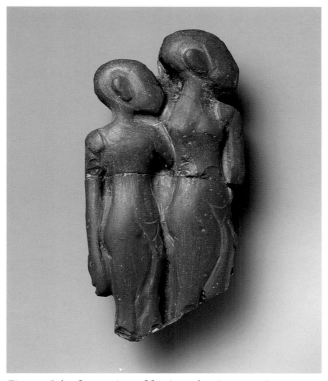

Fig. 113. Inlay from a piece of furniture showing two princesses. Red glass. Petrie Museum, University College, London

Fig. 114. The writing palette of Princess Meketaten. Ivory. The Metropolitan Museum of Art, New York

Fig. 115. A princess on a lotus flower. Glass inlays on an alabaster vase. The Metropolitan Museum of Art, New York

figure of a "baby" princess (fig. 115)[187] can be added to this group; the exquisite object was rightly called by William C. Hayes[188] "a marvel of the lapidary's art," the appliqué being composed of tiny pieces of carnelian and glass. The princess's elegant gesture appears to signify a greeting; standing on a lotus flower according to traditional symbolism, she embodies rebirth and rejuvenation.

More doubtful is the sometimes suggested identification of four alabaster heads forming canopic lids with one of Akhenaten's daughters. The lids were found on four jars, also of Egyptian alabaster, in the most controversial of all Egyptian tombs, Valley of the Kings tomb 55.[189] One of the jars is in the Metropolitan Museum (fig. 116); the other three are in the Egyptian Museum, Cairo.[190] The lids and jars were altered several times in antiquity. The original version of the set has been attributed over time to almost every member of the royal family: Queen Tiye,[191] Akhenaten,[192] Queen Nefertiti,[193] Queen Kiya,[194] Meretaten,[195] and, most recently, to "any of the other" princesses except

Meketaten.[196] The alterations (i.e., the addition of uraei, for instance) were supposedly made either for King Smenkhkare[197] or King Nefernefruaten (Nefertiti?).[198]

While the identification of the original owner of the vessels themselves seems to be settled, since the primary inscription has convincingly been shown to have been dedicated to Queen Kiya,[199] the attribution of the heads has become a more complicated problem since the British Egyptologist Geoffrey T. Martin recognized that the lids fit very awkwardly on the jars and so might not have originally belonged to them.[200] At present, most scholars favor one of Akhenaten's daughters as the original owner—and therefore the subject—of the heads.

It is noteworthy, however, how much the facial features on these canopic lids differ from the known por-

Opposite: Fig. 116. Lid of a canopic jar from tomb 55 in the Valley of the Kings. Alabaster with stone and glass inlays. The Metropolitan Museum of Art, New York

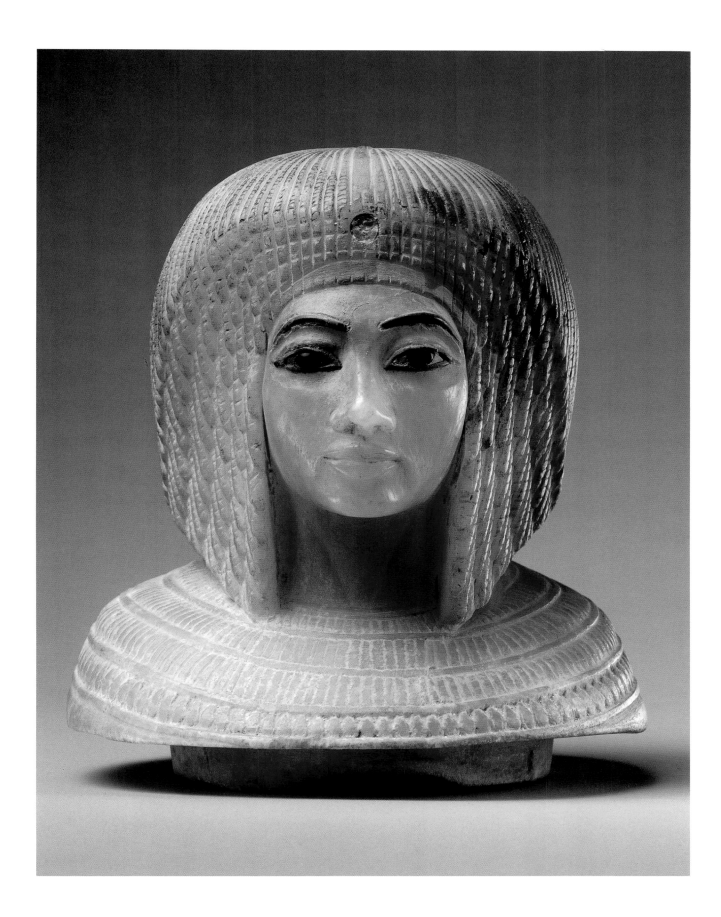

traits of the princesses (figs. 46–53). The alabaster head in The Metropolitan Museum of Art (fig. 116), for instance, lacks not just the boldness of the Thutmose workshop creations; almost none of the characteristic traits of the princesses' heads are present, with the exception, perhaps, of the two diagonal muscles at the sides of the neck and the generally triangular shape of the face. Viewed from the front, the chin of the alabaster head is small and round, but in profile the jawbone is decidedly straight. The mouth is considerably smaller than the mouths of the Thutmose princesses, and the lower lip has a simple semicircular shape, lacking the flattened central portion typically found in the lower lips of the princesses' images. The nose of the alabaster head is long and thin and ends in prominent nostrils, the eyes are narrow and slanting, and the brows form an uneven bow with a peak above the outer eyes.

Looking for parallels for the shape of the jaw, lower lip, nose, eyes, and brows of the alabaster heads,[201] only one masterpiece of the Amarna Period is found that shares all these characteristics: the wooden head of Queen Tiye (figs. 23, 26). Was Theodore Davis right after all in claiming that this is an image of Queen Tiye, rendered as rejuvenated in death by the artists who created the funerary equipment for the royal family?[202] It is not impossible that the canopic lids buried in tomb 55 were originally part of Queen Tiye's funerary outfit, since her gilded shrine was found in the tomb.[203] Further, the writer can confirm Geoffrey Martin's observation that the body of the snake running back over the top of the Metropolitan Museum's head looks original, not recarved.[204] This reaffirms the queenly status of the original owner. Moreover, another late image of Queen Tiye, that on the shrine stela in the British Museum (see p. 97),[205] also depicts her in a Nubian wig and with youthful facial features. Perhaps, after all the identifications that have been affixed to the alabaster heads, one should not jump hastily to yet another conclusion, but at present Queen Tiye again seems a likely candidate.

Summary

By now the reader will have realized that femininity was of crucial importance to Akhenaten—not simply on a personal level but as basic to the structure of his thinking and his faith. Indeed, it is difficult to name another religious founder for whom women played a comparable role. The reason for this remarkable fact lies in the ancient Egyptian culture itself. Living along the Nile surrounded by desert, Egyptians largely perceived their universe in terms of dualities. Agricultural land and desert; Upper and Lower Egypt; sky and earth; the world of the living and the underworld of the dead: this complementarity was fundamental to ancient Egyptian life and thinking. The duality of male and female in human existence was simply a facet of the general scheme. No wonder, then, that Akhenaten, in venerating the one and only god, included his female counterpart, the queen, in order to achieve wholeness in the solar universe.

Given the significant role of royal women in the Aten religion, it is remarkable that the picture of the royal women's personalities presented in the narrative reliefs and paintings is so blurred. Nefertiti, Tiye, Kiya, Meretaten, and the other royal daughters and women were depicted in cult rituals and ceremonies fulfilling their roles as guarantors of life, fertility, and rejuvenation. But it seems that each was able to perform these tasks more or less as well as another. It was even possible to change the image of one woman into a representation of another solely by altering the hairstyle and inscription in order to transfer the identity on a relief portrayal from one royal woman to another (see pp. 87, 105, 106).

On the political level, the attempts by historians to reconstruct the role of Queen Nefertiti during the last years of her husband's reign—or the ultimate fate of Kiya and most of the royal daughters—have to be based on minute traces of evidence: details found almost accidentally in texts and in representations whose initial purpose was not the revelation of individual personalities or their involvement in specific events. The resulting historical picture remains obscure and open to continuous debate.

However, the situation changes when one turns to the art itself, especially sculptures in the round. No one can challenge the fact that these works depict a number of remarkable women: we have come to know every bone and muscle in the faces of Queen Tiye and Nefertiti. The sculptures from the Thutmose workshop even allow us to gauge the impact of time on Nefertiti's face and body. It is true that these images, to a certain extent, depict types rather than individuals. In the

princesses' sculptures (figs. 46–53), for instance, a type is predominantly represented—the young adolescent female—that could be used without much alteration to portray more than one royal daughter. Similarly, the yellow jasper fragment (figs. 27, 29) depicted a certain type of woman, the sensuous beauty. The basically nonrealistic character of the image underlies the difficulty in identifying this impressive female. One could even argue that each representation of Nefertiti depicts a distinctive female type: the softly beautiful queen (figs. 66, 67), the ruler (figs. 31, 65), the experienced older woman (figs. 68, 69, 71, 81), and the monument destined for posterity (figs. 72, 74).

In rendering the wise old woman, Amarna artists used artistic formulas previously derived from earlier depictions of wise old men (p. 30). The queen mother Tiye was first represented in the role (figs. 23, 26) and then Queen Nefertiti (fig. 71). But the shift does not mean that the images of the two women were interchangeable. On the contrary, there is no doubt about the identity of the two queens: Tiye is known for the triangular shape of her face, and her full mouth with its downturned corners; Nefertiti, for the finely modeled features with the telltale condyloid process in front of her ear. An elongated skull and a hump at the back of the neck characterize the princesses' images.

Whether these traits define human types or individuals, it is clear that they are derived from astonishingly close observation of nature. We can never be absolutely sure whether Nefertiti actually shared the prominent knuckle in front of her ear with her husband or whether artists used it to indicate the close relationship of king and queen (p. 74). But the feature is a naturally occurring phenomenon that can be—and surely was—observed on human beings. We cannot know whether Nefertiti had dimples in her lower cheeks, as seen in the yellow quartzite head (figs. 66, 67), but any woman could have such dimples, an endearing personal feature.

Egyptian artists were superb observers of natural forms, as seen in their precise depictions of animals. But in the representations of humans, stylized form was generally preferred and naturalistically rendered details were subordinate to this overall scheme. At various periods, however, more personalized images were created. The bust of Ankhhaf from the Fourth

Dynasty, now in the Museum of Fine Arts, Boston, and the images of the Twelfth Dynasty pharaohs Senwosret III and Amenemhat III are well-known examples. The wooden head of Queen Tiye and the images from the Thutmose workshop certainly belong to that tradition. The Amarna works, however, stand out from their predecessors for two reasons: the rendering of natural features was never before performed with such subtlety and understanding and the Amarna works predominantly represent women. Previously, individualizing portraiture featured mainly male subjects.

Significantly, the subtly naturalistic Amarna images of king, queen, and royal daughters did not evolve in a smooth transition from the sensitive art of the time of Amenhotep III. The earliest portrayals were expressionistic, intentionally ugly and distorted. Close observation of natural forms was not the driving force. Rather, it was the wish to transcend the human sphere and depict the superhuman in the pharaoh and his queen. The distortions in these early works of the Amarna Period were too foreign to Egyptian culture to last. So, after the move to Amarna, an astonishing process of readjustment set in. Under the influence of newly recruited artists from the Amarna region and Memphis, the style softened and became lively and organic. Gradually, it acquired a new balance, a specific lightness and subtlety, and a dedication to naturalism without losing the intensity and general boldness of approach that were hallmarks of the early style.

That this stylistic transformation was related to the final formulation of the Aten creed is a possibility that cannot be dismissed. James P. Allen has described (pp. 3–4) how, around Years 8–12, Akhenaten abandoned the last vestiges of traditional mythology and affirmed that the true object of his worship was light itself. This ultimate definition of the Aten religion is roughly contemporaneous with the early works of the Thutmose workshop, and there can be no doubt that light was a decisive factor in the Amarna artists' depiction of facial features and the careful attention they gave to the interplay among bone structure, flesh, and skin. Egypt's light is not the illusory light of Western art but an overwhelming brightness that causes all objects to stand out with unremitting clarity. It is—as a text in the tomb of Ay says—the presence of god "in our faces."

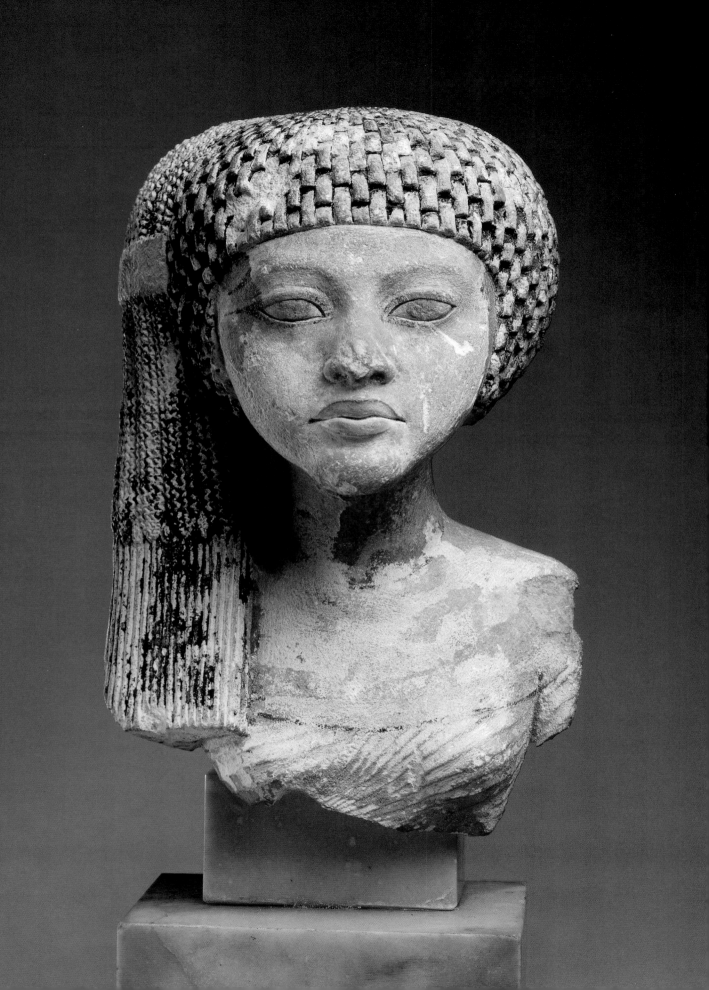

YOUTH AND OLD AGE:
THE POST-AMARNA PERIOD

DOROTHEA ARNOLD

What remained after the glory of Amarna was gone? After the burial sites of king, queens, and princesses had been desecrated and their funerary objects hopelessly intermingled, after the cult in the temples had come to an end and the artists and craftsmen had returned to the old Egyptian capitals of Memphis or Thebes? Three female images of limestone demonstrate some of the stylistic developments in post-Amarna art. The first, now in the Louvre, consists of the head, shoulders, and breasts of a statuette (figs. 117–19, no. 31) representing an adolescent girl, probably a princess. The second piece, in Philadelphia, is a headless statuette (fig. 121, no. 37), and the third work, in Florence, depicts a mature woman (fig. 122, no. 38).

The Louvre princess is depicted wearing the familiar pleated linen dress with ends knotted below the breast. A large capelike collar covers her shoulders and an elaborate wig surrounds her small heart-shaped face. The wig consists of two parts: a tightly fitting cap of rectangular echeloned curls and, on her right side, a massive side lock that begins at the top of the head as a flat triangular piece, thickens at about the height of the ear, and hangs down over the shoulder almost to the breast. The hair of the upper part of the lock is curled in a zigzag pattern; below, the hairpiece ends in thicker tubelike coils. Above the ear, a broad band holds the lock in place. As seen in the profile view (fig. 119), the side lock does not hang straight but sweeps forward over the shoulder, creating an impression of movement.

The face and neck of the young woman were smoothed with a thin layer of gesso and then painted brownish yellow. The hair was painted with a gritty black pigment; the eyelids, eyebrows, pupils, and the edges of the collar were outlined in black. Brightly col-

ored bands evidently decorated the surface of the collar: part of a yellow band and the remains of a broader blue band close to the side lock are preserved. The face has the same triangular shape as those of the Thutmose workshop princesses (figs. 46–53), and below the large mouth with full lips, which are outlined by the sharply cut edge of the vermilion line, the small chin droops in the same manner. But the Louvre princess's round, soft cheeks lack the strong bone structure that is characteristic of the Thutmose princesses. Her face is broader and flatter than any we have yet encountered from the Amarna Period. The wide area between the cheekbones contrasts with the relatively short distance from the cheekbones to the edge of the hair. The impression that this flat face is reminiscent of masklike pre-Amarna female images (see p. 72; figs. 63, 64) is further strengthened by the thick black lines that encircle the eyes and by the treatment of the painted eyebrows. Thick brushstrokes delineate the bushy brows that extend from the bridge of the nose to above the outer corners of the eyes, but the downward-curving ends at the temples are treated as thin, taillike appendages that echo the short cosmetic lines above.

The eyes themselves are naturally shaped and rather flat; the lower lids are simply defined, whereas the upper lids, set off from the flesh above them by shallow grooves, are flattened so that vertical bands of uneven width hood the tops of the eyes.[1] A similar kind of upper eyelid, more angular and more precisely cut, is found in the early Karnak colossi of Akhenaten and Nefertiti (figs. 2, 9). At the very end of the Amarna Period and thereafter (figs. 73, 120), the vertical edges of the flattened upper lids appeared frequently, albeit in a more softly shaped version and in connection with eyes less narrowly slitted than those of the Karnak period of Akhenaten's reign. Now as then, this feature adds a measure of artificiality and remoteness to the somewhat dreamy gaze of the eyes.[2]

Stylistic peculiarities, like the frontality of the Louvre princess's face or the flattened upper eyelids, date the

Opposite: Fig. 117. Upper part of a statuette. Painted limestone. Musée du Louvre, Paris

piece to the years after Akhenaten's death, perhaps during the early years of Tutankhamun's reign. This dating is corroborated by a comparison with the head of King Tutankhamun in The Metropolitan Museum of Art (fig. 120).[3] The king's eyes are larger and his brow ridges more sharply delineated, but the overall shape of the face and the eyes and mouth are very close to those of the princess. Compared with the Metropolitan Museum's Tutankhamun, however, the princess is still closer to Amarna art. Especially when seen in profile (fig. 119), the drooping chin, full mouth, and receding upper part of her face are unmistakably Amarnesque (figs. 23, 26, 46–48). It is also noteworthy that the head of the princess with its heavy hairstyle is balanced on an extremely thin neck. Such expressive use of contrasts in mass and weight was typical of Amarna art from the beginning (figs. 10, 11, 17). Thus, a date slightly earlier than that of the Metropolitan Museum's Tutankhamun's is indicated for the Louvre princess.[4]

The similarities between the Louvre princess and the head of Tutankhamun suggest that the Louvre piece was carved in a Theban workshop. At the back of Tutankhamun's crown, the hand of the god Amun is preserved, indicating that this head was part of a group statue that combined the supreme god of Thebes with a smaller figure of the king.[5] Such a sculptural group was almost certainly made for one of the Theban Amun sanctuaries. Works closely parallel to the Louvre young woman, moreover, are found among the objects from the tomb of Tutankhamun.[6]

The complete figure of the young woman in the Louvre can be reconstructed with the help of a fine headless statuette now in the University Museum, University of Pennsylvania, Philadelphia (fig. 121, no. 37).[7] This young woman is also portrayed in a thin, pleated dress with one short sleeve around her upper right arm; the longer end of the garment covers the left arm down to the elbow, and again a knot is tied below the right breast. A broad, close-fitting collar covers the shoulders, and on the right shoulder the lower end of a side lock is preserved. In contrast to the Louvre princess, this woman's hairpiece lacks the tubelike coils of hair and ends with a simple cut edge of zigzag strands. The Philadelphia woman's right arm hangs at her side; the back of the hand faces forward in the manner familiar from the Berlin statuette of Queen Nefertiti (fig. 68; see p. 79). Her left arm is bent upward from the elbow;

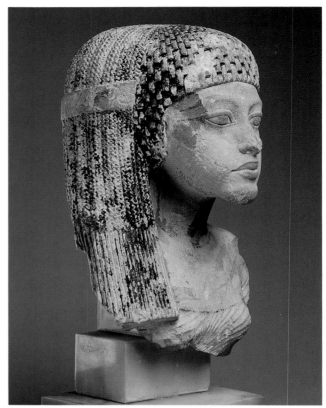

Fig. 118. Bust of a princess. Painted limestone. Musée du Louvre, Paris

a mass of stone extending from the back pillar supports the arm and hand in their raised position, and the back pillar itself slopes down from behind the arm to a point at the side of the left leg and foot.

The surface of the stone on the sloping left-hand side of the back pillar is roughened in a manner already seen on the Petrie torso (fig. 104), indicating that the figure was part of a group. Similar figures among the group sculptures at Amarna (figs. 21, 22, 103, 112, pp. 24, 26, 108–10) might lead one to deduce that she touched a figure on her left with her raised hand.[8] In short: this figure represents a princess and formed part of another group image of the Amarna royal family. The Louvre quartzite torso (figs. 21, 22) has already shown that princesses were not always represented as very young nude children but also as adult women wearing garments (see pp. 24, 26, 60). Indeed, most reliefs depict the daughters of Akhenaten and Nefertiti wearing garments and a side lock, as in the Louvre and Philadelphia limestone statuettes.

Despite the Philadelphia figure's similarities to rep-

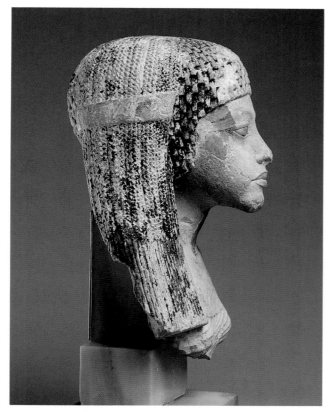

Fig. 119. Bust of a princess. Painted limestone.
Musée du Louvre, Paris

tures in the round and later reliefs,[10] from the quartzite torso in the Louvre (fig. 22) to the torso in the Petrie Museum (fig. 105), the area is softly rounded. In the statuette of Nefertiti in Berlin (fig. 68), a certain triangular abstraction already occurs, increased, no doubt, by the presence of a thin garment. A degree of stylization similar to that of the Philadelphia statuette appears only in the post-Amarna phase. From that time, the figures of the four protective goddesses from the tomb of Tutankhamun, for instance, show a similarly abstracted albeit more graphically defined treatment of the pubic area.[11]

Since the Philadelphia statuette unmistakably exhibits elements found in the art created after Akhenaten's death, the sculptural group to which it belonged was probably one of the very last representations of Akhenaten's family or a group accompanying figures of Smenkhkare or Tutankhamun.[12] Similarities to the Philadelphia statuette strongly suggest that the Louvre figure also represents a princess, but, as usual, it is impossible to assign names to either of these young

resentations of Akhenaten's daughters, like the Louvre torso (figs. 21, 22), the work diverges stylistically from these earlier pieces. The width of the chest in relation to the width of the hips and the more natural distance between breasts and shoulders date the Philadelphia princess to the late years of Amarna art. Moreover, the large broad collar that follows the contours of the shoulders and breasts is most familiar from works of the very end of the Amarna Period (see figs. 68, 69, 71).[9] The Philadelphia statuette also shares important characteristics with the Louvre's limestone piece (figs. 117–19), such as the finely detailed side lock and a notable degree of artificiality and stylization. This is especially noticeable in the rendering of the pubic area of the Philadelphia statuette.

The rendering of the pubic area has its own history in Amarna art. In a number of reliefs carved during the earlier years of Akhenaten's residence at Amarna, a rather harshly abstracted triangle appears (figs. 15, 30), and the same is true for at least some of the early boundary stelae statues of princesses (see pp. 20, 60, 110). In sculp-

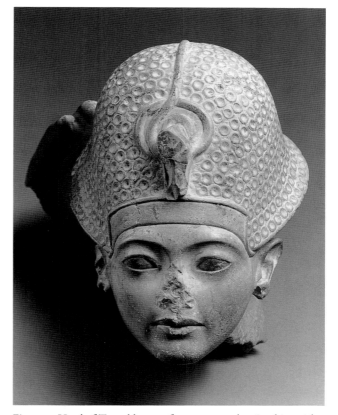

Fig. 120. Head of Tutankhamun from a group showing him with the god Amun. Indurated limestone. The Metropolitan Museum of Art, New York

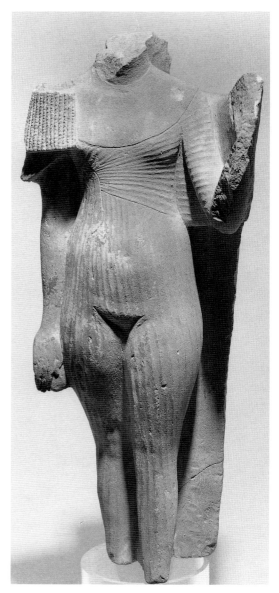

Fig. 121. Statuette of a princess. Limestone. University Museum, University of Pennsylvania, Philadelphia

of youth. This dominating expression of delicate sweetness first appeared in pre-Amarna art, during the reign of Akhenaten's father, King Amenhotep III, and the Louvre princess definitely shares characteristics with works of that time, especially with representations of Amenhotep and Tiye's eldest daughter, Sitamun.[13] Perhaps these trends never completely disappeared in workshops outside Amarna and were ready to emerge again after Akhenaten's death.

As players in the complex political situation that prevailed after Akhenaten's death, childlike young princesses, such as the one depicted in the Louvre statuette, would have been hopelessly lost. Therefore, the young queen who wrote a letter to the Hittite king Shuppiluliumash must have been of different caliber. "My husband has died," she is reported by the Hittites to have written, "and I have no son. They say about you that you have many sons. You might give me one of your sons, and he might become my husband. I would not want to take one of my servants. I am loath to make him my husband." And later, "He will be my husband and king in the country of Egypt." But this attempt by a royal woman to play a role in the politics of the day failed; the Hittite prince who was sent to Egypt in response to these letters disappeared on the way,[14] and there are no Egyptian sources describing the incident, or any other like it. However, numerous sources from the reigns of King Tutankhamun and his successor, King Ay, attest to the rise of the man who was to become King Haremhab. At this time, Haremhab was still, as his coronation inscription in the Egyptian Museum, Turin, describes it, "'widen[ing] his stride' until the day of his receiving his office would come." But "all his plans were as the footsteps of the Ibis [the animal representing the god of wisdom, Thoth]. . . . So he was administering the Two Lands for a period of many years . . . his awesomeness being great in the sight of everybody."[15] Considering the historically decisive political developments of the day, with state institutions such as the temples and the army being reorganized during a general reshuffling of power and the Hittites to be dealt with on the foreign front, an image like the one of the sweet little princess in the Louvre (figs. 117–19) reveals a significant degree of escapism and the resigned melancholy that goes with such attitudes.[16]

Of a limestone statue representing a mature woman, now in the Archaeological Museum, Florence (fig. 122,

women. Meketaten was dead and Meretaten and Ankhesenpaaten had become queens, so we are left with the names of the three remaining daughters, Nefernefruaten-Tasherit, Nefernefrure, and Setepenre, three princesses about whom we know almost nothing.

In many respects the female images depicted in works like the Philadelphia and Louvre statuettes, characterized by flat faces, richly detailed adornment, and a degree of artificiality, represent a return to pre-Amarna ways of portraying women. The Louvre princess expresses, above all, an inherent sense of the sweetness

no. 38), only the upper half is preserved. The woman was originally seated on a chair, the back of which is partly preserved, although not visible from the front. She wears the familiar thin, pleated linen garment and, around the shoulders, a broad collar decorated with various plants and flowers carved in relief. The fringe of the garment falls over her bent left arm, and the left hand rested just under the right breast. A lotus flower was held in the now-destroyed left hand, and a bracelet decorated with a zigzag pattern is incised on her left arm.

An elaborate, enveloping wig covers the head and shoulders. At the back, the top layer of hair is gathered into three braids that overlay the mass of the rest of the wig, a style seen on the early Amarna Period Metropolitan Museum statuette (fig. 20). Like the wig of the statuette and the side lock of the Louvre princess, the wig of the woman in Florence consists of fine, curly strands of hair that are twisted together at the lower end into thick coils. At either side of the face, still finer hair has been collected into two separate crescent-shaped hairpieces that end in tightly twisted thicker curls. A garland of flower petals and roundels encircles the top of the imposing wig.

The most remarkable part of this image is the face. Viewed from the side it seems rather flat, but when viewed frontally it is revealed as richly sculptured and possessing considerable depth, because the finely detailed neck is set back into the shadow created by the two massive side parts of the wig. Above the thin sinewed neck is a face with a square jaw, strong high cheekbones, and boldly carved brow ridges. The elongated cheeks are hollow, and the firmly closed, thin-lipped mouth with only the vestige of a smile is surrounded by taut skin and musculature; the eyes, embedded in looser flesh, seem moist. The thinly rimmed lower lids droop slightly and the upper lids are furrowed by double folds. The upper lids extend considerably over the eyeballs and, especially near the inner corners, they are noticeably undercut. Since the eyeballs are slightly oblique, the eyes appear to be looking downward. The brows are rounded and bushy and cast deep shadows on the areas above the inner corners of the eyes, deepening the thoughtful expression on the woman's face.

Thoughtful eyes, hollow cheeks, a slight double chin, and a sinewed neck characterize the woman in Florence as advanced in age, although her breasts are well rounded and no furrows mar the area around her mouth. The sculptor avoided the deeply lined features and sagging flesh the Amarna artists had used in producing their images of the older Nefertiti (fig. 71) and—even more daring—the gypsum plaster head of an old woman (fig. 36) from the workshop of Thutmose. But the Florence image undoubtedly owes its accentuated bone structure, lean cheeks, sinewed neck, and soft flesh around the mouth and eyes to the artist's thorough knowledge of such Amarna works. This becomes especially evident when one compares the gypsum plaster head (fig. 36) with the Florence woman. The outlines of jaw, cheekbones, and forehead are very similar in the two works, and the masterfully modeled soft flesh around the eyes of the plaster head is echoed in the more stylized eyes and lids of the Florence figure. However, the post-Amarna sculptor of the woman in Florence combined Amarna influences with pre-Amarna traditions by reintroducing a degree of stylization. Under her enormous wig, the Florence woman is

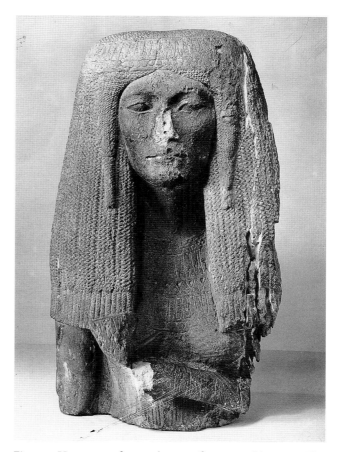

Fig. 122. Upper part of a seated statue of a woman. Limestone. Il Regio Museo Archeologico, Florence

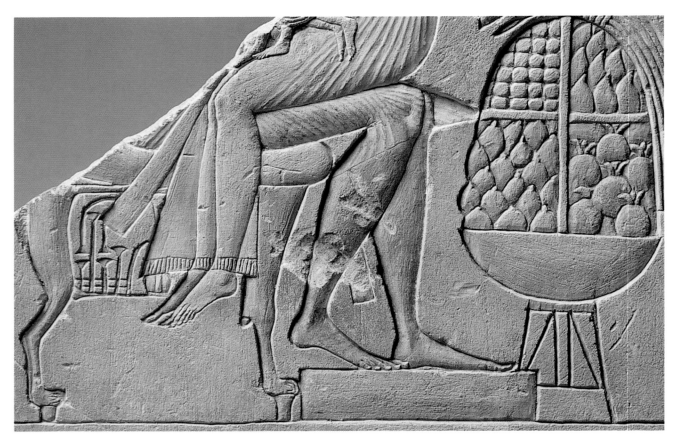

Fig. 123. Detail from the shrine stela (fig. 93). Musée du Louvre, Paris

characterized by the demure reticence typical of Egyptian female images since the Old Kingdom. Only in subtle indications of natural folds and furrows in the face and by the play of light and shadow on the richly detailed hair and around the neck, breasts, and arms are the tensions and complexities of personality and life experience hinted at rather than expressed under the placid surface of the traditional female imagery.

There is a significant relationship between the signs of old age in the individualized face of the Florence woman and the rich plant motifs on the collar and the oversized lotus flower in her hand. This seated figure of a woman was certainly meant to be placed in her tomb chapel. Flowers, especially the lotus, were always a powerful symbol of resurrection for the ancient Egyptians.

Judging from the type of limestone used and from stylistically related works—chiefly, the single statue of the woman named Merit and the pair statue with her husband, Maya, both now in the Rijksmuseum, Leiden, the Netherlands[17]—the Florence woman was created at Memphis, probably for a tomb at Saqqara. Its close relation to the Saqqara statues also places the woman's image within the artistic development of the period. Maya, Merit's husband, was treasurer under King Tutankhamun,[18] and during that king's reign or immediately after, the Florence woman must have been carved. The stylistic similarities between her statue and the sculptures from the tomb of Maya on the one hand, and Amarna art on the other, indicate that some pupils of the master sculptors of Amarna must have found their way back to Memphis. They brought with them the impressive legacy of images of female personality and life experience that were first conceived for the queens, princesses, and court women of Amarna.

Opposite: Fig. 124. Statuette of a female. Wood. Private collection

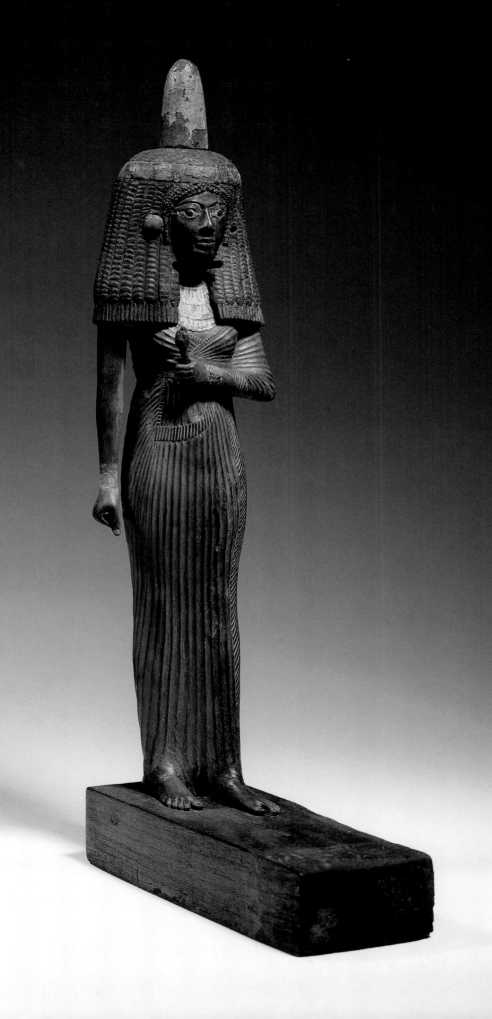

CHECKLIST OF THE EXHIBITION

Absolute dates are the ones used in The Metropolitan Museum of Art Egyptian galleries, following a chronology accepted at present by the majority of scholars. Regnal year dates refer to the seventeen-year reign of Amenhotep IV / Akhenaten (ca. 1353–1336 B.C.); they are based on available sources and the art-historical interpretations put forward in the present publication. The term "Years 8–12" refers to the change of the Aten's names that happened during this time span but cannot be narrowed to a single year. Year dates for works of art should be understood as a means of orientation rather than as a precise statement of the time of execution.

1. Head of Queen Tiye

Medinet el-Ghurab, Years 6–8

Yew and acacia wood; sheet silver, gold, linen, wax and glue, blue glass beads; eyes inlaid with white and black glass in ebony rims; brows inlaid with wood and painted black; red pigment on lips, around nostrils, and possibly on neck

H. 9.5 cm (3¾ in.)

Ägyptisches Museum und Papyrussammlung, Staatliche Museen zu Berlin (inv. no. 21 834)

Bibl.: Kaiser 1967, p. 61, no. 676; Aldred 1973, p. 105, no. 19
(Figs. 23, 26; pp. 27–35)

Accompanied by:

Part of a crown

Medinet el-Ghurab, probably late Eighteenth Dynasty, ca. 1336–1300 B.C.

Wood; gesso; black pigment on horns; yellow and blue pigment on sun disk; feathers gilded

H. 13 cm (5⅛ in.)

Ägyptisches Museum und Papyrussammlung, Staatliche Museen zu Berlin (inv. no. 17 852)

Bibl.: Borchardt 1911, p. 17, fig. 21
(Not illustrated; p. 32)

2. Head of Queen Nefertiti

Tell el-Amarna, workshop of Thutmose, Years 14–17

Yellow quartzite; red pigment on lips and area prepared for crown; black pigment on brows, around eyes and

nostrils, on forehead, ears, and neck; gypsum plaster(?) repair on top tenon

H. 30 cm (11¾ in.)

Ägyptisches Museum und Papyrussammlung, Staatliche Museen zu Berlin (inv. no. 21 220)

Bibl.: Aldred 1973, pp. 170–71, no. 99; Priese, ed. 1991, pp. 110–11, no. 67
(Figs. 66, 67; pp. 74–77)

3. Head of Queen Nefertiti

Tell el-Amarna, workshop of Thutmose, ca. Year 17

Granodiorite; red pigment on lips and area prepared for crown

H. 23 cm (9⅟₁₆ in.)

Ägyptisches Museum und Papyrussammlung, Staatliche Museen zu Berlin (inv. no. 21 358)

Bibl.: Priese, ed. 1991, pp. 112–13, no. 68
(Figs. 41, 72, 74; pp. 79–83)

4. Statuette of Queen Nefertiti

Tell el-Amarna, workshop of Thutmose, Years, 14–17

Limestone; red pigment on lips; black pigment on brows, around eyes, and as indication for the upper and lower edges of the collar

H. 40 cm (15¾ in.)

Ägyptisches Museum und Papyrussammlung, Staatliche Museen zu Berlin (inv. no. 21 263)

Bibl.: Priese, ed. 1991, pp. 108–9, no. 66
(Figs. 68, 69, 71; pp. 77–79)

5. Head of a princess

Tell el-Amarna, workshop of Thutmose, Years 6–8

Brown quartzite; red pigment on lips; black pigment on ears and neck

H. 21 cm (8¼ in.)

Ägyptisches Museum und Papyrussammlung, Staatliche Museen zu Berlin (inv. no. 21 223)

Bibl.: Aldred 1973, p. 160; Priese, ed. 1991, pp. 114–15, no. 69
(Figs. 46–48; pp. 52–58)

6. Shrine stela with relief showing Akhenaten, Nefertiti, and Princesses Meretaten, Meketaten, and Ankhesenpaaten

Before Years 8–12

Limestone

H. 32.5 cm (12¾ in.), W. 39 cm (15⅜ in.)

Inscribed: names and epithets of the Aten (earlier version); names of king, queen, and daughters. After the name of Nefertiti, the inscription reads: "May she live and be made young forever continually."

Ägyptisches Museum und Papyrussammlung, Staatliche Museen zu Berlin (inv. no. 14 145)

Bibl.: Aldred 1973, p. 102, no. 16; Settgast 1983, pp. 88–89; Murnane 1995, p. 87
(Figs. 8, 88, 91, 97; pp. 96–100)

7. Votive stela with two kings dedicated by the soldier Pasi

Before Years 8–12

Limestone

H. 21 cm (8¼ in.), W. 16 cm (6¼ in.)

Inscribed: dedicated by the soldier of [the division], [the king] appearing as right order, Pasi

Ägyptisches Museum und Papyrussammlung, Staatliche Museen zu Berlin (inv. no. 17 813)

Bibl.: Aldred 1973, p. 184, no. 114; Priese, ed. 1991, pp. 118–19
(Fig. 84; pp. 90–91)

8. Fragmentary shrine stela showing Akhenaten and Nefertiti

After Years 8–12

Limestone; remains of gesso and blue, yellow, and red pigment

H. 12 cm (4¾ in.)

Ägyptisches Museum und Papyrussammlung, Staatliche Museen zu Berlin (inv. no. 14 511)

Bibl.: Priese, ed. 1991, pp. 105–6
(Fig. 98; p. 104)

9. Fragment with the head of Queen Nefertiti from Akhenaten's sarcophagus

Tell el-Armana, Royal Tomb, ca. Years 8–12

Granite

H. 29 cm (11½ in.), max. W. 14 cm (5½ in.)

Ägyptisches Museum und Papyrussammlung, Staatliche Museen zu Berlin (inv. no. 14 524)

Bibl.: Martin 1974, 1989, vol. 1, pp. 15–16, pl. 20, no. 2
(Fig. 85; pp. 94–95)

10. Face of a young woman

Tell el-Amarna, workshop of Thutmose, Years 14–17

Gypsum plaster

H. 24 cm (9½ in.)

Ägyptisches Museum und Papyrussammlung, Staatliche Museen zu Berlin (inv. no. 21 239)

Bibl.: Aldred 1973, p. 182, no. 112; Settgast 1983, pp. 80–81
(Fig. 37; pp. 47–48)

11. Face of an old woman

Tell el-Amarna, workshop of Thutmose, Years 14–17

Gypsum plaster

H. 27 cm (10⅝ in.)

Ägyptisches Museum und Papyrussammlung, Staatliche Museen zu Berlin (inv. no. 21 261)

Bibl.: Priese, ed. 1991, pp. 124–25
(Fig. 36; pp. 47–48)

12. Torso of a princess

Years 6–8

Red quartzite; two holes drilled in ancient times, one still filled with a metal pin, attest to repair work done to the right arm

H. 29.4 cm (11½ in.)

Musée du Louvre, Paris (E 25 409)

Bibl.: Aldred 1973, p. 108, no. 22; Ziegler 1990, p. 51
(Figs. 21, 22; pp. 28–29)

13. Upper part of a statuette of a princess

Reign of Tutankhamun, ca. 1336–1327 B.C.

Limestone; red, blue, green, yellow, and black pigments

H. 15.4 cm (6 1/16 in.)

Musée du Louvre, Paris (E 14 715)

Bibl.: Boreux 1938, pp. 1–25; Aldred 1951, p. 79, pl. 117; Ziegler 1990, p. 50
(Figs. 117–19; pp. 121–24)

14. Fragment of a stela showing Akhenaten with Nefertiti and the children on his lap

Tell el-Amarna (from an unspecified house),
Years 14–17

Limestone; remains of white pigment on garments and red pigment on bodies

H. 24.7 cm (9¾ in.), W. 34 cm (13⅜ in.)

Musée du Louvre, Paris (E 11 624)

Bibl.: Petrie 1894, pp. 40–41, pl. 1, no. 16; Aldred 1973, p. 134, no. 56
(Figs. 93, 123; pp. 103–4)

15. Relief with two female figures: Nefertiti and Princess Meretaten(?)

Tell el-Amarna, Years 14–17 (found at Hermopolis)

Limestone; remains of white gesso and red and black pigment

H. 22 cm (8⅝ in.), W. 49.5 cm (19½ in.)

Musée du Louvre, Paris (E 27 150)

Bibl.: Desroches-Noblecourt 1978, pp. 20–27
(Fig. 82; pp. 91–93)

16. Torso from the statuette of a princess

Tell el-Amarna, after Years 8–12

Reddish brown quartzite

H. 15.3 cm (6 in.)

Petrie Museum, University College, London (UC 002)

Bibl.: Aldred 1973, pp. 162–63, no. 90; Samson 1978, pp. 24–26, figs. 8a, 8b
(Figs. 104–7; pp. 108–10)

17. Relief fragment with Nefertiti in Nubian wig, offering

Tell el-Amarna, possibly the Great Aten Temple, after Years 8–12

Red quartzite

H. 15.2 cm (6 in.), W. 10 cm (3⅞ in.)

Petrie Museum, University College, London (UC 040)

Bibl.: Samson 1978, pp. 49–50, fig. 24
(Fig. 77; pp. 85–86, 95)

18. Relief fragment with Nefertiti or Tiye wearing horned sun-disk crown and feathers

Tell el-Amarna, probably from the Great Palace,
Years 6–8

Indurated limestone

H. 12.5 cm (5 in.)

Petrie Museum, University College, London (UC 038)

Bibl.: Aldred 1973, p. 115, no. 29; Samson 1978, pp. 41–42, fig. 18
(Fig. 5; pp. 9, 22, 27)

19. Relief fragment showing a queen, probably Nefertiti, wearing a tripartite wig and a sash

Temple of the god Ptah, Memphis, Years 6–8

Limestone; red pigment on face and body

H. 20 cm (7⅞ in.), W. 18.5 cm (7¼ in.)

Petrie Museum, University College, London
(UC 073)

Bibl.: Samson 1978, pp. 45–46, fig. 21
(Fig. 18; pp. 22–23)

20. Sculptor's trial piece with head of Nefertiti in tall, flat-topped crown, wearing ear ornament

Tell el-Amarna, ca. Years 8–12

Limestone; black pigment

H. 8.7 cm (3⅜ in.), W. 7.5 cm (3 in.)

Petrie Museum, University College, London (UC 011)

Bibl.: Aldred 1973, p. 136, no. 59; Samson 1978, pp. 42–43, fig. 19; for the ear ornament, see T. Davis et al. 1910, pl. 33
(Fig. 80)

21. Inlay from a piece of furniture showing two princesses

After Years 8–12

Red glass, molded, parts applied; traces of sculpting

H. 9 cm (3½ in.), W. 4.5 cm (1¾ in.), D. .8 cm (⁵⁄₁₆ in.)

Petrie Museum, University College, London (UC 2235)

Bibl.: Samson 1978, p. 74
(Fig. 113; p. 115)

22. Female face, probably from a piece of furniture

After Years 8–12

Glass inlay, originally red

H. 3.1 cm (1¼ in.), W. 2.8 cm (1⅛ in.), D. .6 cm (¼ in.)

Petrie Museum, University College, London (UC 22078)

Bibl.: Samson 1978, pp. 75–76, fig. 45 (ii)
(Fig. 87; p. 95)

23. Part of the wig from a composite statue

Tell el-Amarna

Granodiorite; broken on the front edge behind the uraeus, at the top of the head, and on the back edge; inside hollowed and smooth

H. 25.5 cm (10 in.), W. 13.5 cm (5¼ in.)

Petrie Museum, University College, London (UC 076)

Bibl.: Samson 1973, p. 56, pl. 28
(Fig. 56; p. 62)

24. Fragment from a column showing Nefertiti and Princess Meretaten offering to the Aten

Tell el-Amarna, probably from the Great Palace, Years 6–8

Limestone; traces of red and blue pigment

H. 36.2 cm (14¼ in.), W. 30 cm (11¾ in.), D. 12.8 cm (5 in.)

Inscribed: Lady of the Two Lands Nefernefruaten Nefertiti, alive forever continually (behind queen); Lady of the Two Lands Nefernefruaten . . . (in front). Rare accoutrements of flat-topped crown: horizontal (sheep) horns, sun disk, and plumes

Ashmolean Museum, Oxford (1893.1–41 [71])

Bibl.: Aldred 1973, p. 116, no. 31
(Figs. 15, 17; p. 24)

25. Fragment from a column showing the royal family offering

Tell el-Amarna, Great Palace, area of mud-brick walls, ca. Years 8–12

Limestone

H. 24 cm (9½ in.), W. 28 cm (11 in.)

Inscribed: remains of names and epithets of Akhenaten and Meretaten

Ashmolean Museum, Oxford (1893.1–41 [75])

Bibl.: Aldred 1973, p. 127, no. 49
(Fig. 30; p. 38)

26. Fragment from a column showing Nefertiti offering flowers

Tell el-Amarna, probably from the Great Palace, after Years 8–12

Limestone; remains of gesso and red and blue pigment

H. 18.5 cm (7¼ in.), W. 30.5 cm (12 in.)

Ashmolean Museum, Oxford (1893.1–41 [171])

Bibl.: Aldred 1973, p. 128, no. 50
(Fig. 75; p. 86)

27. Relief with the head of the minor queen Kiya, later changed into Princess Meretaten

Tell el-Amarna, after Years 8–12 (found at Hermopolis)

Limestone; red, yellow, and blue pigment, apparently partly applied in modern times

H. 24 cm (9½ in.), W. 51.2 cm (20¼ in.)

Inscribed: the King's Daughter of his flesh, his beloved . . . Meretaten

Ny Carlsberg Glyptotek, Copenhagen (AE.I.N. 1776)

Bibl.: Cooney 1965, p. 34; Jørgensen 1992, pp. 8–9, 12–13, fig. 6
(Fig. 100; p. 106)

28. Fragment with the faces of Akhenaten and the minor queen Kiya as changed into Princess Meretaten

Tell el-Amarna, after years 8–12 (found at Hermopolis)

Limestone; red and blue pigment, apparently partly applied in modern times

H. 23 cm (9 in.)

Ny Carlsberg Glyptotek, Copenhagen (AE.I.N. 1797)

Bibl.: Roeder 1969, p. 157, no. 189, pl. 198, Jørgensen 1992, pp. 5–6, 12
(Fig. 79; pp. 87, 105)

29. Fragment from a colossal head of Amenhotep IV

Karnak, Years 2–5

Sandstone

H. 32.2 cm (12¾ in.)

Staatliche Sammlung Ägyptischer Kunst, Munich (ÄS 6290)

Bibl.: Schoske 1993, p. 32, no. 27
(Fig. 1; pp. 17–18)

30. Sculptor's model showing the heads of Akhenaten and Nefertiti

Tell el-Amarna, Years 14–17

Limestone; traces of red pigment

H. 15.7 cm (6³⁄₁₆ in.), W. 22.1 cm (8¾ in.), D. 4.2 cm (1¾ in.)

The Brooklyn Museum, Gift of the Estate of Charles Edwin Wilbour (16.48)

Bibl.: Aldred 1973, pp. 190–91, no. 121
(Fig. 81; pp. 89–90)

31. Fragment from a column showing Nefertiti, behind Akhenaten, offering a bouquet of flowers to the Aten

Tell el-Amarna, before Years 8–12 (found at Hermopolis)

Limestone

H. 23.5 cm (9¼ in.), W. 37.7 cm (14¾ in.)

The Brooklyn Museum, Charles Edwin Wilbour Fund (71.89)

Bibl.: Aldred 1973, p. 112, no. 26
(Fig. 76; p. 85)

32. Relief showing Nefertiti offering

Karnak, Years 2–5

Sandstone; traces of red and blue pigment

H. 20.9 cm (8¼ in.), W. 42.3 cm (16⅝ in.)

Inscribed: [of] his [body] Meret[aten] (at the queen's back) refers to Nefertiti's daughter, who stands behind her.

The Brooklyn Museum, Gift of Christos G. Bastis in honor of Bernard V. Bothmer (78.39)

Bibl.: Aldred 1973, p. 111, no. 25
(Fig. 10; pp. 18–19)

33. Two adjoining blocks from a relief representation of royal barges; on the cabin wall Nefertiti is depicted slaying a female enemy

Tell el-Amarna, after Years 8–12 (found at Hermopolis)

Limestone; blue and red pigment, partly applied in modern times

Upper block: H. 23.9 cm (9⅜ in.), W. 54 cm (21¼ in.)
Lower block: H. 23.4 cm (9¼ in.), W. 53.1 cm (20⅞ in.)

Museum of Fine Arts, Boston; upper block: Egyptian Curator's Fund (64.521); lower block: Helen and Alice Colborn Fund (63.260)

Bibl.: Aldred 1973, p. 135, no. 57
(not illustrated; p. 85)

34. Relief fragment with the head of a princess

Tell el-Amarna, Broad Hall of the Great Palace, Years 6–8

Limestone; red and blue pigment, the latter in the inscription

H. 19 cm (7½ in.)

Inscribed: the wish "alive forever continually" applies to Nefertiti, who was depicted at the left.

Museum of Fine Arts, Boston, Gift of Egypt Exploration Fund (37.1)

Bibl.: Aldred 1973, p. 118, no. 33
(Fig. 109; p. 112)

35. Relief fragment from a column showing the royal couple and Meretaten offering

Tell el-Amarna, before Years 8–12 (found at Hermopolis)

Limestone; traces of red and blue pigment

H. 22.4 cm (8¾ in.), circ. 59.5 cm (23½ in.)

Museum of Fine Arts, Boston, Mary S. and Edward J. Holmes Fund (67.637)

Bibl.: Aldred 1973, p. 103, no. 17

(Not illustrated; p. 85)

36. Relief fragment (from a parapet?) with the name of Akhenaten and a princess with raised hands

Tell el-Amarna, brick part of the Great Palace, ca. Years 8–12

Granite

H. 10.5 cm (4⅛ in.), W. 13.8 cm (5⁷⁄₁₆ in.)

Museum of Fine Arts, Boston, Gift of Egypt Exploration Fund (36.96)

Bibl.: Aldred 1973, p. 137, no. 60; for balustrades and parapets, see Shaw 1994, pp. 109–12

(Not illustrated; p. 22)

37. Statuette of a princess

ca. Year 17

Limestone; traces of black (on hair) and red pigment (on right arm)

H. 31.1 cm (12¼ in.)

University Museum, the University of Pennsylvania, Philadelphia (E 14 349)

Bibl.: Aldred 1973, p. 178, no. 106
(Fig. 121; pp. 122–24)

38. Upper part of a seated statue of a woman

Late Eighteenth Dynasty, ca. 1336–1300 B.C.

Limestone

H. 50 cm (19¾ in.)

Il Regio Museo Archeologico di Firenze (inv. no. 5626)

Bibl.: Wenig 1969, p. 51, ill. p. 76
(Fig. 122; pp. 124–26)

39. Relief showing Nefertiti offering

Karnak, Years 2–5

Sandstone; traces of red and blue pigment

H. 20 cm (7⅞ in.), W. 45 cm (17¾ in.)

Inscribed: . . . of his body, his beloved Meretaten (refers to the figure of the princess who followed the queen).

Collection of Jack Josephson, New York
(Fig. 11; pp. 18–19)

40. Relief showing Akhenaten as a sphinx

Years 6–8

Limestone; traces of red in rays, blue on the sphinx's body

H. 58.5 cm (23 in.), W. 92.5 cm (36⅜ in.)

Inscribed: the inscription contains the names and epithets of the Aten (early version), Akhenaten, and Nefertiti, and the Aten is said to be "within the Sunshade temple [whose name is] Creator of the Horizon [and this temple is] in Akhetaten."

Thalassic Collection, courtesy of Mr. and Mrs. Theodore Halkedis, New York

Bibl.: Aldred 1973, p. 99, no. 13
(Fig. 14; p. 22)

41. Fragment from a colossal head of Nefertiti

Karnak, Years 2–5

Sandstone

H. 45 cm (17¾ in.)

Egyptian Museum, Cairo (CG 42 089)

Bibl.: Legrain 1906, p. 51, pl. 54
(Fig. 2; pp. 17–18)

42. Head of Queen Nefertiti

Area of the palace of King Merneptah at Memphis, after Years 8–12

Brown quartzite; red pigment on lips

H. 18 cm (7⅛ in.)

Egyptian Museum, Cairo (JE 45 547)

Bibl.: Saleh and Sourouzian 1987, no. 162
(Figs. 31, 65; pp. 70–74)

43. Head of a princess

Tell el-Amarna, workshop of Thutmose, Years 14–17

Yellow quartzite; red and black pigment; head was broken from neck and rejoined in ancient times

H. 19 cm (7½ in.)

Egyptian Museum, Cairo (JE 44 870)

Bibl.: Borchardt 1913, pp. 46–47, fig. 23; Aldred 1973, p. 55, fig. 32
(Fig. 51; pp. 63–65)

44. Sculptor's model showing a princess eating a roasted duck

Tell el-Amarna, North Palace, after Years 8–12

Limestone; black pigment

H. 23.5 cm (9¼ in.), W. 22.3 cm (8¾ in.)

Egyptian Museum, Cairo (JE 48 035)

Bibl.: Newton 1924, p. 295, pl. 23, 1; Saleh and Sourouzian 1987, no. 169
(Fig. 108; pp. 110–12).

45. Sculptor's model showing a bust of Nefertiti in profile

Tell el-Amarna, Great Aten Temple, before Years 8–12

Limestone

H. 27 cm (10⅝ in.), W. 16.5 cm (6½ in.), D. 4 cm (1⁹⁄₁₆ in.)

On reverse and upside down: relief representation of kneeling man, his hands raised adoringly; stylistically this relief is more advanced than the image of Nefertiti (after Years 8–12?)

Egyptian Museum, Cairo (JE 59 296)

Bibl.: Pendlebury et al. 1951, vol. 1, p. 19; vol. 2, pl. 59, 2.3; Wildung and Schoske 1984, pp. 76–77, no. 32
(Fig. 62; p. 70)

46. Statuette of the Chief of the Household, Tiya

Medinet el-Ghurab, late years of Amenhotep III to early years of Amenhotep IV/Akhenaten, ca. 1360–1350 B.C.

Wood; fringe of garment inlaid with Egyptian blue; remains of white pigment in inscription; necklace of gold, glass, and carnelian beads

H. 24 cm (9½ in.)

Inscribed on the base in front of the feet: A royal offering of Mut, lady of the sky, giving life, soundness, and health, while giving blessing and love, for the *ka* of the Chief of the Household, Tiya. (The left hand originally held a flower or similar object.)

The Metropolitan Museum of Art, New York, Rogers Fund, 1941 (41.2.10)

Bibl.: Chassinat 1901, pp. 227, 229, pl. 1, 1; Hayes 1990, pp. 266–67, fig. 161
(Figs. 20, 64; pp. 24, 72)

47. Fragment from a relief showing Nefertiti

Before Years 8–12

Reddish quartzite

H. 13 cm (5⅛ in.), W. 9 cm (3½ in.)

The Metropolitan Museum of Art, New York, Rogers Fund, 1947 (47.57.1)

Bibl.: Hayes 1990, p. 284
(Fig. 19; p. 95)

48. Fragmentary relief block with head of Nefertiti

Karnak, Years 2–5

Sandstone; traces of red and blue pigment

H. 22 cm (8⅝ in.), W. 32 cm (12⅝ in.)

Inscribed: The King's Daughter of his flesh, his beloved Meretaten. (This refers to the princess whose figure followed her mother on the right.)

The Metropolitan Museum of Art, New York, Rogers Fund, 1961 (61.117)

(Not illustrated; pp. 23, 95)

49. Sculptor's sketch: figure of a princess

Amarna Period, ca. 1349–1336 B.C.

Limestone

H. 8 cm (3⅛ in.), W. 6.5 cm (2½ in.)

The Metropolitan Museum of Art, New York, Rogers Fund, 1922 (22.2.13)

(Not illustrated; p. 60)

50. Facsimile of a painting showing Princesses Nefernefruaten-Tasherit and Nefernefrure at the feet of Nefertiti

Original: Tell el-Amarna, King's House, ca. Year 12; Ashmolean Museum, Oxford (1893.1–41 [267])

Facsimile (1:1): tempera on paper by Nina de Garis Davies (1928)

H. 30 cm (11¾ in.), W. 38 cm (15 in.)

The Metropolitan Museum of Art, New York, Rogers Fund, 1930 (30.4.135)

Bibl.: Wilkinson and Hill 1983, p. 133
(Fig. 49; pp. 60–61)

51. Facsimile (partly restored) of a painting: bird life in the swamps

Original: North Palace at Amarna, Amarna Period, ca. 1349–1336 B.C.

Facsimile (1:1): tempera on paper by Norman and Nina de Garis Davies (1926)

H. 105.5 cm (41½ in.), W. 425 cm (167¼ in.)

The Metropolitan Museum of Art, New York, Rogers Fund, 1930 (30.4.136)

Bibl.: Wilkinson and Hill 1983, p. 132

(Not illustrated; pp. 111–12)

52. Facsimile of a painting: parts of an olive tree

Original: Tell el-Amarna, North Palace, Amarna Period, ca. 1349–1336 B.C.

Facsimile (1:1): tempera on paper by Nina de Garis Davies (1926–27)

H. 18 cm (7⅛ in.), W. 13 cm (5⅛ in.)

The Metropolitan Museum of Art, New York, Rogers Fund, 1930 (30.4.223)

Bibl.: Wilkinson and Hill 1983, p. 133

(Not illustrated; p. 112)

53. Facsimile of a painting: geese feeding

Original: Tell el-Amarna, North Palace, Amarna Period, ca. 1349–1336 B.C.

Facsimile (1:1): tempera on paper by Norman de Garis Davies (1926–27)

H. 40.5 cm (15¹⁵⁄₁₆ in.), W. 97 cm (38³⁄₁₆ in.)

The Metropolitan Museum of Art, New York, Rogers Fund, 1930 (30.4.134)

Bibl.: Wilkinson and Hill 1983, pp. 132–33

(Not illustrated; p. 112)

54. Statuette of a female

Medinet el-Ghurab, late years of Amenhotep III to early years of Amenhotep IV/Akhenaten, ca. 1360–1350 B.C.

Wood (originally a necklace of faience and/or glass beads was attached)

H. 35.5 cm (14 in.)

Private collection

Bibl.: Chassinat 1901, pp. 227, 229, pls. 1, 3; Kozloff and Bryan 1992, pp. 258–60
(Fig. 124)

NOTES

THE RELIGION OF AMARNA (pages 3–5)

1. Sandman 1938, p. 94, l. 17.
2. Bickel 1994, pp. 53–54.
3. For Amun's nature and role in creation, see Allen (1988a, pp. 48–55). For a discussion of monotheistic thought in Egyptian religion, see Assmann (1993).
4. Assmann 1983, pp. 145–88.
5. C 42120 (temp. Thutmosis III): Legrain 1903, p. 182.
6. Assmann 1984, pp. 235–43.
7. The name Horakhty means "Horus of the Akhet," a reference to the power of kingship (Horus) as it becomes manifest in the sun's rising from the Akhet (the zone that lies between the netherworld and the visible horizon).
8. The earliest instance of this name is perhaps on Amenhotep IV's Gebel Silsila stela, which also describes the king as "beloved of Amun-Re" (Sandman 1938, pp. 143–44).
9. On a block reused in the Tenth Pylon at Karnak (Aldred 1988, pl. 27). The image identifies the anthropomorphic deity as Horus, often depicted as a falcon.
10. One of the earliest instances can be seen in Aldred (1988, pl. 28).
11. Often preceded by the definite article *pa*, as in the name of the Amarna princess Ankhesenpaaten (May She Live for the Sun Disk). Instances without this element reflect an older form of the language, which had no definite article: e.g., the name of the eldest Amarna princess, Meretaten (Beloved of the Sun Disk).
12. Note the descriptions of Akhenaten as "the son . . . who came from the disk, effective for the one who is effective for him," "your son, who is effective for you," and "your effective image" (Sandman 1938, pp. 91, ll. 9–10; 14, ll. 13–16; and 59, ll. 9–10, respectively).
13. Assmann 1984, p. 244.
14. Hari 1984, pp. 1039–41.
15. Besides mention of Horus, the original didactic name also used the word *šw* (light), which could be construed as a reference to the god *šw* (Shu). The newer name replaced this with the more neutral word *ḥ3jt*, also meaning *light*.
16. Sandman 1938, p. 93, l. 17–p. 94, l. 4.
17. E.g., "You are the one who made when there was no one to make all these things: it is from your mouth that they came": Sandman 1938, p. 46, l. 15.
18. Assmann 1975, col. 532.
19. Sandman 1938, p. 95, l. 16.
20. Ibid., p. 96, ll. 1–3. For the king as object of worship, note, for example, the shrine from the tomb of Huya, whose doorway texts alternate between "Adoration to your life-force, O living Aten" and "Adoration to your life-force, O Neferkheperu-re wa-en-re" (ibid., pp. 38–40).
21. See pp. 96–107, below.
22. Allen 1988a, pp. 8–12. The traditional Ennead comprised Atum; Shu and Tefnut (the atmosphere); Geb and Nut (earth and sky); and Osiris and Isis, Seth and Nephthys (life principles).
23. Coffin Texts Spell 80 (Buck 1935–61, CT II 39e). The twinship of Shu and Tefnut is expressed, inter alia, by their common designation as the Double Lion—e.g., Pyramid Texts Spell 301 (Sethe 1908–22, Pyr. 447): "Atum and Double Lion . . . that is, Shu and Tefnut."
24. See Assmann 1984, pp. 251–53.
25. Sandman 1938, p. 60, ll. 4–7; sim. ibid., p. 92, ll. 2–7.
26. Ibid., p. 86, ll. 12–16; see also Assmann 1980, pp. 1–32.
27. Gardiner 1905, p. 140, l. 3.
28. Aldred 1988, p. 113.
29. Breasted 1924, p. 127.
30. See Allen 1989, pp. 89–101.

THE ROYAL WOMEN OF AMARNA: WHO WAS WHO (pages 7–15)

1. There are various ways in which the titles of the royal women have been translated into English, all more or less valid. A recent discussion of the meanings of all queenly titles can be found in Troy (1986, pp. 227–31). Translations of names used here are by James P. Allen.
2. The names of Tiye's parents appear on commemorative scarabs (see Blankenburg-van Delden 1969). The theories concerning Tiye's background are discussed in Aldred (1988, p. 141). Aldred believed that Tiye was a descendant of Ahmes Nefertari, mother of Amenhotep III. For the royal connections of Tiye's family, see ibid., p. 219.
3. Aldred 1988, p. 96.
4. Mercer 1939, vol. 1, pp. 159, 165, 175, 177; Moran 1992, pp. 86–99. A discussion of the political impact of the royal women will be included in L. Green, *Queens and Princesses of the Amarna Period* (KPI, forthcoming).
5. Fragments of faience *shawabti*-figures, which the Japanese expedition believed to be Tiye's, are evidence of the burial in KV 22 (Kondo 1992, p. 46, pl. 8).
6. Bell (1990) discusses KV 55, as do T. Davis et al. (1990) and Dodson (1994b, passim).
7. For the original identification, see J. E. Harris et al. (1978, pp. 1149–51); however, Germer (1984, pp. 85–90) raised objections.
8. Quibell 1908, pp. 53–54, pls. 37, 38; Eaton-Krauss 1989, pp. 77–88.
9. The evidence in favor appears in Connolly, Harrison, and Ahmed (1976, pp. 184–86) but is disputed by a number of scholars, e.g., Meltzer (1978, pp. 134–35). Aldred (1968, p. 82) originally considered this idea, but by 1988 he had discarded it. See Aldred 1988, pp. 293–94.
10. The titles from the Cairo colossus are published best in Urkunden (1957, p. 1775); new photos appeared in Trad and Mahmoud (1995, pp. 40–50). Previously, most scholars assumed that Isis, who is attested more frequently, was older

than Henut-taneb, but Trad and Mahmoud note that of the princesses only Henut-taneb is represented as a mature woman.

11. Most of the texts mentioning this princess can be found in Walle 1968, pp. 36–54; Hayes 1948, pp. 272–79 (as well as L. Green, *Queens and Princesses of the Amarna Period* [KPI, forthcoming]). The statue of Isis from the George Ortiz Collection and an eye-paint tube inscribed with her name and titles were displayed in the "Egypt's Dazzling Sun" exhibition. See Kozloff and Bryan 1992, pp. 206–8, 401.

12. Hayes 1948, pp. 272–79; id. 1990, pp. 242–43, fig. 147.

13. She is visible only as a small, headless figure to the right of Amenhotep III's knees; see Trad and Mahmoud (1995, pp. 41, 44).

14. R. Smith and Redford 1976, p. 80; Murnane 1995, pp. 38, 69.

15. The prominence of the queen is especially surprising since her parentage is unknown. In no inscription is Nefertiti called King's Daughter, and in fact, unlike Tiye, the names of her parents are not specifically recorded anywhere. Many scholars now follow Aldred (1988, pp. 221–22) in thinking that she was the daughter of Ay, probably by an unknown first wife (see above, p. 51).

16. Aldred 1988, pp. 221–22; id. 1957a, pp. 35–41.

17. Aldred 1988, pp. 220–21.

18. Loeben 1986, pp. 99–107.

19. Allen 1988b, p. 121; Aldred (1988, p. 227) prefers Year 14.

20. Originally suggested by J. R. Harris (1973b, pp. 5–13; id. 1974b, pp. 11–17), with support from Samson (1978, pp. 132–37; id. 1985, ch. 8) and in numerous articles. An excellent rebuttal to many of the points presented may be found in Allen (1994, pp. 7–13).

21. Burridge 1993.

22. N. Davies 1903–8, vol. 3, pls. 4, 6, 9, 17, 18.

23. Gabolde (1992, pp. 27–39) has presented unconvincing arguments that Kiya was the mother of Baketaten, based on the latter's titles and her apparent age in the reliefs.

24. R. Smith and Redford 1976, pls. 19, 28–33.

25. Robins 1981, pp. 75–81.

26. Kitchen (1962, pp. 11–12) and Redford (1984, p. 192) date Meretaten's becoming chief queen to Year 15 of Akhenaten's reign, whereas Allen (1988b, p. 121) argues for a date not before Year 17 on the ground of his interpretation of the "coregency stela." See also here, pp. 89, 93.

27. Moran 1992, pp. 19, 22. There has even been a suggestion that she became first coruler and then sole ruler of Egypt. See Krauss 1978, passim.

28. Reeves 1990, p. 193.

29. N. Davies 1903–8, vol. 2, pl. 41.

30. Allen 1991, pp. 84–85.

31. Krauss (1978, pp. 43–47, 118–21) has suggested that Meretaten reigned alone for six months after her father's death, and that it was she who wrote the letter referred to (pp. 11–12) and quoted on p. 124.

32. R. Smith and Redford 1976, pls. 32, 33.

33. Helck 1982, col. 22; Martin (1974, 1989, vol. 2, pp. 37–41) has identified the woman on the bier in room alpha of the Royal Tomb as Kiya but assigned the child in room gamma to Meketaten (ibid., pp. 44–45). For Meketaten's sarcophagus and possible other items of burial equipment, see p. 115 (figs. 6, 114). The date of Meketaten's death was after Year 13, when

she is last mentioned in a dated inscription. See Pendlebury et al. 1951, vol. 2, pl. 86, no. 37.

34. Although a small third princess is added to a few blocks from the Karnak temple, the name and figure of Ankhesenpaaten do not appear on the boundary stelae at Amarna, which are dated to the fourth month of the growing season of Akhenaten's sixth regnal year. Murnane and Van Siclen III (1993, pp. 177–78) have suggested she was born about Year 7 or Year 8 on the grounds that a third princess had been added to the statues flanking boundary stelae A, B, P, Q, and U "by the time the later stelae were being finished" (Murnane 1995, p. 82).

35. MMA acc. no. 1985.328.5. Aldred 1973, no. 129, p. 196; Mertens et al. 1992, p. 57, no. 36.

36. Goetze 1975, p. 18.

37. Most recently, in Bryce (1990, pp. 102–5).

38. The ring was scientifically examined and the results were published by Krauss and Ullrich (1982, pp. 199–212).

39. A fuller discussion of the career of Ankhesenamun is in Green (1990–91, pp. 22–29, 67), including speculations about the possible offspring of the queen and Tutankhamun.

40. N. Davies 1903–8, vol. 2, pl. 10.

41. Ibid., vol. 1, pl. 19.

42. Evidence for the tomb comes from excavations by El-Khouly and Martin (1987, p. 8). The box lid from the tomb of Tutankhamun has been published in various places, but a good description of it is included in the catalogue of the exhibition in Vienna (1975, no. 56); however, J. R. Harris (1992, p. 57) does not think that the box represents Nefernefrure.

43. N. Davies 1903–8, vol. 2, pls. 37, 38.

44. This suggestion was made first by Aldred (1988, p. 289).

45. Redford 1984, p. 193.

46. Roeder 1969, pls. 14, 23, 70, 200; Redford 1975, p. 11.

47. There are many discussions of this problematic princess, including Meyer (1984, pp. 261–63).

48. Published in Blankenburg-van Delden 1969, pp. 18, 129–33, pl. 29; Moran 1992, pp. 41–42.

49. Kitchen (1962, p. 24, n. 2) believed that she died about the time of Tadukhipa's arrival in Egypt. Redford (1984, p. 150) has suggested that she survived into Akhenaten's reign and was, in fact, the woman known as Kiya.

50. Gundlach 1986, cols. 144–45; Moran 1992, pp. 57, 61, 68, 84, 86, 87, 89, 90, 92, 93, 98.

51. Fairman 1961, pp. 25–40.

52. For example, Manniche (1975, pp. 34, 37, n. 20) with some support from Reeves (1988, p. 100). Thomas (1994, p. 81) does not accept the identification.

53. Petrie 1894, pl. 25, no. 95. Kiya has also been identified as the prototype for the foreign wife mentioned in the "Tale of Two Brothers" (Manniche 1975, pp. 33–35).

54. Kemp 1995, p. 461. Green (1988) and Troy (1986, p. 193 c2/4) translate the first-mentioned title as "Greatly Beloved Wife." The translation used here conforms to Murnane (1995, p. 90, sec. 45A).

55. Hanke 1978, pp. 190–92; Martin 1974, 1989, vol. 2, pp. 37–41; J. R. Harris 1974a, pp. 25–30; id. 1992, p. 72, n. 115; Robins 1992, pp. 25–26; Gabolde 1992, p. 39.

56. Perepelkin (1978, passim) has even argued for a role as coruler; support for this theory has also come from Vandersleyen (1992, p. 78). The presumption underlying this

theory is that Kiya had the status equivalent to a King's Chief Wife, but evidence of Kiya's titles and iconography does not bear this out.

57. Frankfort and Pendlebury 1933, pl. 58, no. 16; Aldred 1988, p. 227; Helck 1984, p. 160.

58. Krauss 1986, pp. 67–68; Reeves 1988, p. 92, n. 8.

59. Aldred 1957a, pp. 35–41; id. 1988, pp. 221–22.

60. Unfortunately, many of the monuments of the reigns of Tutankhamun and Ay were usurped by later kings, so extant documents of Tiy's queenship are rare. However, there are unaltered reliefs at Akhmim in Middle Egypt (perhaps the hometown of Ay's family), published by Kuhlmann (1979, pp. 176–77, Abb. 2, Tf. 51, 52:1); W. R. Johnson 1994, pp. 136–49.

61. N. Davies 1903–8, vol. 6, pls. 38, 39. See above, p. 51, for the possibility that the gypsum plaster head is a portrayal of Ay (fig. 28).

62. Hari 1964.

63. N. Davies 1903–8, vol. 5, pl. 3 (tomb of May); ibid., vol. 6, pl. 4 (tomb of Parennefer), pls. 26, 28 (tomb of Ay).

64. Not everyone has accepted this identification; for example, see Martin (1982, pp. 277–78).

65. Strouhal 1982, p. 321. For the date of her death, see Martin (1982, p. 277).

AN ARTISTIC REVOLUTION (pages 17–39)

1. Desroches-Noblecourt 1974, pp. 1–44; Redford 1984, pp. 102–9; Forbes 1994, pp. 46–55.

2. Robins 1994, pp. 119–48. See also, Gilderdale 1984, pp. 7–20.

3. Headdresses and ceremonial garments vary among the statues from the Gem pa Aten temple at Karnak: double crowns on a *khat* headdress, as illustrated here; double crowns on a *nemes* headdress; four tall feathers on a *nemes*, whose lappets in some cases were ornamented with an echeloned pattern that makes the lappets look like parts of a ceremonial wig. In a fourth variant the double crown is worn directly on the forehead of the king without either *nemes* or *khat* in between. The body of a statue of the last type appears to lack genitals, a fact that has led to the interpretation of this version of the Karnak colossi as images of Queen Nefertiti. See J. R. Harris (1977, pp. 5–10); see also, however, Eaton-Krauss (1981, pp. 245–47, n. 3).

4. Legrain 1906, p. 51, no. 42089, pl. 54. First assigned to Nefertiti by J. R. Harris (1977, p. 9) and Eaton-Krauss (1977, p. 38, n. 92).

5. Eaton-Krauss 1981, p. 217, n. 3.

6. Of earlier Eighteenth Dynasty queens, the one in The Metropolitan Museum of Art (Hayes 1990, p. 55, fig. 26) does not look like any early Eighteenth Dynasty king; Queen Ahmose, in her famous relief at Deir el-Bahri (Leclant et al. 1979, p. 69, fig. 54), bears a strong but not exact family likeness to Amenhotep I (the previous king and arguably her father; see Aldred 1951, pl. 9); she does not look at all like her husband, Thutmosis I (see Naville 1895, pl. 9); and Thutmosis III's queen, Meretamun, has facial features different from those of her husband (see Naville 1907, pl. 28).

7. In the tomb of Queen Tiye's steward Kheruef the king and queen look decidedly different (see Chicago 1980, pls. 9, 25, 41, 48). In sculpture in the round, however, there are

instances where the queen's face is rather similar to that of the king (see Kozloff and Bryan 1992, pp. 175–77, 202–3, and compare with ibid., pp. 159–63 [the king's "baby face"]), although the queen always seems to have a smaller mouth, and the mouth and chin protrude.

8. Kozloff and Bryan 1992, p. 178; El-Saghir 1991, figs. 75–89, 141–48; W. R. Johnson 1994, pp. 128–49.

9. Murnane 1995, pp. 109–10.

10. R. Smith and Redford 1976, pp. 76–94, pls. 13–23; Redford 1984, pp. 76–82; Romano 1979, pp. 116–19; Loeben 1994a, pp. 41–45, see also, pp. 11–12.

11. R. Smith and Redford 1976, pls. 1–6; Romano 1979, pp. 108, 110–12. Differently styled, less lined features of king and queen are seen in ibid. (p. 109); R. Smith and Redford 1976, pls. 2, 10, 16; Loeben 1994a, p. 44.

12. Robins 1986, pp. 10–14; Bryan in Kozloff and Bryan 1992, pp. 170–71, 176.

13. Most prominently in Schäfer (1931, pp. 39–41).

14. Aldred and Sandison 1962, pp. 203–16; Aldred 1988, pp. 231–36.

15. Russman 1989, p. 115. See also, Kemp 1991, p. 265.

16. For easily accessible examples, see Leclant et al. 1978, pls. 124, 165, 212, 302, 341; W. Smith 1981, figs. 50, 180, 220, 250.

17. In the letter of Apy (Murnane 1995, pp. 50–51) written on day 19 of the third month of the growing season, the king's name is still Amenhotep, whereas the boundary stela dated day 13 of the fourth month of the same season (ibid., pp. 73–81) calls him Akhenaten.

18. Ibid., p. 7.

19. Ibid., pp. 6, 78.

20. Petrie (1894, p. 2) states, "The name of Tell el Amarna seems to be a European concoction. The northern village is known as Et Till. . . . The Beni Amran have given their name to the neighbourhood."

21. Kemp 1991, p. 267.

22. A head of Nefertiti—albeit very battered—from one of these statues is preserved in the National Gallery of Victoria, Australia; see Hope 1983, pp. 54–62. Another is in Leipzig; see Murnane and Van Siclen III 1993, pl. 24; see also, ibid., pp. 183–92.

23. Murnane 1995, pp. 73–86.

24. Ibid., p. 74.

25. Ibid., p. 77.

26. Kemp 1991, pp. 274–85.

27. Petrie 1894, pp. 7–20.

28. Pendlebury et al. 1951, vol. 1, pp. 33–85; vol. 2, pls. 13A–C, 14, 15, 33–44.

29. Kemp 1991, p. 279.

30. Aldred 1988, p. 61.

31. Kemp 1991, p. 279. For the controversy on the structure's function, see Uphill (1970, pp. 151–66) and Assmann (1979, pp. 143–55).

32. Pendlebury et al. 1951, vol. 2, pls. 63–74; Aldred 1973, pp. 101, 188 (trial pieces), pp. 104–5 (indurated limestone), p. 110 (alabaster), p. 115 (balustrade fragments), pp. 116, 118–19 (wall relief), pp. 126–28 (column fragments), p. 137 (granite), p. 215 (faience tile with inset flowers).

33. Pendlebury et al. 1951, vol. 1, pp. 57, 70, 79; vol. 2, pl. 41, nos. 2, 3; pl. 68, nos. 3, 4.

34. Aldred 1973, p. 118, no. 34 (from the *weben Aten*), p. 118, no. 33,

and p. 126, no. 48 (both from the broad hall), p. 127, no. 49 (from the brick-walled part of the complex called a "harim" by the excavators). For the excavation reports, see Pendlebury et al. 1951, vol. 1, pp. 50–51 (*weben Aten*), pp. 51–54 (broad hall), pp. 38–46 ("harim").

35. The fragments (figs. 15, 5, nos. 24, 18) have been designated (Aldred 1973, pp. 115–16) as "perhaps" or "probably" from this area. Fig. 109, no. 34, was excavated in the broad hall of the palace. See Pendlebury et al. 1951, vol. 1, pl. 68, no. 264; vol. 2, pl. 73, no. 1.

36. Bryan 1990, pp. 65–80; Kozloff and Bryan 1992, pp. 292–96. Excellent examples of Middle Egyptian Amenhotep III relief style are two stelae in the Metropolitan Museum (acc. nos. 12.182.39 and 18.2.5); see Hayes (1990, p. 273, fig. 167); it is interesting to compare these to the late Amenhotep III Luxor reliefs (W. R. Johnson 1990, pp. 29–31), which are in high relief but not sculpturally round, as are the Middle Egyptian and Memphite examples.

37. See also Aldred 1973, p. 61. If the sculptor Bek (Habachi 1965, pp. 85–92) was, indeed, head sculptor at Amarna in the early years (Aldred 1973, pp. 53–57) and was a Theban, he can only have had a general position as overseer.

38. For the fertility type of statue, see Hayes 1990, pp. 285–86, fig. 173; Aldred 1973, pp. 106, 125; Doresse 1984–85, pp. 89–102; Stadelmann 1969, p. 163, n. 4. For the statue type with stela, see boundary stela statues (Aldred 1988, pl. 14) and statuette, Berlin (id. 1973, p. 90).

39. Hayes 1990, p. 286, fig. 174.

40. For a fragment of a head of Nefertiti in this group, see Eaton-Krauss (1981, pp. 245–51).

41. Both royal names were found on accompanying objects from the same tomb. See Chassinat 1901, pp. 225–34, pls. 1–3; Kozloff and Bryan 1992, pp. 258–60, 466–67, table 3.

42. Tefnin 1971, pp. 39–41. Linen shawls of this type were found with the burials of the parents of Senenmut (Hayes 1990, p. 204).

43. Compare the separate back supports of the statues of king and queen now in the Ashmolean Museum, Oxford, and the British Museum, London (Griffith 1931, pp. 179–84), and at the boundary stela A (Aldred 1988, pl. 14; here, fig. 103). The figures of princesses have one joint back pillar in this monument as in the one to which the Petrie Museum (here, figs. 104–7, no. 16) and Philadelphia (here, fig. 121, no. 37) princesses belonged. It is possible that the tighter join of these princesses' statues goes back to unfortunate experiences with the Louvre torso: two drill holes—one still filled with the remains of a metal pin—in the break of the right arm are signs of ancient repair work.

44. Boundary stelae statues: Aldred 1988, pl. 14. Statuettes in the Petrie Museum, London (figs. 104–7, no. 16), and the University Museum, Philadelphia (fig. 121, no. 37). See also, Hamburg 1965, p. 20, no. 21, fig. 12. An earlier example of a princess statue group with a similar gesture is the Princess Isis in the Ortiz Collection (Kozloff and Bryan 1992, pp. 206–8).

45. The Louvre seated king with remains of the hand and arm of a queen (N 831) is best seen in Leprohon (1991, p. 69). For a date of this piece in the post-Amarna Period, see Aldred (1951, pp. 84–85, pl. 134).

46. For example, the group of Akhenaten and Nefertiti in the Louvre (see Leclant et al. 1979, p. 175, fig. 162).

47. Aldred 1973, pp. 92–93, 106.

48. See pp. 10–11 and Aldred 1973, pp. 48–49. Meretaten is depicted on many scenes from the Karnak Aten temples performing rituals (R. Smith and Redford 1976, pls. 19, 22, nos. 1, 28–33) and thus cannot have been a small infant at the time the court moved to Amarna. She was probably born even before Amenhotep IV/Akhenaten ascended the throne. Edward Wente (J. E. Harris and Wente, eds., 1980, p. 255) argues that she was more than twelve years old by Year 5, which L. Green rejects as "most unlikely" (Green 1988, p. 530, n. 4).

49. Aldred 1973, pp. 116–17, no. 32; see also, the princesses in the relief from boundary stela S: N. Davies 1903–8, vol. 5, pl. 39.

50. Aldred 1988, pp. 169–82; Murnane 1995, p. 5.

51. Her name appears on a stone doorjamb in the northern city (Aldred 1988, p. 219). See also, Petrie 1894, pl. 42, for an inscription with Tiye's name from a quarry near Amarna.

52. Akhenaten had an elaborate gilded wood shrine made for the queen's burial; on this shrine the inscriptions of the didactic names of the Aten are in the later form that was introduced between Year 8 and Year 12 of the reign. This dates the queen's burial to at least Year 9 of Akhenaten's reign. See T. Davis et al. 1990, pp. 13–15, pls. 32, 33; Murnane 1995, pp. 100–101. For the date of the change of the names of the Aten after Year 8 and before Year 12, see Fairman (1951, pp. 152–53), Aldred (1988, p. 19, fig. 3, p. 278), and Murnane (1995, p. 8). Fragments of Tiye's sarcophagus were found in the Royal Tomb at Amarna (see Raven 1994, pp. 8–16). For a comparatively late date for this sarcophagus, see the late names of the Aten (ibid., p. 10, fig. 3). For the figure of Nefertiti, see here, p. 79, fig. 70.

53. Wine from the Queen Mother's estate was delivered to Akhetaten as late as Year 14, as attested by a docket written in ink from a jar found by Petrie at Amarna. See Petrie 1894, pl. 22, no. 14. The text is translated in Helck (1963, p. 527 [723]). For problems in using dates from jar dockets, see Redford (1967, pp. 94–95).

54. N. Davies 1903–8, vol. 3, pp. 4–7, pls. 4–7.

55. Ibid., pl. 5. The agricultural scene is, unfortunately, not very well preserved, but Davies's drawings attest to the predominant presence of women in the uppermost field. They may be reaping or harvesting flax (see Klebs 1934, pp. 21–22; Robins 1993, pp. 120–21).

56. N. Davies, 1903–8, vol. 3, pls. 8–12.

57. Stadelmann 1969, pp. 163–78; Kemp 1995, pp. 452–61.

58. Kozloff and Bryan 1992, pp. 170–71, 175–77, 202–3, 212–13, 289–90, 363–64; Hayes 1990, p. 269, fig. 164. The latter are representations of Tiye or of goddesses with similar facial features. For ebony statuettes, see Kozloff and Bryan (1992, pp. 211–12).

59. Especially in the later quartzite style, as demonstrated by Kozloff and Bryan (1992, pp. 141–42, 159–63), but also in granodiorite and granite images (ibid., pp. 145–46, 164–70).

60. Saleh and Sourouzian 1987, no. 144.

61. The piece has been assigned by Kozloff and Bryan (1992, p. 210) to a "Gurob [Ghurab] style," without implying that the head was actually made there. In fact, a Memphis or Delta workshop origin is most probable and would explain the "feel" for the organic that the head displays.

62. Kozloff and Bryan 1992, pp. 23–24.

63. Borchardt 1911, passim.

64. Kemp (1978, pp. 122–33), with references to the British excavations.

65. For Malqata: Arnold 1994, pp. 145–46, and Waseda University 1993, p. 58.

66. Borchardt 1911, pp. 14–23.

67. Chief among these are literary sources for a "harim palace" said to have existed in the Ghurab area (Gardiner 1943, pp. 37–46; see Kemp 1978, pp. 131–32, for additional references). These sources, however, are all of Ramesside date (Dynasties Nineteen–Twenty). None of the inscriptions or papyri that date to the time of Amenhotep III, Queen Tiye, and their son Akhenaten contain a reference to this palace (Griffith 1898, pp. 91–92, pls. 38, 39; Gardiner 1906, pp. 27–47). Another group of objects associated by scholars with a palace of Queen Tiye at Ghurab consists of statuettes of high-status women found in the region: Chassinat 1901, pp. 225–34, pls. 1–3; Quibell 1901, pp. 141–43, pls. 1, 2; Saleh and Sourouzian 1987, no. 154 (here, figs. 20, 64, 124). These female statuettes are indeed contemporary with Tiye, and one is of a Chief of the Household (see here, p. 27, fig. 20, no. 46), but nothing points to the fact that this was the queen's household in a palace at Ghurab. The report of 1901, which Chassinat (1901, pp. 225–27) obtained from local diggers, claimed that the statuettes of five different women were found in *one* tomb chamber. This seems extremely unlikely because there is no indication in the inscriptions giving evidence that the women were in any way related to one another. A mass burial of five unrelated females of high rank would be unparalleled. Should one rather assume that the statuettes came from a deposit associated with the cult of King Amenhotep III? Such deposits of female statuettes are known from the pyramid temples of Pepi II (Jéquier 1940, pp. 33–34, pl. 51) and Senwosret I (Arnold 1992, pp. 80–82, pls. 97–99).

68. Russmann 1989, p. 110; Kozloff and Bryan 1992, p. 210; Wildung 1995, p. 249.

69. Such as ceramic tiles, inlays, paintings on stucco and plaster; also, no ink-inscribed jars were found. See W. Smith 1981, pp. 283–95; Kozloff and Bryan 1992, pp. 18–20.

70. Petrie 1891, p. 20, pl. 24, no. 7; Borchardt 1911, p. 19, fig. 26, p. 20. Especially the latter inscription: "The King's Chief Wife, his beloved, the Lady of the Two Lands Tiye made it as her monument for her beloved brother [i.e., husband] for the *ka* of the Osiris the King [Amenhotep III] justified [i.e., deceased]" is a strong, hitherto insufficiently cited document that argues against a prolonged coregency of Amenhotep III and Akhenaten. See Murnane (1995, p. 5) with additional references. See also Kozloff and Bryan 1992, pp. 59–61, 211–12.

71. For a cult of the king at Amarna, see Redford 1967, pp. 111–12. A cult of the deceased Thutmosis III is well attested at Ghurab (see Loat 1905, pp. 1–2, 7–8, pls. 14–19).

72. Wildung 1992, pp. 133–47; id. 1995, pp. 245–49.

73. Tiye, who was already married to Amenhotep III in his second regnal year, must have been at least fifty years old when her son came to the throne (14 plus 37 equals 51). If one accepts a coregency, her age would be up to ten years less. See Kozloff and Bryan 1992, pp. 33, 41–43.

74. Egyptian Museum, Cairo (CG 42 127). See Sourouzian 1991, pp. 341–55, pls. 46, 47.

75. Moran 1992, p. 91; see also, ibid., p. 92.

76. Eaton-Krauss 1977, pp. 21–39.

77. Only a small piece of the inlay remains in the right brow; otherwise, the black resin adhesive is visible.

78. Wildung 1992, p. 141, fig. 6.

79. Borchardt 1911, p. 17, fig. 21 left. See also, Wildung 1992, p. 141, fig. 6.

80. N. Davies 1903–8, vol. 3, pls. 4, 6, 8, 9, 11, 18. Also on her funerary shrine (T. Davis et al. 1990, pl. 29).

81. MMA acc. no. 26.7.1409; see Hayes 1990, p. 261, fig. 157; ex Carnarvon Collection, unknown provenance. The fragment in its present shape was used as a stone scraper with the sharpened edge to the right (here, fig. 3). Originally, the piece was part of a cubically shaped object; there is a piece of carved surface at right angles to the one seen in fig. 3 with remains of another border behind Tiye's figure. A reconstruction of the piece as part of a throne on which a figure of King Amenhotep III sat can be envisaged.

82. Chicago 1980, pls. 24, 41, 42.

83. This would be different if a prolonged coregency of Akhenaten with his father is assumed (Murnane 1995, p. 5; Kozloff and Bryan 1992, pp. 59–61). See, however, note 70 above.

84. Gohary 1992, passim.

85. Eaton-Krauss 1977, pp. 29–32.

86. Edwards 1976, pls. 158–61.

87. Admittedly, Nefertiti appears on the sarcophagus with a plumed and horned modius crown, not a *khat*. But there is no suggestion of a cult for the deceased Akhenaten connected with this sarcophagus.

88. Wildung (1995, p. 249) interprets the change as a deification of Tiye after her husband's death. But was the round wig enough to make this an image of deification after the king's death, when the plumed crown had clearly been Tiye's normal headgear during the reign of her husband (Kozloff and Bryan 1992, pp. 170–71, 175–77, 202–3, 211–13), and the round wig had already appeared at that time in an image with otherwise queenly attributes (here, fig. 3)?

89. MMA acc. no. 26.7.1396. Hayes, 1990, pp. 259–60, fig. 156; Dorman, Harper, and Pittman 1987, p. 57, fig. 38. An Amarna date for the piece had already been advocated by Aldred (1973, p. 107).

90. It was first published in an exhibition catalogue of the Burlington Fine Arts Club in 1922 as a loan from the collection of the earl of Carnarvon just months before the discovery of the tomb of Tutankhamun: Burlington 1922, p. 80, pl. 6.

91. Egyptian Museum, Cairo, JE, no. 59740, mentioned by Hayes 1990, p. 102. The nose mentioned by Hayes, however, was shown by Christine Lilyquist in 1979 to join two mouth fragments found by Petrie at Amarna. A foot fragment of red jasper was also found at Amarna (Samson 1978, p. 64, fig. ii). Theban works in similarly hard stone are the bracelet plaques of Amenhotep III (Hayes 1990, pp. 242–43, fig. 147; here, figs. 4, 102).

92. Hayes 1990, pp. 259–60.

93. Robins 1993, pp. 180–81.

94. Phillips 1994, pp. 58–71, and above, p. 62. In the Thutmose workshop the tenon was of one piece with the head, not the body, which would have been a waste of precious material in the case of the jasper piece.

95. For the most impressive example, see Cooney (1965, pp. 20–22).

96. Aldred 1973, p. 187; more neck is covered in the reliefs (ibid., pp. 98, 99, 101); the back of the neck is free in ibid., p. 185. Good examples for a backward position of the lobes of the *khat* can be seen in some of the *shawabti* figures of the king: ibid., pp. 218–21. Martin 1974, pls. 26, no. 59, 29, 33, no. 97, 37, 42, no. 195.

97. N. Davies 1903–8, vol. 2, pl. 8. For cloth that is more forward at the side of the neck, see Aldred (1973, p. 56, fig. 33).

98. Eaton-Krauss 1981, pp. 245–51.

99. Aldred 1957b, pp. 141–47.

100. MMA acc. no. 31.114.1. Frankfort and Pendlebury 1933, pp. 61–62, pl. 44, nos. 1–3; Hayes 1990, p. 289, fig. 177.

101. Stela from Amarna in the British Museum (EA 57 399; Kozloff and Bryan 1992, pp. 213–14).

102. Aldred 1973, pp. 104–5, 109, 110, 126, 165, figs. 54, 182, 194.

103. See especially J. R. Harris 1974a, pp. 25–30; Thomas 1994, pp. 72–81.

104. Peet and Woolley 1923, pp. 109–24; Thomas 1994, pp. 74–77.

105. Woolley 1922, pls. 14, 80.

106. Translation from Allen (1991, p. 81). For philological uncertainties in this translation, see the brackets and question marks in ibid.

107. Petrie 1894, p. 10, pl. 10.

108. The shrine stela in Cairo (Borchardt 1923, pp. 2–24, pl. 1) is only slightly less advanced in introducing the new face of the queen. The extreme version of the early face of Nefertiti does not occur in the Amarna tombs. Still close to the early style are the queen's faces in the tomb of Parennefer (N. Davies 1903–8, vol. 6, pl. 4), tombs 20 and 22 (id., vol. 5, pls. 15, 16), Tutu (id., vol. 6, pl. 14). In most cases the old version of the Aten name is used on the same wall. The new face occurs with the earlier Aten writing in the tombs of Apy (id., vol. 4, pls. 31, 44) and Ay (id., vol. 6, pl. 29); and with the later version of the god's name: Mahu (id., vol. 4, pl. 15).

THE WORKSHOP OF THE SCULPTOR THUTMOSE

(pages 41–83)

1. Kemp and Garfi 1993, sheet 7. The broad east–west gap in the center of the main city was caused by water destruction (a wadi) in recent times but before the nineteenth-century excavations began.

2. Krauss 1983, pp. 119–32.

3. Schott 1980, cols. 833–36; Černý 1973; Valbelle 1985; Kemp 1989, pp. 56–63, with further references.

4. N. Davies 1903–8, vol. 3, pls. 17, 18. The scene is usually said to show Iuty working on the statue or painting it, but a scribal palette would not have been used for painting. Iuty must be applying correction lines with ink, as seen here in fig. 32.

5. Kemp 1989, p. 60.

6. Steinmann 1980, pp. 144–46; Eyre 1987, pp. 190–92.

7. Kemp 1989, p. 57, fig. 2.26, pp. 58–59.

8. Janssen 1975, especially pp. 558–62.

9. Borchardt and Ricke 1980, pp. 91–100; Phillips 1991, pp. 33–40, with further references.

10. For alabaster, see Borchardt and Ricke 1980, p. 95, no. 375 (Berlin inv. no. 21 290); Eaton-Krauss 1983, pp. 127–32, pls. 2–4. Other fragments of the same piece were found in

the well (Borchardt and Ricke 1980, p. 100, no. 1356) and between the "son's" house and the enclosure wall (Eaton-Krauss 1983, p. 127, n. 5; not in Borchardt and Ricke 1980). For obsidian, see Borchardt and Ricke 1980, p. 95, no. 447 (Berlin inv. no. 21 192).

11. Borchardt and Ricke 1980, p. 95, nos. 430 (Berlin inv. no. 21 336), 432 (Berlin inv. no. 21 224); chips of alabaster, no. 431. The excavator's designation is "east of room 18" in Thutmose's house, which must be the area north of the westernmost tree pit in the courtyard.

12. Ibid., p. 100, no. 1042 (Cairo); Borchardt 1913, p. 44, fig. 21.

13. Borchardt and Ricke 1980, p. 100, no. 1329 (Berlin inv. no. 21 289).

14. Ibid., p. 100, no. 746 (Berlin inv. no. 21 358).

15. Ibid., p. 90, no. 190 (Berlin inv. no. 21 238); Schäfer 1931, pl. 50.

16. Borchardt and Ricke 1980, p. 90, no. 423 (Berlin inv. no. 21 186); p. 91, no. 1326 (Berlin inv. no. 21 312).

17. Ibid., p. 91, no. 1250 (Berlin inv. no. 21 222).

18. Ibid., p. 91, no. 1327 (Berlin inv. no. 21 209).

19. Ibid., pp. 217–21. For walls of a previous building, see ibid., p. 218, plan 63.

20. Ibid., p. 220, no. 27.

21. Ibid., pp. 88–89.

22. Ibid., pp. 89–91, 95–98, 100. Remarkably, few metal tools are listed among the finds.

23. Ibid., p. 97, no. 748 (Berlin inv. no. 21 300); Borchardt 1923, pp. 30–38.

24. Borchardt and Ricke 1980, pp. 96–98. All pieces are from rooms 18 and 19, as numbered in Borchardt and Ricke: the main area of the deposit room (19) and the cubicle for storage (18).

25. Ibid., p. 92, plan 27.

26. Ibid., p. 98, no. 1279. For the use of side rooms of the first hall as "pantries," see Ricke 1932, p. 27.

27. Borchardt and Ricke 1980, p. 92.

28. Borchardt 1913, pp. 28–50.

29. Ibid., p. 29.

30. Roeder 1941, pp. 145–70; Lucas 1962, p. 77.

31. Borchardt and Ricke 1980, pp. 96–98, nos. 516–18, 522–27, 730–37, 739, 741, 743, 853–55, 857, 871, 1249, 1330; 1331 is a piece of 736.

32. San Francisco 1991, p. 42, lower left (Berlin inv. no. 21 349 [521]), found in the "reception hall": Borchardt and Ricke 1980, p. 96, no. 521, with plan 27 for numbers of rooms. Also: Settgast 1985, pp. 76–77 (Berlin inv. no. 21 299 [739]); ibid., pp. 90–91 (Berlin inv. no. 21 351 [743]); Roeder 1941, p. 157, figs. 11, 12 (Berlin inv. no. 21 353 [736]). Numbers in square brackets are from Borchardt and Ricke 1980, pp. 95–98.

33. San Francisco 1991, pp. 41–45, illustrates both variants.

34. For images of Amenhotep III, see Settgast 1985, pp. 76–77 (Berlin inv. no. 21 299 [739]), 96–97 (Berlin inv. no. 21 354 [527] called "queen's head" by the excavators and "king or queen" by Settgast). An identification of this head with any of the successors of Akhenaten (Kaiser 1967, pp. 71–72; Settgast 1985, p. 97) is ruled out by the date of this head as well as of the two related gypsum plaster heads. This is shown by the Metropolitan head (figs. 42, 44) to lie well within Akhenaten's reign. A female designation for Berlin inv. 21 354—despite the arguments advanced by Krauss (1978, pp.

43–46)—is ruled out by the presence of a Blue Crown. For a possible identification as Amenhotep III, compare the shrine stela (Aldred 1973, p. 10, fig. 3). For representations that are probably of Akhenaten, see ibid., pp. 90–91 (Berlin inv. no. 21 351 [743]), 94–95 (Berlin inv. no. 21 340 [526]); Priese, ed., 1991, pp. 102–3 (Berlin inv. no. 21 348 [741]); fragmented: Berlin inv. no. 21 343 [735]. For the seventh head, see below, note 36.

35. San Francisco 1991, p. 42, bottom left (Berlin inv. no. 21 349 [521]); Roeder 1941, p. 157, figs. 9, 10 (Berlin inv. no. 21 353 [736], smaller size); ibid., p. 157, figs. 11, 12. Both heads were thought by the excavators to represent a male king, but they were rightly identified as female by Roeder (1941, p. 151). See also, Krauss 1987, pp. 102–3, fig. 18.

36. Borchardt and Ricke 1980, p. 96 (Berlin inv. no. 21 355 [518]); Kaiser 1967, pp. 71–72, no. 770 (ill.).

37. Roeder 1941, p. 157, figs. 11, 12 (Berlin inv. no. 21 353 [736]).

38. Besides the two female faces in the checklist (nos. 10, 11), see Berlin inv. no. 21 341 [517] (here, fig. 38); San Francisco 1991, p. 43, bottom; Roeder 1941, p. 167, fig. 21, could be a man (Berlin inv. no. 21 281 [857]); ibid., p. 149, fig. 8 (Berlin inv. no. 21 347 [730]).

39. Aldred (1973, p. 182, no. 112) identified the wig as Nubian, but the horizontal arrangement of the curls shows it is a round wig, as in the relief (ibid., p. 193, no. 124).

40. Ibid., p. 179, no. 107 (Berlin inv. no. 21 228 [523]); Schäfer 1931, pl. 40 (Berlin inv. no. 21 262 [737]); Settgast 1985, pp. 100–101 (Berlin inv. no. 21 350 [522]); ibid., pp. 74–75 (Berlin inv. no. 21 356 [516]); Schäfer 1931, pl. 41 (Berlin inv. no. 21 359 [734]). Of lesser quality are Berlin inv. nos. 21 357 [1248] (Roeder 1941, p. 165, fig. 19, which could also be female), 21 280 [731], 21 342 [525], 21 346 [733], and 21 366 [871] (not illustrated).

41. Petrie 1894, frontispiece.

42. Borchardt 1913, p. 35.

43. Roeder 1941, pp. 154–60.

44. For the possibility that Akhenaten took part in artistic decisions, see Habachi 1965, p. 89.

45. Details indicating the juncture of the two molds are the fine lines that run over forehead, nose, mouth, and chin and below the ears on the neck (fig. 40). Other observations include folds of extremely thin linen that was evidently spread over the clay or wax model before casting (see Roeder 1941, pp. 155–58). The unpublished dissertation by Detlef Ullrich on the technical aspects of the gypsum plaster heads was not available at the time of writing; see Krauss 1991a, p. 7, n. 4. For the composition of the Amarna gypsum plaster, see Pendlebury et al. 1951, vol. 1, pp. 243–45.

46. San Francisco 1991, p. 43, bottom.

47. Both in the Egyptian Museum, Cairo. Saleh and Sourouzian 1987, no. 163 (JE 44 869); Aldred 1973, p. 55, fig. 32 (JE 44 870).

48. Berlin inv. no. 21 245 [868] (Settgast 1985, pp. 82–83), shaped to be part of the representation of a woman wearing an enveloping wig (Ay's wife, Tiy? See Aldred 1988, pp. 260–61, pl. 4). An identification as Kiya is probably ruled out by the necessity of reconstructing this image with an enveloping wig; the Nubian wig leaves more of the neck visible; see Krauss 1986, p. 80. The same woman may have been represented in the pink quartzite head found in the younger sculptor's house

(Borchardt and Ricke 1980, p. 100, no. 1329, Berlin inv. no. 21 289). Similarities between these female images and the wife of Bek (Settgast 1985, pp. 78–79) are striking.

49. For statuette fragments, see Borchardt and Ricke 1980, p. 98, nos. 1332, 1333; for arms and hands, ibid., p. 97, nos. 865, 869, 870, 874; for "unfinished sculpture," ibid., p. 98, no. 1039.

50. For instance, the statuette in Cairo (JE 53 249; Frankfort and Pendlebury 1933, p. 43, pl. 37).

51. For unfinished statue niches, see Meryre I (N. Davies 1903–8, vol. 1, pl. 2), Panehsy (ibid., vol. 2, pl. 2), Meryre II (ibid., vol. 2, pl. 28), Tutu (ibid., vol. 6, pl. 12), Ay (ibid., vol. 6, pls. 22, 37). For finished statues whose heads were later destroyed, see Huya (ibid., vol. 3, pl. 1), Ahmose (ibid., vol. 3, pl. 26). A statue was possibly removed from the tomb of Pentu (ibid., vol. 4, p. 2, pl. 1). A couple with battered faces were found in the tomb of Ramose (ibid., vol. 4, pls. 34, 45). For statues of tomb owners with battered faces, see May (ibid., vol. 5, pls. 1, 2), Any (ibid., vol. 5, pls. 8, 20).

52. Aldred 1988, pp. 220–22. There is certainly a strong resemblance between this face (here, fig. 28) and that of the mummy of Yuya (ibid., pl. 39).

53. N. Davies 1903–8, vol. 4, p. 21, pl. 45.

54. MMA acc. no. 11.150.26; see Aldred 1973, p. 174; Dorman, Harper, and Pittman 1987, p. 63, fig. 44; Hayes 1990, p. 288, fig. 176.

55. Aldred 1973, p. 174. For skin-color conventions, see Robins 1993, pp. 180–81.

56. Bothmer 1990, pp. 84–92; see especially, p. 89, pls. 26, 27, figs. 34, 35.

57. A broader face is found on Berlin inv. no. 21 354 [527] (Settgast 1985, pp. 96–97). The overall height is 20 cm (7⅞ in.), the height of the face 12.5 cm (4⅞ in.). A more slender face is found on Berlin inv. no. 21 355 [518]; Kaiser 1967, pp. 71–72, no. 770 (ill.; here, figs. 43, 45). The overall height is 21 cm (8¼ in.), the height of the face is 12 cm (4¾ in.).

58. Berlin inv. no. 21 340 [526]; Settgast 1985, pp. 94–95; San Francisco 1991, p. 43 top. The total height is 20.5 cm (8⅛ in.), whereas the height of the face is only 11 cm (4⅜ in.). MMA acc. no. 11.150.26: total height, 13 cm (5⅛ in.); face, also 11 cm (4⅜ in.).

59. N. Davies 1903–8, vol. 3, pls. 8, 10. The relationship of the Metropolitan head to the Sunshade temple statuary has been suggested by Aldred (1973, p. 174).

60. Ägyptisches Museum, Berlin, inv. no. 21 364; Borchardt 1912, pp. 23–25, figs. 16, 17; Schäfer 1931, pl. 25. The find spot was a group of small houses (O 49, 13) situated at the East Road South (High Priest Street), south of the Thutmose compound. The face of this head is more frontal and the mouth smaller than those of the Thutmose princesses.

61. In granite, Borchardt and Ricke 1980, p. 100, no. 750; Borchardt 1913, p. 45, fig. 22. In quartzite, a head in Borchardt and Ricke 1980, p. 100, no. 1045 (Aldred 1973, p. 131, fig. 51), and no. 1046. See also the quartzite head no. 1042 (Borchardt 1913, p. 44, fig. 21). From outside the Thutmose compound, head of a princess from house U 37, 1 at Amarna (Cairo JE 65 040): Wildung and Grimm 1978, no. 34. These smaller versions are closely related to the larger quartzite heads under discussion here. Stylistically somewhat different is the very small figure of marblelike stone (Berlin inv. no. 17 951; purchased): Lise Lotte Möller in Hamburg 1965, p. 21, no. 23,

figs. 53, 54. Of early date is a quartzite piece in a private collection, ibid., p. 20, no. 21, fig. 12.

62. Gerhardt 1967, pp. 51–56.

63. G. Smith 1912, pp. 51–56, pl. 36; Leek 1972, p. 28, pl. 7.

64. Bothmer and De Meulenaere 1986, pp. 10–12.

65. C. Müller 1980, cols. 291–92; Grieshammer 1984, cols. 212–13.

66. Karnak: R. Smith and Redford 1976, pls. 36, 37, 39, 41, 58, 63, 91; Amarna, officials: N. Davies 1903–8, vol. 1, pls. 8, 14, 35, 38; ibid., vol. 2, pls. 5, 7, 8, 10, 11, 22, 23, 33, 34, 37; ibid., vol. 4, pls. 9, 20, 22, 24, 26 (vizier); ibid., vol. 6, pls. 4, 6, 8, 15, 16, 18, 20, 29; priests and temple personnel: ibid., vol. 1, pls. 10A, 11, 22, 25, 27, 30; ibid., vol. 2, pls. 12, 18, 19; ibid., vol. 3, pls. 8, 10, 30; harpists and other musicians: ibid., vol. 1, pls. 21, 23; ibid., vol. 3, pls. 30, 33; son or family of deceased in offering or mourning scenes: ibid., vol. 3, pl. 22; ibid., vol. 5, pls. 10, 22, 23.

67. Servants: ibid., vol. 1, pls. 18, 29 (feeding cattle, for offerings?); ibid., vol. 2, pls. 14, 32; ibid., vol. 6, pls. 17, 19, 28.

68. For example, see ibid., vol. 6, pl. 30.

69. Martin 1991, p. 54, fig. 18; p. 55, fig. 19; p. 57, fig. 22; p. 75, fig. 46; p. 79, figs. 50–54; p. 85, fig. 56; p. 89, fig. 60; p. 107, fig. 67; pp. 128–31, figs. 84–90; pp. 202–5, figs. 122–28.

70. In reference to the Late Period shaved heads, Bothmer and De Meulenaere (1986, pp. 14–15), rightly stressed the infantile character of the elongated bare heads with high forehead and argued that "the Egyptians' yearning for a youthful appearance in life eternal" was the basis of such representations. One might go further and perceive the depiction of Late Period officials with "baby" heads and small mouths as indicating a hope for rebirth in the afterlife. This interpretation of the shaved head does not seem to apply to the bareheaded men represented in Amarna and post-Amarna reliefs.

71. Feucht 1995, pp. 497–98.

72. N. Davies 1903–8, vol. 2, pls. 5, 33, 34; ibid., vol. 6, pls. 2, 29; see ibid., vol. 2, pl. 10, where, exceptionally, the tallest princess has the bare head. See also, Aldred 1973, p. 119, no. 35; Roeder 1969, p. 182, no. 455/VII B, pl. 8. In the Cairo shrine stela (Saleh and Sourouzian 1987, no. 167) the correlation of names to princesses is somewhat confusing. We would like to suggest that the name Ankhesenpaaten, which appears above the head of Meretaten, refers to the bareheaded child. Significantly, in the Berlin family relief (here, fig. 88) the youngest daughter and the one cradled by Akhenaten (here, fig. 97) do not have side locks.

73. Murnane and Van Siclen III 1993, pp. 113–46; for the chronology, ibid., pp. 145–62.

74. N. Davies 1903–8, vol. 5, pp. 23, 26, pl. 44; Aldred 1973, pp. 116–17, no. 32; Murnane and Van Siclen III 1993, pp. 188, 192, 223 n. 20; Vassilika 1995, pp. 64–65 (no side lock ?).

75. This goes beyond the expression "egghead" used figuratively by Bothmer and De Meulenaere (1986, pp. 10–15).

76. Caminos 1975, col. 1185.

77. Assmann 1995, p. 158.

78. Murnane 1995, p. 114.

79. A three-dimensional representation of a chick emerging from a nest of eggs was found on the lid of an alabaster jar in the tomb of Tutankhamun. See Desroches-Noblecourt 1963, p. 227, pl. 47.

80. Eaton-Krauss 1983, pp. 127–32, pls. 1–4.

81. Ibid., pp. 129–31.

82. Reeves 1990, p. 190; Hildesheim 1976, no. 64.

83. Eaton-Krauss 1983, p. 131; Boyce 1995, pp. 345, 350: A16; MMA acc. nos. 10.130.2489; .2490; .2491; 26.7.1025; .1025; 45.4.12 (two pieces strung with other beads and amulets); Hayes 1990, pp. 290–91.

84. Gerhardt 1967, p. 54. For anatomical terms, see Pernkopf 1980, especially figs. 3, 26, 27, 136, 262, 283, 289.

85. Ibid., p. 54.

86. Feucht 1995, p. 498. See note 13, above, for references to princesses in reliefs.

87. N. Davies 1903–8, vol. 5, pl. 44; Murnane and Van Siclen III 1993, pp. 113, 114, 116, 121, 135.

88. See note 61, above.

89. Aldred 1973, p. 53, no. 53.

90. Kemp 1976, pp. 81–88; for the room with the painting, see p. 86; for the position of the painting, see Petrie (1894, p. 15, pl. 40).

91. Acc. no. 19893.1–41 (267); see Aldred 1973, pp. 38–39, fig. 20.

92. MMA acc. no. 30.4.135; see Wilkinson and Hill 1983, p. 133.

93. Now in the Petrie Museum, University College, London; see N. Davies 1921, pp. 1–7, pls. 3–4.

94. Ibid., pls. 1, 2.

95. Aldred 1973, p. 209, no. 147.

96. Ibid., p. 136.

97. There may have been a first version, with knees slightly higher, of the legs of the girl on the left. Remnants of this earlier version are seen in the erroneously added third "leg" at the back of the thighs of the girl on the left and in the darker areas around her feet.

98. Borchardt 1913, pp. 47, 48, figs. 23, 24.

99. For princesses with fruits, see Aldred 1973, p. 131, fig. 51 and n. 29; for the naked adolescent girl, see Robins 1993, pp. 185–86.

100. Phillips 1994, pp. 58–71; Griffith 1931, p. 181–82, pl. 26, fig. 1. For a recent find from Kom el-Nana of a lower torso in red quartzite with back pillar, see Phillips 1994, p. 66.

101. Borchardt and Ricke 1980, pp. 90–91, nos. 423, 1326; pp. 95–98, nos. 376, 432, 473, 858, 865, 866, 869, 870, 872, 873, 874, 1332; p. 100, no. 581.

102. The method may have been to set a partially cut headdress piece onto the head tenon, then shave off all projections touched by red paint.

103. Pieces found in the Thutmose workshop were parts of a royal *nemes* (Borchardt and Ricke 1980, p. 97, nos. 1035, 1036) and a princess's side lock (ibid., p. 98, no. 1040).

104. MMA acc. no. 22.5.2; see Hayes 1990, p. 235, fig. 140.

105. It should be noted that the shoulder attachments of the Metropolitan Museum statue of Amenhotep III remained in place through the various dislocations the piece underwent when it was inscribed with the names of King Merneptah and erected at the side entrance to the Luxor temple.

106. Checklist no. 43 and Saleh and Sourouzian 1987, no. 163 (Cairo JE 44 869); Borchardt and Ricke 1980, p. 97, no. 740; this head—like the other princess head in Cairo (here, no. 43)—was found in the small cubicle that was once a cupboard in the deposit room.

107. This feature is also seen in a princess's head, now on long-term loan in the Museum of Fine Arts, Boston (Borchardt 1912, pp. 23–25, figs. 16, 17; Borchardt and Ricke 1980, p. 252, no. 403; Berlin inv. no. 21 364), from house O 49, 13, see note 60, above.

108. Aldred (1973, p. 160) identifies the Berlin head with Meretaten.

109. Berlin inv. no. 21 217; Borchardt and Ricke 1980, p. 95, no. 390. On the preserved lower part, a center line in ink is visible.

110. Berlin inv. no. 21 360; Borchardt and Ricke 1980, p. 98, no. 1300. The best illustration is Kaiser (1990, pp. 280–85, pl. 66, nos. 3, 4).

111. A very similar bust, of unknown provenance, is in the Musée du Louvre, Paris: Bénédite 1906, pp. 5–27, pls. 1, 2.

112. Berlin inv. no. 21 300; Borchardt and Ricke 1980, p. 97, no. 748; Settgast 1985, pp. 92–93; Borchardt 1923, pp. 30–40; Anthes 1958.

113. Good illustrations can be found in Borchardt (1923, pl. 5) and Anthes (1958, p. 17).

114. The existing—and often conflicting—art historical views on the Nefertiti bust have been succinctly summarized by Krauss (1991c, pp. 143–51).

115. Borchardt 1923, p. 32; Wiedemann and Bayer 1982, pp. 619A–628A.

116. Krauss 1987, pp. 89, 117, n. 13.

117. Borchardt 1923, p. 33; see also, Kaiser 1967, p. 71.

118. The adhesive used to fix the right eye appears to be wax (Wildung 1992, p. 148).

119. The missing eye inlay cannot be explained by the bust having been unfinished when it was deposited, because the piece is not a late product of the Thutmose workshop (see above, p. 70).

120. Krauss 1987, p. 102; Kaiser 1990, pp. 280–85.

121. Besides the three busts from the Thutmose workshop deposit mentioned above, there is one depicting a young successor of Akhenaten, now in Berlin (inv. no. 20 496; Priese, ed., 1991, pp. 120–21), which was found in another sculptor's workshop, given the number P 49, 6 by the excavators (Borchardt and Ricke 1980, pp. 266–67, no. 751).

122. Krauss 1991c, pp. 150–53; id. 1991b, pp. 46–49.

123. Published as the cover of the periodical *Berliner Beiträge zur Archäometrie*, vol. 1 (1976).

124. There is a noticeable indentation at this point between the brow ridge and the forehead; see here, fig. 60.

125. A projection of this kind is legitimate because ancient Egyptian artists started a sculpture by drawing on the sides of a cubic stone block. See Schäfer 1986, pp. 327–34.

126. Wildung 1992, pp. 147–48, figs. 12, 13 on pp. 150–51.

127. Borchardt 1923, p. 32; Anthes 1958, pp. 6–8.

128. Anthes 1958, pp. 10–11; Krauss 1991c, p. 147.

129. Borchardt 1923, p. 33.

130. Krauss 1991c, p. 144.

131. For a straight, or almost straight, neck in representations of the king and queen at Karnak, see R. Smith and Redford 1976, pls. 5, 8, 10, 19, 20, 21; see here, figs. 10, 11. For rare straight necks at Amarna, see here, figs. 5, 19, 20, 85.

132. Breasted 1948, especially pls. 9a, 9b, 15–20, 30, 31b, and from the New Kingdom, pls. 22–24.

133. Kozloff and Bryan 1992, pp. 251–52; Hayes 1990, p. 265, fig. 160.

134. Spencer 1993, p. 75.

135. Berlin inv. no. 21 352, thought by the excavators to have been an image of Akhenaten. See Borchardt and Ricke 1980, p. 97, no. 744; Aldred 1973, pp. 172–73.

136. Berlin inv. no. 21 349, found in the columned reception hall (figs. 34, 35:5) just in front of the entrance to the deposit room

(Borchardt and Ricke 1980, p. 96, no. 521, with plan 27 for the numbers of the rooms).

137. Pendlebury et al. 1951, vol. 1, p. 19.

138. Fisher 1917, pp. 227–28, fig. 88; Saleh and Sourouzian 1987, no. 162.

139. For the Blue Crown, see Aldred (1973, pp. 98, 166–69); for the tall, flat-topped crown, ibid. (pp. 102, 112, 116, and passim). The cap crown is discussed in Fay 1986, pp. 359–76.

140. For Smenkhkare, see Aldred 1951, pl. 135.

141. See Fay 1986, no. 54.

142. Löhr 1975, pp. 155–57.

143. In the literature on Egyptian women there is, up to now, no in-depth study of the female image in art.

144. Tefnin 1979, passim. Measurements show that the distance between the ear and the nostril on the granite Hatshepsut in The Metropolitan Museum of Art (acc. no. 29.3.3; Hayes 1990, pp. 100–101) is one-fourth greater than in the Memphite Nefertiti and one-half greater than in the three princesses' heads in Berlin and Cairo. The distance between the ear and the jawbone is double that of the Berlin princess and slightly less than double that of the Memphite head.

145. Murnane 1995, p. 135.

146. Ibid., p. 147.

147. MMA acc. no. 1993.326; see Roehrig 1994, p. 9; Roeder 1969, pl. 185, no. PC 90. For the date of reliefs of this style, see Aldred (1973, pp. 186–87, 192 passim).

148. Technically, one should note the repair to the stumplike tenon on top of the head and the dark brown paint that covers most of the areas intended to receive the headdress. See note 102 for a possible explanation of the red pigment.

149. For remains of other limestone statuettes from the workshop, see Borchardt and Ricke 1980, p. 98, nos. 1044, 1049, 1337.

150. This can be deduced from the different numbers that the various fragments received in the excavators' journal (Borchardt and Ricke 1980, pp. 97–98, nos. 749, 856, 1041, 1276, 1278). The original parts of the piece are best seen in Aldred (1951, pls. 119–20).

151. See, for example, N. Davies (1903–8, vol. 1, pl. 30: Nefertiti and daughters; vol. 2, pl. 10: daughters and foreigners; vol. 3, pl. 8: king, Queen Tiye, daughters, and nurses).

152. This one-sided sleeve is a well-documented feature of Amarna dress. See N. Davies (1903–8, vol. 1, pl. 30) for a very similar figure of the queen.

153. Other examples are found in Borchardt 1913, pl. 4.

154. Fay 1986, pp. 359–76.

155. Martin 1974, 1989, vol. 1, pp. 28–29, pl. 21, no. 8; Raven 1994, p. 12.

156. Borchardt and Ricke 1980, p. 99, plan 27: room 11. For the piece, see ibid., p. 100, no. 746.

157. For the stone called "black granite" by the excavators, which is mottled gray on the rough surface but very dark gray to black in the break, see Klemm 1993, pp. 342–50; Borchardt and Ricke 1980, pp. 89–100.

158. Borchardt and Ricke 1980, pp. 97–98, nos. 1035, 1036, 1040.

159. Ibid., p. 95, no. 430. Berlin inv. no. 21 336 (8.5 cm [3⅜ in.] in width).

160. Ibid., p. 99, plan 27: rooms 5, 6, 10.

161. Among the statue fragments from the Great Aten Temple in the Metropolitan Museum are hundreds of pieces of indurated limestone but only a few of diorite. These include fragments

of a neck (MMA acc. no. 21.9.495), a finger (MMA acc. no. 21.9.494), and a shoulder (MMA acc. no. 21.9.535).

162. See the statuette of Akhenaten from house N 48, 15 in Amarna, now in the Cairo Museum, JE 43580 (Saleh and Sourouzian 1987, no. 160; Borchardt 1912, pp. 24–27, pls. 2–4).

163. Russmann 1989, pp. 130–32; El-Saghir 1991, pp. 65–68, figs. 141–48; W. R. Johnson 1994, pp. 128–49.

164. MMA acc. no. 07.228.34; Hayes 1990, p. 300, fig. 185.

165. Memphite sculptures in diorite from the post-Amarna Period are stylistically different; see Hayes 1990, pp. 304–5, fig. 190.

ASPECTS OF THE ROYAL FEMALE IMAGE DURING THE AMARNA PERIOD (pages 85–119)

1. Cooney 1965; Roeder 1969; Hanke 1978 (all passim); Aldred 1973, p. 238. For the Lady of the Two Lands title, see Green 1988, pp. 303–5.

2. MMA acc. no. 1985.328.15, Gift of Norbert Schimmel, 1985; Mertens et al. 1992, p. 58, no. 41; Aldred 1973, p. 133.

3. Also at Karnak: R. Smith and Redford 1976, p. 81, pl. 23, no. 2.

4. Green 1988, pp. 420–22; R. Smith and Redford 1976, pp. 80–82, pl. 8, nos. 3, 4, pls. 10, 77. For her role in the *sed*-festival, see Gohary (1992, pp. 40–44, pls. 1, 2; p. 46, pl. 4; p. 59, pl. 18; pp. 61–62, pl. 20; p. 83, pl. 38).

5. Robins 1993, pp. 145–48.

6. R. Smith and Redford 1976, pl. 8, no. 4.

7. Ibid., pp. 80–81, pls. 19–23, 29–31; Redford 1984, pp. 75–78, figs. 6, 7; Loeben 1994a, pp. 41–45.

8. Robins 1993, p. 25, fig. 2, pp. 45–52.

9. Robins 1995, p. 19.

10. Green 1988, p. 422; Aldred 1973, pp. 127, 192 (object not visible).

11. R. Smith and Redford 1976, pp. 83–84, pl. 30; Aldred 1973, pp. 88, 118, 127, 185; for an exception with raised hands, see ibid., p. 137. For royal women with sistra in offering scenes before the Amarna Period, see Robins (1993, pp. 41, 145–48, 156).

12. In the tomb reliefs, the queen's head usually reaches to about the king's shoulder; for example: N. Davies 1903–8, vol. 1, pls. 22, 30; vol. 2, pls. 5, 7, 12; vol. 4, pl. 15; vol. 6, pl. 2; for greater difference in height, see ibid., vol. 2, pl. 8; vol. 5, pl. 3 (because of the tall crown?). Even taller than Nefertiti is Queen Tiye, who almost reaches her son's height in the Sunshade temple scene. See ibid., vol. 3, pl. 9.

13. Hathor connection: Troy 1986, pp. 73–91. For the function as "god's wife," see ibid., pp. 97–99, and Robins 1993, pp. 43–45, 151–53. For illustrations, see ibid., p. 26, fig. 3 ("donation stela" for Queen Ahmes Nefertari), p. 43, fig. 8; Naville 1907, pls. 27, 28. Wives and children were commonly included in funerary cult scenes in the nonroyal sector, and one wonders whether influences coming from this private realm made possible and acceptable the remarkably widespread inclusion of the queen and princesses in the cult in Amarna temples (M. Müller 1982, pp. 281–84; id. 1988, pt. 2, pp. 109–21). It would not be the only instance in which the official Amarna art was opened up to influences from the private sphere.

14. Porter and Moss 1972, p. 544; "Queens and Princesses with King" as opposed to p. 542Ia, b, d.

15. Hanke 1978, pp. 106–32. For Meretaten, see especially the two blocks in The Brooklyn Museum (Aldred 1973, pp. 185, 193) and the scene in the tomb of Meryre II (N. Davies 1903–8, vol. 2, pl. 41).

16. Aldred (1988, pp. 178–81, 279–81) actually described this celebration as the accession of Akhenaten to the throne after a twelve-year coregency. He linked the festivities with a visit of Akhenaten to Thebes that is attested by a hieratic note on cuneiform letter EA 27 (Moran 1992, pp. 86–90). According to Aldred, the occasion of this visit was the death and funeral of Amenhotep III. The reading of the date in the hieratic note is, however, uncertain and could be "Year 12" or "Year 2" (see ibid., pp. xxxvii–xxxviii, n. 135). However the coregency question is resolved, the festivities of Year 12 are described as the "appearance [of the king] on the throne of his (divine and royal) father, the Aten . . ." (Murnane 1995, p. 162). See n. 177 below for a possible connection between the festival and a victory in Nubia.

17. Furniture adorned with lions, which is represented in the palanquin for the king and queen in the tomb of Huya (N. Davies 1903–8, vol. 3, pl. 13) as part of the Year 12 festival, was a traditional element of thirty years' festivals; see Gohary 1992, pp. 7, 10–11, 19, 139. For lion palanquins, see ibid., pp. 151–52, pl. 94.

18. N. Davies 1903–8, vol. 3, pls. 13–15; Murnane 1995, pp. 134–35.

19. N. Davies 1903–8, vol. 2, pls. 37–40; Murnane 1995, pp. 162–64.

20. Thomas 1994, pp. 72–81.

21. Hanke 1978, pp. 175–87, figs. 59–61. For the changes of names in inscriptions, see ibid., pp. 133–70, and Murnane 1995, pp. 90–92.

22. For Kiya's role in rituals, see Hanke 1978, pp. 90–92, 97–98.

23. Aldred 1988, p. 285.

24. J. R. Harris 1974b, pp. 11–21, with earlier literature.

25. Allen 1991, pp. 74–85; Allen 1994, pp. 7–17; Loeben 1994b, pp. 104–9. All with further references.

26. Gardiner 1928, pp. 10–11, pls. 5, 6.

27. Murnane 1995, p. 208.

28. Allen 1991, pp. 74–85, and Murnane 1995, pp. 10, 205–8, with earlier references.

29. Allen 1991, p. 85, n. 56.

30. Krauss (1978, pp. 1–47) has argued for Meretaten as sole ruler before her marriage to Smenkhkare.

31. Loeben 1986, pp. 99–107.

32. For other examples, see Aldred 1973, p. 94, no. 7; p. 98, no. 12; p. 101, no. 15.

33. Aldred (1973, p. 191) has argued for a close connection between the plaque and the Thutmose workshop. Romano (1995, p. 91) suggests an identification of the King with Tutankhamun. The present author does not feel that the similarities between the Wilbour king and the Luxor relief go beyond stylistic traits. The Luxor king, for instance, has a straight nose.

34. Since the strong rejection by Cyril Aldred (1973, p. 190), doubts about the authenticity of the Wilbour plaque have recently been reiterated by Thomas Hoving (1996, pp. 330–31). Such doubts are rejected here again with conviction. Aside from the sheer quality of the piece, a simple iconographic observation speaks for this being a work by an Egyptian artist of the late Amarna Period. The uraeus cobra on the queen's cap crown coils its body in a complicated triple curve. The closest parallel to that pattern of curve on that particular crown is found on the limestone statuette of Nefertiti (here, figs. 68, 69). The plaque was acquired by Charles Edwin Wilbour at Amarna in 1881; the limestone statuette was excavated in 1912. Relief representations of the queen in this rarely worn crown were known in 1881 (N. Davies 1903–8, vol. 6,

pl. 14; vol. 1, pl. 30) but none of them show that particular pattern of the coiled cobra (see also Fay 1986, pp. 359–76), and it would have been a rare faker who had, in 1881, when knowledge of Amarna art was slight indeed, the foresight to combine a complicated cobra curve that he might have seen on an image of Akhenaten in the Blue Crown (N. Davies 1903–8, vol. 4, pls. 31, 35) with an unusual headdress of Nefertiti in just the way seen on a piece that would be excavated thirty years later. The rather curious inclusion of the queen's clavicles is paralleled on a head in the tomb of Pentu (N. Davies 1903–8, vol. 4, pl. 7).

35. A connection between the Wilbour plaque, the limestone statuette, and a relief block in Berlin was made by Fay (1986, pp. 359–76).

36. The figure of the king seated with one arm falling at his back and the other raised and bent recurs in several of the domestic shrine stelae; see Borchardt 1923, p. 18, figs. 13, 14, pl. 1.

37. N. Davies 1903–8, vol. 5, pls. 8, 21–23.

38. For example, see Peet and Woolley 1923, pl. 28. For the ancestor cult, see Bomann 1991, p. 68 and passim.

39. For earlier suggestions, see Aldred 1973, p. 184; J. R. Harris 1973a, p. 15; Allen 1991, p. 76.

40. For Karnak, see R. Smith and Redford 1976, pls. 1–23, especially pl. 8, no. 1. For Amarna, see also Aldred 1973, pp. 95–96, 98, 100–101.

41. One might also consider the pectoral worn by the king (in the center of the stela). Such ornaments are not common for Akhenaten, but they are for Amenhotep III (Kozloff and Bryan 1992, pp. 436–37).

42. We refrain from discussing in detail the so-called coregency stela; see Allen 1991, pp. 76–77, fig. 4; p. 79, n. 14. We also leave aside the small unfinished stela in Berlin (inv. no. 20 716; Schäfer 1931, pl. 31), although it appears to be a late Amarna work and, in fact, is best explained as showing Akhenaten and Nefertiti (in Blue Crown) as corulers.

43. Desroches-Noblecourt 1978, pp. 20–27.

44. Roehrig 1990, pp. 262–67.

45. N. Davies 1903–8, vol. 2, pls. 33, 34; vol. 3, pl. 17; vol. 6, pls. 4, 29. For ordinary people carrying the gold on plates, see ibid., vol. 4, pl. 9.

46. Ibid., vol. 1, pl. 22; vol. 3, pls. 4, 16; vol. 4, pl. 15; vol. 6, pls. 3, 4, 17, 26, 40.

47. Ibid., vol. 2, pl. 33; vol. 6, pls. 20, 29.

48. See also, ibid., vol. 3, pl. 34, and Saleh and Sourouzian 1987, no. 167.

49. Krauss 1978, pp. 43–46; Allen 1991, pp. 74–76 with fig. 1; N. Davies 1903–8, vol. 2, pl. 41. The latter is also a scene of bestowing the Gold of Honor.

50. Borchardt 1923, pp. 3–19, pl. 1.

51. Murnane 1995, p. 78.

52. Martin 1974, 1989, vol. 2, pp. 17–50, pls. 1–14, 19; G. Johnson 1991, pp. 50–61.

53. Martin 1974, 1989, vol. 1, pp. 13–30, 104, pls. 6–15; Raven 1994, pp. 7–20. Most fragments of the sarcophagus are in Cairo; they have been preliminarily reconstructed in the garden of the Egyptian Museum.

54. Ibid., p. 17, fig. 10.

55. Martin 1974, 1989, vol. 1, pls. 6–9. The details of the reconstruction of Akhenaten's sarcophagus are currently being studied by various scholars, and a new reconstruction is planned. (May Trad, personal communication.)

56. Nims 1973, p. 183; Bothmer 1990, pp. 88–89, pl. 26, figs. 30–33. Both scholars point out that this manner of rendering the eye goes back at least to the reign of Akhenaten's father.

57. Martin 1974, 1989, vol. 1, pp. 47–54, pls. 29–33. See also, *shawabtis* in other materials, ibid., pp. 54–55, pl. 36, nos. 136, 138; pp. 55–56, pl. 37, no. 142 (limestone); pp. 62–63, pls. 40, 41, nos. 190–93 (quartzite); p. 67, pls. 45, 46, nos. 216, 218–21 (sandstone).

58. Aldred 1973, p. 219, no. 166.

59. Berlin inv. no. 19 524; Schäfer 1931, pl. 57; Reeves 1990, p. 105.

60. T. Davis et al. 1912, pls. 65–73.

61. Reeves 1990, pp. 119–22.

62. Daressy 1902, pp. 243–44, pl. 50.

63. Wilson 1973, pp. 235–41; Tawfik 1981, pp. 472–73.

64. Wilson 1973, pp. 239–40.

65. Green 1992, pp. 28–41.

66. Green 1988, pp. 450–60; for the last quote, see ibid., p. 456.

67. Murnane 1995, pp. 160–61.

68. Ibid., p. 161.

69. Aldred 1988, p. 305. The scene is in room alpha of the Royal Tomb at Amarna; see G. Johnson 1991, p. 57. For the present condition, see Martin 1974, 1989, vol. 2, pls. 58, 60, 61.

70. N. Davies 1903–8, vol. 2, pl. 32; vol. 3, pls. 4 (here, fig. 110), 6, 18, 32a, 34; vol. 4, pls. 20, 22; vol. 6, pls. 3, 17, 29.

71. Mertens et al. 1992, cover and p. 26.

72. Borchardt 1923, pp. 3–24, pl. 1.

73. Schäfer 1931, p. 42.

74. M. Müller 1988, pt. 2, p. 115.

75. Aldred 1973, p. 102.

76. Hamann 1944, pp. 242–43; Groenewegen-Frankfort 1951, p. 105; Krauss 1991a, pp. 19–23.

77. W. Davis 1978, p. 388; Krauss 1991a, pp. 7–36. For additional compositional peculiarities, such as the uneven height of the mat on which the royal pair sits, the bases of the columns, and the width of the sky bar above the couple, see Krauss 1991a, pp. 14, 30.

78. See also, Krauss (1991a, p. 17), where he makes a close comparison with the tomb of Tutu, and N. Davies 1903–8, vol. 6, pls. 17v, 19.

79. For similarly intricate figure arrangements, see the tomb of Meryre II (N. Davies 1903–8, vol. 2, pls. 32–41) and Aldred (1973, p. 196).

80. Aldred 1973, pp. 10–11, fig. 3. Here the top is similar to the Berlin fragment (fig. 98), whereas the elaborate frame is reminiscent of the Cairo stela (Borchardt 1923, pl. 1).

81. Borchardt 1923, p. 18, figs. 13, 14. Each shows a figure of the king or queen in the same pose that Akhenaten assumes in the Cairo relief (see here, fig. 94); they were probably carved in the same workshop as the Cairo piece, the British Museum fragment at a somewhat later date than the Cairo stela.

82. Ibid., pp. 20–24; Borchardt and Ricke 1980, p. 132.

83. Borchardt and Ricke 1980, p. 255.

84. Krauss 1991a, pp. 35–36.

85. Ikram 1989, pp. 91–93, 95–96, with the repeated listing of "king worshipping Aten," "royal family offering to Aten," etc.

86. Griffith 1931, pp. 179–84, pls. 23, 24. The statues are now in the Ashmolean Museum, Oxford (king), and the British Museum (Nefertiti).

87. For ancestor cults in private chapels, see Bomann 1991, pp. 68–69.

88. Griffith 1926, p. 2. For the term *loggia* used in this text, see Peet and Woolley 1923, pp. 39–40.
89. Krauss 1991a, pp. 7–9 with fig. 2.
90. Borchardt 1923, pl. 1.
91. Bruyère 1939, pp. 67, 193–204; Demaree 1983, pp. 30, 106–8, 286–87. Most Deir el-Medina stelae are of the round-topped type, but the niches appear to have been fitted with shrine cornices and jambs (Bruyère 1939, pp. 193–96, pls. 15, 16).
92. Most elaborate is the stela (57 399) in the British Museum (Aldred 1973, pp. 10–11, fig. 3) with a uraeus frieze very similar to the one on the Berlin fragment (see here, fig. 98). The British Museum piece also has plant decorations on the side pilasters and a frieze of grapes, and is thus close in shape to the baldachin in fig. 99 here. The Cairo stela (JE 44865; Borchardt 1923, pl. 1; detail, fig. 94 here, does not include the frame) has a simpler cornice and torus on top of two side pilasters.
93. Aldred 1973, pp. 10–11, fig. 3.
94. For illustrations demonstrating the use of mats to highlight the recipients of offerings, see Lange and Hirmer 1961, pls. 221, 222 (to gods); Wilkinson and Hill 1983, pp. 97, 100 (to the deceased). Mats were also used for persons of high status: guests at the funerary festivals, ibid., p. 96; and the king and queen, ibid., p. 125. See also Krauss 1991a, p. 14, with further references.
95. The horizontal bar in this relief must be reconstructed with the two downward pointing triangular ends of a sky ideogram (Krauss 1991a, p. 14). According to Amarna convention, the sun disk was always placed below a sky emblem (N. Davies 1903–8, vol. 1, pl. 10; vol. 2, pls. 5, 7, 8; vol. 3, pl. 4) or, at least, on the lower line of the sky ideogram (ibid., vol. 1, pl. 30; vol. 2, pls. 10, 12–14, 18, 20). However, a version of the sky emblem with rounded ends was used most frequently in Amarna reliefs.
96. From the Old Kingdom on, the sky ideogram was depicted above all types of scenes, but especially above representations of kings and gods. Compare, for example, the relevant scene from the tomb of Kheruef in which Amenhotep III and Queen Tiye are seated on thrones under a double baldachin topped by the sky ideogram (Chicago 1980, pl. 47 left).
97. Krauss 1991a, p. 14.
98. Andrews 1991, p. 129, fig. 112; p. 131, fig. 114. From the tomb of Tutankhamun: ibid., p. 136, fig. 119; p. 62, fig. 47 (with pillars).
99. Feucht 1967; id. 1971.
100. Assmann 1995, p. 80.
101. Allen 1988a, pp. 14–27; Assmann 1995, pp. 178–89.
102. Allen 1988a, p. 9; Troy 1986, p. 136.
103. Allen 1988a, pp. 27–29.
104. N. Davies 1903–8, vol. 3, pls. 16, 17; vol. 6, pls. 4, 29; Krauss 1991a, pp. 23–24.
105. Krauss 1991a, pp. 23–24.
106. Brunner-Traut 1955, pp. 11–30; Robins 1993, p. 83.
107. Vandier d'Abbadie 1937–[46], pls. 49–54, nos. 2335, 2336, 2341–2343, 2346, 2351, 2352.
108. Klebs 1934, pp. 188–90; Arnold 1994, p. 95 (Gotteszelt).
109. Wilkinson and Hill 1983, p. 144 (MMA acc. no. 30.4.145). For the *senet* game, see Kendall 1978.
110. Kemp 1979, pp. 47–53.
111. Robins 1993, pp. 185–86.

112. N. Davies 1917, pl. 24; Brack 1980, pl. 70. For the tomb of Menna, see Wilkinson and Hill 1983, p. 121 (MMA acc. no. 30.4.48). For the pointed finger as a magical gesture, see Pinch 1994, pp. 59–60, 121.
113. For the frequency of Bes and Taweret in Amarna amulets, see Boyce 1995, pp. 338–39, fig. d, p. 342. For the paintings, see above, n. 110.
114. Assmann 1975b, p. 322, pl. 299.
115. See, for example, Hornung 1990b, p. 85, fig. 52.
116. Petrie 1891, p. 20, pl. 24, no. 10.
117. The style of this limestone block in the University Museum, the University of Pennsylvania (acc. no. E 325), is different from reliefs at Amarna and is closest to the Memphite work seen here in figure 18.
118. For the amount of white or some other light color at the time of excavation, see Petrie 1894, pl. 1.
119. The interior of the basket is divided into four compartments, which are depicted as if they were on top of the basket and turned 90 degrees toward the viewer. See Schäfer 1986, p. 101, n. 40, p. 355, fig. 329.
120. Cairo group: Saleh and Sourouzian 1987, no. 168; Brooklyn relief: Aldred 1973, pp. 164–65, no. 92.
121. For an Old Kingdom scene, see Moussa and Altenmüller 1977, p. 163, pl. 91. For a Middle Kingdom example, see Lange and Hirmer 1961, pl. 95.
122. Eaton-Krauss and Graefe 1985, pp. 34–35, pl. 17. For the use in Amarna houses of floral collars made of faience, see Boyce 1995, pp. 336–71, especially p. 342.
123. Saleh and Sourouzian 1987, no. 179.
124. N. Davies 1903–8, vol. 2, pl. 32.
125. Kemp 1995, pp. 411–62. For the designation as "parklands," see ibid., p. 454.
126. Ibid., p. 452.
127. Ibid., pp. 413–32.
128. Peet and Woolley 1923, pp. 109–24.
129. MMA acc. nos. 23.2.32, 33: Hayes 1990, p. 290; Peet and Woolley 1923, pls. 36, 37, 39. The painting (Hayes 1990, p. 291, fig. 179) is not from Amarna but from the palace of Amenhotep III at Malqata, a fact that was discovered by Fran Weatherhead (personal communication to the Department of Egyptian Art, The Metropolitan Museum of Art).
130. Peet and Woolley 1923, pls. 31, 32, 62; Kemp 1995, pp. 418–25.
131. Kemp 1995, pp. 454–60.
132. Murnane 1995, p. 90.
133. See here, pp. 14–15; Hanke 1978, pp. 188–96; Helck 1980, cols. 422–24; id. 1984, pp. 159–67, with references; Thomas 1994, pp. 72–81.
134. Hanke 1978, p. 140.
135. Ibid., figs. 60, 61: B 1–4.
136. MMA acc. no. 1985.328.8; Mertens et al. 1992, p. 57, no. 37; Cooney 1965, pp. 29–30.
137. For comparison, the face of Kiya on her coffin in the Cairo Museum is very damaged; only the wooden core of the coffin and one eye on the gold outer shell are preserved; a good illustration is in Romer (1981, plate opposite p. 217). Very tentatively it may be suggested that the unfinished head of quartzite found in the area of the houses O.47.16a and O.47.20 farther south from the workshop of Thutmose (Saleh and Sourouzian 1987, no. 161) does not represent Nefertiti but Kiya.

138. Hanke 1978, pp. 128–29, pls. 38, 39. For the position of the rays compare, for instance, N. Davies 1903–8, vol. 1, pl. 22, with Akhenaten at the altar.

139. On the original creation of this throne during the Amarna Period, see Saleh and Sourouzian 1987, no. 179.

140. Aldred 1978, p. 57.

141. Troy 1986, pp. 37–38.

142. Kozloff and Bryan 1992, pp. 443–44.

143. The throne of the statue group of King Haremhab and Queen Mutnedjmet includes the same plant crown on a winged sphinx; see Donadoni Roveri, ed., 1989, p. 153, fig. 237. Associations with the headdress of the goddesses Anukis and Satis of Elephantine (Valbelle 1981, passim) are usually rejected by Egyptologists (Kozloff and Bryan 1992, p. 444).

144. Montet 1937, pp. 110–11, 141, 172–74.

145. Stadelmann 1967, pp. 88–96. Although Stadelmann finds no fertility cult performed in Egypt for the goddess Anat (ibid., p. 94), she cannot have lost her Near Eastern character completely. The fact that the sources appear to show the tall, flat headdress as a hairstyle leads to a question: Does the peculiar surface of Nefertiti's crown in a relief of the Royal Tomb at Amarna indicate hair? In a brilliant find, the relief was rediscovered by George B. Johnson (G. Johnson 1991, pp. 50–61, especially pp. 60–61).

146. Feucht 1980, cols. 424–37; id. 1995, pp. 468–502; Janssen 1990.

147. Murnane 1995, pp. 110–11.

148. Hornung 1990a, p. 164, fig. 18. In this complex theological image the horizon mountains are replaced by two lions, referring not only to the double lion form in which Egyptians depicted the (male) earth god Aker (Wit 1951, pp. 91–106) but also to the primeval deities Shu and Tefnut, with whom creation started (Wit 1951, pp. 107–22). The sun is surrounded by the Ouroboros snake (Hornung 1990a, loc. cit., "regenerating nonexistence that encircles the world"); below the sun disk is the head of a cow (the sky goddess), and above are the arms that lift and receive the sun at the beginning and end of its daily voyage. Marianne Eaton-Krauss (1983, p. 131) denied that the anthropomorphic image of the rising sun as a child could be related to Amarna ideology. The text (Murnane 1995, pp. 110–11), however, stands as clear evidence of this imagery's continued presence in the minds of believers in the Aten.

149. Assmann 1995, pp. 80–96.

150. Murnane 1995, p. 114.

151. Aldred (1973, p. 163) shows this side of the sculpture.

152. For examples, especially of the later Middle Kingdom, see Vandier 1958, pl. 66, no. 1; pl. 84, nos. 5, 6; pl. 85, nos. 1, 3; for the New Kingdom, see ibid., pl. 121, no. 4, etc.

153. Samson 1978, pp. 22–23, figs. 5a, b; Aldred 1973, pp. 63–64, figs. 39–41. W. Raymond Johnson, in a lecture at The Metropolitan Museum of Art, New York, 1992, advocated identifying the group in the Petrie Museum, London, as Amenhotep III, Queen Tiye, and their small daughter Baketaten. This would, indeed, explain the tripartite wig of the queen, which does not occur in images of Nefertiti in quite this way. Another view pertinent to the present discussion of the group of Akhenaten and Nefertiti in the Louvre is found in Desroches-Noblecourt (1963, p. 134, fig. 70).

154. Aldred (1973, p. 162) reconstructed the torso in the Petrie Museum (here, figs. 104–7) as part of a three-dimensional monument with the various figures facing in different directions. There is, however, no necessity for such a reconstruction, and the one advanced here corresponds more closely to other Amarna groups.

155. N. Davies 1903–8, vol. 5, pl. 43.

156. Compare the group of two men and a boy in The Metropolitan Museum of Art (acc. no. 11.150.21; see Hayes 1990, p. 312, fig. 194).

157. Feucht 1995, pp. 501–2.

158. Aldred 1973, p. 162.

159. Newton 1924, p. 295, pl. 23, 1. For the North Palace, see ibid., pp. 294–98, and Whittemore 1926, pp. 4–8.

160. N. Davies 1929, pp. 58–68, pls. 2–9; Wilkinson and Hill 1983, pp. 25, 132–33: MMA acc. no. 30.4.136.

161. Name of Meretaten: Newton 1924, p. 295, pls. 23, 3; Whittemore 1926, p. 4; Kemp 1986, col. 313.

162. Feucht 1995, pp. 497–98.

163. Eaton-Krauss 1981, p. 253, n. 7; Green 1988, pp. 115–16.

164. N. Davies 1903–8, vol. 1, pl. 22; vol. 2, pls. 5, 18; vol. 3, pl. 18; vol. 4, pls. 5, 9, 31.

165. Ibid., vol. 2, pls. 7, 8, 32.

166. Ibid., vol. 2, pl. 12.

167. Ibid., vol. 6, pl. 3.

168. Ibid., vol. 3, pl. 17.

169. Ibid., vol. 1, pl. 30.

170. Ibid., vol. 3, pl. 16.

171. Ibid., vol. 2, pl. 38; see also, ibid., pls. 33, 34.

172. Since no groups of two in which a taller girl embraces a smaller one are known from the rock tombs, the two girls on the relief in The Metropolitan Museum of Art (acc. no. 1985.328.6; see Mertens et al. 1992, p. 26) most probably belonged to a group of three with an even smaller girl at right. See N. Davies 1903–8, vol. 2, pl. 10.

173. N. Davies 1903–8, vol. 6, pl. 4.

174. Ibid., vol. 2, pls. 10, 33, 34, with breasts seen in profile.

175. Schäfer 1986, pp. 205–10.

176. N. Davies 1903–8, vol. 2, pls. 5, 10; vol. 6, pls. 2–4, 7.

177. Aldred 1988, pp. 178–81. For the Nubian victory: Murnane 1995, pp. 101–3.

178. For the last mention of the princess, in an ink inscription on a jar dated Year 13, see Pendlebury et al. 1951, vol. 2, pl. 86, no. 37.

179. Martin 1974, 1989, vol. 2, pp. 41–48, pls. 11A, 63–81. As to whom the reliefs in room alpha of the Royal Tomb refer, see ibid., pp. 27–41, where the author rejects earlier statements that the scenes in this room refer to Meketaten. See also Aldred 1988, pp. 30–31 (a more cautious approach), and p. 305; G. Johnson 1991, p. 57.

180. Helck 1982, col. 22.

181. For the princess's birth date, see here, p. 11.

182. See, however, Martin 1974, 1989, vol. 2, pp. 47–48.

183. A date for Queen Kiya is mentioned in Year 11 and a more doubtful one in Year 16. The many erasures of her names and images seem to preclude the latter date (Helck 1980, cols. 422–24; Hanke 1978, pp. 133–204).

184. MMA acc. no. 26.7.1295; see Hayes 1990, pp. 296–97, fig. 183.

185. MMA acc. no. 30.8.372; see ibid., p. 296.

186. A palette with six instead of four cakes of pigment with the names of the princess's sister Meretaten was found as an heir-

loom in the tomb of King Tutankhamun (Carter 1933, p. 45, pl. 22A).

187. MMA acc. no. 40.2.4.

188. Hayes 1990, pp. 314, 315, 317, fig. 199.

189. T. Davis et al. 1910, pp. 24–25, pls. 7–19; Bell 1990, pp. 97–137; Dodson 1994a, pp. 57–60, 122–23; id. 1994b, pp. 92–103.

190. MMA acc. no. 30.8.54; see Hayes 1990, pp. 297–99, fig. 184; Saleh and Sourouzian 1987, no. 171.

191. T. Davis et al. 1910, pp. 4, 25.

192. Martin 1985, pp. 111–24.

193. Schäfer 1918, pp. 43–49.

194. Krauss 1986, pp. 67–80.

195. Aldred 1957b, pp. 141–42, 147.

196. Dodson 1994a, p. 59.

197. Aldred 1957b, p. 142.

198. Dodson 1994a, pp. 59–60, 122–23.

199. Krauss 1986, pp. 67–76.

200. Martin 1985, p. 112.

201. There are differences among the four heads but none concern the points raised here (see T. Davis et al. 1910, pls. 8–19).

202. Stylistic similarities with Akhenaten's *shawabtis* are noticeable; see Martin 1974, 1989, vol. 1, pp. 37–72, and especially pl. 33, no. 97, pl. 42, no. 193a, etc.

203. T. Davis et al. 1910, pp. 13–15, pls. 28–33.

204. Martin 1985, pp. 112–13. The arguments advanced by Krauss (1986, p. 74) are for once unconvincing.

205. Aldred 1973, pp. 10–11, fig. 3.

YOUTH AND OLD AGE (pages 121–26)

1. Bothmer (1990, pp. 89–90) used the broader term *hooded eye* in his treatment of this type of eyelid, although that does not really seem to describe this particular shape of the upper lid. For more examples dating to the reign of Tutankhamun, see Russmann (1989, pp. 133–35, nos. 61, 62).

2. Compare the fragment of a head in The Brooklyn Museum (Aldred 1973, p. 168, no. 98). The features of this fragment, although very similar to the Louvre princess, are slightly less stylized: the eyes are more rounded, the mouth is more natural, and the musculature of the cheeks is subtly detailed. The fragment may come from a late Amarna workshop whose sculptors influenced the creator of the Louvre princess. In contrast to the Louvre statuette, the Brooklyn piece has no side lock. The limestone head of a princess in Berlin (inv. no. 14 113; Priese, ed. 1991, pp. 116–17, no. 70; Aldred 1973, p. 175) is reminiscent of the statuette of Nefertiti (see here, figs. 68, 69), but it is not a work of the Thutmose workshop.

3. MMA acc. no. 50.6; Hayes 1990, pp. 300–301, fig. 186, from a statue group with the god Amun.

4. The Louvre princess's closeness to late Amarna art is also emphasized by the numerous similarities to the bust of a young king (Smenkhkare or Tutankhamun) found in the sculptor's workshop (P 49, 6) at Amarna; see Borchardt and Ricke 1980, p. 266, plan 87; Phillips 1991, pp. 31–33; Priese,

ed. 1991, pp. 120–21, no. 72. The eyes and mouth of this king are close to those of the Louvre piece, but the face of the P 49, 6 bust has considerably more depth.

5. See the group of Amun and King Haremhab from the Luxor cachette (El-Saghir 1991, pp. 65–68, figs. 141–48).

6. For instance, works in wood like the head emerging from the lotus flower (Edwards 1976, ills. 22, 45). For works in stone, see Russmann (1989, pp. 133–35, nos. 61, 62).

7. A fragment of a very similar statuette of comparable limestone, but dating to earlier in the Amarna Period, is MMA acc. no. 21.9.16, with other fragments from the Great Aten Temple deposit (the "favissa" find). See Hill, in *Amarna Art in the Metropolitan Museum* (forthcoming).

8. Aldred (1973, p. 178) reconstructed her with an object (a sistrum?) in her raised left hand. This reconstruction is improbable since the left side of the princess adjoins another figure, and sistra are usually held in the right hand.

9. In addition to the Louvre limestone princess and the Berlin Nefertiti statuette, see also the bust of Akhenaten from the Thutmose workshop, now in Berlin, and a bust of unknown provenance in the Louvre (Borchardt 1913, pl. 4).

10. Roeder 1969, pls. 11, 13, 30; 172: PC 15 (MMA acc. no. 1985.328.10), 173: PC 25, 193: PC 147. The earlier Karnak reliefs (here, figs. 10, 23, 58) do not have the harshly abstract pubic triangles (R. Smith and Redford 1976, pls. 19, 29). Traditionally, of course, such triangles were seen on fertility figurines (Robins 1993, p. 57, fig. 17).

11. Edwards 1976, p. 159; clearer in Saleh and Sourouzian 1987, no. 177. This, of course, is another revival of pre-Amarna stylistic traits (Kozloff and Bryan 1992, pp. 206–8, 257–60). The statuette of Tama is an example of a more Amarnesque rendering of the body combined with a hairstyle similar to that of the Louvre and Philadelphia pieces (Russmann 1989, p. 111, no. 52). See also the statue of the wife of Nakhtmin (Saleh and Sourouzian 1987, no. 196).

12. The group might have resembled the scene on the so-called coregency stela (Allen 1991, pp. 76–77, fig. 4). For royal buildings probably erected at Amarna after Akhenaten's death, see Pendlebury et al. 1951, vol. 1, p. 60.

13. T. Davis et al. 1907, pp. 37–44, pls. 33–36; T. Davis and Forbes 1991, pp. 10–11, 24. Also of this date (or early in the Amarna Period?) but from the Faiyum region is the statuette of Tama (Saleh and Sourouzian 1987, no. 154; Russmann 1989, pp. 110–11, no. 52).

14. Goetze 1975, p. 18. The debate about the identity of the author of this letter is ongoing; see Martin 1991, p. 36.

15. Murnane 1995, p. 231.

16. For monumental stone images of queens and goddesses of this period, see W. R. Johnson 1994, pp. 136–49.

17. Boeser 1913, pls. 5, 6, nos. 11, 13.

18. Martin 1991, pp. 147–88; fig. 105 on p. 163 shows the Leiden group; p. 86, fig. 57 shows another contemporaneous statue group, of Haremhab and his first wife, Amenia, which is stylistically similar.

GLOSSARY

Gem pa Aten. "The Aten Is found": The name of temples of the Aten at Karnak (Thebes) and Amarna.

Karnak Cachette. Egyptologists use the French term for deposit, *cachette*, to designate certain finds of large numbers of mummies or statues that were buried or hidden in ancient times. The Karnak Cachette was an assemblage of eight hundred statues and statuettes and seventeen thousand smaller objects discovered by the French archaeologist Georges Legrain in 1903–4 in a court of the Karnak temple north of the seventh pylon (large gateway structure). Today, the statues are in the Egyptian Museum, Cairo.

Khat. Headdress of Egyptian kings. The counterpart to the *nemes*, it was also worn by goddesses, especially in a funerary context, and by Queens Tiye and Nefertiti. The narrow edge of a rectangular piece of cloth was placed across the forehead and temples and tied behind the ears with two bands attached to the corners under the section hanging in the back. The *khat* covered the hair completely but did not cling tightly to the head. It bulged behind the ears and was kept upright on top of the head by two stiff folds above each ear. In the back, the remaining cloth was gathered into a rectangular pouch that fell between the shoulder blades.

Late Period. Twenty-fifth through Thirtieth Dynasties, ca. 743–332 B.C.

Middle Kingdom. Period from the reunification of Egypt under Mentuhotep II through the Thirteenth Dynasty, ca. 2040–1640 B.C.

Modius. Latin word for a cylindrical grain measure used by the ancient Romans. The term is used by Egyptologists to designate the cylindrical base of a female crown, which often has concave sides.

Nemes. Traditional head cover of Egyptian kings. In most cases, a pleated, rectangular piece of cloth was fastened over the forehead and covered the entire head while leaving the ears exposed. Two lappets on either side of the neck fell over

the breasts, and in the back the remaining cloth was twisted into a tight coil. In front, the cloth was held upright by a system of stiff folds that created flat triangular planes at either side of the head.

New Kingdom. Eighteenth through Twentieth Dynasties, ca. 1550–1070 B.C.

Old Kingdom. Third through Eighth Dynasties, ca. 2649–2134 B.C.

Renpet sign. Hieroglyphic ideogram for "year" showing a palm branch stripped of leaves and notched to serve as a tally. Many notches indicate many years, and thus the emblem conveys the wish for a long life

Sed-festival. Ancient ritual of rejuvenation performed for Egyptian kings after thirty years (theoretically) of rule. Following the first *heb sed* (Egyptian for *sed*-festival) celebration, further *sed*-festivals were held after shorter intervals. Texts often mention *sed*-festivals that a pharaoh wished to celebrate but that had not yet actually taken place. Akhenaten celebrated a *sed*-festival remarkably early in his reign, even before the move to Amarna, most probably in Year 2 or 3, and Queen Nefertiti participated in the rites. Whether other *sed*-festivals were performed at Amarna, and whether the Aten himself was the recipient of such rites are matters of debate.

Shawabtis. Small images, mostly in the form of mummies, that were deposited in tombs and sacred places. A spell, often written on the *shawabti*'s body, sought the figure's magical help in case a deceased person was required to do manual labor in the afterlife. Since the *shawabtis* were most often called upon to perform agricultural tasks, many figures had sacks slung over their arms or shoulders and held implements in their hands. During the Amarna Period, some *shawabtis* were inscribed with prayers to the Aten.

Sistrum. Musical instrument in the form of a rattle, used mostly by females in the service of a deity. When shaken, a

jingling sound is created by the loose pieces of metal that are either inserted into holes in a metal loop or attached to the sides of a metal box shaped like a small shrine.

Sunshade temple. Sanctuary used for the daily rites devoted to a solar deity. The Sunshade temple of Queen Tiye at Amarna is depicted in the tomb of her steward, Huya. It had an open court with pylons at each end and surrounding porticoes. The inner sanctuary consisted of three parallel courts; the center court included another portico, and the main altar, at which the royal family is depicted offering, was located in the innermost transversal court. Statues of the Queen, her (deceased?) husband Amenhotep III, and her son Akhenaten stand between the columns of the porti-coes and in the transversal court. Archaeological finds suggest that some Sunshade temples were situated in parkland settings.

Talatat. Building stones used exclusively during the Amarna Period. They were roughly standardized in size: 53–54 cm (20⅞–21¼ in.) in width; 23–24 cm (9–9½ in.) in height; and 26–27 cm (10¼–10⅝ in.) in depth. The origin of the Arabic name *talatat* (threes) is unclear. It has been explained by the fact that the width of the blocks is equal to about three spans of a hand.

Vermilion line. Light reddish outer margins of the lips; in Egyptian art, usually indicated as a sculpted ridge.

BIBLIOGRAPHY

Aldred 1951. Cyril Aldred. *New Kingdom Art in Ancient Egypt During the Eighteenth Dynasty, 1590 to 1315 B.C.* London, 1951.

Aldred 1957a. Cyril Aldred. "The End of the el-ʿAmārna Period." *The Journal of Egyptian Archaeology* 43 (1957), pp. 30–41.

Aldred 1957b. Cyril Aldred. "Hairstyles and History." *Metropolitan Museum of Art Bulletin* 15, no. 6 (February 1957), pp. 141–47.

Aldred 1968. Cyril Aldred. *Akhenaten, Pharaoh of Egypt —A New Study.* London, 1968.

Aldred 1973. Cyril Aldred. *Akhenaten and Nefertiti.* Brooklyn, 1973.

Aldred 1978. Cyril Aldred. "Tradition and Revolution in the Art of the XVIIIth Dynasty." In Denise Schmandt-Besserat, ed., *Immortal Egypt: Invited Lectures on the Middle East at the University of Texas at Austin*, pp. 51–62. Malibu, 1978.

Aldred 1988. Cyril Aldred. *Akhenaten, King of Egypt.* London, 1988.

Aldred and Sandison 1962. Cyril Aldred and A. T. Sandison. "The Pharaoh Akhenaten: A Problem in Egyptology and Pathology." *Bulletin of the History of Medicine* 36, no. 4 (July–August 1962), pp. 293–316.

Allen 1988a. James P. Allen. *Genesis in Egypt: The Philosophy of Ancient Egyptian Creation Accounts.* Yale Egyptological Studies 2. New Haven, 1988.

Allen 1988b. James P. Allen. "Two Altered Inscriptions of the Late Amarna Period." *Journal of the American Research Center in Egypt* 25 (1988), pp. 117–26.

Allen 1989. James P. Allen. "The Natural Philosophy of Akhenaton." In William Kelly Simpson, ed., *Religion and Philosophy in Ancient Egypt*, pp. 89–101. Yale Egyptological Studies 3. New Haven, 1989.

Allen 1991. James P. Allen. "Akhenaten's 'Mystery' Coregent and Successor." In *Amarna Letters*, vol. 1, pp. 74–85. San Francisco, 1991.

Allen 1994. James P. Allen. "Nefertiti and Smenkh-ka-re." *Göttinger Miszellen* 141 (1994), pp. 7–17.

Andrews 1991. Carol Andrews. *Ancient Egyptian Jewelry.* New York, 1991.

Anthes 1958. Rudolf Anthes. *The Head of Queen Nofretete.* Berlin, 1958.

Arnold 1992. Dieter Arnold. *The Pyramid Complex of Senwosret I.* Vol. 3 of *The South Cemeteries of Lisht.* New York, 1992.

Arnold 1994. Dieter Arnold. *Lexikon der ägyptischen Baukunst.* Zürich, 1994.

Assmann 1975a. Jan Assmann. "Aton." In Wolfgang Helck and Wolfhart Westendorf, eds., *Lexikon der Ägyptologie*, vol. 1, cols. 526–40. Wiesbaden, 1975.

Assmann 1975b. Jan Assmann. "Flachbildkunst des Neuen Reiches." In Claude Vandersleyen, ed., *Das alte Ägypten*, pp. 304–25. Propyläen Kunstgeschichte 15. Berlin, 1975.

Assmann 1979. Jan Assmann. "Palast oder Tempel? Überlegungen zur Architektur und Topographie von Amarna." *Journal of Near Eastern Studies* 31, no. 3 (July 1979), pp. 143–55.

Assmann 1980. Jan Assmann. "Die 'Loyalistische Lehre' Echnatons." *Studien zur altägyptischen Kultur* 8 (1980), pp. 1–32.

Assmann 1983. Jan Assmann. *Re und Amun: Die Krise des polytheistischen Weltbilds im Ägypten der 18.–20. Dynastie.* Orbis Biblicus et Orientalis 51. Fribourg, 1983.

Assmann 1984. Jan Assmann. *Ägypten: Theologie und Frömmigkeit einer frühen Hochkultur.* Kohlhammer Urban-Taschenbücher 366. Stuttgart, 1984.

Assmann 1992. Jan Assmann. "Akhanyati's Theology of Light and Time." *Proceedings of The Israel Academy of Sciences and Humanities* 7, no. 4 (1992), pp. 143–76.

Assmann 1993. Jan Assmann. *Monotheismus und Kosmotheismus: Ägyptische Formen eines "Denkens des Einen" und ihre europäische Rezeptionsgeschichte.* Sitzungsberichte der Heidelberger Akademie der Wissenschaften, Philosophisch-historische Klasse, 1993, 2. Heidelberg, 1993.

Assmann 1995. Jan Assmann. *Egyptian Solar Religion in the New Kingdom: Re, Amun and the Crisis of Polytheism.* Translated by Anthony Alcock. London and New York, 1995.

Bell 1990. Martha Bell. "An Armchair Excavation of KV 55." *Journal of the American Research Center in Egypt* 27 (1990), pp. 97–137.

Bénédite 1906. Georges Bénédite. "À propos d'un buste égyptien récemment acquis par le Musée du Louvre." *Fondation Eugène Piot, monuments et mémoires* 13 (1906), pp. 5–27.

Berlin 1983. Ägyptisches Museum der Staatlichen Museen Preussischer Kulturbesitz. *Ägyptisches Museum Berlin.* Berlin, 1983.

Berliner Beiträge 1976. *Berliner Beiträge zur Archäometrie* 1 (1976).

Bickel 1994. Susanne Bickel. *La cosmogonie égyptienne avant le nouvel empire.* Orbis Biblicus et Orientalis 134. Fribourg, 1994.

Blackman 1914. Aylward M. Blackman. *The Tomb-Chapel of Ukh-Ḥotp's Son Senbi.* Vol. 2 of *The Rock Tombs of Meir.* Archaeological Survey of Egypt 22. London, 1914.

Blankenburg-van Delden 1969. C. Blankenburg-van Delden. *The Large Commemorative Scarabs of Amenhotep III.* Leiden, 1969.

Boddens-Hosang 1988. F. J. E. Boddens-Hosang. "Akhenaten's Year Twelve Reconsidered." *Discussions in Egyptology* 12 (1988), pp. 7–9.

Boeser 1913. Pieter Adriaan Boeser. *Pyramiden, Kanopenkasten, Opfertische, Statuen.* Pt. 2 of *Die Denkmäler des Neuen Reiches.* Beschreibung der aegyptischen Sammlung des Niederländischen Reichsmuseums der Altertümer in Leiden. The Hague, 1913.

Bomann 1991. Ann H. Bomann. *The Private Chapel in Ancient Egypt: A Study of the Chapels in the Workmen's Village at el Amarna with Special Reference to Deir el Medina and Other Sites.* London and New York, 1991.

Borchardt 1911. Ludwig Borchardt. *Der Porträtkopf der Königin Teje im Besitz von Dr. James Simon in Berlin.* Vol. 1 of *Ausgrabungen der Deutschen Orient-Gesellschaft in Tell el-Amarna.* Leipzig, 1911.

Borchardt 1912. Ludwig Borchardt. "Ausgrabungen in Tell el-Amarna 1911/12, Vorläufiger Bericht." *Mitteilungen der Deutschen Orient-Gesellschaft zu Berlin* 50 (October 1912), pp. 1–40.

Borchardt 1913. Ludwig Borchardt. "Ausgrabungen in Tell el-Amarna 1912/13, Vorläufiger Bericht." *Mitteilungen der Deutschen Orient-Gesellschaft zu Berlin* 52 (October 1913), pp. 1–55.

Borchardt 1923. Ludwig Borchardt. *Porträts der Königin Nofret-ete aus den Grabungen 1912/13 in Tell el-Amarna.* Vol. 3 of *Ausgrabungen der Deutschen Orient-Gesellschaft in Tell el-Amarna.* Leipzig, 1923.

Borchardt and Ricke 1980. Ludwig Borchardt and Herbert Ricke. *Die Wohnhäuser in Tell el-Amarna.* Vol. 5 of *Ausgrabungen der Deutschen Orient-Gesellschaft in Tell el-Amarna.* Berlin, 1980.

Boreux 1938. Charles Boreux. "Une nouvelle tête amarnienne du Musée du Louvre." *Fondation Eugène Piot, monuments et mémoires* 36 (1938), pp. 1–26.

Bothmer 1990. Bernard V. Bothmer. "Eyes and Iconography in the Splendid Century: King Amenhotep III and His Aftermath." In Lawrence Michael Berman, ed., *The Art of Amenhotep III: Art Historical Analysis, Papers Presented at the International Symposium Held at The Cleveland Museum of Art, Cleveland, Ohio, 20–21 November 1987*, pp. 84–92. Cleveland, 1990.

Bothmer and De Meulenaere 1986. Bernard V. Bothmer and Herman De Meulenaere. "The Brooklyn Statuette of Hor, Son of Pawen (with an Excursus on Eggheads)." In Leonard H. Lesko, ed., *Egyptological Studies in Honor of Richard A. Parker Presented on the Occasion of his 78th Birthday, December 10, 1983*, pp. 1–15. Hanover and London, 1986.

Boyce 1995. Andrew Boyce. "Collar and Necklace Designs at Amarna: A Preliminary Study of Faience Pendants." Chap. 11 of Barry J. Kemp, ed., *Amarna Reports VI*, pp. 336–71. London, 1995.

Brack 1980. Annelies and Artur Brack. *Das Grab des Haremheb: Theben Nr. 78.* Archäologische Veröffentlichungen 35. Mainz am Rhein, 1980.

Breasted 1924. James Henry Breasted. "Ikhnaton, the Religious Revolutionary." Chap. 6 of J. B. Bury et al., eds., *The Cambridge Ancient History*, vol. 2, pp. 109–30. First edition. Cambridge, 1924.

Breasted 1948. James Henry Breasted Jr. *Egyptian Servant Statues.* The Bollingen Series 13. New York, 1948.

Brunner-Traut 1955. Emma Brunner-Traut. "Die Wochenlaube." *Mitteilungen des Instituts für Orientforschung* 3 (1955), pp. 11–30.

Bruyère 1939. Bernard Bruyère. *Le village, les décharges publiques, la station de repos du col de la Vallée des Rois.* Pt. 3 of *Rapport sur les fouilles de Deir el Médineh (1934–1935).* Cairo, 1939.

Bryan 1990. Betsy M. Bryan. "Private Relief Sculpture Outside Thebes and Its Relationship to Theban Relief Sculpture." In Lawrence Michael Berman, ed., *The Art of Amenhotep III:*

Art Historical Analysis, Papers Presented at the International Symposium Held at The Cleveland Museum of Art, Cleveland, Ohio, 20–21 November 1987, pp. 65–80. Cleveland, 1990.

Bryce 1990. Trevor R. Bryce. "The Death of Niphururiya and its Aftermath." *The Journal of Egyptian Archaeology* 76 (1990), pp. 97–105.

Buck 1935–61. Adriaan de Buck. *The Egyptian Coffin Texts.* The University of Chicago Oriental Institute Publications 34, 49, 64, 67, 73, 81, 87. 7 vols. Chicago, 1935–61.

Burlington 1922. Burlington Fine Arts Club. *Catalogue of an Exhibition of Ancient Egyptian Art.* London, 1922.

Burridge 1993. Alwyn Burridge. "A New Perspective on Akhenaten: Amarna Art, Evidence of a Genetic Disorder in the Royal Family of 18th Dynasty Egypt." *The Journal of the Society for the Study of Egyptian Antiquities* 23 (1993). Forthcoming.

Caminos 1975. Ricardo A. Caminos. "Ei." In Wolfgang Helck and Wolfhart Westendorf, eds., *Lexikon der Ägyptologie,* vol. 1, cols. 1185–88. Wiesbaden, 1975.

Carter 1933. Howard Carter. *The Tomb of Tut.ankh.amen Discovered by the Late Earl of Carnarvon and Howard Carter.* Vol. 3. London, 1933.

Černý 1973. Jaroslav Černý. *A Community of Workmen at Thebes in the Ramesside Period.* Bibliothèque d'Étude 50. Cairo, 1973.

Chassinat 1901. Émile Chassinat. "Une tombe inviolée de la XVIIe Dynastie découverte aux environs de Médinet el-Gorab dans le Fayoùm." *Bulletin de l'Institut Français d'Archéologie Orientale* 1 (1901), pp. 225–34.

Chicago 1980. The Epigraphic Survey in cooperation with The Department of Antiquities of Egypt. *The Tomb of Kheruef: Theban Tomb 192.* The University of Chicago Oriental Institute Publications 102. Chicago, 1980.

Connolly, Harrison, and Ahmed 1976. R. C. Connolly, R. G. Harrison, and Soheir Ahmed. "Serological Evidence for the Parentage of Tutꜥankhamūn and Smenkhkarēꜥ." *The Journal of Egyptian Archaeology* 62 (1976), pp. 184–86.

Cooney 1965. John D. Cooney. *Amarna Reliefs from Hermopolis in American Collections.* Brooklyn, 1965.

Daressy 1902. Georges Daressy. *Catalogue général des antiquités égyptiennes du Musée du Caire nos. 24001–24990: Fouilles de la Vallée des Rois (1898–1899).* Cairo, 1902.

B. Davies 1992, 1994, 1995. Benedict G. Davies. *Egyptian Historical Records of the Later Eighteenth Dynasty.* Fascicles 4, 5, 6. Warminster, England, 1992, 1994, 1995.

N. Davies 1903–8. Norman de Garis Davies. *The Rock Tombs of el Amarna.* 6 vols. Archaeological Survey of Egypt, edited by Francis Ll. Griffith. London, 1903–8.

N. Davies 1917. Norman de Garis Davies. *The Tomb of Nakht at Thebes.* New York, 1917.

N. Davies 1921. Norman de Garis Davies. "Mural Paintings in the City of Akhetaten." *The Journal of Egyptian Archaeology* 7 (1921), pp. 1–7.

N. Davies 1929. Norman de Garis Davies. "The Paintings of the Northern Palace." In H. Frankfort, ed., *The Mural Painting of el-ꜥAmarneh*, pp. 58–71. London, 1929.

T. Davis and Forbes 1991. Theodore M. Davis, with commentary by Dennis C. Forbes. "Finding Pharaoh's In-Laws." In *Amarna Letters*, vol. 1, pp. 4–14. San Francisco, 1991.

T. Davis et al. 1907. Theodore M. Davis et al. *The Tomb of Iouiya and Touiyou.* London, 1907.

T. Davis et al. 1910. Theodore M. Davis et al. *The Tomb of Queen Tîyi: The Discovery of the Tomb.* Theodore M. Davis Excavations, Bibân el Molûk, 6. London, 1910.

T. Davis et al. 1912. Theodore M. Davis et al. *The Tombs of Harmhabi and Touatânkhamanou.* London, 1912.

T. Davis et al. 1990. Theodore M. Davis. *The Tomb of Queen Tîyi: The Discovery of the Tomb.* Theodore M. Davis Excavations, Bibân el Molûk, 6. 1910. Reissued with an introduction and bibliography by Nicholas Reeves and contributions by Gaston Maspero, G. Elliot Smith, Edward Ayrton, George Daressy, and E. Harold Jones. San Francisco, 1990.

W. Davis 1978. Whitney Davis. "Two Compositional Tendencies in Amarna Relief." *American Journal of Archaeology* 82 (1978), pp. 387–93.

Demaree 1983. Robert Johannes Demaree. *The ꜣḫ ꞽḳr n rꜥ-Stelae on Ancestor Worship in Ancient Egypt.* Leiden, 1983.

Desroches-Noblecourt 1963. Christiane Desroches-Noblecourt. *Tutankhamen: Life and Death of a Pharaoh.* London, 1963.

Desroches-Noblecourt 1974. Christiane Desroches-Noblecourt. "La Statue colossale fragmentaire d'Aménophis IV offerte par l'Égypte à la France." *Fondation Eugène Piot, monuments et mémoires* 59 (1974), pp. 1–44.

Desroches-Noblecourt 1978. Christiane Desroches-Noblecourt. "Une exceptionnelle décoration pour 'la nourrice qui devint reine.'" *La Revue du Louvre et des Musées de France* 28 (1978), pp. 20–27.

Desroches-Noblecourt 1986. Christiane Desroches-Noblecourt. *La femme au temps des pharaons.* Paris, 1986.

Dodson 1994a. Aidan Dodson. *The Canopic Equipment of the Kings of Egypt.* London and New York, 1994.

Dodson 1994b. Aidan Dodson. "Kings' Valley Tomb 55 and the Fates of the Amarna Kings." In *Amarna Letters,* vol. 3, pp. 92–103. San Francisco, 1994.

Donadoni Roveri, ed. 1989. Anna Maria Donadoni Roveri, ed. *Egyptian Museum of Turin: Egyptian Civilization, Monumental Art.* Milan, 1989.

Doresse 1984–85. Marianne Doresse. "Une statuette d'Akhenaton d'époque amarnienne et le culte quotidien de l'Aton." *Bulletin de la Société d'Égyptologie Genève* 9–10 (1984–85), pp. 89–102.

Dorman, Harper, and Pittman 1987. Peter F. Dorman, Prudence Oliver Harper, and Holly Pittman. *The Metropolitan Museum of Art: Egypt and the Ancient Near East.* New York, 1987.

Eaton-Krauss 1977. Marianne Eaton-Krauss. "The *Khat* Headdress to the End of the Amarna Period." *Studien zur altägyptischen Kultur* 5 (1977), pp. 21–39.

Eaton-Krauss 1981. Marianne Eaton-Krauss. "Miscellanea Amarnensia." *Chronique d'Égypte* 56 (1981), pp. 245–64.

Eaton-Krauss 1983. Marianne Eaton-Krauss. "Eine rundplastische Darstellung Achenatens als Kind." *Zeitschrift für ägyptische Sprache und Altertumskunde* 110, no. 2 (1983), pp. 127–32.

Eaton-Krauss 1989. Marianne Eaton-Krauss. "Walter Segal's Documentation of CG5 1113, the Throne of Princess Sat-Amun." *The Journal of Egyptian Archaeology* 75 (1989), pp. 77–88.

Eaton-Krauss and Graefe 1985. Marianne Eaton-Krauss and Erhart Graefe. *The Small Golden Shrine from the Tomb of Tutankhamun.* Oxford, 1985.

Edwards 1976. Iowerth E. S. Edwards. *Tutankhamun: His Tomb and its Treasures.* Cairo and New York, 1976.

El-Khouly and Martin 1987. Aly el-Khouly and Geoffrey Thorndike Martin. *Excavations in the Royal Necropolis at el-ʿAmarna 1984.* Supplément aux Annales du Service des Antiquités de l'Égypte, no. 33. Cairo, 1987.

El-Saghir 1991. Mohammed el-Saghir. *Das Statuenversteck im Luxortempel.* Zaberns Bildbände zur Archäologie 6. Mainz am Rhein, 1991.

Eyre 1987. Christopher J. Eyre. "Work and the Organisation of Work in the New Kingdom." In Marvin A. Powell, ed., *Labor in the Ancient Near East,* pp. 167–221. New Haven, 1987.

Fairman 1951. Herbert W. Fairman. "The Inscriptions." Chap. 10 of John D. S. Pendelbury et al., *The Central City and Official Quarters, The Excavations at Tell el-Amarna during the Seasons 1926–1927 and 1931–1936,* pt. 3 of *The City of Akhenaten,* vol. 1, pp. 143–223. London, 1951.

Fairman 1961. Herbert W. Fairman. "Once Again the So-called Coffin of Akhenaten." *The Journal of Egyptian Archaeology* 47 (1961), pp. 25–40.

Fay 1986. Biri Fay. "Nefertiti Times Three." *Jahrbuch Preussischer Kulturbesitz* 23 (1986), pp. 359–76.

Feucht 1967. Erika Feucht-Putz. "Die königlichen Pektorale: Motive, Sinngehalt und Zweck." Ph.D. diss., University of Munich, Bamberg, 1967.

Feucht 1971. Erika Feucht. *Pektorale nichtköniglicher Personen.* Ägyptologische Abhandlungen 22. Wiesbaden, 1971.

Feucht 1980. Erika Feucht. "Kind." In Wolfgang Helck and Wolfhart Westendorf, eds., *Lexikon der Ägyptologie,* vol. 3, cols. 424–37. Wiesbaden, 1980.

Feucht 1995. Erika Feucht. *Das Kind im alten Ägypten: Die Stellung des Kindes in Familie und Gesellschaft nach altägyptischen Texten und Darstellungen.* Frankfurt and New York, 1995.

Fisher 1917. Clarence Stanley Fisher. "The Eckley B. Coxe Jr. Egyptian Expedition." *The Museum Journal (University of Pennsylvania)* 8, no. 4 (December 1917), pp. 211–37.

Forbes 1994. Dennis C. Forbes. "The Akhenaten Colossi of Karnak: Their Discovery and Description." In *Amarna Letters,* vol. 3, pp. 47–55. San Francisco, 1994.

Frankfort and Pendlebury 1933. Henry Frankfort and John D. S. Pendlebury. *The North Suburb and the Desert Altars: The Excavations at Tell el Amarna during the Seasons 1926–1932.* Pt. 2 of *The City of Akhenaten.* London, 1933.

Gabolde 1992. Marc Gabolde. "Baketaton fille de Kiya?" *Bulletin de la Société d'Égyptologie Genève* 16 (1992), pp. 27–40.

Gardiner 1905. Alan H. Gardiner. *The Inscription of Mes: A Contribution to the Study of Egyptian Judicial Procedure.* In *Untersuchungen zur Geschichte und Altertumskunde Aegyptens,* vol. 4, no. 3, pp. 87–140. Leipzig, 1905.

Gardiner 1906. Alan H. Gardiner. "Four Papyri of the 18th Dynasty from Kahun." *Zeitschrift für ägyptische Sprache und Altertumskunde* 43 (1906), pp. 27–47.

Gardiner 1928. Alan H. Gardiner. "The Graffito from the Tomb of Pere." *The Journal of Egyptian Archaeology* 14 (1928), pp. 10–11.

Gardiner 1943. Alan H. Gardiner. "The Name of Lake Moeris." *The Journal of Egyptian Archaeology* 29 (1943), pp. 37–46.

Gerhardt 1967. Kurt Gerhardt. "Waren die Köpfchen der Echnaton-Töchter künstlich deformiert?" *Zeitschrift für ägyptische Sprache und Altertumskunde* 94 (1967), pp. 50–62.

Germer 1984. Renate Germer. "Die angebliche Mumie de Teje: Probleme interdisziplinärer Arbeiten." *Studien zur alt-ägyptischen Kultur* 11 (1984), pp. 85–90.

Gilderdale 1984. Peter Gilderdale. "The Early Amarna Canon." *Göttinger Miszellen* 81 (1984), pp. 7–20.

Goetze 1975. Alfred Goetze. "The Struggle for the Domination of Syria (1400–1300 B.C.)." Chap. 17 of Iowerth E. S. Edwards et al., eds. *The Cambridge Ancient History*, vol. 2, pt. 2, pp. 1–20. Third edition. Cambridge, 1975.

Gohary 1992. Jocelyn Gohary. *Akhenaten's Sed-festival at Karnak.* London and New York, 1992.

Green 1988. L. Green. "Queens and Princesses of the Amarna Period: The Social, Political, Religious and Cultic Role of the Women of the Royal Family at the End of the Eighteenth Dynasty." Ph.D. diss., University of Toronto, 1988.

Green 1990–91. L. Green. "A 'Lost Queen' of Ancient Egypt, King's Daughter, King's Great Wife, Ankhesenamen." *KMT: A Modern Journal of Ancient Egypt* 1, no. 4 (Winter 1990–91), pp. 22–29, 67.

Green 1992. L. Green. "Queen as Goddess: The Religious Role of Royal Women in the Late-Eighteenth Dynasty." In *Amarna Letters*, vol. 2, pp. 28–41. San Francisco, 1992.

Grieshammer 1984. Reinhard Grieshammer. "Reinheit, kultische." In Wolfgang Helck and Wolfhart Westendorf, eds., *Lexikon der Ägyptologie*, vol. 5, cols. 212–13. Wiesbaden, 1984.

Griffith 1898. Francis Ll. Griffith. *Hieratic Papyri from Kahun and Gurob (Principally of the Middle Kingdom).* London, 1898.

Griffith 1926. Francis Ll. Griffith. "Stela in Honour of Amenophis II and Taya, from Tell el-ʿAmarnah." *The Journal of Egyptian Archaeology* 12 (1926), pp. 1–2.

Griffith 1931. Francis Ll. Griffith. "Excavations at Tell el-ʿAmarnah—1923–4: A. Statuary." *The Journal of Egyptian Archaeology* 17 (1931), pp. 179–84.

Groenewegen-Frankfort 1951. Henriette A. Groenewegen-Frankfort. *Arrest and Movement: An Essay on Space and Time in the Representational Art of the Ancient Near East.* London, 1951.

Gundlach 1986. Rolf Gundlach. "Taduhepa." In Wolfgang Helck and Wolfhart Westendorf, eds., *Lexikon der Ägyptologie*, vol. 6, cols. 144–45. Wiesbaden, 1986.

Habachi 1965. Labib Habachi. "The Graffito of Bak and Men at Aswan and a Second Graffito Close by Showing Akhenaten before the Hawk-Headed Aten." *Mitteilungen des Deutschen Archäologischen Instituts, Abteilung Kairo* 20 (1965), pp. 85–92.

Hamann 1944. Richard Hamann. *Ägyptische Kunst: Wesen und Geschichte.* Berlin, 1944.

Hamburg 1965. *Ägyptische Kunst aus der Zeit des Königs Echnaton.* Exh. cat. Museum für Kunst und Gewerbe. Hamburg, 1965.

Hanke 1978. Rainer Hanke. *Amarna-Reliefs aus Hermopolis: Neue Veröffentlichungen und Studien.* Hildesheimer Ägypto-logische Beiträge 2. Hildesheim, 1978.

Hari 1964. Robert Hari. *Horemheb et la reine Moutnedjemet, ou, la fin d'une dynastie.* Geneva, 1964.

Hari 1984. Robert Hari. "La religion amarnienne et la tradi-tion polythéiste." In Friedrich Junge, ed., *Studien zu Sprache und Religion Ägyptens zu Ehren von Wolfhart Westendorf, Religion*, vol. 2, pp. 1039–55. 2 vols. Göttingen, 1984.

J. E. Harris and Wente, eds. 1980. James E. Harris and Edward F. Wente, eds. *An X-Ray Atlas of the Royal Mummies.* Chicago, 1980.

J. E. Harris et al. 1978. James E. Harris et al. "Mummy of the 'Elder Lady' in the Tomb of Amenhotep II: Egyptian Museum Catalog Number 61070." *Science*, vol. 200, no. 3436 (9 June 1978), pp. 1149–51.

J. R. Harris 1973a. J. R. Harris. "Nefernefruaten." *Göttinger Miszellen* 4 (1973), pp. 15–17.

J. R. Harris 1973b. John R. Harris. "Nefertiti Rediviva." *Acta Orientalia* 35 (1973), pp. 5–13.

J. R. Harris 1974a. John R. Harris. "Kiya." *Chronique d'Égypte* 49 (1974), pp. 25–30.

J. R. Harris 1974b. John R. Harris. "Nefernefruaten Regnans." *Acta Orientalia* 36 (1974), pp. 11–21.

J. R. Harris 1977. John R. Harris. "Akhenaten or Nefertiti?" *Acta Orientalia* 38 (1977), pp. 5–10.

J. R. Harris 1992. John R. Harris. "Akhenaten and Nefer-nefruaten in the Tomb of Tutʿankhamūn." In C. Nicholas Reeves, ed., *After Tutʿankhamūn: Research and Excavation in the Royal Necropolis at Thebes*, pp. 55–72. London, 1992.

Hawass 1995. Zahi Hawass. *Silent Images: Women of Pharaonic Egypt.* Cairo, 1995.

Hayes 1948. William C. Hayes. "Minor Art and Family History in the Reign of Amun-Hotpe III." *Metropolitan Museum of Art Bulletin* 6, no. 10 (June 1948), pp. 172–79.

Hayes 1959. William C. Hayes. *The Hyksos Period and the New Kingdom (1675–1080 B.C.).* Pt. 2 of *The Scepter of Egypt: A Background for the Study of the Egyptian Antiquities in The Metropolitan Museum of Art.* New York, 1959.

Hayes 1990. William C. Hayes. *The Hyksos Period and the New Kingdom (1675–1080 B.C.).* Pt. 2 of *The Scepter of Egypt: A Background for the Study of the Egyptian Antiquities in The Metropolitan Museum of Art.* 1959. Revised edition. New York, 1990.

Helck 1963. Wolfgang Helck. *Eigentum und Besitz an verschiedenen Dingen des täglichen Lebens.* Pt. 4 of *Materialien zur Wirtschaftsgeschichte des Neuen Reiches.* Akademie der Wissenschaften und der Literatur: Abhandlungen der Geistes- und Sozialwissenschaftlichen Klasse, Jahrgang 1963, no. 3. Wiesbaden, 1963.

Helck 1980. Wolfgang Helck. "Kija." In Wolfgang Helck and Wolfhart Westendorf, eds., *Lexikon der Ägyptologie*, vol. 3, cols. 422–24. Wiesbaden, 1980.

Helck 1982. Wolfgang Helck. "Meketaton." In Wolfgang Helck and Wolfhart Westendorf, eds., *Lexikon der Ägyptologie*, vol. 4, cols. 22–23. Wiesbaden, 1982.

Helck 1984. Wolfgang Helck. "Kijê." *Mitteilungen des Deutschen Archäologischen Instituts, Abteilung Kairo* 40 (1984), pp. 159–67.

Hildesheim 1976. *Echnaton, Nofretete, Tutanchamun.* Exh. cat. Roemer-Pelizaeus-Museum. Hildesheim, 1976.

Hill n.d. Marsha Hill. "The Temple Sculpture." In Dorothea Arnold et al., *Amarna Art in The Metropolitan Museum of Art.* Forthcoming.

Hope 1983. Colin A. Hope. "A Head of Nefertiti and a Figure of Ptah-Sokar-Osiris in the National Gallery of Victoria." *Art Bulletin of Victoria* 24 (1983), pp. 47–62.

Hornung 1990a. Erik Hornung. *Conceptions of God in Ancient Egypt: The One and the Many.* Translated by John Baines. Ithaca, 1990.

Hornung 1990b. Erik Hornung. *The Valley of the Kings: Horizon of Eternity.* Translated by David Warburton. New York, 1990.

Hoving 1996. Thomas Hoving. *False Impressions: The Hunt for Big-Time Art Fakes.* New York, 1996.

Ikram 1989. Salima Ikram. "Domestic Shrines and the Cult of the Royal Family at el-ᶜAmarna." *The Journal of Egyptian Archaeology* 75 (1989), pp. 89–101.

Janssen 1975. Jac. J. Janssen. *Commodity Prices from the Ramessid Period: An Economic Study of the Village of Necropolis Workmen at Thebes.* Leiden, 1975.

Janssen 1990. Rosalind M. and Jac. J. Janssen. *Growing up in Ancient Egypt.* London, 1990.

Jéquier 1940. Gustave Jéquier. *Le Monument funéraire de Pepi II.* Vol. 3 of *Les Approches du temple.* Fouilles à Saqqarah. Cairo, 1940.

G. Johnson 1991. George B. Johnson. "From What Material was Her Unique Regalia Constructed? Seeking Queen Nefertiti's Tall Blue Crown: A Fifteen-Year Quest Ends in the Royal Tomb at el Amarna." In *Amarna Letters*, vol. 1, pp. 50–61. San Francisco, 1991.

W. R. Johnson 1990. W. Raymond Johnson. "Images of Amenhotep III in Thebes: Styles and Intentions." In Lawrence Michael Berman, ed., *The Art of Amenhotep III: Art Historical Analysis, Papers Presented at the International Symposium Held at The Cleveland Museum of Art, Cleveland, Ohio, 20–21 November 1987*, pp. 26–46. Cleveland, 1990.

W. R. Johnson 1994. W. Raymond Johnson. "Hidden Kings and Queens of the Luxor Temple Cachette." In *Amarna Letters*, vol. 3, pp. 128–49. San Francisco, 1994.

Jørgensen 1992. Mogens Jørgensen. "En palimpsest fra el-Amarna." *Meddelelser fra Ny Carlsberg Glyptotek* 48 (1992), pp. 5–13.

Kaiser 1967. Werner Kaiser. *Ägyptisches Museum Berlin.* Berlin, 1967.

Kaiser 1990. Werner Kaiser. "Zur Büste als einer Darstellungsform ägyptischer Rundplastik. *Mitteilungen des Deutschen Archäologischen Instituts, Abteilung Kairo* 46 (1990), pp. 269–85.

Kemp 1976. Barry J. Kemp. "The Window of Appearance at el-Amarna, and the Basic Structure of this City." *The Journal of Egyptian Archaeology* 62 (1976), pp. 81–99.

Kemp 1978. Barry J. Kemp. "The Harim-Palace at Medinet el-Ghurab." *Zeitschrift für ägyptische Sprache und Altertumskunde* 105 (1978), pp. 122–33.

Kemp 1979. Barry J. Kemp. "Wall Paintings from the Workmen's Village at el-ᶜAmarna." *The Journal of Egyptian Archaeology* 65 (1979), pp. 47–53.

Kemp 1986. Barry J. Kemp. "Tell el-Amarna." In Wolfgang Helck and Wolfhart Westendorf, eds., *Lexikon der Ägyptologie*, vol. 6, cols. 309–19. Wiesbaden, 1986.

Kemp 1989. Barry J. Kemp. "Appendix: Workshops and Production at el-Amarna." In *Amarna Reports V*, pp. 56–63. London, 1989.

Kemp 1991. Barry J. Kemp. *Ancient Egypt: Anatomy of a Civilization.* 1989. Reprint. London and New York, 1991.

Kemp 1995. Barry J. Kemp. "Outlying Temples at Amarna." Chap. 15 of Barry J. Kemp, ed., *Amarna Reports VI*, pp. 411–62. London, 1995.

Kemp and Garfi 1993. Barry J. Kemp and Salvatore Garfi. *A Survey of the Ancient City of el-ʿAmarna.* The Egypt Exploration Society Occasional Publications, no. 9. London, 1993.

Kendall 1978. Timothy Kendall. *Passing Through the Netherworld: The Meaning and Play of Senet, an Ancient Egyptian Funerary Game.* Boston, 1978.

Kitchen 1962. K. A. Kitchen. *Suppiluliuma and the Amarna Pharaohs: A Study in Relative Chronology.* Liverpool, 1962.

Klebs 1934. Luise Klebs. *Szenen aus dem Leben des Volkes.* Pt. 1 of *Die Reliefs und Malereien des Neuen Reiches.* Heidelberg, 1934.

Klemm 1993. Rosemarie and Dietrich D. Klemm. *Steine und Steinbrüche im alten Ägypten.* Berlin and Heidelberg, 1993.

Kondo 1992. Jiro Kondo. "A Preliminary Report on the Re-clearance of the Tomb of Amenophis III (WV22)." In C. Nicholas Reeves, ed., *After Tutʿankhamūn: Research and Excavation in the Royal Necropolis at Thebes*, pp. 41–54. London, 1992.

Kozloff and Bryan 1992. Arielle P. Kozloff and Betsy M. Bryan, with Lawrence M. Berman. *Egypt's Dazzling Sun: Amenhotep III and His World.* Exh. cat. The Cleveland Museum of Art. Cleveland, 1992.

Krauss 1978. Rolf Krauss. *Das Ende der Amarnazeit: Beiträge zur Geschichte und Chronologie des Neuen Reiches.* Hildesheimer Ägyptologische Beiträge 7. Hildesheim, 1978.

Krauss 1983. Rolf Krauss. "Der Bildhauer Thutmose in Amarna." *Jahrbuch Preussischer Kulturbesitz* 20 (1983), pp. 119–32.

Krauss 1986. Rolf Krauss. "Kija—ursprüngliche Besitzerin der Kanopen aus KV 55." *Mitteilungen des Deutschen Archäologischen Instituts, Abteilung Kairo* 42 (1986), pp. 67–80.

Krauss 1987. Rolf Krauss. "1913–1988: 75 Jahre Büste der NofretEte/Nefret-iti in Berlin." *Jahrbuch Preussischer Kulturbesitz* 24 (1987), pp. 87–124.

Krauss 1991a. Rolf Krauss. "Die amarnazeitliche Familienstele Berlin 14145 unter besonderer Berücksichtigung von Massordnung und Komposition." *Jahrbuch der Berliner Museen* 33 (1991), pp. 7–36.

Krauss 1991b. Rolf Krauss. "Nefertiti—A Drawing-Board Beauty? The 'most lifelike work of Egyptian art' is Simply the Embodiment of Numerical Order." In *Amarna Letters*, vol. 1, pp. 46–49. San Francisco, 1991.

Krauss 1991c. Rolf Krauss. "1913–1988: 75 Jahre Büste der NofretEte/Nefret-iti in Berlin, Zweiter Teil." *Jahrbuch Preussischer Kulturbesitz* 28 (1991), pp. 123–57.

Krauss and Ullrich 1982. Rolf Krauss and Detlef Ullrich. "Ein gläserner Doppelring aus Altägypten." *Jahrbuch Preussischer Kulturbesitz* 19 (1982), pp. 199–212.

Kuhlmann 1979. K. P. Kuhlmann. "Der Felstempel des Eje bei Achmim." *Mitteilungen des Deutschen Archäologischen Instituts, Abteilung Kairo* 35 (1979), pp. 165–88.

Lange and Hirmer 1961. Kurt Lange and Max Hirmer. *Egypt: Architecture, Sculpture, Painting in Three Thousand Years.* Third edition, revised. Greenwich, Conn., 1961.

Leclant et al. 1978. Jean Leclant et al. *Le temps des pyramides, de la préhistoire aux Hyksos (1560 av. J.-C.).* Pt. 1 of *Le monde égyptien: Les pharaons.* Paris, 1978.

Leclant et al. 1979. Jean Leclant et al. *L'empire des conquérants.* Pt. 2 of *Le monde égyptien: Les pharaons.* Paris, 1979.

Leclant et al. 1980. Jean Leclant et al. *L'Égypte du crépuscule.* Pt. 3 of *Le monde égyptien: Les pharaons.* Paris, 1980.

Leek 1972. F. Filce Leek. *The Human Remains from the Tomb of Tutʿankhamūn.* Tutʿankhamūn's Tomb Series 5. Oxford, 1972.

Legrain 1903. Georges Legrain. "Notice sur le temple d'Osiris Neb-djeto." *Annales du Service des Antiquités de l'Égypte* 4 (1903), pp. 181–84.

Legrain 1906. Georges Legrain. *Statues et statuettes de rois et de particuliers.* Vol. 1. Catalogue général des antiquités égyptiennes du Musée du Caire 30. Cairo, 1906.

Leprohon 1991. Ronald J. Leprohon. "A Vision Collapsed: Akhenaten's Reforms Viewed Through Decrees of Later Reigns." In *Amarna Letters*, vol. 1, pp. 66–73. San Francisco, 1991.

Lesko 1987. Barbara S. Lesko. *The Remarkable Women of Ancient Egypt.* Second edition, revised. Providence, R.I., 1987.

Lesko, ed. 1989. Barbara S. Lesko, ed. *Women's Earliest Records From Ancient Egypt and Western Asia. Proceedings of the Conference on Women in the Ancient Near East, Brown University, Providence, Rhode Island, November 5–7, 1987.* Atlanta, 1989.

Loat 1905. L. Loat. *Gurob.* Egyptian Research Account 10. London, 1905.

Loeben 1986. Christian E. Loeben. "Eine Bestattung der grossen königlichen Gemahlin Nofretete in Amarna?: Die Totenfigur der Nofretete." *Mitteilungen des Deutschen Archäologischen Instituts, Abteilung Kairo* 42 (1986), pp. 99–107.

Loeben 1994a. Christian E. Loeben. "Nefertiti's Pillars: A Photo Essay of the Queen's Monument at Karnak." In *Amarna Letters*, vol. 3, pp. 41–45. San Francisco, 1994.

Loeben 1994b. Christian E. Loeben. "No Evidence of Coregency: Two Erased Inscriptions from Tutankhamen's Tomb." In *Amarna Letters*, vol. 3, pp. 105–9. San Francisco, 1994.

Löhr 1975. Beatrix Löhr. "Aḫānjāti in Memphis." *Studien zur altägyptischen Kultur* 2 (1975), pp. 139–87.

Lucas 1962. Alfred Lucas. *Ancient Egyptian Materials and Industries.* Fourth edition, revised and enlarged by John R. Harris. London, 1962.

Manniche 1975. Lisa Manniche. "The Wife of Bata." *Göttinger Miszellen* 18 (1975), pp. 33–38.

Martin 1982. Geoffrey Thorndike Martin. "Queen Mutnodjmet at Memphis and el-ʿAmarna." In *L'Égyptologie en 1979: Axes prioritaires de recherches*, vol. 2, pp. 275–78. Colloques internationaux du Centre national de la Recherche Scientifique, no. 595. 2 vols. Paris, 1982.

Martin 1985. Geoffrey Thorndike Martin. "Notes on a Canopic Jar from Kings' Valley Tomb 55." In Paule Posener-Kriéger, ed., *Mélanges Gamal eddin Mokhtar*, vol. 2, pp. 111–24. Cairo, 1985.

Martin 1974, 1989. Geoffrey Thorndike Martin. *The Royal Tomb at el-ʿAmarna.* 2 vols. Pt. 7 of *The Rock Tombs of el-ʿAmarna.* London, 1974, 1989.

Martin 1991. Geoffrey Thorndike Martin. *The Hidden Tombs of Memphis: New Discoveries from the Time of Tutankhamun and Ramesses the Great.* London, 1991.

Meltzer 1978. Edmund S. Meltzer. "The Parentage of Tutʿankhamūn and Smenkhkarēʿ." *The Journal of Egyptian Archaeology* 64 (1978), pp. 134–35.

Mercer 1939. Samuel A. B. Mercer. *The Tell el-Amarna Tablets.* 2 vols. Toronto, 1939.

Mertens et al. 1992. Joan R. Mertens et al. "Ancient Art: Gifts from The Norbert Schimmel Collection." *Metropolitan Museum of Art Bulletin* 49, no. 2 (Spring 1992), pp. 1–64.

Meyer 1984. Christine Meyer. "Zum Titel "*ḥmt njswt*" bei den Töchtern Amenophis' III. und IV. und Ramses' II." *Studien zur altägyptischen Kultur* 11 (1984), pp. 253–63.

Montet 1937. Pierre Montet. *Les reliques de l'art syrien dans l'Égypte du nouvel empire.* Paris, 1937.

Moran 1992. William L. Moran. *The Amarna Letters.* Baltimore, 1992.

Moussa and Altenmüller 1977. Ahmed M. Moussa and Hartwig Altenmüller. *Das Grab des Nianchchnum und Chnumhotep.* Archäologische Veröffentlichungen 21. Mainz am Rhein, 1977.

C. Müller 1980. Christa Müller. "Kahlköpfigkeit." In Wolfgang Helck and Wolfhart Westendorf, eds., *Lexikon der Ägyptologie*, vol. 3, cols. 291–92. Wiesbaden, 1980.

M. Müller 1982. Maya Müller. "Die Darstellungen der Königsfamilie in Amarna." In *L'Égyptologie en 1979: Axes prioritaires de recherches*, vol. 2, pp. 281–84. Colloques internationaux du Centre national de la Recherche Scientifique, no. 595. 2 vols. Paris, 1982.

M. Müller 1988. Maya Müller. *Die Kunst Amenophis' III. und Echnatons.* Basel, 1988.

Murnane 1995. William J. Murnane. *Texts from the Amarna Period in Egypt.* Atlanta, 1995.

Murnane and Van Siclen III 1993. William J. Murnane and Charles C. Van Siclen III. *The Boundary Stelae of Akhenaten.* London and New York, 1993.

Naville 1895. Édouard Naville. *Plates I.–XXIV.: The North-Western End of the Upper Platform.* Pt. 1 of *The Temple of Deir el Bahari.* London, 1895.

Naville 1907. Édouard Naville. *The XIth Dynasty Temple at Deir el-Bahari.* London, 1907.

Newton 1924. Francis G. Newton. "The North Palace." *The Journal of Egyptian Archaeology* 10 (1924), pp. 294–98.

Nims 1973. Charles F. Nims. "The Transition from the Traditional to the New Style of Wall Relief under Amenhotep IV." *Journal of Near Eastern Studies* 32, nos. 1–2 (January–April 1973), pp. 181–87.

Nur el Din [1995]. Abdel Halim Nur el Din. *The Role of Women in the Ancient Egyptian Society.* Cairo, [1995].

Peet and Woolley 1923. T. Eric Peet and C. Leonard Woolley. *Excavations of 1921 and 1922 at el-'Amarneh.* Pt. 1 of *The City of Akhenaten.* London, 1923.

Pendlebury et al. 1951. John D. S. Pendlebury et al. *The Central City and Official Quarters: The Excavations at Tell el-Amarna during the Seasons 1926–1927 and 1931–1936.* 2 vols. Pt. 3 of *The City of Akhenaten.* London, 1951.

Perepelkin 1978. Yuri Perepelkin. *The Secret of the Golden Coffin.* Moscow, 1978.

Pernkopf 1980. Eduard Pernkopf. *Head and Neck.* Vol. 1 of *Atlas of Topographical and Applied Human Anatomy.* Second edition, revised. Baltimore and Munich, 1980.

Petrie 1891. William M. Flinders Petrie. *Illahun, Kahun and Gurob, 1889–90.* London, 1891.

Petrie 1894. William M. Flinders Petrie. *Tell el Amarna.* London, 1894.

Phillips 1991. Jacke Phillips. "Sculpture Ateliers of Akhetaten: An Examination of Two Studio-Complexes in the City of the Sun-Disk." In *Amarna Letters,* vol. 1, pp. 31–40. San Francisco 1991.

Phillips 1994. Jacke Phillips. "The Composite Sculpture of Akhenaten: Some Initial Thoughts and Questions." In *Amarna Letters,* vol. 3, pp. 58–71. San Francisco, 1994.

Pinch 1994. Geraldine Pinch. *Magic in Ancient Egypt.* London, 1994.

Porter and Moss 1972. Bertha Porter and Rosalind L. B. Moss, assisted by Ethel W. Burney. *Theban Temples.* Pt. 2 of *Topographical Bibliography of Ancient Egyptian Hieroglyphic Texts, Reliefs, and Paintings.* Second edition, revised. Oxford, 1972.

Priese, ed. 1991. Karl-Heinz Priese, ed. *Ägyptisches Museum: Museumsinsel Berlin.* Mainz, 1991.

Quibell 1901. James Edward Quibell. "A Tomb at Hawaret el Gurob." *Annales du Service des Antiquités de l'Égypte* 2 (1901), pp. 141–43.

Quibell 1908. James Edward Quibell. *Tomb of Yuaa and Thuiu: Catalogue général des antiquités égyptiennes 51001–51191.* Cairo, 1908.

Raven 1994. Maarten J. Raven. "A Sarcophagus for Queen Tiy and Other Fragments from the Royal Tomb at el-Amarna." *Oudheidkundige Mededelingen uit het Rijksmuseum van Oudheden te Leiden* 74 (1994), pp. 7–20.

Redford 1967. Donald B. Redford. *History and Chronology of the Eighteenth Dynasty of Egypt: Seven Studies.* Toronto, 1967.

Redford 1975. Donald B. Redford. "Studies on Akhenaten at Thebes, II: A Report on the Work of the Akhenaten Temple Project of the University Museum, University of Pennsylvania, for the Year 1973–4." *Journal of the American Research Center in Egypt* 12 (1975), pp. 9–14.

Redford 1984. Donald B. Redford. *Akhenaten: The Heretic King.* Princeton, 1984.

Reeves 1988. C. Nicholas Reeves. "New Light on Kiya from Texts in the British Museum." *The Journal of Egyptian Archaeology* 74 (1988), pp. 91–101.

Reeves 1990. C. Nicholas Reeves. *The Complete Tutankhamun: The King, The Tomb, The Royal Treasure.* London, 1990.

Ricke 1932. Herbert Ricke. *Der Grundriss des Amarna-Wohnhauses.* Vol. 4 of *Ausgrabungen der Deutschen Orient-Gesellschaft in Tell el-Amarna.* Leipzig, 1932.

Robins 1981. Gay Robins. "hmt nsw wrt Meritaton." *Göttinger Miszellen* 52 (1981), pp. 75–81.

Robins 1986. Gay Robins. "The Role of the Royal Family in the 18th Dynasty up to the End of the Reign of Amenhotpe III, 1. Queens." *Wepwawet* 2 (Summer 1986), pp. 10–14.

Robins 1992. Gay Robins. "The Mother of Tutankhamun (2)." *Discussions in Egyptology* 22 (1992), pp. 25–27.

Robins 1993. Gay Robins. *Women in Ancient Egypt.* Cambridge, Mass., 1993.

Robins 1994. Gay Robins. *Proportion and Style in Ancient Egyptian Art.* Austin, Texas, 1994.

Robins 1995. Gay Robins. *Reflections of Women in the New Kingdom: Ancient Egyptian Art from The British Museum.* Exh. cat. Michael C. Carlos Museum, Emory University. San Antonio, Texas, 1995.

Roeder 1941. Günther Roeder. "Lebensgrosse Tonmodelle aus einer altägyptischen Bildhauerwerkstatt." *Jahrbuch der preussischen Kunstsammlungen* 62, no. 4 (1941), pp. 145–70.

Roeder 1969. Günther Roeder. *Amarna-Reliefs aus Hermopolis: Ausgrabungen der Deutschen Hermopolis-Expedition in Hermopolis 1929–1939.* Pelizaeus-Museum zu Hildesheim Wissenschaftliche Veröffentlichung 6. Hildesheim, 1969.

Roehrig 1990. Catharine Hershey Roehrig. "The Eighteenth Dynasty Titles Royal Nurse (mn't nswt), Royal Tutor (mn'n-swt), and Foster Brother/Sister of the Lord of the Two Lands (sn/snt mn' n nb t3wy)." Ph.D. diss., University of California, Berkeley, 1990.

Roehrig 1994. Catharine Hershey Roehrig. "Relief Block with the Face of Nefertiti." *Metropolitan Museum of Art Bulletin* 52, no. 2 (Fall 1994), p. 9.

Romano 1979. James F. Romano. *The Luxor Museum of Ancient Egyptian Art: Catalogue.* Cairo, 1979.

Romano 1995. James F. Romano. "The 'Wilbour Plaque.'" In Nancy Thomas, ed., *The American Discovery of Ancient Egypt,* pp. 91–92. Exh. cat. Los Angeles County Museum of Art. Los Angeles, 1995.

Romer 1981. John Romer. *Valley of the Kings: Exploring the Tombs of the Pharaohs.* New York, 1981.

Russmann 1989. Edna R. Russmann. *Egyptian Sculpture: Cairo and Luxor.* Austin, Texas, 1989.

Saleh and Sourouzian 1987. Mohamed Saleh and Hourig Sourouzian. *The Egyptian Museum Cairo: Official Catalogue.* Mainz, 1987.

Samson 1973. Julia Samson. "Amarna Crowns and Wigs: Unpublished Pieces from Statues and Inlays in the Petrie Collection at University College, London. *The Journal of Egyptian Archaeology* 59 (1973), pp. 47–59.

Samson 1978. Julia Samson. *Amarna: City of Akhenaten and Nefertiti, Nefertiti as Pharaoh.* Warminster, England, 1978.

Samson 1985. Julia Samson. *Nefertiti and Cleopatra: Queen-Monarchs of Ancient Egypt.* London, 1985.

Sandman 1938. Maj Sandman. *Texts from the Time of Akhenaten.* Bibliotheca Aegyptiaca 8. Brussels, 1938.

San Francisco 1991. "Pictorial Essay: Amarna Rogues Gallery." In *Amarna Letters,* vol. 1, pp. 41–45. San Francisco, 1991.

Schäfer 1918. Heinrich Schäfer. "Die angeblichen Kanopenbildnisse König Amenophis des IV." *Zeitschrift für ägyptische Sprache und Altertumskunde* 55 (1918), pp. 43–49.

Schäfer 1931. Heinrich Schäfer. *Amarna in Religion und Kunst.* Berlin, 1931.

Schäfer 1986. Heinrich Schäfer. *Principles of Egyptian Art.* Edited by Emma Brunner-Traut. Translated by John Baines. Oxford, 1986.

Schoske 1993. Sylvia Schoske. *Egyptian Art in Munich.* Staatliche Sammlung Ägyptischer Kunst. Munich, 1993.

Schott 1980. Erika Schott. "Künstler." In Wolfgang Helck and Wolfhart Westendorf, eds., *Lexikon der Ägyptologie,* vol. 3, cols. 833–36. Wiesbaden, 1980.

Sethe 1908-22. Kurt Sethe. *Die altaegyptischen Pyramidentexte nach den Papierabdrücken und Photographien des Berliner Museums.* 4 vols. Leipzig, 1908–22.

Settgast 1985. Jürgen Settgast. *Ägyptisches Museum Berlin.* Rev. ed. Berlin, 1985.

Settgast, ed. 1976. Jürgen Settgast, ed. *Nofretete Echnaton.* Exh. cat. Ägyptisches Museum der Staatlichen Museen Preussischer Kulturbesitz. Berlin, 1976.

Shaw 1994. Ian Shaw. "Balustrades, Stairs and Altars in the Cult of the Aten at el-Amarna." *The Journal of Egyptian Archaeology* 80 (1994), pp. 109–27.

G. Smith 1912. G. Elliot Smith. *Catalogue général des antiquités égyptiennes du Musée du Caire nos. 61051–61100: The Royal Mummies.* Cairo, 1912.

R. Smith and Redford 1976. Ray Winfield Smith and Donald B. Redford. *Initial Discoveries.* Vol. 1 of *The Akhenaten Temple Project.* Warminster, England, 1976.

W. Smith 1981. William Stevenson Smith. *The Art and Architecture of Ancient Egypt.* 1958. Revised with additions by William Kelly Simpson. London, 1981.

Sourouzian 1991. Hourig Sourouzian. "La statue d'Amenhotep fils de Hapou, âgé, un chef-d'oeuvre de la XVIIIe dynastie." *Mitteilungen des Deutschen Archäologischen Instituts, Abteilung Kairo* 47 (1991), pp. 341–55.

Spencer 1993. A. J. Spencer. *Early Egypt: The Rise of Civilization in the Nile Valley.* London, 1993.

Stadelmann 1967. Rainer Stadelmann. *Syrisch-Palästinensische Gottheiten in Ägypten.* Probleme der Ägyptologie 5. Leiden, 1967.

Stadelmann 1969. Rainer Stadelmann. "Šwt-R'w als Kultstätte des Sonnengottes im Neuen Reich." *Mitteilungen des Deutschen Archäologischen Instituts, Abteilung Kairo* 25 (1969), pp. 159–78.

Steinmann 1980. Frank Steinmann. "Untersuchungen zu den in der handwerklich-künstlerischen Produktion beschäftigten Personen und Berufsgruppen des Neuen Reichs." *Zeitschrift für ägyptische Sprache und Altertumskunde* 107 (1980), pp. 137–57.

Strouhal 1982. Eugen Strouhal. "Queen Mutnodjmet at Memphis: Anthropological and Paleopathological Evidence." In *L'Égyptologie en 1979: Axes prioritaires de recherches,* vol. 2, pp. 317–22. Colloques internationaux du Centre national de la Recherche Scientifique, no. 595. 2 vols. Paris, 1982.

Tawfik 1981. Sayed Tawfik. "Aton Studies." *Mitteilungen des Deutschen Archäologischen Instituts, Abteilung Kairo* 37 (1981), pp. 469–73.

Tefnin 1971. Roland Tefnin. "La date de la statuette de la dame Toui au Louvre." *Chronique d'Égypte* 46 (January 1971), pp. 35–49.

Tefnin 1979. Roland Tefnin. *La statuaire d'Hatshepsout: Portrait royale et politique sous la 18e dynastie.* Monumenta Aegyptiaca 4. Brussels, 1979.

Thomas 1994. Angela P. Thomas. "The Other Woman at Akhetaten: Royal Wife Kiya." In *Amarna Letters*, vol. 3, pp. 72–81. San Francisco, 1994.

Trad and Mahmoud 1995. May Trad and Adel Mahmoud. "Amenhotep III in the Egyptian Museum, Cairo." *KMT: A Modern Journal of Ancient Egypt* 6, no. 3 (Fall 1995), pp. 40–50.

Troy 1986. Lana Troy. *Patterns of Queenship in Ancient Egyptian Myth and History.* Uppsala, 1986.

Uphill 1970. Eric P. Uphill. "The Per Aten at Amarna." *Journal of Near Eastern Studies* 29, no. 3 (July 1970), pp. 151–66.

Urkunden 1957. *Urkunden der 18. Dynastie.* Compiled by Wolfgang Helck. Vol. 4. Pt. 20. Berlin, 1957.

Valbelle 1981. Dominique Valbelle. *Satis et Anoukis.* Mainz am Rhein, 1981.

Valbelle 1985. Dominique Valbelle. *Les Ouvriers de la tombe: Deir el-Médineh à l'époque Ramesside.* Bibliothèque d'Étude 96. Cairo, 1985.

Vandersleyen 1992. Claude Vandersleyen. "Royal Figures from Tutꜥankhamūn's Tomb: Their Historical Usefulness." In C. Nicholas Reeves, ed., *After Tutꜥankhamūn: Research and Excavation in the Royal Necropolis at Thebes*, pp. 73–84. London, 1992.

Vandier 1958. Jacques Vandier. *Les grandes époques: La statuaire.* Vol. 3 of *Manuel d'archéologie égyptienne.* Paris, 1958.

Vandier d'Abbadie 1937–[46]. Jeanne Vandier d'Abbadie. *Catalogue des Ostraca figurés de Deir el Médineh [2001 à 2733].* Vol. 2, fascicles [1–3] of *Documents de fouilles publiés par les membres de l'Institut Français d'Archéologie Orientale du Caire.* Cairo, 1937–[46].

Vassilika 1995. Eleni Vassilika. *Egyptian Art.* Fitzwilliam Museum Handbooks. Cambridge, 1995.

Vienna 1975. *Echnaton-Nofretete-Tutanchamun.* Exh. cat. Neue Hofburg. Vienna, 1975.

Walle 1968. Baudouin van de Walle. "La princesse Isis, fille et épouse d'Aménophis III." *Chronique d'Égypte* 43 (1968), pp. 36–54.

Waseda University 1993. Waseda University, Architectural Research Mission. *Studies on the Palace of Malqata, 1985–1988.* Tokyo, 1993.

Wenig 1969. Steffen Wenig. *The Woman in Egyptian Art.* New York, 1969.

Whittemore 1926. Thomas Whittemore. "The Excavations at el-ꜥAmarnah, Season 1924–5." *The Journal of Egyptian Archaeology* 12 (1926), pp. 3–12.

Wiedemann and Bayer 1982. H. G. Wiedemann and G. Bayer. "The Bust of Nefertiti." *Analytical Chemistry* 54, no. 4 (April 1982), pp. 619–28.

Wildung 1992. Dietrich Wildung. "Einblicke: Zerstörungsfreie Untersuchungen an altägyptischen Objekten." *Jahrbuch Preussischer Kulturbesitz* 29 (1992), pp. 133–56.

Wildung 1994. Dietrich Wildung. "Späte Offenbarung: Die Neuaufstellung der Berliner Amarna-Sammlung." *Jahrbuch Preussischer Kulturbesitz* 31 (1994), pp. 77–97.

Wildung 1995. Dietrich Wildung. "Metamorphosen einer Königin: Neue Ergebnisse zur Ikonographie des Berliner Kopfes der Teje mit Hilfe der Computertomographie." *Antike Welt* 26, no. 4 (1995), pp. 245–49.

Wildung and Grimm 1978. Dietrich Wildung and Günter Grimm. *Götter Pharaonen.* Exh. cat. Haus der Kunst. Munich, 1978.

Wildung and Schoske 1984. Dietrich Wildung and Sylvia Schoske. *Nofret—Die Schöne: Die Frau im alten Ägypten.* Exh. cat. Haus der Kunst. Munich, 1984.

Wilkinson and Hill 1983. Charles K. Wilkinson and Marsha Hill. *Egyptian Wall Paintings: The Metropolitan Museum of Art's Collection of Facsimiles.* New York, 1983.

Wilson 1973. John A. Wilson. "Akh-en-Aton and Nefert-iti." *Journal of Near Eastern Studies* 32, nos. 1–2 (January–April 1973), pp. 235–41.

Wit 1951. Constant de Wit. *Le rôle et le sens du lion dans l'Égypte ancienne.* Leiden, 1951.

Woolley 1922. C. Leonard Woolley. "Excavations at Tell el-Amarna." *The Journal of Egyptian Archaeology* 8 (1922), pp. 48–82.

Ziegler 1990. Christiane Ziegler. *The Louvre: Egyptian Antiquities.* Paris, 1990.